Edvard Munch
The Modern Eye

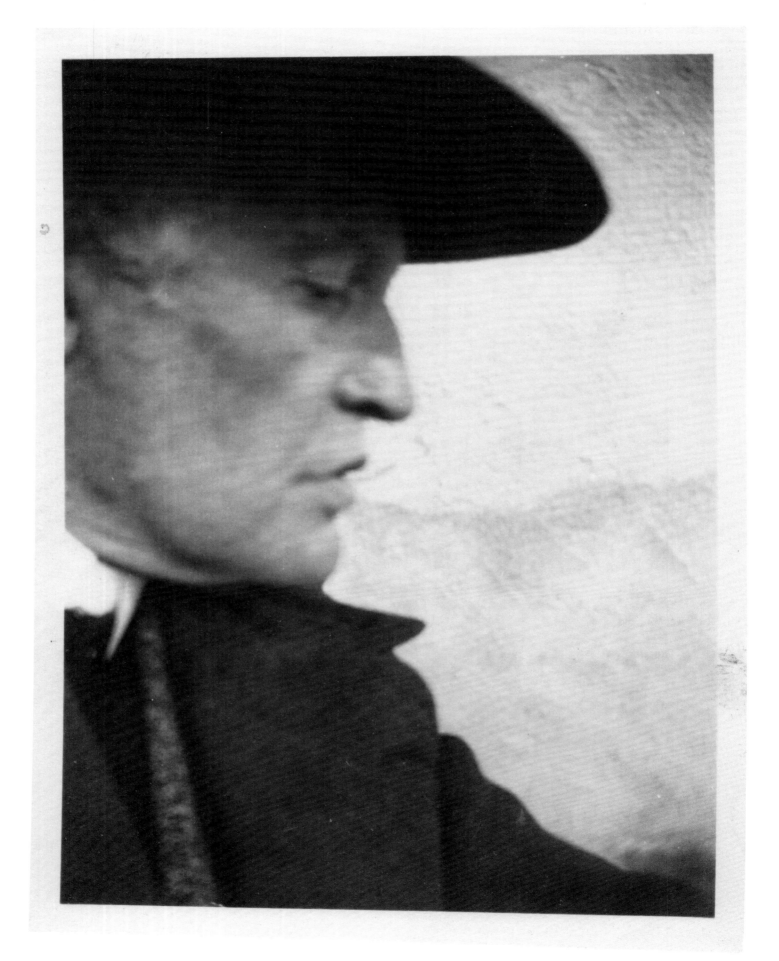

Edvard Munch
The Modern Eye

Edited by
**Angela Lampe
and Clément Chéroux**

With contributions by
**François Albera
Magne Bruteig
Clément Chéroux
Nicholas Cullinan
Arne Eggum
Mai Britt Guleng
Lasse Jacobsen
Angela Lampe
Philippe Lanthony
Aurore Méchain
Iris Müller-Westermann
Pascal Rousseau
Sivert Thue
Gerd Woll
Ingebjørg Ydstie**

Tate Publishing

First published in French by Editions du Centre Pompidou, Paris 2011

First published in English 2012 by order of the Tate Trustees

by Tate Publishing, a division of Tate Enterprises Ltd, Millbank, London SW1P 4RG www.tate.org.uk/publishing

on the occasion of the exhibition *Edvard Munch: The Modern Eye*

Centre Pompidou, Paris
22 September 2011 –
23 January 2012

Schirn Kunsthalle, Frankfurt
9 February – 28 May 2012

Tate Modern, London
28 June – 14 October 2012

The exhibition is organised by the Centre Pompidou, Musée national d'art moderne, Paris, in cooperation with the Munch-museet, Oslo, and in association with Tate Modern, London

The exhibition at Tate Modern is supported by Samuel and Nina Wisnia and sponsored by

A catalogue record for this book is available from the British Library

ISBN 978 1 84976 023 2 (hbk)
ISBN 978 1 84976 058 4 (pbk)

Distributed in the United States and Canada by ABRAMS, New York

Library of Congress Control Number: 2011940734

Designed by Guénola Six
Colour reproduction by Printmodel, Paris
Printed in Belgium by Deckers Snoeck, Anvers

Front cover: Edvard Munch, *The Girls on the Bridge* 1927 (no.21, detail)
Back cover: Edvard Munch, *Self-Portrait with Hat (left Profile), Ekely* 1930 (no.114, detail)
Page 2: Edvard Munch, *Self-Portrait with Hat (right profile) at Ekely* 1930 (no.113)
Page 5: Edvard Munch, *Starry Night* 1922–4 (no.83)

Measurements of artworks are given in centimetres, height before width and depth

MIX
Paper from responsible sources
FSC® C018676

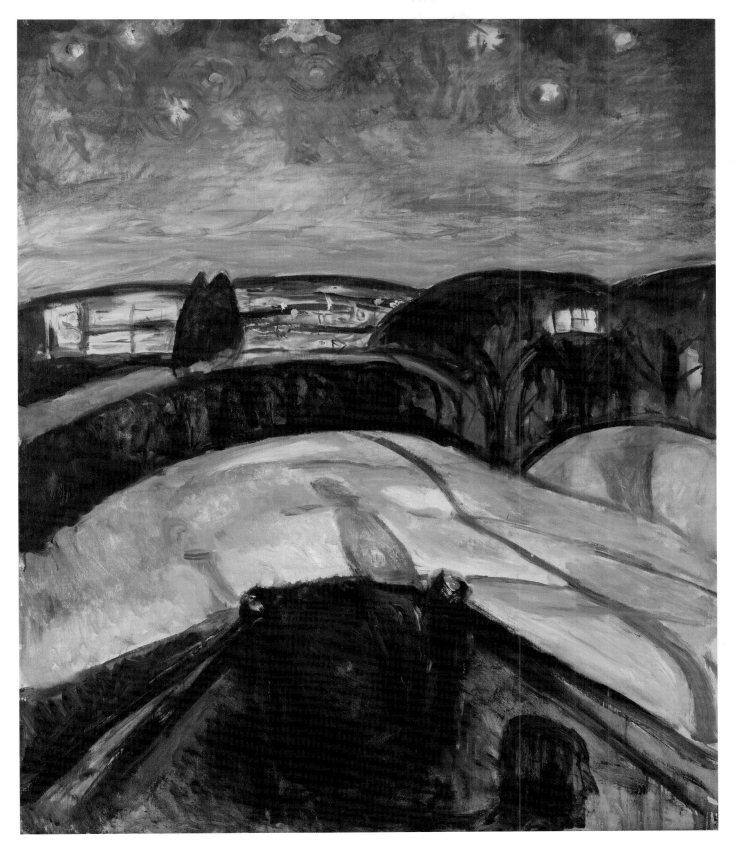

Contents

Sponsor's Foreword

Statkraft is proud to sponsor the 2012 Edvard Munch exhibition at Tate Modern. Edvard Munch had a modern eye in regard to art; similarly, Statkraft has a modern approach to energy.

Statkraft firmly believes the world needs more renewable energy in order to combat climate change. As the largest producer of renewable energy in Europe, Statkraft is well positioned to invest and provide expertise to realise the ambition of a more sustainable future. As an independent generator, Statkraft invests in large renewable energy projects, making a major contribution to meeting the UK's climate and energy security ambitions. This will strengthen the development of a supply-chain industry in the UK, generate growth and create new jobs.

The Statkraft group develops and generates hydropower, windpower, gas power and district heating, and is a major player on the European energy exchanges. Based in Norway, Statkraft is active in more than twenty countries, and has over a hundred years' experience of providing pure energy. In the UK the company operates hydropower and onshore wind-power plants and has an important trading and origination role.

As part of a long-term commitment to offshore wind power in the UK, Statkraft, in partnership with Statoil, is in the process of constructing the 317 MW Sheringham Shoal wind farm off the coast of Norfolk. The company has also been granted a licence to develop Europe's largest offshore wind zone Dogger Bank 9000 MW.

Statkraft is delighted to be associated with *Edvard Munch: The Modern Eye* at Tate Modern, and is proud to share one of Norway's most significant artists with the UK and all the visitors to the exhibition.

Bente E. Engesland
Corporate Communication
Director, Statkraft

Directors' forewords

Few other modern artists are perhaps better known and yet less understood than Edvard Munch (1863–1944). *Edvard Munch: The Modern Eye* proposes a path-breaking rereading of the artist's work by examining the dialogue between his paintings, drawings and prints made in the first half of the twentieth century and his often overlooked interest in the rise of other media during that time, including photography, film and theatre. Munch has often been presented primarily as a late nineteenth-century painter, as symbolist or a pre-expressionist, but this exhibition shows instead how he emphatically engaged with concerns that were thoroughly representative of the modernity of the early twentieth century. The new vantage points and modes of perception offered by cinema, photography and the introduction of electric lighting for theatre stages all make themselves apparent in Munch's painting, and his work in these mediums shows his embrace of modernity. This exhibition questions some of the clichés that have sometimes followed Munch's work and obscured a full understanding of it – of the artist as a tortured outsider, for example – and instead reveals Munch's lively interest in the world around him as it underwent phenomenal change. As we approach the 150th anniversary of Munch's birth in 2013, his prescient interest in repetition also seems germane to contemporary eyes: his version of *The Sick Child* from 1907 is a work in the Tate collection much loved by visitors, and so it is thrilling to be able to present it here in such a fascinating and enriching context. This exhibition therefore very much reflects Tate Modern's interest in rereading modernism from a contemporary perspective, and it is to this end that we are working with Stuart Comer, our Curator of Film, to present Peter Watkins's wonderful filmic portrait *Edvard Munch* from 1974, as part of a series of screenings dedicated to his work.

Edvard Munch: The Modern Eye has been organised by the Centre Pompidou, Musée national d'art moderne, Paris, in cooperation with the Munch-museet in Oslo and in association

with Tate Modern. At the Pompidou, we should like to thank our colleagues warmly for making it possible to present such an important exhibition in London: Alain Seban, President, Agnès Saal, Director General, Alfred Pacquement, Director, and Angela Lampe and Clément Chéroux, the curators of the exhibition, who have put together such an intelligent and nuanced reading of Munch's career and worked with us so diligently. At the Pompidou, our thanks are also due to Yvon Figueras, Head of Exhibition Management, and Lora Houssaye, Registrar, for overseeing an array of logistical issues; and on the publishing side Francesca Baldi, Matthias Battestini, Bernadette Borel, Marie-Sandrine Cadudal, Jean-Christophe Claude, Marion Diez, Nicolas Roche, and Amarante Szidon. It has been a pleasure working with all the staff of the Pompidou again on another fruitful collaboration between our two institutions. We are also deeply indebted to the staff of the Munch-museet in Oslo for supporting us every step of the way in mounting this exhibition. We are grateful to the Director, Stein Olav Henrichsen, for his crucial help in this endeavour. Special thanks must also go to Chief Curator Ingebjørg Ydstie for so generously helping us with myriad requests for loans and information, and for her patience and good humour through-out. Rikke Lundgreen, Registrar, has also been a vital point of contact. The exhibition travels to us from the Schirn Kunsthalle, Frankfurt, where it was beautifully installed, and so we wish to extend our thanks to Max Hollein, Director, and Ingrid Pfeiffer, Curator, for such a good-natured dialogue.

At Tate Modern, we would first of all like to offer sincere thanks to Nicholas Cullinan, Curator of International Modern Art, for working closely with Angela Lampe, Clément Chéroux and Ingebjørg Ydstie in curating the exhibition in London, and for overseeing all aspects of such a complex and ambitious project. In all of this, he has been brilliantly supported by Shoair Mavlian, Assistant Curator, who has proved invaluable in all aspects of the exhibition organisation. Thanks are also due to Lincoln Dexter, Curatorial Intern, for working on the exhibition at an early stage. We are also grateful as ever to Helen Sainsbury, Head of Exhibitions Realisation, Rachel Kent, Exhibitions Touring Manager, Caroline McCarthy, Registrar, and Phil Monk and Kerstin Doble for negotiating all aspects of the exhibition organisation so skilfully.

This catalogue is a remarkably rich publication containing a great deal of important scholarship. In addition to all the authors for their distinguished contributions, we would like to thank the Tate Publishing team: Nicola Bion, Roanne Marner, Richard Mason, Roz Young and all the translators. Thanks also to Guénola Six, for her elegant and thoughtful design.

We also wish to thank all the lenders to the exhibition, who have so graciously parted with such highly-prized works: the Munch-museet, Oslo; Nasjonalmuseet for Kunst, arkitektur og design, Oslo; Göteborgs Konstmuseum, Göteborg; The Stenersen Collection, Bergen Kunstmuseum; Westfälisches Landesmuseum für Kunst und Kulturgeschichte Münster; Kunstmuseum Basel; Philip and Lynn Straus and the collectors who wish to remain anonymous.

This exhibition has been made possible by the provision of insurance through the Government Indemnity Scheme. Tate would like to thank HM Government for providing Government Indemnity and the Department for Culture, Media and Sport and Arts Council England for arranging the indemnity.

Finally, we would like to offer profound thanks to Samuel and Nina Wisnia and to Statkraft for supporting the exhibition and therefore making such an historic endeavour possible.

Chris Dercon
Director
Tate Modern

It is a great pleasure for the Munch-museet to collaborate with one of the world's greatest museums – Tate Modern – in presenting the exhibition *Edvard Munch: The Modern Eye*, the broadest and most extensive presentation of Munch's art in Britain in nearly twenty years.

The exhibition originally began as a research-based collaboration with Centre Pompidou in Paris and their curators Angela Lampe and Clément Chéroux, with the aim of placing Edvard Munch's late works in a new and broadened perspective. By conducting a pioneering and extensive investigation of the artist's use of the aesthetic possibilities of photography, and his response to modern visual media and the theatre, new insight has been gleaned regarding the artist and his oeuvre that contradicts traditional perceptions of Edvard Munch as an introverted painter of recollected mental images.

The exhibition was a great success in Paris in the autumn of 2011, and was one of the most visited exhibitions in the history of Centre Pompidou with nearly 500,000 visitors. A positive response from both the public and the press testifies to the actuality of the project and not least to the artist's relevance for our times. The exhibition has travelled to Schirn Kunsthalle in Frankfurt, where the interest in Edvard Munch's art has likewise been substantial.

At the time of his death in 1944, Edvard Munch bequeathed all of the work still in his possession to the Municipality of Oslo, nearly 24,000 works of art. Added to this are Munch's experimental photographs and attempts at filmmaking, literary manuscripts, letters and written documents. In order to maintain this fantastic treasure, the Munch-museet was established in 1963. The museum has developed extensive international collaborations related to research, exhibitions and loans. This activity has been decisive in establishing Munch's position as a major modernist painter in an international perspective, and it is a central task of the museum's own art historians to contribute to such endeavours. We are therefore very proud that our Senior Curator, Ingebjørg Ydstie, has participated in the research together with the museum's previous Senior Curators, Arne Eggum and Gerd Woll.

We have enjoyed working with our colleagues at Tate Modern tremendously, and we hope that the exhibition will reach a large public in London, and at the same time inspire art lovers to visit our museum in Oslo, where we will be celebrating the 150th anniversary of Munch's birth throughout 2013 with one of the most inclusive exhibitions of his works ever presented.

Stein Olav Henrichsen
Museum Director
Munch-museet, Oslo

Angela Lampe and
Clément Chéroux

Edvard Munch: The Modern Eye

Art history monographs often begin with a date of birth. This one begins with a death; the Norwegian painter Edvard Munch passed away on 23 January 1944 in Oslo. That very same year was marked by the passing of two other great painters, Vassily Kandinsky and Piet Mondrian. Munch was therefore a contemporary of these two modernist painters who left a lasting imprint on the art of the twentieth century. He is instead, however, generally considered a nineteenth-century artist, a symbolist or proto-expressionist, who more readily finds his place in the chronology of art alongside Vincent van Gogh and Paul Gauguin. Munch was born in 1863 and began to paint in the 1880s, but three-quarters of his production dates from after 1900.[1] His friend Rolf E. Stenersen claims that 'the most prosperous period in his life was undoubtedly the interval between 1913 and 1930'.[2] With the exception of an exhibition at the High Museum of Art in Atlanta in 2002, *After the Scream: The Late Paintings of Edvard Munch*,[3] most retrospectives dedicated to the artist since his death have focused on his work during the 1890s, predominantly showing canvases from the *Frieze of Life*: *The Scream, The Kiss, Vampire, Puberty,* and so on. While some of these pieces have been revisited by way of an introduction, this exhibition is centred on his work after 1900. It aims to show that Munch was also very much a twentieth-century painter.

Munch experts generally see the early twentieth century as marking a break in the painter's work. Studies suggest that this takes place either in 1902, at the time of the violent lovers' quarrel with Tulla Larsen during which a pistol shot damaged a bone in the painter's left hand, or after his stay in Dr Jacobson's clinic between 1908 and 1909, where he underwent treatment for a nervous disorder. An understanding of historical contexts is not always facilitated by simply addressing them through the prism of rupture or its inevitable corollary: newness. The Munch of the twentieth century is not a radically new painter

compared to that of the nineteenth century. He returns to some of his favourite themes and patterns of composition that he has already explored, and transposes particular subjects from the *Frieze of Life* into new settings. The perspective in his pictures deepens, the outlines of shapes are less distinct, dynamic effects multiply, and colours become more intense. The principle adopted here envisages the evolution of Munch's work less in terms of *newness* than of *intensity*. For, more than being new, it is the cumulative effect of this intensity that ultimately pushes the boundaries. At the point in art history when it is generally considered that the transition from modernity to modernism could take place only through a formal break, a policy of tabula rasa, the establishment of radically different aesthetic principles bringing about a generational shift, Munch accomplishes the equivalent of a Copernican revolution all on his own.

The general public tends to see Munch as a lonely, angst-ridden artist. Since his death, the dominant discourse has struggled to avoid the pitfall of the dual cliché of the artist's Nordic origins and a psychologising approach to his work. On the one hand, a certain Scandinavian melancholy, the light of the North, the earthly temperament associated with the northern lands have been the recurrent keys to an interpretation by commentators who, more often than not, succumbed to a kind of northern exoticism. On the other hand, illness, repeated bereavements, emotional dramas, and the problems with alcohol and depression that peppered the life of the artist have provided a field of study particularly suited to a psychoanalytical approach to art. For this movement in art history, which became particularly well developed in the second half of the twentieth century, Munch was a godsend. Of course, it cannot be denied that Munch was a northern European artist who led a difficult life, to say the least. His work is not only the fruit of this dual assessment, however. Munch travelled throughout his life, multiplying his encounters and experiences, and was subject to many

influences, to which he was not always impervious. During the first decades of the twentieth century he went to the cinema, listened to the radio, read the international press and subscribed to a number of illustrated magazines. He was also interested in current affairs, following political debates as much as artistic ones, and was moved by the news items that dominated the headlines, as well as by the war that engulfed Europe. In short, he was completely in tune with his time and this had an impact on his work – something which this exhibition also attempts to show.

Edvard Munch: The Modern Eye is therefore not a retrospective, content to assemble masterpieces in a more or less chronological order, like threading beads onto a necklace. It is resolutely an exhibition of themes and theories, which seeks to explore the various aspects of Munch's modernity.[4] It is organised into eleven sections, each corresponding to *signs of modernity* identified in the painter's work. The exhibition examines Munch's habit of reworking a subject, sometimes years later, of repeating it identically or reinterpreting it in a new context, or with the assistance of a different medium. Some of his motifs exist in this way in drawing, engraving, painting, photography and even sculpture. Among the artists of his generation, Munch is undoubtedly the one who most keenly posed a major question for twentieth-century art – the reproducibility of images. The exhibition also shows how the artist maintained a permanent dialogue with the most modern forms of representation. He was fully aware of the fact that cinema, the postcard industry and the illustrated press, booming at that very time, were introducing new ways of telling stories. He had well understood that films, photographs and the productions of his friends August Strindberg and Max Reinhardt were generating new spatial relationships between the viewer and the representation, thereby contributing to a redefining of *the position of the spectator*.

As Arne Eggum, the former director of the Munch-museet, clearly showed in his seminal study in the late 1980s, the Norwegian artist maintained a special relationship with the analogue image.[5] Munch himself took many photographs, predominately self-portraits, from 1902 right up to the 1930s. In 1927, while travelling in France, he purchased a small amateur film camera with which he recorded the visual impressions he gained from his experience in the big city. These photographic and cinematographic practices exist independently, they have their own *raison d'être* and are not always inevitably subordinate to painting. The exhibition, however, also examines the impact these modern images – those which Munch created himself, but also those that he would have been able to see in the illustrated press and at the cinema – may have had on his painting. It is not therefore a matter of asserting, as the majority of interdisciplinary studies are content to do, that such and such a canvas by Munch was directly 'inspired' by a photograph or by a film, but instead that there is something *photographic* or *filmic* about it; a way of composing, an effect of transparency, a form of energy or alternatively something static, a visual stereotype, a kind of narrative specific to these new media. The account of intermediality given here is much less *illustrative* than completely *constitutive*.

Munch intensified his production of self-portraits during the twentieth century. Five self-portraits were painted in the last two decades of the nineteenth century, compared with forty-one between 1900 and 1944.[6] This does not include the many photographic self-portraits, nor the final short film sequence directed by Munch himself in which he appears, approaching the still-running camera, and leans towards it, examining it intently as if hoping to understand how it works. Through self-portraits Munch turns the gaze inside out. This is particularly apparent in the penultimate section of the exhibition, which presents a series of drawings and paintings created by

Munch in 1930, when a haemorrhage in his right eye interfered with his vision. By drawing and painting what he could see through his damaged eye, Munch depicts his gaze, vision itself, or 'the inside of sight', to pick up on a formula suggested at the time by Max Ernst.[7] Munch said readily that he painted 'what he saw'.[8] We must take this statement seriously, without dwelling only on its naturalistic or realistic implication. Munch undoubtedly paints what he sees before him, but he also tries to represent the very filter of the gaze itself. He is interested in the mediation of this gaze through the eye, as much as by modern instruments of vision such as photography and cinema. It is here that the Norwegian painter displays such great modernity. This then is the very purpose of this exhibition, and the reason why it has been given the title *Edvard Munch: The Modern Eye*.

Notes

1 Munch's catalogue raisonné includes 1,789 items, of which 461 (25 per cent) were painted before 1900 and 1,328 (75 per cent) during the twentieth century. See Gerd Woll, *Edvard Munch, Complete Paintings. Catalogue raisonné,* London 2009, 4 vols.

2 Rolf E. Stenersen, *Edvard Munch: Close-Up of a Genius,* trans. R. Dittmann, Sem & Stenersen A/S, Oslo 2001, p.123.

3 Elizabeth Prelinger (ed.), *After the Scream: The Late Paintings of Edvard Munch,* exh. cat., Atlanta High Museum of Art, New Haven and London 2002.

4 The exhibition is pursuing here a topic that has already been explored by Dieter Buchhart for the 2007 Basel exhibition, focusing more on the painter's production during the twentieth century. See Dieter Buchhart (ed.), *Edvard Munch: Signs of Modern Art,* exh. cat., Hatje Cantz, Ostfildern-Ruit 2007.

5 See Arne Eggum, *Munch and Photography,* New Haven and London 1989.

6 Only the paintings clearly identified as self-portraits in the catalogue raisonné have been considered here. See Woll 2009.

7 This is the title of a 1929 painting by Max Ernst and of one section of his 1934 series of collages, *A Week of Kindness.*

8 Original note by Munch, MM N 57, 1890, Munch-museet, Oslo.

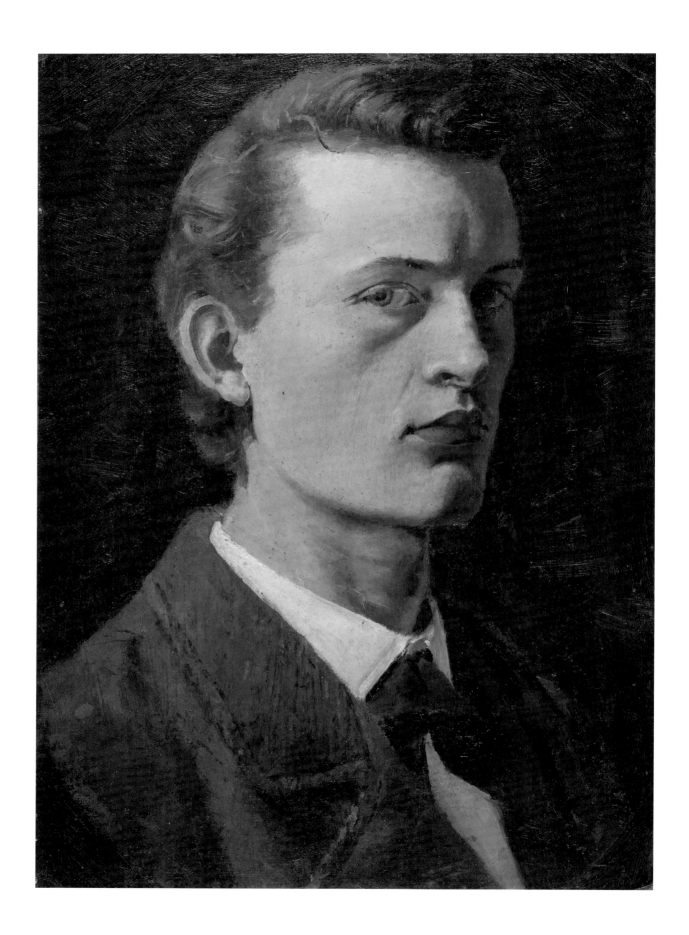

MEDIUM AS MUSE

While discussion of Edvard Munch's prolific self-portraiture has long been a mainstay of scholarship about the artist, the focus on his changing self-image throughout his life has tended to obscure another equally important aspect of Munch's oeuvre, namely the array of media he employed with which to depict himself. Privileging biography overlooks Munch's early (pioneering, one might say) engagement with an emblematic concept of modernism – that of medium specificity. Each of the works in this group, spanning his whole career, exploits the very characteristics of its medium or support to striking effect, while the sole constant of self-portraiture throws into even sharper relief how Munch's image changes not just according to the period in his life, mood or circumstances, but also from one medium to another and as we move from static images to moving ones.

1
Self-Portrait
1882
Oil on paper mounted on cardboard
26 x 19
Munch-museet, Oslo

Nicholas Cullinan

Munch, Medium Specificity and Modernity

2
Self-Portrait in front of the House at Ekely
1930
Photograph, gelatin silver print on paper
11.4 x 8.4
Munch-museet, Oslo

During a long and prolific career, there are two defining characteristics in the work of Edvard Munch – his engagement with self-portraiture and his insatiable interest in the particular pictorial qualities of certain media. Although Munch's fascination with self-portraiture has been the subject of recent studies, his prescient involvement with a range of media – most famously painting and printmaking, but also film and photography, as this exhibition shows – has been less considered.[1]

Munch's first *Self-Portrait* was painted in 1882 (no.1), when the artist was eighteen years old. Using that most conventional medium, oil painting, the carefully controlled handling of the paint with a fine brushstroke is the very opposite of what Munch would later become famous for – gestural expressionist brushwork, intended to make interiority manifest through a loose application of paint on the canvas. The careful composition and modelling of the features mirror the precociously self-possessed demeanour of the sitter. Munch squares up to the mirror to paint himself in three-quarters profile, his steady gaze casting a cold eye back toward the viewer. The strong directional and rather dramatic shadows over the left-hand side of the face, nose and under his eyes, etch a gravitas onto his youthful visage that might not otherwise be apparent in a less carefully staged painting. This is very much the work of a young artist seeking to initiate himself into a grand tradition, with only the fact of the cardboard support upon which it is painted giving away Munch's modest means at this stage in a career only just begun.

Made thirteen years after this pre-expressionist painting, *Self-Portrait* 1895 (no.3) shows a marked development in Munch's stylistic progression, one that is again generated by the very medium used to create the image. The process of lithography had only recently been revived in Germany, where it had been pioneered a century before.[2] This lithograph is also indebted to the growing influence of symbolist artists such as

Odilon Redon and the work of the post-impressionists including Paul Gauguin and Vincent van Gogh, whose paintings Munch had encountered, and been impressed by, during a three-year stay in Paris between 1889 and 1892. *Self-Portrait* 1895 is among the first of Munch's lithographs, a medium in which he would go on to distinguish himself and the quality of which arguably rivals his paintings.

Employing the lithographic technique to subsume the sitter in black tusche ink, save for his disembodied head and the bones of a hand and forearm beneath him, Munch here plays with the high contrast of the lithographic process to accentuate the dramatic play between light and shade, mass and void, found in his first self-portrait. This rather sepulchral atmosphere is enhanced by the handwriting in the entablature above, which appears as if from a tombstone, and chimes both formally and materially with the lithographic stone upon which it was created. However, even such a seemingly bold and modern composition by Munch has its antecedent in Old Master works. Like the parapet encountered in Giovanni Bellini's portrait of *Doge Leonardo Loredan* 1501–2 in the National Gallery, London, and many other Renaissance portraits besides, the forearm placed across the bottom of Munch's composition serves to delineate the fictive realm of pictorial space from that of the viewer's. This painterly aspect of Munch's lithographs, located in the free, gestural handling of the wash of lithographic ink as if it were paint, is striking, and demonstrates the way his style migrated from one medium to another and thus produced uniquely hybrid results. It is also worth pointing out that we know from Munch's letters during the year *Self-Portrait* was created that he would even place the lithographic stone on an easel as he worked on it, as if it were a painting on panel.[3]

In this work, Munch's cool gaze again confronts the viewer head on, with a wispy matrix of fine, subtle lines being used to model the facial features in lithographic crayon. The first state of this lithograph, with its less saturated background, recalls the smoky atmosphere of Munch's wonderfully evocative painting, *Self-Portrait with Cigarette,* also from 1895. This seemingly represents another cross-pollination between media, with an all-enveloping painterly *chiaroscuro* that can best be described as cinematic.

Munch's acquisition of a camera in 1902, covered in depth elsewhere in this volume, resulted in a series of strikingly posed self-portrait photographs, such as *Self-Portrait on a Trunk in the Studio, 82 Lützowstrasse, Berlin* from 1902 (no.5), which is a fairly conventional, almost documentary image of the artist supposedly lost in thought (albeit a moment of reverie that looks rather staged), surrounded by the accoutrements of a painter's studio, such as the palette hung just behind his head on the wall, and by some of his paintings, including *Evening on Karl Johan Street* 1892, which sits in the right-hand background. Munch's *Self-Portrait in the Garden at Åsgårdstrand* 1903 (no.6) shows him surveying the landscape, as we are equally invited to gaze at his painting *Girls on the Bridge,* propped against a sapling, while *Self-Portrait Naked in the Garden at Åsgårdstrand* (no.7) from the same year (1903) is rather more remarkable. It shows Munch standing stark naked in a garden with his left arm firmly placed on his hip and the right one pointing upwards in a heroic gesture.

Compared to this, Munch's photographic *Self-Portrait on the Beach in Warnemünde with Brush and Palette* from 1907 (no.8) is somewhat tame, showing him framing himself as an heroic-looking *plein-air* painter. *Self-Portrait as an Invalid in the Clinic of Dr Jacobson, Copenhagen* from 1908–9 (no.9) is noteworthy not just for its image, which shows Munch being waited on as a patient in the clinic, and confronted by the mirror image of his painting *Self-Portrait in the Clinic* 1909, but also for its revealing title – 'Self-Portrait *as* an Invalid' –

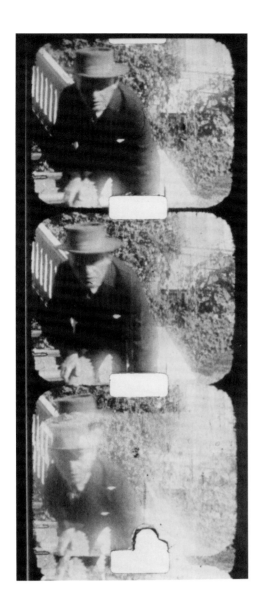

Fig.1
**Stills from a film made with a
Pathé-Baby camera in Dresden,
Oslo, and Aker**
1927
5 min 17 sec, 9.5mm black and white
silent film
Munch-museet, Oslo

with its suggestion that here the photograph documents Munch using the medium to frame his subjectivity and playing just another role, albeit that of a world-weary convalescent, rather than the heroic artist as before.

The woodcut *Self-Portrait Facing Left* from 1912–13 (no.4) again shows Munch exploiting the characteristics and salient features of the medium – here the intaglio provided by the gouges into the grain of the wood itself – to striking effect, as his face is entirely formed by a dramatic series of striations of white against a black background, rather than modulations of light and shade as before in the paintings and lithographs.

Finally, the film from 1927, shot on 9.5mm stock with Munch's Pathé-Baby camera, shows the artist peering inquisitively into the camera's lens on the steps of his studio in Ekely, expressing the same curiosity and intensity with which he first painted his visage over four decades earlier (fig.1). Here, Munch is clearly not only keen to capture his own image but also to find out the workings of the mysterious apparatus as he tries to fathom this new and quintessentially modern medium, and to see himself reflected back in it.

1 See, for example, the detailed account by Iris Müller-Westermann, *Munch by Himself,* exh. cat., Moderna Museet, Stockholm, 2005.

2 For more on this, see Jay A. Clarke's excellent essay, 'The Matrix and the Market: Exploring Munch's Prints', in *Becoming Edvard Munch: Influence, Anxiety, and Myth,* The Art Institute of Chicago, Yale University Press, New Haven and London, 2009, pp.112–55, esp. pp.119–24.

3 Gerd Woll, *Edvard Munch, 1895: First Year as a Graphic Artist*, exh. cat., Munch-museet, Oslo, 1995, pp.15-16.

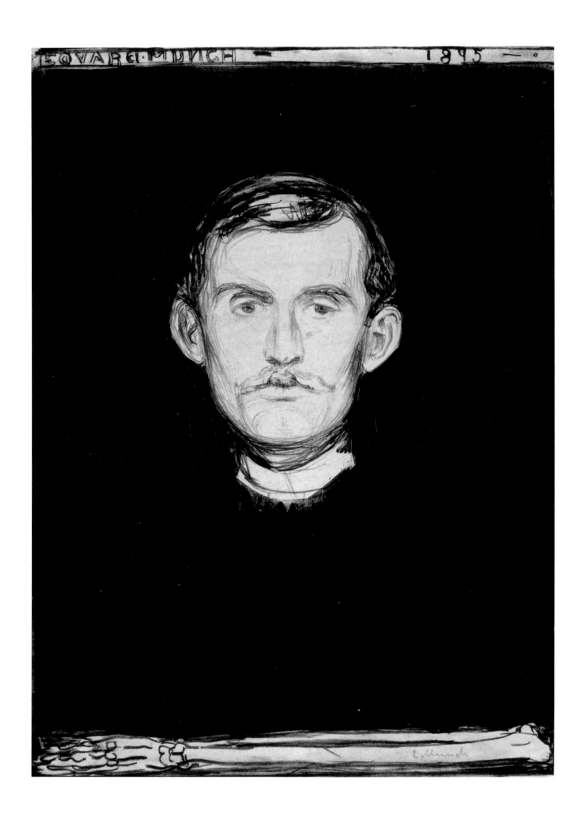

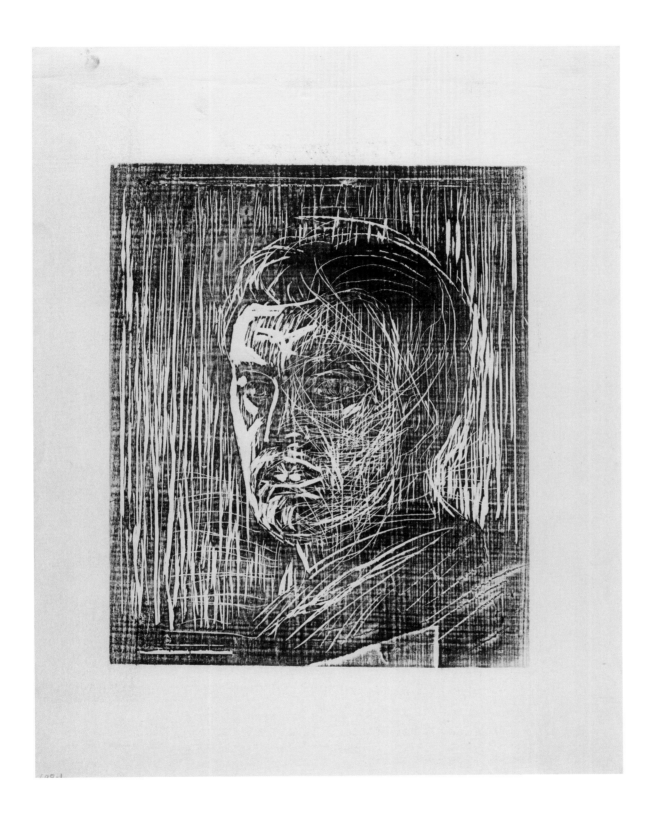

3
Self-Portrait
1895
Lithographic crayon, tusche and
scraper
46.2 x 32.4
Munch-museet, Oslo

4
Self-Portrait Facing Left
1912–13
Woodcut with gouges
44 x 35.3
Munch-museet, Oslo

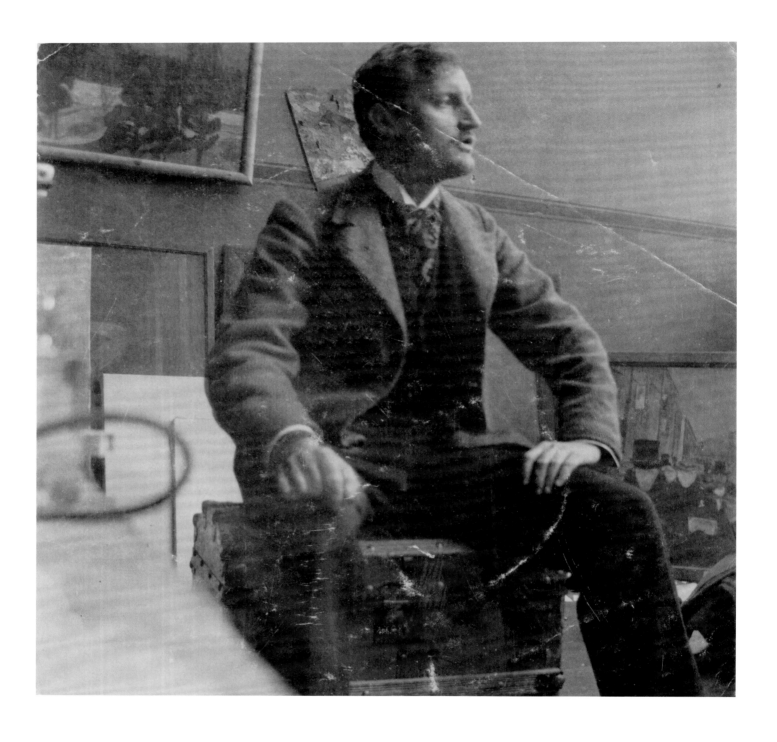

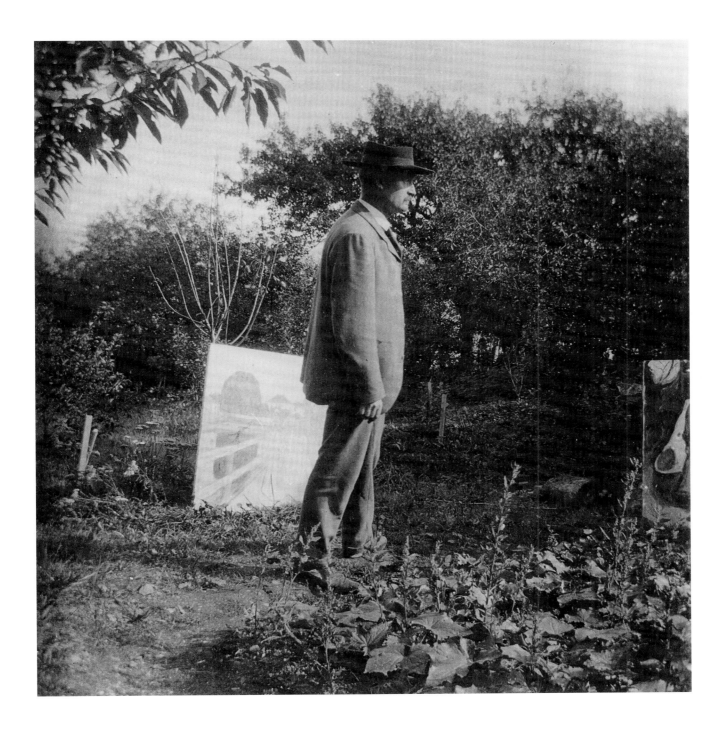

5
**Self-Portrait on a Trunk in the
Studio, 82 Lützowstrasse, Berlin**
1902
Photograph, gelatin silver print on
paper
7.9 x 8
Munch-museet, Oslo

6
**Self-Portrait in the Garden
at Åsgårdstrand**
1903
Photograph, gelatin silver print on
paper
8.7 x 8.4
Munch-museet, Oslo

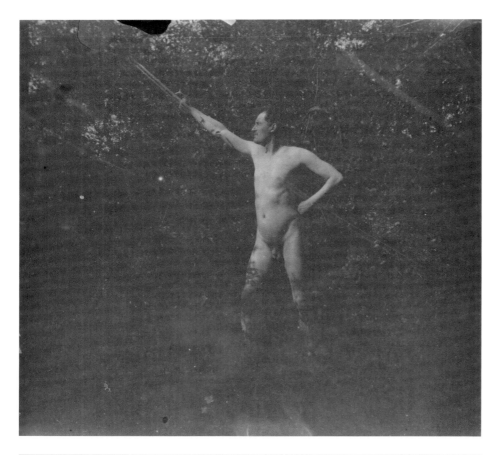

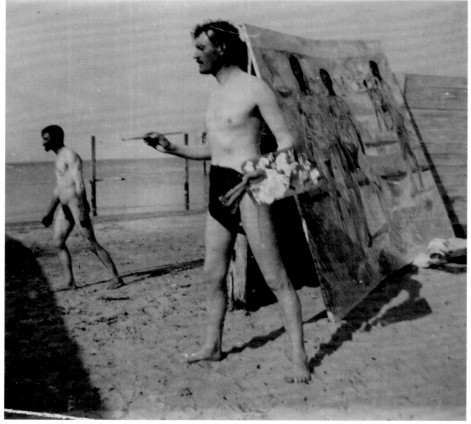

7
Self-Portrait Naked in the Garden at Åsgårdstrand
1903
Photograph, gelatin silver print on paper
8.6 x 8.2
Munch-museet, Oslo

8
Self-Portrait on the Beach in Warnemünde with Brush and Palette
1907
Photograph, gelatin silver print on paper
8.7 x 8.7
Munch-museet, Oslo

9
Self-Portrait as an Invalid in the Clinic of Dr Jacobson, Copenhagen
1908–9
Photograph, gelatin silver print on paper
8.5 x 9.1
Munch-museet, Oslo

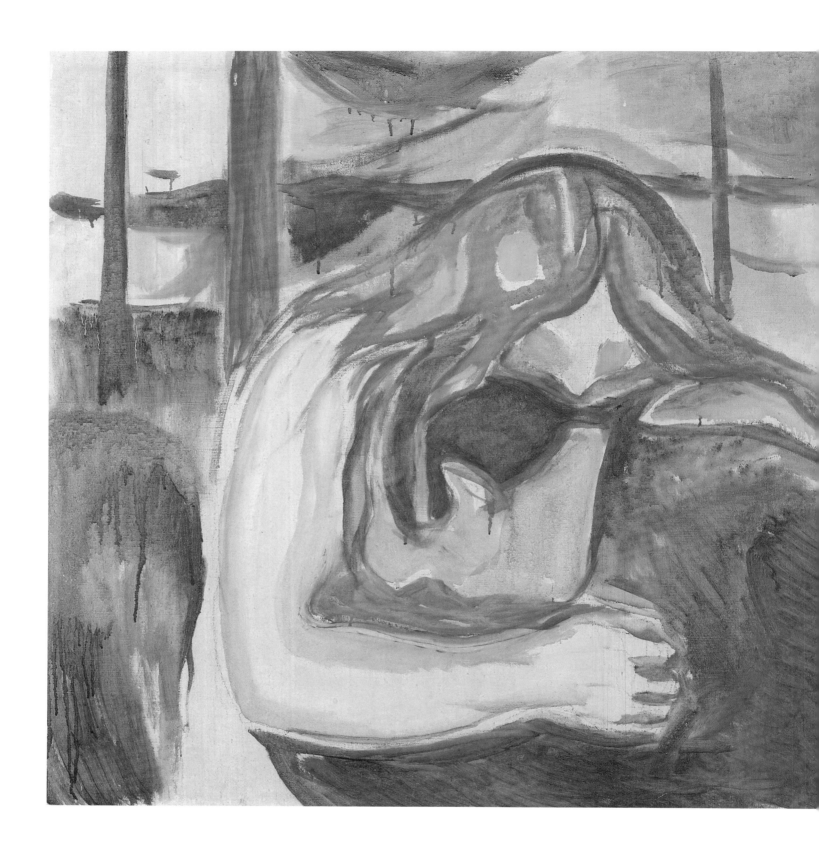

REWORKINGS

Copies, reworkings, variations – Munch endlessly returned to subjects he had tackled before. Six versions of *The Sick Child,* seven of *The Girls on the Bridge,* ten of *Vampire*; if we add to that the multiple graphic adaptations, repetition appears to be a predominant and permanent feature in Munch's work. Contrary to a sacrosanct and romantic idea of uniqueness, he is undoubtedly the artist of his generation who most keenly posed the fundamental question for twentieth-century art: the reproducibility of a work of art. The reasons for such reiteration were many: the original canvas had been destroyed, sold or copied for a collector, or he wanted to explore the subject further or include it in a new frieze project. The cathartic value of repetition should also not be underestimated. By dint of being reprised, often reduced to its simplest expression, the motif becomes autonomous. It ultimately exists for itself, as a sort of manufacturer's brand, or a Munch 'trademark'.

Vampire
1916–18
Oil on canvas
82 x 110
Munch-museet, Oslo
(fig.3)

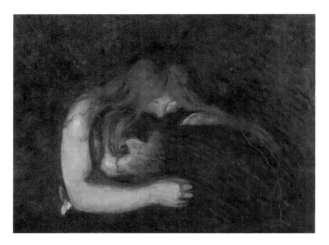

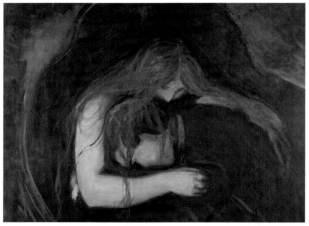

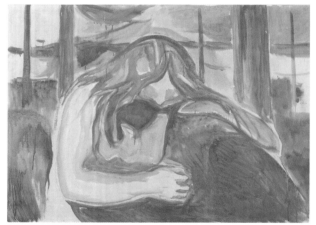

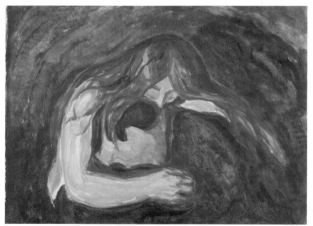

Fig.2
Vampire
1893
Oil on canvas
77 x 98
Munch-museet, Oslo

Fig.3
Vampire
1916–18
Oil on canvas
82 x 110
Munch-museet, Oslo

Fig.4
Vampire
1895
Oil on canvas
91 x 109
Munch-museet, Oslo

Fig.5
Vampire
1916–18
Oil on canvas
83 x 104
Munch-museet, Oslo

Angela Lampe

Dislocated Motifs: Munch's Tendency Towards Repetition

A good picture never disappears. A great idea never dies.
Edvard Munch, c.1928–30[1]

The publication of the catalogue raisonné of Edvard Munch's paintings in 2009 provided confirmation, if any were needed, of the extent to which he repeated important motifs and pictorial themes throughout his life. None of his early masterpieces remained a one-off. It was of course known that Munch frequently created new versions of works, such as *The Sick Child*, which brought him his artistic breakthrough, and his world-renowned *The Scream* exists as two paintings, two pastels and a lithograph. Nevertheless it was astonishing to see at a glance the sheer number of reworkings and the extent of their variation in the excellent catalogue raisonné by Gerd Woll. Munch painted four variants of *Puberty* (no.60) and six of *The Sick Child* (nos.12 and 13); *The Girls on the Bridge* (nos.20 and 21) exists in seven versions and its offshoot, *Women on the Bridge*, in five versions; *Vampire* (nos.14 and 15, figs.2–5) features in twelve different paintings and the embracing couple, with the title *The Kiss* (nos.16 and 17), figures in eleven variants, clothed or naked, at a window or by the shore. If one adds to these the large number of reworkings as prints, it appears that the recurrence of motifs is one of the main constants in Munch's work as a whole.

However, it has only been in the last ten years that Munch's interest in repetition has come under closer scholarly scrutiny. In 2003 the Albertina in Vienna presented the exhibition *Thema und Variation*, which explored the connections between pictorial themes in Munch's *Frieze of Life*.[2] Four years later the catalogue for the exhibition *Edvard Munch: Signs of Modern Art* in Basel included an essay on the serial nature of much of his work.[3] However, the most interesting contributions to this area of research are the more recent studies by Jay A. Clarke[4] and Gerd Woll[5] on the repetition of early pictorial subjects, with particular reference to *The Sick Child*. Neither of these authors follows the usual line on this much-discussed key work, which is generally analysed in terms of Munch's subjective

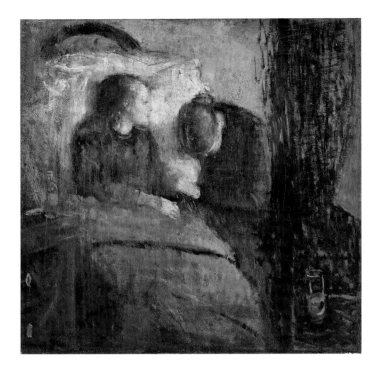

Fig.6
The Sick Child
1885–6
Oil on canvas
120 x 118.5
Nasjonalmuseet for kunst,
arkitektur og design, Oslo

Fig.7
**Stage design for Henrik
Ibsen's** *Ghosts*
1906
Oil on board
47.5 x 68
Munch-museet, Oslo

approach to the theme, based on memories of his own experience and impressions and the colour moods of that situation. Both Clarke and Woll strike out into new territory and take into account external factors, such as commercial and practical considerations, in their investigations into the numerous reworkings of this theme. It is by examining precisely these non-artistic issues that we may arrive at a more accurate and differentiated view of Munch's artistic praxis. These issues may also modify our notion of his singularity, for in the nineteenth century numerous artists similarly copied and varied their paintings. Nevertheless, few artists of his generation pursued this practice as consistently as Munch, who in effect elevated motivic relocation to an artistic principle.

Experience and Memory
The first and hitherto most widely accepted explanation for Munch's repetition of motifs was provided in 1984 by Uwe M. Schneede when he suggested that this was above all the artist's way of working through old memories or, as he called it, 'memory work'. This involved a lengthy process of searching for the initial internal mood-pictures that had lodged in his memory at significant moments in his life, or as he himself put it, that had burnt into his 'retina'. The prime example of this is the painting *The Sick Child* (fig.6), the key work in Munch's early years.[6] It was painted eight years after the agonising death of his younger sister Sophie, which devastated her fourteen-year-old brother. Many years later Munch provided a moving description of how hard he had to fight to achieve this painting, which for him embodied his parental home and his own childhood, overshadowed by death and illness:

> When I saw the sick child for the first time – her pale face with vigorous red hair against a white pillow – it made an impression on me, only to disappear as I worked. – I painted a good picture on the canvas, but it was a different one. –

I repainted that picture many times over the years – scraped it off – let it dissolve into layers of paint – and tried again and again to capture that first impression – the translucent – pale skin against the canvas – the tremulous mouth – the shaking hands – . . . in the end I stopped, exhausted. – I had captured a lot of that first impression, the tremulous mouth – the translucent skin – the tired eyes – but the colours in the painting were not finished – it was pale grey. The painting as a whole was heavy, like lead.[7]

The making of *The Sick Child,* which Munch originally exhibited with the title *Study,* is described by him as deeply disturbing, as a debilitating struggle to portray a subjective truth. In 1975 the English film director Peter Watkins movingly depicted this process in his outstanding film portrait of the Norwegian artist. The over-painted, scratched and furrowed surfaces of the paintings, left in the unfinished, raw state that so enraged Norwegian critics at the time, still bear witness today to the destructive nature of this act of creation. In the early 1930s Munch remarked that in his view there was no other painter 'who had lived through his motif until the last cry of agony as [he] had in the sick child. For it was not only [him] that was sitting there, but also [his] loved ones.'[8] Schneede thus interprets the act of painting in Munch's case as a 'revitalisation of autobiographical experiences', as 'memory work', which – like a form of catharsis – the artist had to repeat until he had captured and perfected that very first impression.[9] Clarke compares Munch's work process to a 're-enactment' of the endlessly painful memory of the death of his sister.[10] It may be that it was another artist, Joseph Beuys, who most aptly described the 'memory work' in Munch's *The Sick Child*: 'He certainly was not trying to repeat something that was over and done with. It was about his own reality. He constantly wanted to see if he could

rediscover what had originally led to a painting and what had arisen from it, a kind of self-test.'[11]

However, little attention has hitherto been paid to the fact that these memory theories are largely based on statements that Munch made in 1929 and 1930,[12] that is to say, around forty-five years after the first version of *The Sick Child*; at the time, in preparation for a new presentation of his *Frieze of Life,* he was working on a self-published volume, entitled *Livsfrisens tilblivelse (The Genesis of 'The Frieze of Life'),* on the making of this key work. Although he made his famous statement, 'I don't paint what I see – but what I saw',[13] in 1890, the description of the genesis of the work and additional passages on remembering first impressions were written retrospectively. And we know from letters written not long after this, that around that time Munch was specifically under attack for making numerous copies of *The Sick Child.* In a letter to the museum director Jens Thiis he defends himself against this criticism and explains the new versions in light of the initial struggle he had with this motif, lasting over a year, which was not to be resolved with a single painting.[14] Even when Munch, here and in other letters,[15] presents his repetitions as part of an open work process, he is also defending his status as an original, authentic creative artist, as a painter who is beholden to memory and who has no choice but to revisit motifs. Each new version 'adds in its own way to the feeling of the first impression', as he wrote in *Livsfrisens tilblivelse.*[16]

Here Munch is drawing on subjective, post-Romantic artistic attitudes that were found in northern Europe towards the end of the nineteenth century. It was the Danish art historian Julius Lange, writing in 1889, who first introduced the concept of 'memory art'. And following a review by the Norwegian art critic and friend of Munch's, Andreas Aubert, his ideas quickly spread throughout Norway and reached Berlin within three years. As one of the intellectuals and artists,

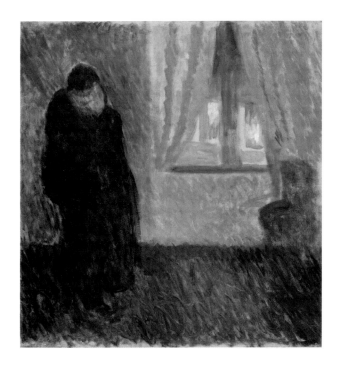

Fig.8
Kiss by the Window
1891
Oil on canvas
72 x 64.5
Munch-museet, Oslo

Fig.9
Vampire in the Forest
1924–5
Oil on canvas
200 x 138
Munch-museet, Oslo

including Munch, who frequented the wine bar Zum Schwarzen Ferkel (The Black Piglet), Max Dauthendey referred to an art of internalised memories and cited Munch as one of its leading exponents.[17] Later on August Strindberg similarly talked of art derived from memory, which has to go through the 'smelter of the percipient and sensitive subject'.[18]

However, we have Gerd Woll to thank for questioning Munch's own suggested connection between memory and the urge to repeat motifs. Woll points to the well-known fact that the red-haired girl in the painting is not Munch's sister but the eleven-year-old Betzy Nielsen, whom Munch had seen when he accompanied his physician father on a house-call, sitting limply in a chair, and whom he later used as his model.[19] Thus it was the sight of a girl, a stranger, that prompted him to embark on the painting and that Munch refers to in his description of the work's genesis. It is not possible to tell to what extent this experience mingled with Munch's memories of the death of his sister. Munch's reference to the presence of his loved ones, in connection with the painting, was made in a much later note and was in all probability intended to underline the uniqueness of *The Sick Child,* which was made at a time when motifs of this kind were much in demand. Munch himself called it the 'pillow time'. As Woll has said, the fact that, shortly after the exhibition, Munch gave this painting as a present to his fellow painter Christian Krohg, who had also painted a sick girl in an armchair five years earlier, hardly suggests that this was a representation of a deeply significant memory. Moreover, the first two new versions that Munch made, one in 1896 for the collector Olaf Schou and one in 1907 for Ernest Thiel, were both commissioned works. However, in 1907 Munch also painted a variant for himself, which he sold to the Staatliche Gemäldesammlung in Dresden in 1927[20] and replaced with two more new replicas.

Original and Copy

In view of these facts, Munch's repetitions of *The Sick Child* may arise less from insistent memories than from an artistic practice that was widespread in the nineteenth century. Many painters did not hesitate to repeat and to rework their most popular motifs. Paul Delaroche painted a replica of his *Bonaparte Crosses the Alps* of 1848 two years after the original; Jean-Auguste-Dominique Ingres painted *Oedipus and the Sphinx* three times, in 1808, 1826 and 1864; Jean-Léon Gérôme reproduced his renowned *Duel after the Masked Ball* 1857 both in oils and in various print techniques with the help of Maison Goupil.[21] Copying paintings, which had always been part of an artist's training, thus did not detract from the Romantic myth of the creator and was regarded as a legitimate artistic activity. What mattered above all was the pictorial idea and not (yet) the market value of uniqueness. Moreover, with the growing popularity of prints in the nineteenth century, not least thanks to new techniques such as lithography, the dividing line between original and copy was blurring appreciably. This was in part due to the success of original prints towards the end of the century, that is to say, prints composed as such by the artist and sometimes even produced by the artist. In 1894 Munch started to make etchings and lithographs, which mainly depicted well-known paintings of his own. These reproductions not only raised the profile of his paintings, but also drew in new, less well-to-do groups of collectors, who both increased demand and added to the pressure on artists to produce popular motifs. In addition to acquiring print reproductions, collectors also liked to commission painted copies. Marie Berna, for instance, commissioned Arnold Böcklin to paint a replica of his famous *Island of the Dead* in memory of her late husband, Georg Berna.[22] Munch's friend, the Norwegian painter Frits Thaulow, copied popular motifs of his own on request. His atmospheric landscape in watercolours, *Thawing Snow* of 1887,

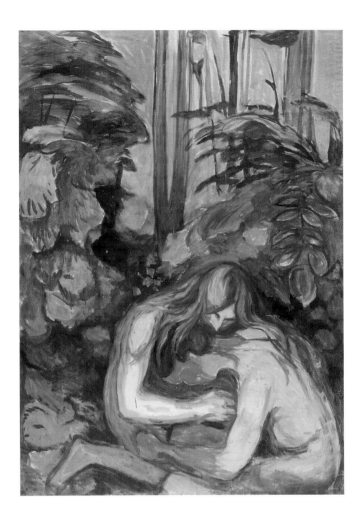

exists in at least five versions, which he presented and sold, one after the other, in various exhibitions.[23]

Financial considerations in all likelihood may also have persuaded Munch to make new versions of paintings for collectors. Munch was not from a wealthy family like Gustave Caillebotte or Paul Cézanne. He had to earn a living with his art, which posed a serious dilemma to an idiosyncratic, independent artist who would have liked to gather his paintings around him as if they were his children.[24] Besides selling paintings at prohibitively high prices,[25] Munch secured another lucrative source of income by participating in the ticket sales for his exhibitions. In a letter to his aunt, for instance, he is openly annoyed – following the excellent publicity and loud protests at the closing down of his scandalous exhibition in Berlin in 1892 – that he was not able to transfer the exhibition more quickly to Düsseldorf, where he took a third of ticket sales.[26] This new-found source of income could also explain why it was that, once the exhibition had also been shown in Cologne, he himself presented his controversial exhibition for a second time in Berlin. On this occasion and at his own expense, he rented an exhibition space in the city centre, the Equitable Palast in Friedrichstrasse; he also advertised in the main Berlin daily newspapers and even organised a press preview of his provocative anti-hanging (fig.10).[27] By contemporary standards, the publicity for the event was highly professional and the exhibition earned Munch a considerable sum of money. It subsequently toured to Copenhagen, Breslau (Wrocław), Dresden and Munich.[28]

Thus some of Munch's replicas, as in the case of his friend Thaulow, were made for exhibitions, so that following a sale or a loss (the first version of *Puberty* of 1886 was burnt and the original version of *Two Human Beings: The Lonely Ones,* of 1892 (nos.18 and 19) was destroyed when a boat exploded) the paying public could always see his most important motifs. This

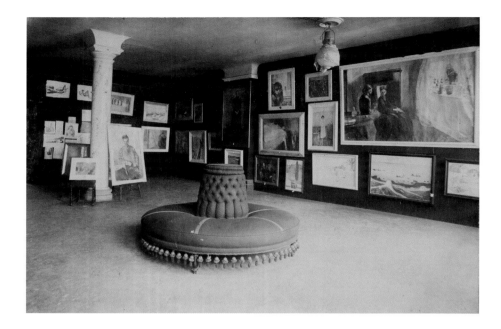

Fig.10
Anonymous
Photograph of the exhibition at Equitable Palast
1892–3
Munch-museet, Oslo

Fig.11
Peer Gynt: Les Lamentations d'Ingrid
1930s
Crayon, pen and wash
21.3 x 27.5
Munch-museet, Oslo

Fig.12
Summer Night's Dream: The Voice
1893
Oil on canvas
88 x 108
Museum of Fine Arts, Boston. Ernest Wadsworth Longfellow Fund

applied particularly to the subjects in his magnum opus, *The Frieze of Life.* Following substantial sales to the Nasjonalgalleriet and to the collector Rasmus Meyer in Bergen around 1909, in the catalogue for a new presentation of *The Frieze of Life* at Blomqvist in Oslo in 1918, Munch expressed his regret that so many of the works on show were copies. At the same time, when he sold various works to Meyer, he retained a contractual right to borrow back four paintings, for a period of three weeks, in order to make copies of them. As late as 1925 he applied to the Nasjonalgalleriet to make copies of *The Ashes* and *The Dance of Life* for a monumental reconstruction of *The Frieze of Life* in his studio at Ekely. He also retained all his printing plates and lithograph stones, now in the Munch-museet, so that he could make new prints whenever he needed.[29]

However, besides making replicas of major works for exhibitions or sales, Munch above all repeated motifs for his own artistic purposes.[30] As he put it: 'I am entirely against what you might call a picture factory – turning out replicas to sell – but I also say, you should promise "nothing" – and I have in fact often made copies of my paintings – but there was always progress, too, and they were never the same – I build one painting on the last.'[31] Thus it was essential to him always to have immediate access to his most celebrated motifs. In a later letter to Johan Langaard, Munch again restated his position: 'I never make copies of my paintings. And whenever I have used the same motif again, it has been solely for artistic reasons and because it allows me to find out so much more about that motif.'[32] Jean-François Millet gave very similar reasons for the numerous repetitions of his well-known painting *The Sower* 1847–8.[33] Munch justified his practice somewhat more vehemently in the letter to Jens Thiis mentioned earlier here. Alluding to Cézanne and to Monet's series, he asks, why can he not repeat an important motif five times 'when you see other artists painting apples, palms, church towers and haystacks ad

infinitum'?[34] Unlike Monet, however, Munch's interest was not in alterations in the appearance of an object during a particular period of time but rather in subjective, new interpretations of one and the same motif. At the heart of all this is *The Frieze of Life,* which was conceived as an open-ended series, as a 'work in progress' on life's great themes – love, fear and death. For Schneede *The Frieze of Life,* 'open-ended and impossible to complete, stands as one of the very great projects of modernism'.[35]

Munch's reiterations of early motifs, such as his *Kiss by the Window* (fig.8), see them developing and changing. Over the years he played out different compositional schemes, with the kissing couple in different positions and surroundings (nos.16 and 17). When he reworked the famous *Vampire* motif for the exhibition at Blomqvist (1918), instead of placing it in a dark, monochrome space, as in the first versions, he shows it against a typical Åsgårdstrand landscape with the beach as a horizontal band and trees as verticals (*Vampire in the Forest,* no.15). Eight years later the *Vampire* appeared, with the same title, in a leafy forest (fig.9). In 1914, Munch set *Puberty* (no.60) against an expressionist-style coloured backdrop, reminiscent of the paintings of Van Gogh. Two years before this, Van Gogh and Munch had been among the main artists featured at the great *Sonderbund* exhibition in Cologne. Munch seems here to be trying out new, unfamiliar means of expression for his old motifs. Gerd Woll talks of Munch 'updating his motifs' in order to keep up with the times.[36]

Self-Quotation and Artistic Branding
In terms of Munch's modernism, of greater interest than the immediate results of his adaptation to contemporary pictorial styles are the longer-term consequences of this practice. Dislocated from their original emotional meaning and personally experienced context, these motifs become independent, free-floating entities, which the artist can reinstate as he likes in new

contexts. These motifs are not liberated from a pictorial subject, as in Cézanne's case, but rather from their origins. They are uprooted and turned into props, which – like *The Kiss* or *Vampire* – can be shifted into different settings without Munch having to change the title of the drama. For Poul Erik Tøjner, the many repetitions in Munch's paintings, and particularly in his prints, turn his motifs into 'repeatable icons'.[37]

In effect Munch created his own fund of quotations, which he himself drew on but of which later artists also availed themselves. Ingrid Junillon has shown in detail how Munch recycled older pictorial motifs and used them to illustrate different stage plays by Henrik Ibsen.[38] For the final scene of Max Reinhardt's famous production of *Ghosts* (1906; fig.7), Munch placed the two main characters – the young painter, Oswald, and his mother, Mrs Alving – in almost exactly the same positions that he had devised for his aunt by the sick girl twenty years earlier. In drawings from the 1930s for both *Peer Gynt* (fig.11) and the play *When We Dead Awaken* (1899), Munch cites figures from *Ashes* of 1895 (no.10); more than that, the woman tearing her hair and the bowed figure of a man were already quotations from the series *Melancholy,* which Munch began around 1891. Besides motifs, Munch also reuses backgrounds, such as the elongated reflection of the moon on the sea, which first appears in 1893 (*Summer Night's Dream: The Voice,* fig.12) and reappears in *Kiss on the Shore by Moonlight* (no.17). On closer examination Munch's oeuvre proves to be a complicated network of self-quotations.

Thus Munch left the nineteenth century behind him and advanced towards another (if much more controversial) master of self-copying, namely, Giorgio de Chirico. After the Second World War, the Italian artist started to produce multiple replicas of his *pittura metafisica* motifs – such as *Piazza d'Italia* and *Troubadour.* His aim was, not least, to profit from being able to fulfil the demands of insistent collectors. However, this

also led to works being wrongly dated and to a certain disdain for his art in some circles. In the catalogue of the major retrospective of his work at the Museum of Modern Art in New York in 1982, the curator of the exhibition, William Rubin, included a double page showing all eighteen replicas de Chirico made of his *Disquieting Muses* (originally painted in 1917) between 1945 and 1962 (fig.13). This extremely telling tableau, which Rubin reproduced from an Italian source, still shows only too well how repetition can drain a work of art of its meaning and diminish it, turning it into a series of reduced, self-contained signs, into simulacra, into no more than a commodity.[39] Even if – as in Munch's case – there were originally painted copies by the artist's own hand, and not technical reproductions, de Chirico's replicas perfectly illustrated what Walter Benjamin famously said on the loss of aura in his essay on 'The Work of Art in the Age of Its Technological Reproducibility', and on the loss of the Here and Now of the original as a sign of its authenticity and as part of a tradition or ritual.

It does not come as a surprise that, according to the artist himself, it was the sight of precisely this tableau of multiple muses that prompted Andy Warhol to investigate de Chirico's pictorial world more closely, having already met and felt drawn to him in 1972.[40] In the context of postmodern citation art and appropriation art, in 1982 Warhol created his own tableau with a quartet of *Disquieting Muses.* As though he sensed an affinity between de Chirico and Munch, a year later Warhol also started to borrow motifs from Munch for his adaptations. Inevitably Warhol made a screen print of *The Scream,* but he also made a print with a double motif, combining Munch's lascivious *Madonna* and his *Self-Portrait* 1895, now highly stylised and strongly coloured (fig.14), as in the case of his version of *The Scream,* in order to update them in keeping with the times. Warhol had understood that Munch's motifs were

Fig.13
Giorgio de Chirico
**Eighteen copies of Muses
Inquiétantes**
1917, made between 1945 and 1962,
in William Rubin et al., *Giorgio
de Chirico*, exh. cat., Paris 1983,
pp.30–1

Fig.14
Andy Warhol
**Madonna and Self-Portrait with
Skeleton Arm (after Munch)**
1983
Silkscreen ink and acrylic on canvas
129.5 x 180.3
The DnB NOR Savings Bank
Foundation Art Collection

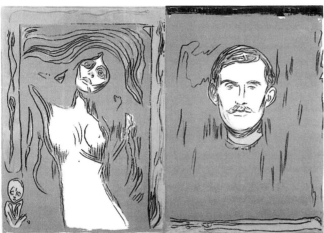

just as autonomous and free as a Campbell's soup can or a
Marilyn image, and could readily be recombined. He recog-
nised their iconic value as forms of artistic branding, with *The
Scream* standing for fear, *Madonna* for ecstasy and *Self-Portrait*
for death.[41]

The sheer impact of Munch's paintings may perhaps in part
explain why his motifs are still so often repeated and quoted.
Scarcely any other artist of his generation received a similar
response from younger artists; besides Warhol these include
artists such as Jasper Johns, Georg Baselitz, Günther Förg,
Sarkis, Peter Doig, Tracey Emin and Anne-Kathrin Dolven.[42]
Regardless of the underlying reasons for Munch's many reprises
of earlier themes, this practice ultimately led to his art in effect
becoming a highly recognisable 'brand', in the modern sense.
Only there is no knowing to what extent he may have foreseen
that at the time.

Translated by Fiona Elliott

Notes

1 Edvard Munch, Note MM N 38, c.1928–30, Munch-museet, Oslo; in this catalogue, pp.52–3.

2 Klaus Albrecht Schröder and Antonia Hoerschelmann (eds.), *Edvard Munch. Thema und Variation,* exh. cat. Albertina, Vienna, Ostfildern-Ruit 2003. See also Ulrich Weisner (ed.), *Edvard Munch, Liebe, Angst, Tod. Themen und Variationen. Zeichnungen und Graphiken aus dem Munch-Museum Oslo,* exh. cat. Kunsthalle Bielefeld 1980.

3 Philippe Büttner, 'Auf der Netzhaut der Seele. Edvard Munchs Vermächtnis an die Moderne', in *Edvard Munch. Zeichen der Moderne,* ed. Dieter Buchhart, exh. cat. Fondation Beyeler, Basel Kunsthalle Würth, Schwäbisch Hall, Ostfildern 2007, pp.38–9.

4 Jay A. Clarke, 'Originality and Repetition in Edvard Munch's The Sick Child', in Erik Mørstad (ed.), *Edvard Munch: An Anthology,* Oslo 2006, pp.43–63.

5 Gerd Woll, 'Use and Re-use in Munch's Earliest Paintings', in *Munch Becoming Munch: Artistic Strategies, 1880–1892,* exh. cat. Munch-museet, Oslo 2008, pp.85–103.

6 The specific term used by Uwe M. Schneede is 'Erinnerungsarbeit'; see idem, *Das kranke Kind. Arbeit an der Erinnerung,* Frankfurt am Main 1984, pp.42–4.

7 Note MM N 70, 1928–9, Munch-museet, Oslo, as cited in Arne Eggum, 'Das Todesthema bei Edvard Munch', in Weisner 1980, pp.197–8. Eggum and Clarke read note MM N 71 as a continuation of the text. However, it is not clear whether this was Munch's intention, since there is no record of the existence of three versions two years after the first version of 1885–6.

8 Note MM N 45, 1931–4, Munch-museet, Oslo, as cited in Eggum 1980, p.342.

9 Schneede 1984, pp.44 and 62–4.

10 Clarke 2006, p.50.

11 Dieter Koepplin, 'Gespräche mit Beuys und Baselitz über Edvard Munch', in *Edvard Munch. Sein Werk in Schweizer Sammlungen,* exh. cat. Kunstmuseum Basel 1985, p.144.

12 One exception is a newspaper article by Hans Jaeger (*Dagen,* 20 October 1886), drawing on Munch's own comments, in which he describes the exhausting process of making this painting, during which Munch repainted the canvas twenty times in order to capture the right mood. For more on this see Schneede 1984, p.36. See also Øyvind Storm Bjerke, 'Edvard Munch, *The Sick Child*: Form as Content', in Mørstad 2006, p.69.

13 Note MM N 57, 1890, Munch-museet, Oslo.

14 Letter to Jens Thiis, 1932, as cited in Clarke 2006, p.43.

15 Letter to Axel Romdahl, MM N 3359, 1933, Munch-museet, Oslo.

16 As cited in Schneede 1984, p.62.

17 Ibid., pp.25–6.

18 August Strindberg, *The Growth of a Soul,* trans. Claud Field, London 1913.

19 Schneede 1984, p.14, also Woll 2008, p.86.

20 On this see letter MM N 3359, in the Tate collection, London.

21 For more on this, see Stephen Bann, 'Reassessing Repetition in Nineteenth-Century Academic Painting: Delaroche, Gérôme, Ingres', in Eik Kahng (ed.), *The Repeating Image: Multiples in French Painting from David to Matisse,* New Haven, CT, Baltimore, MD, and London 2007, pp.27–51.

22 Clarke 2006, p.48.

23 Ibid., pp.49–50.

24 Woll 2008, p.97.

25 Letter MM N 3359.

26 Woll 2008, p.98.

27 There was a report in the Berliner *Nachrichten* on 31 December 1892: 'Half a hundred paintings hung on four walls in an unflattering sidelight, side by side in no particular artistic order, some badly mounted, many in the most primitive white-painted wooden frames – and from morning to night an animated throng of arguing, laughing, shoulder-shrugging spectators gazing at them, half of them no doubt only there out of curiosity', as cited in Monika Krisch, *Die Munch-Affäre. Rehabilitierung der Zeitungskritik,* Berlin 1997, p.178.

28 Ibid., p.22.

29 See Woll 2008, pp.88 and 101–2.

30 For more on this, see Mai Britt Guleng, 'Edvard Munch und die verborgenen Tiefen der Erinnerung', in *Edvard Munch und das Unheimliche,* exh. cat. Leopold Museum, Vienna 2009. See in particular the third section, 'Wiederholung und Kreativität', pp.26–8.

31 Letter to Axel Romdahl, MM N 3359, 1933, Munch-museet, Oslo.

32 Note MM N 1787, 1935, Munch-museet, Oslo.

33 Simon Kelly, 'Strategies of Repetition: Millet/Corot', in Kahng 2007, p.54.

34 Letter to Jens Thiis, 1932, as cited in Clarke 2006.

35 Uwe M. Schneede, 'Munchs Lebensfries, zentrales Projekt der Moderne', in *Munch und Deutschland,* exh. cat. Kunsthalle der Hypo-Kulturstiftung, Munich, Hamburger Kunsthalle, Nationalgalerie, Staatliche Museen zu Berlin, Ostfildern-Ruit 1994, p.20.

36 Woll 2008, p.101.

37 Poul Erik Tøjner, 'Warhol after Munch', in Michael Juul Holm and Henriette Dedichen (eds.), *Warhol After Munch,* exh. cat. Louisiana Museum of Modern Art, Humlebæk, Esbjerg 2010, p.24.

38 Ingrid Junillon, *Edvard Munch. Face à Henrik Ibsen: impressions d'un lecteur,* Leuven 2009, pp.257–4.

39 For more on this, see Pia Müller-Tamm, 'Der "andere" de Chirico. Zur Rezeption des Werkes in den achtziger Jahren', in *Die andere Moderne. De Chirico, Savinio,* ed. Paolo Balducci and Wieland Schmied, exh. cat. Kunstsammlung Nordrhein-Westfalen, Düsseldorf, Städtische Galerie im Lenbachhaus, Munich, Ostfildern-Ruit 2001, pp.173–4.

40 'Industrial Metaphysics', interview with Andy Warhol and Achille Bonito Olivia, in *Warhol versus de Chirico,* exh. cat. Milan 1982, p.70, as cited in exh. cat. Düsseldorf/Munich 2001, p.173.

41 See Tøjner, 'Warhol after Munch', 2010, p.26.

42 For more on this, see Tina Yarborough, 'The Strange Case of Postmodernism's Appropriation of Edvard Munch', in Mørstad 2006, pp.191–205. See also *Echoes of the Scream,* exh. cat. Arken, Museum for Moderne Kunst, Ishøj, Munch-museet, Oslo 2002, and *Munch Revisited. Edvard Munch und die heutige Kunst,* ed. Rosemarie Pahlke, exh. cat. Museum am Ostwall, Dortmund 2005.

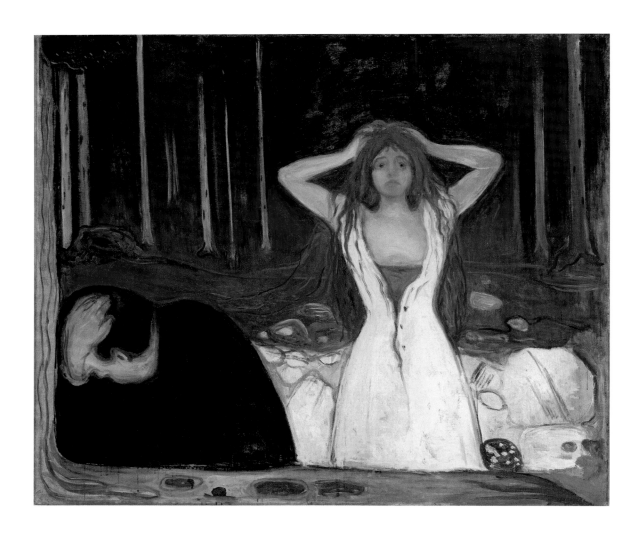

10
Ashes
1895
Oil on canvas
120.5 x 141
Nasjonalmuseet for kunst,
arkitektur og design, Oslo

11
Ashes
1925
Oil on canvas
139.5 x 200
Munch-museet, Oslo

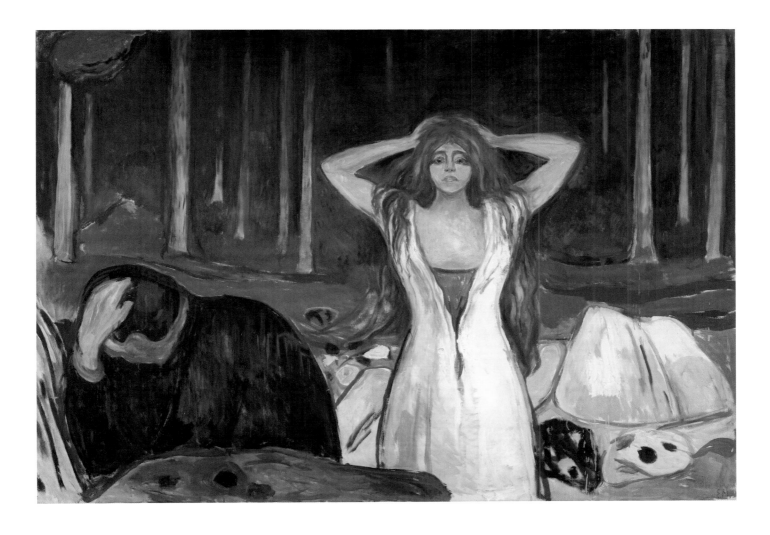

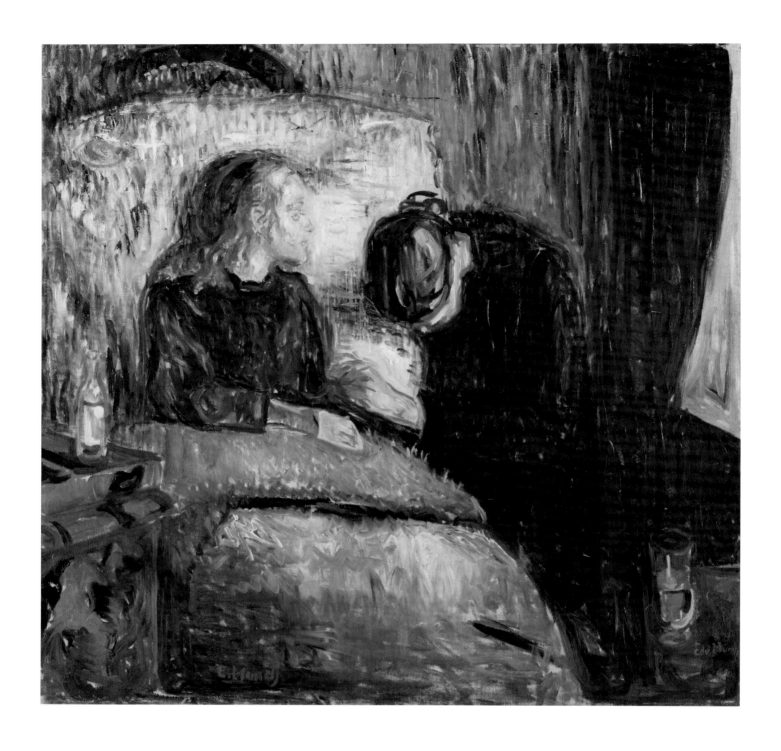

12
The Sick Child
1907
Oil on canvas
118.7 x 121
Tate. Presented by Thomas Olsen 1939

13
The Sick Child
1925
Oil on canvas
117 x 118
Munch-museet, Oslo

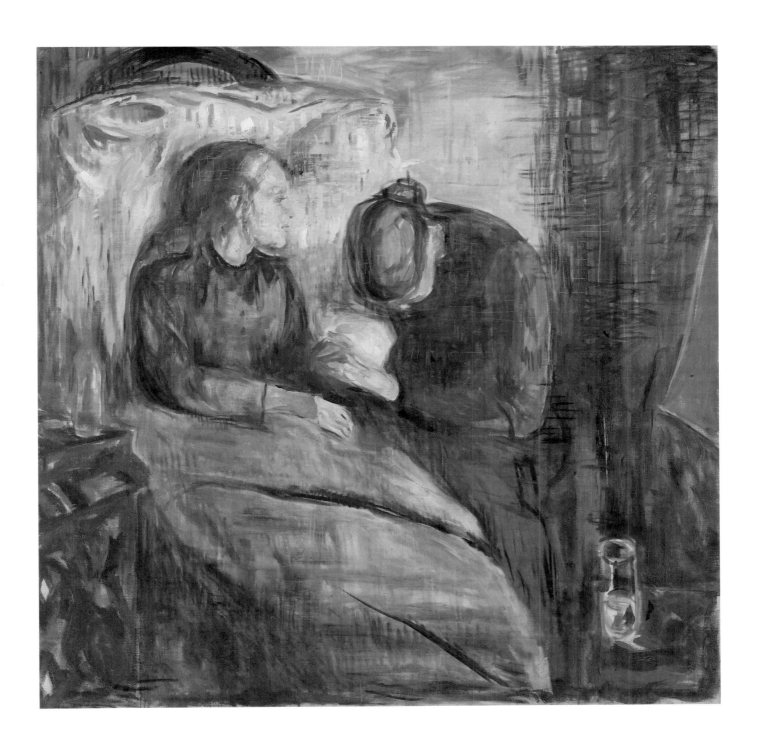

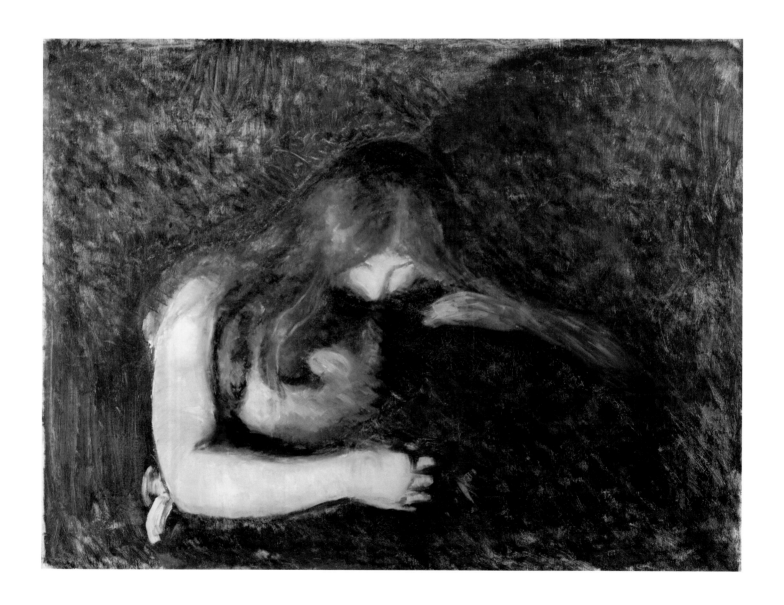

14
Vampire
1893
Oil on canvas
80.5 x 100.5
Göteborgs konstmuseum,
Gothenborg

15
Vampire in the Forest
1916–18
Oil on canvas
150 x 137
Munch-museet, Oslo

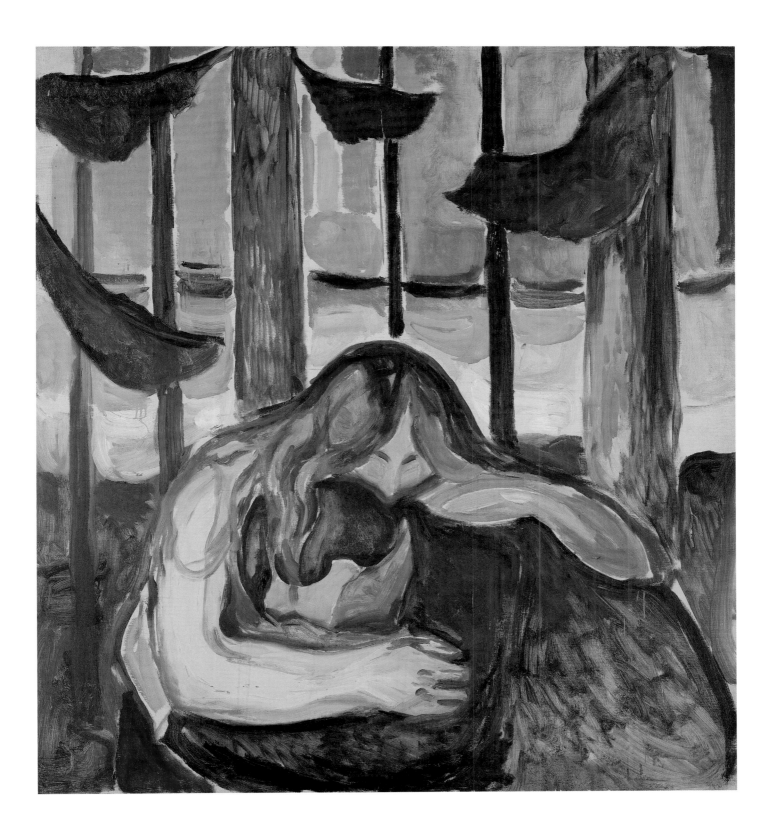

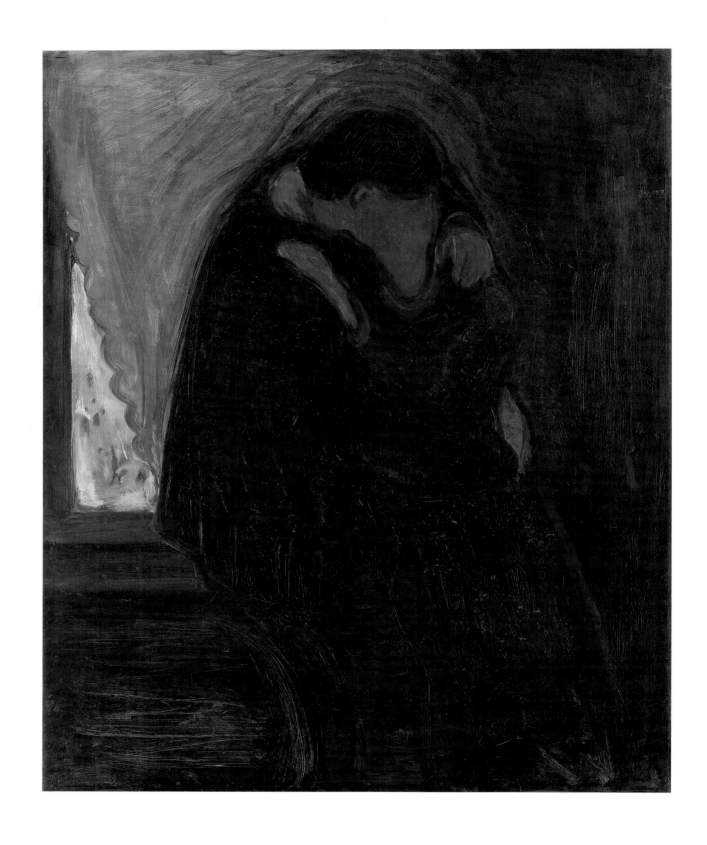

16
The Kiss
1897
Oil on canvas
99 x 81
Munch-museet, Oslo

17
Kiss on the Shore by Moonlight
1914
Oil on canvas
77 x 100
Munch-museet, Oslo

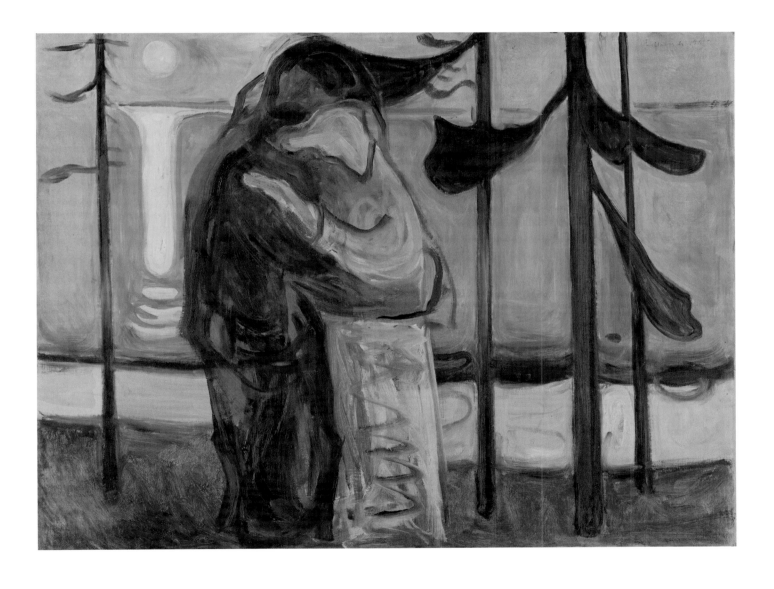

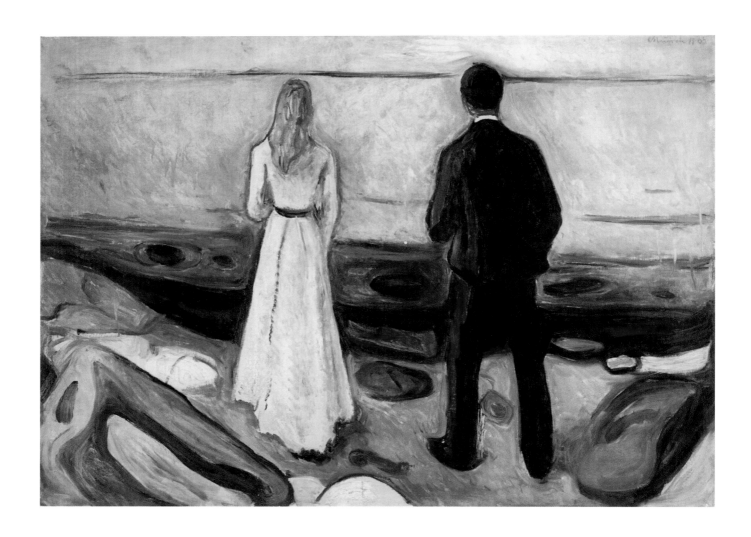

18
Two Human Beings: The Lonely Ones
1905
Oil on canvas
80 x 110
Philip and Lynn Straus

19
Two Human Beings: The Lonely Ones
1933–5
Oil on canvas
90.5 x 130
Munch-museet, Oslo

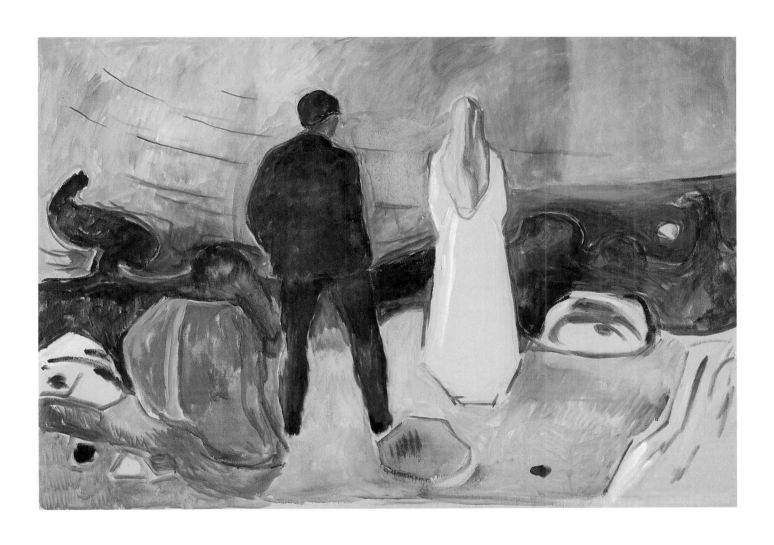

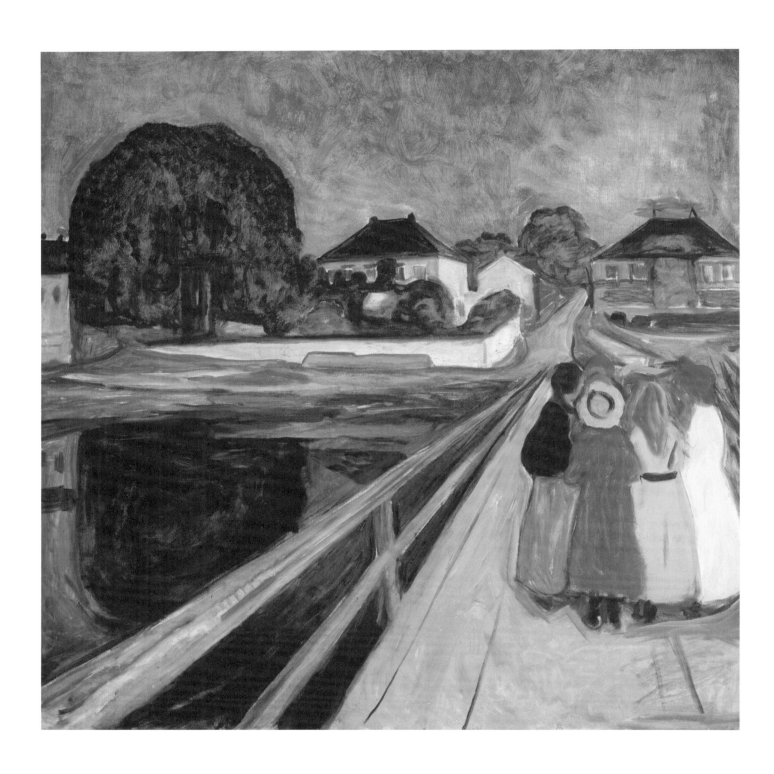

20
The Girls on the Bridge
1902
Oil on canvas
100 x 102
Private Collection

21
The Girls on the Bridge
1927
Oil on canvas
100 x 90
Munch-museet, Oslo

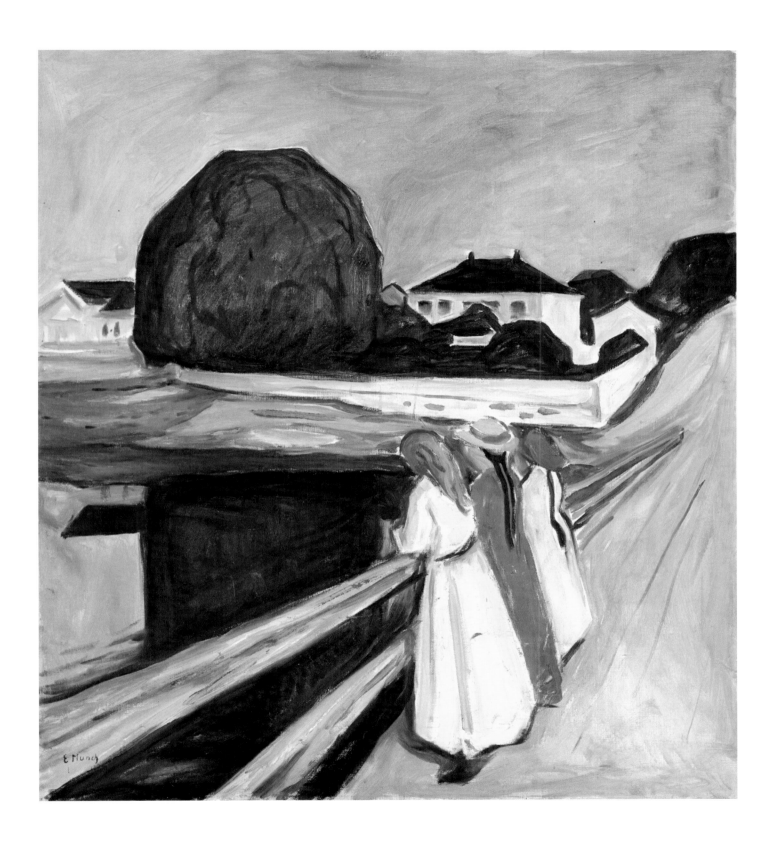

Edvard Munch
Notes

Dear Axel Romdahl

Thank you for your letter! I was
delighted to hear from you –
Yes, it is possible that I will
head to Gøteborg
one day in the course of the winter – You are
 well
aware of my difficulties:
my "embarrassment" when it comes to being
 sociable
Unfortunately I am not capable
of anything other than sitting in the corner of
 a café
with a friend – this has not improved
with time – Yes, "The Sick Child"
Funnily enough – I am
entirely against what is known as
the manufacturing of pictures – making
 replicas
for sale – But I say, never say never
– and I have more often copied

2
my pictures – But there is always an
evolution and it is never the same –
I construct one picture based on another.
Such as with "The Sick Child", which is
in our National Gallery and on which I
 worked for
a year – How many times did I repaint it
and scrape it –
I finally stopped when it was
simply no longer possible to work on it –
I had not managed to make it as I
wanted – But I had saved its soul!
For a long time the image was more powerful
and brighter in colour –
This is why I was able to continue
to paint this image – but then
on other canvases –
Oh yes, the price! – We have seen

remarkable prices for pictures
over the last few years, 15,000 kroner is
a lot
but I believe that if one does not sell

3
the prices will be maintained.
I myself only received 2,000 kroner
in total for the 3 pictures in
our gallery, Thiel's and yours –
If I want to have one I
can always paint another – It was only
after countless
attempts at persuasion and almost threats
that I finally agreed
to sell it to the gallery in Dresden
for the proposed sum of 25,000 kroner –
It was difficult – I went to
Dresden twice to persuade the director not to
buy it
Now I have heard that the picture
has been put in the cellar –
I have painted yet another picture
After this one was sold
I had sworn not to
part with it –
Now I have been persuaded to
send it to the Carnegie exhibition
– I received a letter from the director,

4
who emphatically expresses
his own enthusiasm and that of others for
the picture –
and I almost have the impression that
I can expect a buying offer
– and then
probably for the Carnegie Gallery
So what can one say – It is
most embarrassing to refuse –
All these pictures [are] different –
Some people reproach me for
having painted such a great number – But I
 say:
when I am so filled by this image –
and – is this not just as valid as
painting hundreds of apples or violins
on a table –
What's more – is it true
that in reality a painter only
paints one picture? What makes this
picture successful everywhere
whether it is a canvas or a print?

> Draft of a letter to Axel Romdahl,
> MM N 3359
> 1933
> Oslo, Munch-museet

Hvidtsten

Mr. Secretary Johan Langaard!

I have never made copies of
my pictures. Whenever I have used
the same motif it has solely
been for artistic reasons and to explore the
 motif
in greater depth. When certain painters
complained that I have painted several
 versions of
The Sick Child I was able to direct them to
Heine's somewhat boastful response
to a similar attack,
*"Ich der Gott kopiere
mich selber. Ich schuf Löwen und
Gazellen und ich machte auch die Affen"*
['I, God, I copy / myself. I have created lions
and / gazelles and even monkeys'] –
As for the small "Three Girls on the Bridge"
anyone who understands a little
about painting can see that its colours and
lines and its conception are completely
different – the first one
was painted in a different period –
"The Waves" was painted at my place in
Hvidtsten where the real motif can be found

2
outside my house – I was supported by
an unfinished sketch. I decided to send
that one because I found the first one too
 weak given that half
of the canvas was empty. I am not satisfied
 with
this picture either. I would like it to be firmer
and with slightly deeper colours
I considered almost everything in
my studio to be studies
it is therefore absurd to require tax on them
As you know I am in a period
when I have a particular need for calm and I
 have sought
refuge at Hvidsten –

The replicas of "The Sick Child"
were made because I wanted to reconnect
with my earlier period in order to free myself
from a slight flatness in my art
and pick up on naturalist studies in order to
obtain greater depth. However,
I consider this long period to be like a new
 phase
of apprenticeship and this is why I see them
 mostly
as studies –
– That is why I have not wanted to sell these
 most unfinished
paintings and this is why it is absurd that
 various
malicious tongues in Oslo should talk about
 stockpiling –
What painter does not
have lots of studies?

> Note or draft of a letter to
> Johan Langaard, MM N 1787
> 1935
> Oslo, Munch-museet

1

A good painting with 10 holes
is better to have than
ten poor paintings without holes

Sehr verehrter
I prefer not to comment on my art
That would easily become a manifesto
All manifestos are
condemned to be abandoned – just as
all associations and federations –
They hang around your feet
like heavy chains

All manifestos are
condemned to death in advance
like chained feet

Everything flickers and gets lost in the mist
before the eyes of someone condemned to
 death
en route to the scaffold – whose gaze
rests on a bud – on a flower – whose thought
 attaches itself
and clings on How strange this yellow
flower is – how odd this bud is

2

A good painting with 10
holes is better than 10
poor paintings without holes
A good painting with weathered paint
on a poor ground
is preferable to 10 poor paintings
on a good ground
A good image never disappears
An ingenious ida does not die
A charcoal line on a wall
can have more artistic value
than more than many a richly–framed
picture

3

Most paintings by Leonardo da Vinci
have been destroyed – but they live on
nevertheless – an ingenious thought
never dies

War
Agony
A man bathing

4

A charcoal line on a wall
can be a greater work of art
that the most perfectly executed painting
Many painters take
so many precautions and give so much care
to the ground – and to the execution of the
 picture – in order
to ensure its eternity – that they lose
their fervour for it
It then happens that the picture
becomes so boring and so poor that
it is relegated to a dark attic
Even if a luminous expressionist picture
loses its colours
over time – it can retain
its soul and its vitality – even
if only one line of it remains
And at least it dies in beauty

In any case it has brought
new goals to painters
who have set off with other intentions

Note, MM N 38
c.1928–1930
Oslo, Munch-museet

*Translated by Luce Hinsch
and Laura Bennett*

Autobiography

Munch, like Bonnard, Vuillard and Mucha, is part of the generation of painters who took up amateur photography at the turn of the century. It was in 1902 in Berlin that the Norwegian painter purchased a small Kodak camera and began to take photographs. Apart from some images documenting his canvases or particular locations linked to his memories, Munch predominantly created self-portraits. It would be more accurate to compare him to the writer-photographers of the period than to other painters of his generation. There is in his photography, as in that of Strindberg, Loti and Zola, the same obsession with the self-portrait, a similar desire to keep track of his life in images. In 1930 Munch also declared in an interview: 'One day when I am old, and I have nothing better to do than write my autobiography, all my self-portraits will see the light of day again.'

22
The Late *Frieze of Life* in the Outdoor Studio at Ekely
1927–30
Photography, gelatin silver print on paper
8.7 x 11.2
Munch-museet, Oslo

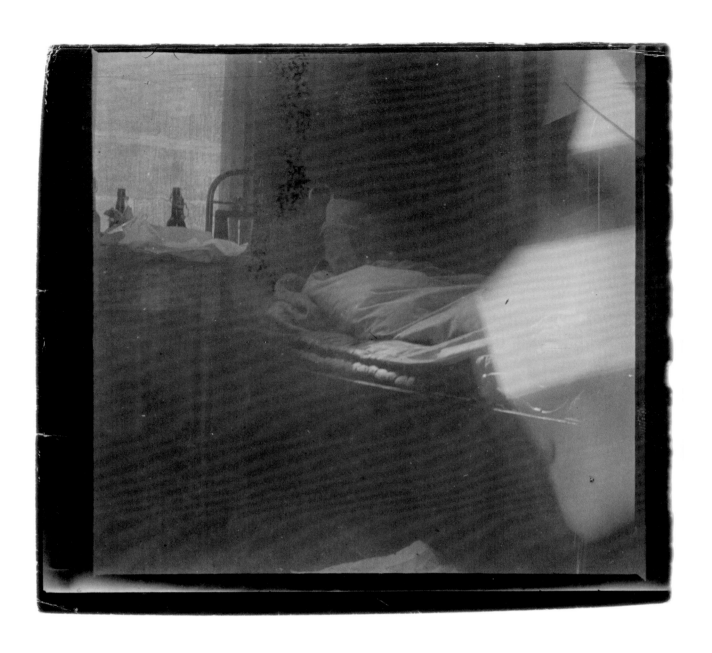

Fig.15
Self-Portrait in Bed
c.1902
Photograph, collodion print on paper
10 x 9.5
Munch-museet, Oslo

Fig.16
**Illustration from 'Instructions for
Using the Bull's-Eye no.2 Camera'**
Rochester, Eastman Kodak
Company 1897, p.7
Private Collection

Clément Chéroux

'Write your life!': Photography and Autobiography

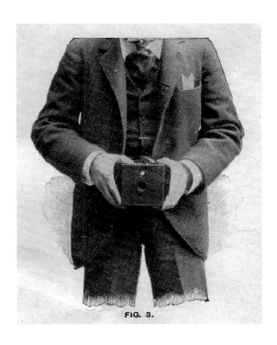

FIG. 3.

Edvard Munch belongs to a generation of artists – that of Pierre Bonnard, Édouard Vuillard, Félix Vallotton, Alfons Mucha, Fernand Khnopff, Franz von Stuck and others – all born around 1860,[1] who achieved their first stylistic maturity in the final two decades of the nineteenth century, at the time of the great boom in amateur photography.[2] It was, indeed, from the 1880s onwards, thanks to the development of a new sensitive medium, silver-gelatin bromide, and the technological revolution that followed, that photography became easier to use. The number of amateur photographers increased like never before. It was the first real democratisation of photography. Despite their considerable pictorial differences, Bonnard, Vuillard, Vallotton, Mucha, Khnopff, Stuck and Munch all, at one time or another, took up a camera in order to preserve the position of a model, take visual notes, create self-portraits or fix memories of trips and family members. They make up the first generation of painters to have *also* been amateur photographers.

It was in February 1902 in Berlin that Munch began to take photographs.[3] At that time he used one of the most common amateur cameras of the age: the Kodak Bull's-Eye no.2 manufactured by the American company Eastman (figs.16 and 17).[4] It was a simple rectangular box made from walnut wood and sheathed in black Moroccan leather, measuring 11 × 12 × 15 cm and weighing 600 grams. It had only two features: a small knob allowing you to choose between instant snapshot and exposure, and another allowing you to regulate the aperture, depending on the light, in three different positions. No focusing was required; the fixed-focus lens was pre-set to be clear from around one metre to infinity. The camera was equipped with a viewfinder, less to assist with framing and more to ensure that the subject to be photographed was properly within the field. This Kodak allowed for six or twelve shots in a line on a flexible silver-gelatin film. The negatives, measuring 9 × 9 cm (fig.18), were printed on contact, without enlargement. The work could

be done in Kodak pharmacies, but these also marketed developing kits, allowing the amateur to make his own prints in an improvised darkroom, a cupboard or a bathroom, for example.[5] The fingerprints that appear on several of Munch's photographs indicate that it is very likely he progressed to developing his own films. He used this camera until 1910, after which he stopped taking photographs for sixteen years.

At the end of 1926, Munch became interested in taking photographs once more. He gave his sister Inger a gift of an 8.2 × 14 cm camera and taught her how to take photographs. For himself he bought a new extendable 4 × 6.3 cm format Kodak Vest Pocket which, once folded, only measured 2.5 cm in thickness and fitted easily into a pocket. With a relatively clear viewfinder, four different exposure times and five apertures, it was a slightly more elaborate camera than the one he owned at the beginning of the century.[6] The existence in the Munch archives of 8.3 × 10.8 cm format negatives indicates that at that time he owned another camera that it has not been possible to identify. The images corresponding to these negatives were printed on contact, but undoubtedly by Munch himself. The presence in the archives of five proofs of the same negative suggests that a retailer offered him a sample of different types of prints. In order to complete our description of Munch's technical equipment, we should add that, during a trip to Paris in 1927, he also purchased a small Pathé-Baby amateur film camera (fig.76, p.178), implying that this second phase of his interest in analogue images, which would last until 1932, was particularly intense.

Compared to the photographic production of someone like Vuillard, which includes thousands of shots, Munch's production is relatively limited: only 244 prints of 183 different subjects.[7] In an overview of artists who adopted photography at that time, his production is relatively *unusual*. For painters of this generation, the use of photography responded in the main to two motivations: *documentary* or *family*. Mucha, Khnopff and Stuck photographed their models in the poses they wanted to then transpose onto the canvas. For them photography was merely an extension of the sitting. For Bonnard, Vuillard and Vallotton, the camera served above all to keep track of moments of happiness spent among friends, as a couple, or with family (fig.19). Certainly on some occasions their shots were subject to transcription onto canvas *after the fact*, but on no occasion was this the first, or main, motivation for their photography.

Munch's photographs do not correspond overall to either of these two practices. Only two photographs depicting nude models can be directly linked to pictorial motifs (figs.20 and 21).[8] It is difficult to say, however, whether Munch painted directly from the photograph or whether he was simply content to photograph his model while he was painting; something that implies, admittedly, a quite different relationship between cause and effect. In any case, neither of these two examples shows a *documentary* use of photography that is as systematic and manifest as it was for Mucha, Khnopff and Stuck. Although Munch's work includes a modest dozen shots depicting his sister Inger, his aunt Karen Bjølstadt, or some friends at Kragerø, and though he took many photographs of his canvases, which he considered a little like his children, it is difficult nonetheless to view his production in its entirety merely through the prism of *family* photography, as with Bonnard, Vuillard and Vallotton.

What fundamentally distinguishes Munch from the other painters who practised photography at the same time is the quantity of self-portraits he produced. Among all the images kept at the Munch-museet, one image in every three depicts the artist himself.[9] Bonnard, Vuillard, Vallotton, Mucha, Khnopff and Stuck photographed themselves, of course, but not to such an extent. The very first photographs taken by Munch, immediately after he purchased the Kodak box camera, were two

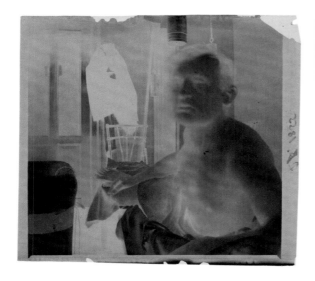

self-portraits in which he is seated on a chest in his studio in Berlin. He sent them to his aunt Karen on 14 February 1902 with this note: 'I enclose two photographs taken with a small camera I bought. As you can see, I've shaved off almost all my moustache.'[10] In the various locations in which he would later take photographs, in Åsgårdstrand in 1904, in Warnemünde in 1907, and in Copenhagen during the winter of 1908–9, then again in Ekely in 1930, it is always the desire to depict himself that dominates. It should be noted here that the majority of the photographic self-portraits of the painter depict him in profile or in three-quarter view, with his face arranged in a way that a mirror would not be able to see. In a letter to his friend Ludvig Ravensberg dated 23 June 1904, Munch wrote: 'When I saw my body photographed in profile, I decided, after consulting with my vanity, to dedicate more time to throwing stones, throwing the javelin and swimming.'[11] (no.7, p.26) Behind what is being expressed here in a tone of friendly banter, it should be understood that Munch uses self-portraiture in order to stare at himself. 'Know thyself', goes the Greek adage written on the pediment of the Temple at Delphi. For Munch, photography is the instrument of this introspection. It allows him to better understand his appearance.

Among Munch's self-portraits, there are many that depict him surrounded by his pictures. One photograph taken in 1909 in his studio in Kragerø is particularly interesting in this regard (no.36). Munch is seen in full-length, surrounded by life-sized portraits of his friends Ludvig Ravensberg, Jappe Nilssen and Christian Gierløff, as if they were really there, as if the painter were posing with them for a group portrait. Through the intermediary of photography, Munch establishes a kind of playful complicity with his works. During the winter of 1908–9, at the clinic of the doctor Daniel Jacobson, where he was being treated for depression, he poses in an armchair opposite a painted self-portrait that depicts him in a similar pose, on the

same chair (no.9). During a stay at Warnemünde, he photographed himself in profile, between two canvases, one depicting children and the other an old man,[12] as if he was walking along the path separating these two ages (no.37). But, having moved during the shot, the transparency of his body reveals a third picture in the background, the one of which, of all his works, he was the most fond: *The Sick Child.* The incorporation of the painter into his own works would be pushed even further in a series of self-portraits created in the Ekely studio in 1930. In one of the first shots, Munch appears facing the camera (no.102). Another image, with exactly the same framing, shows that the painter moved during the shot (no.103). He is now nothing but a disembodied and transparent ghost that seems to have been projected onto a canvas in the background, the title of which, *Metabolism,* calls to mind precisely a transformation of molecules and energy.[13] Through his photography Munch is at one with his paintings.

Munch was already aware of this ghostly effect in 1902. In the October of that year he had used it to photograph his exhibition at the Blomqvist Gallery in Kristiania (nos.34 and 35). Opened on 24 September, the exhibition received limited visitors until an anonymous letter calling for it to be boycotted was circulated by the *Aftenposten* newspaper on 2 October, triggering public curiosity and a scandalous success. Two weeks later, on 17 October, the satirical newspaper *Tyrihans* gave an account of the incident with a double cartoon by Ragnvald Blix showing the exhibition haunted at first by the lonely silhouette of the artist, then suddenly besieged by crowds (fig.22). As Arne Eggum has amply demonstrated, Munch re-enacted this cartoon using longer exposures to signify his spectral presence next to his pictures.[14]

Alongside self-portraits or backdrops with his pictures, Munch also regularly photographed his canvases on their own, but, usually, without any concern for the elementary rules for

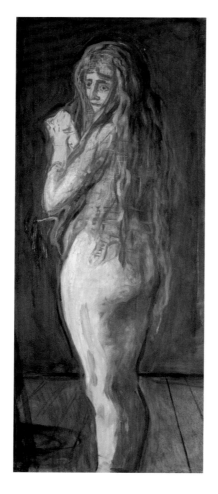

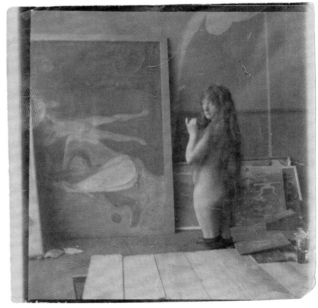

reproducing works of art (nos.38–41). The pictures appear
off-centre, badly lit, usually truncated or interfered with by
surrounding objects. The shooting conditions are so unorthodox
that it is difficult to envisage these images as documentary
reproductions. It would undoubtedly be better to consider them
the result of a sort of compulsive recording. Munch photographed
his canvases as if they were loved ones of which he wanted to
keep track at all costs, for fear that they might disappear. These
shots are in fact portraits of pictures.

Alongside these portraits of pictures, or self-portraits,
Munch's body of photographic work also includes a small set
of images of places. These locations were not chosen by chance;
they all occupy an important place in Munch's memory. In
1902, he photographed the entrances, rear-courtyard and
garden of the building located at 30b Pilestredet, in Kristiania,
where he lived as a child and where his mother died during the
winter of 1868, when he was just five years old (nos.42 and 43).
Two years later, in 1904, he photographed the beach at
Åsgårdstrand, the setting for the most tumultuous episodes in
his private life, and where he was preparing to relocate some of
the most important motifs of his painting from the 1890s, for
the decorative frieze intended for the German collector Max
Linde. The short-focus lens fitted to Munch's small Kodak
characteristically produced images in which space appears
stretched in relation to eyesight. This vacuum effect emphasises
even further the absence of the loved ones who, in Munch's
memory, populated these places. As a result the images appear
haunted. They seem even more so whenever the photographer's
hand trembled while the shot was being taken. The image of
the rear-courtyard of the building in which his mother died is
slightly blurred, as if it had been seen through tears (no.43).
This imprecision gives the image a certain aura, at the same
time as encouraging the projection of the viewer. In the
indistinct forms that occupy the right-hand side of the image,

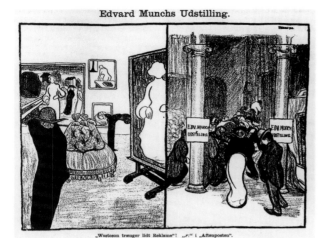

Nedre Foss. Fra «Kongens Mølles» efter flom.

Munch also saw 'a swan on the wall' appear, as is revealed by an inscription from his hand on the back of the shot. This symbol of purity is far from insignificant in this place of childhood and mourning. Munch's photographs are haunted, not least by his own memories.

In the whole of Munch's photographic production, one image does not fit into any of the sets that have just been described (no.31). Taken on the beach at Warnemünde in the autumn of 1907, it shows the lower bodies of two women: Olga Meissner and her sister Rosa, a model from Berlin who had come to sit for Munch. The strange composition of this image, which does not correspond to anything else being done in the photography of the period, even in the most avant-garde circles, forces an examination of the reasons why it was taken. In a fit of fetishism, did the painter want to photograph the ankles and lower calves of the young girl who is caught unawares while crossing her legs? Is it more simply a failed shot, triggered accidentally while lowering the camera towards the ground? If that is the case, then we have to ask why Munch took the trouble to print the image and keep it. The solution to the riddle is definitely elsewhere. On closer examination of the shot, a dark mass can be seen occupying the lower part of the image and is none other than the silhouette of the photographer, his head and shoulders blocking the sunlight. It is his shadow, overlapping the feet of the young girls, that the photographer seems to have wanted to fix here. The very same projected shadow that would haunt several of his engravings and pictures over the years to come (figs.24 and 25, and no.83). Here once again we have a self-portrait. Even in the most abstract image that Munch produced, it is still about him.

Munch's photographic work therefore is principally divided between self-portraits and photographs of his pictures or locations in which he was particularly emotionally invested. The common denominator of all these images is that Munch is always the main subject. This bears no comparison, as we have gathered, to the production of other painters of his generation who also practised photography. Not even to Bonnard, Vuillard or Vallotton, who nevertheless documented their family life at some length. This is for two reasons: because Munch's work is his only real family, but also because his photographic motivation is much more egocentric, if not narcissistic. In the manner of Charles Schweitzer in *Words* by Jean-Paul Sartre, it is obvious that the painter 'relished those brief moments of eternity when he became his own statue'.[15] More so than with the photographs of painters of his generation, it would in fact be wiser to compare Munch's photographic production with that of writers of the period. There is, indeed, in the photographs of August Strindberg, Leonid Andreïev, George Bernard Shaw, Pierre Loti and Émile Zola, or even earlier, in those of Victor Hugo, the same obsession with the self-portrait, a similar wish to trace life's path through images.

It is undoubtedly with his fellow Scandinavian, the Swedish playwright August Strindberg, that the connection is the most legitimate.[16] In 1886, when starting to write his autobiography, Strindberg created an astonishing series of self-portraits documenting his daily life, showing him in the company of his children or working at his table. Always among the avant-garde of his time, the writer suggested to his editor Albert Bonnier that his photography should be published alongside his text. This highly innovative editorial project would sadly never see the light of day.[17] In Berlin in 1892, when Munch got to know Strindberg, he was still very concerned with photographic experiments. Ten years later, when the painter began to take his own photographs, he did not forget the experiences of the older man. Just like him, he made endless self-portraits; in his own way, he documented his work and recorded the places that had counted in his own life. The comparison with Strindberg allows the *literary* nature of Munch's photographic project to be

measured. We will assume here that Munch's photography is, in fact, linked less to painting than to writing. In this respect, a much better understanding of this photographic production would undoubtedly be gained by reconciling it with the hundreds of texts, drafts and notes left by Munch, than by comparing it with his pictorial works, as has always been done up to now.

In the late 1920s and early 1930s, Munch faced a further series of family bereavements, as he had already experienced during his childhood. In 1926 his sister Laura, who had long been confined to a psychiatric hospital, died. In 1931 his aunt, Karen Bjølstad, who had taken him in and brought him up after the death of his mother, also passed away. These further deaths plunged the artist back into his memories. He began to write more, or to rework older texts such as that about *The Frieze of Life*.[18] This also corresponded to the period in which he began to take photographs again. In 1926 specifically, he bought a new camera, then another soon after with which he would create many self-portraits in his studio or outdoors. He even invented a new technique for photographing himself. Up to now he had been content to photograph his shadow, or to position the camera on a stand, and then set himself up in front of the lens. At Ekely in 1930, in the manner of the Greek tragedians, who at a certain point during the performance would rip off their mask in order to brandish it towards their face, Munch had the idea of taking the camera in his hand and turning it around on himself like a mirror (nos.108–14). In the history of photography, as far as we currently know, he was the first to take this kind of self-portrait at arm's length, something that has become particularly common today in the era of the mobile-phone camera.

At the same time Munch also encouraged his sister Inger to take photographs near the Aker river in Oslo, on the banks of which they had spent part of their childhood (no.23).[19] Whether

through the intermediary of his sister, or through his own shots, it does seem that Munch associated the act of taking a photograph with a very personal introspective quest. Moreover, he confirms this in November 1930 in an interview with the Danish writer Hans Tørsleff for the German magazine *Die Dame*. 'I've learnt a great deal from photography for example,' he declared. 'I have an old camera with which I've take countless pictures of myself, often with amazing results. One day, when I am old and I have nothing better to do than write my autobiography, all my self-portraits will see the light of day again.'[20] Munch's photographic project is not just literary, it is also eminently autobiographical. In fact, it responds perfectly to the charge of his former mentor, Hans Jæger, who in 1889 drew up the first commandment of Kristiania's literary Bohème: 'Write your life!'[21]

Translated by Laura Bennett

Fig.24
Edvard Munch's Dog, Fips
c.1930
Photograph, gelatin silver print on paper
8 x 11.7
Munch-museet, Oslo

Fig.25
Starry Night
1930
Woodcut
37 x 40
Munch-museet, Oslo

Notes

1 Munch and Stuck were born in 1863, Khnopff in 1858, Mucha in 1860, Vallotton in 1865, Bonnard in 1867 and Vuillard in 1868. We could extend the list even further by citing George Hendrik Breitner, born in 1857, Medardo Rosso in 1858, Henri Rivière in 1864 and Akseli Gallen-Kallela in 1865.

2 See Dorothy Kosinski (ed.), *The Artist and the Camera,* New Haven and London 2000.

3 In addition to my personal research in the archives of the Munch-museet in Oslo, to which I was granted access by Ingebjørg Ydstie – for which I am eternally grateful to her – and the information kindly provided by Halvor Bjørngård, who has recently established a new inventory of the photographic collection, the majority of information relating to Munch's photographic practice comes from the seminal study by Arne Eggum, *Munch and Photography,* New Haven and London 1989.

4 This camera has not survived. According to Eggum (ibid., p.95), a Kodak was mentioned several times in Munch's correspondence. The existence in the small house at Åsgårdstrand of a pack of film (format 101) intended for the Kodak Bull's-Eye no.2 allows us here, for the first time, to accurately identify the camera that Munch was using at the start of the century.

5 The technical information relating to the Kodak Bull's-Eye no.2 comes from the photographic materials catalogue *Photo-Plait* from 1915.

6 This camera is kept today at the Preus Museum in Horten.

7 I would like to thank Halvor Bjørngård for having provided me with these figures, as well as those in note 9.

8 Respectively numbered 133 and 196, in the book by Arne Eggum 1989, pp.98 and 128. In 1973 the first study on Munch and photography, by Josef Adolf Schmoll Gen. Eisenwerth ('Munchs fotografische Studien', in Henning Bock, Günter Bush [ed.], *Edvard Munch. Probleme, Forschungen, Thesen,* Munich 1973, pp.187–225), put forward the hypothesis that certain shots may have been destroyed by Munch himself, or by his sister after his death. At that time only thirty images had been identified. The complete study of the collection and the absence of particularly obvious lacunae now make this hypothesis unlikely.

9 Exactly 57 photographs from 183.

10 Eggum 1989, p.95.

11 Ibid., p.117 (editor's note: our translation).

12 Respectively *Rue à Warnemünde,* 1907 (*Street in Warnemünde,* Woll 757), and *Vieil homme à Warnemünde,* 1907 (*Old Man in Warnemünde,* Woll 755).

13 *Métabolisme,* 1898–9 (*Metabolism,* Woll 428).

14 Eggum 1989, pp.102–3.

15 Jean-Paul Sartre, *Les Mots,* Paris 1964, p.23.

16 See Per Hemmingsson, *August Strindberg som fotograf,* Aarhus 1989; Clément Chéroux, *L'Expérience photographique d'August Strindberg,* Arles 1994.

17 The album of images sent by Strindberg to his editor was found several years ago in the archives of Éditions Bonnier and has since been the subject of a reprint: August Strindberg, *Impressionist-Bilder,* Stockholm 1997.

18 See Poul Erik Tøjner (ed.), *Munch in His Own Words,* Munich, London, New York 2001; Mai Britt Guleng (ed.), *eMunch.no. Text and Image,* Oslo, Munch-museet, 2011, and the text by M.B. Guleng in this book, see p.153.

19 See Inger Munch, *Akerselven, Utarbeidet og Fotografert av Inger Munch,* Oslo 1932.

20 Hans Tørsleff, 'Edvard Munch… Der Einsiedler von "Ekely"', *Die Dame,* no.4, November 1930, pp.42–4. The interview has been published in Norwegian in '"Europa et galehus" sier Edvard Munch', *Dagblabet,* no.4, 6 January 1931 (editor's note: our translation).

21 See Frank Høifødt, 'The Kristiania Bohemia Reflected in the Art of the Young Munch', in Erik Mørstad (ed.), *Edvard Munch: An Anthology,* Oslo 2006, pp.15–41.

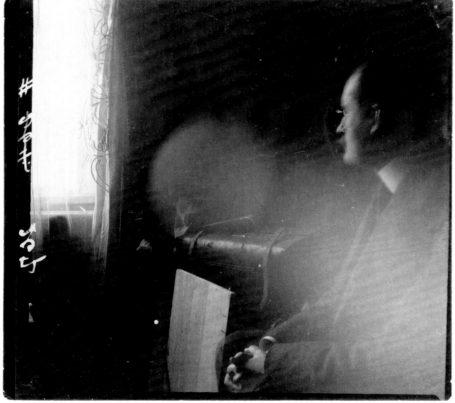

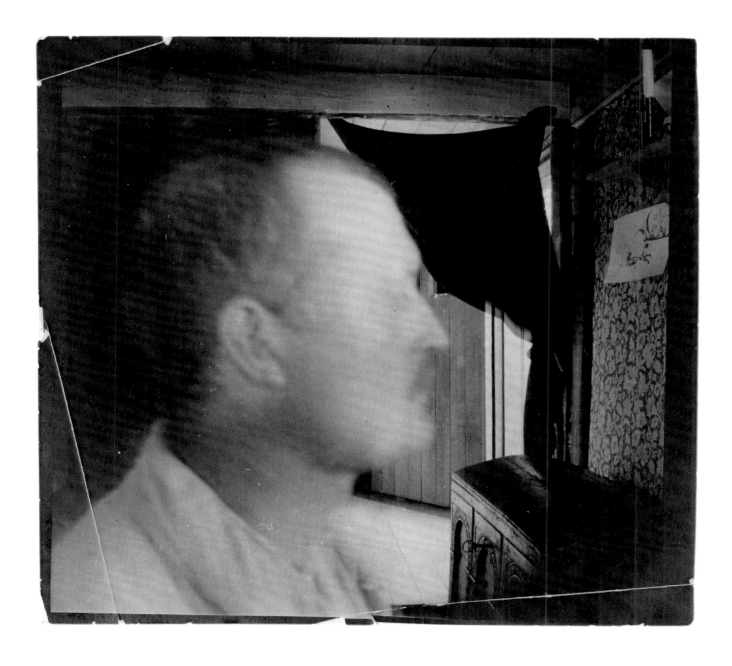

23
Self-Portrait
c.1906
Photograph, collodion print on paper
8.1 x 8.3
Munch-museet, Oslo

24
Self-Portrait
c.1906
Photograph, collodion print on papert
8.9 x 9.5
Munch-museet, Oslo

25
**Self-Portrait Inside the
House at Åsgårdstrand**
c.1904
Photograph, gelatin silver
print on paper
8.8 x 9.5
Munch-museet, Oslo

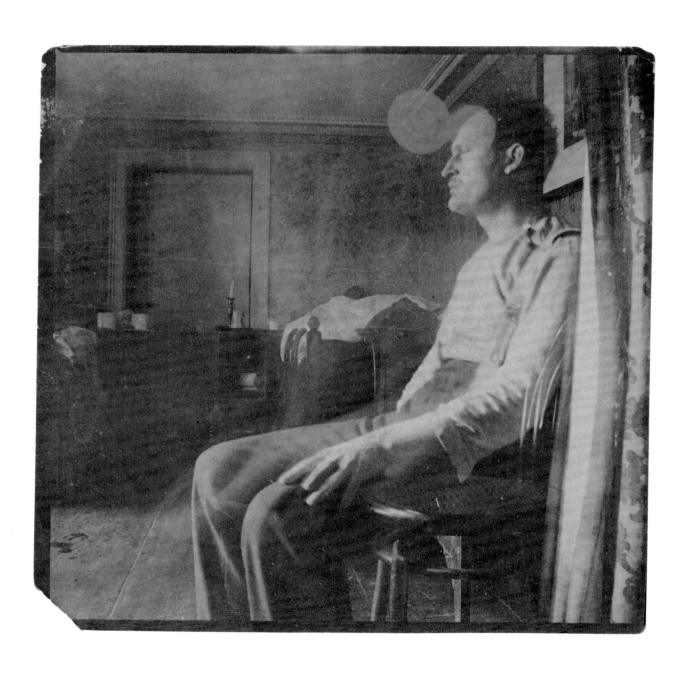

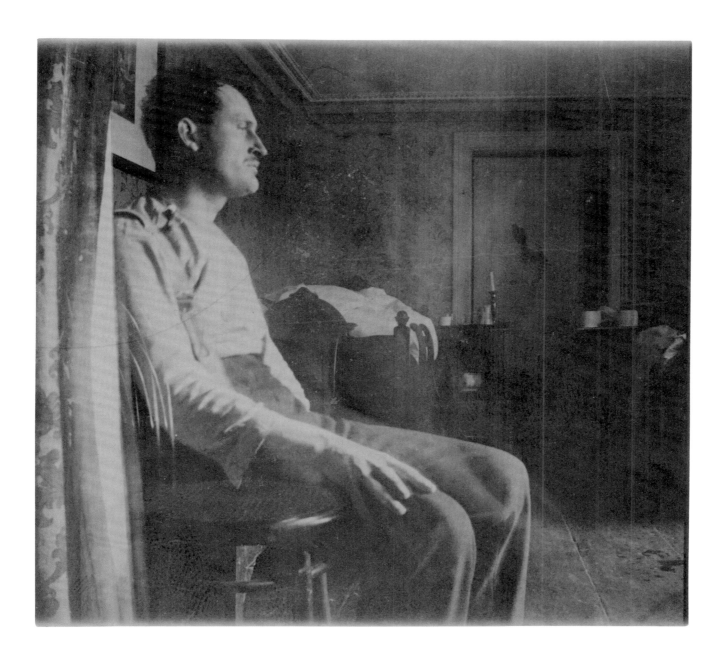

26
**Self-Portrait in a Room
on the Continent I**
c.1906
Photograph, gelatin silver
print on paper
9 x 9
Munch-museet, Oslo

27
**Self-Portrait in a Room
on the Continent II**
c.1906
Photograph, gelatin silver
print on paper
8.3 x 8.7
Munch-museet, Oslo

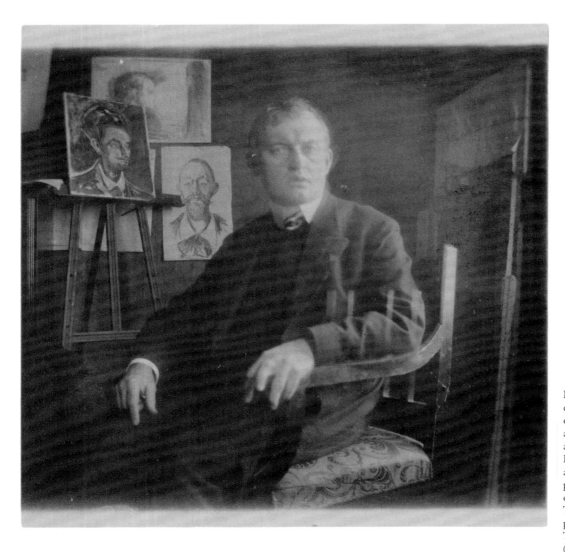

Put in the suitcase
envelope with photographs
of me and of the house
and of my aunt. A film of me
at Ekely.
Put in the suitcase are
a document holder and some
photographs of the fatal destiny
of 1902–1908
To which must be added a
photograph of me in 1943
The hand of fate
(revealed). The left hand
is ~~revealed~~ crippled
One of the middle fingers was
 burned
during childhood [sic] half
pierced by the bullet of a revolver
The other all

Edvard Munch
Note, MM T 2731-04V
1943
Munch-museet, Oslo

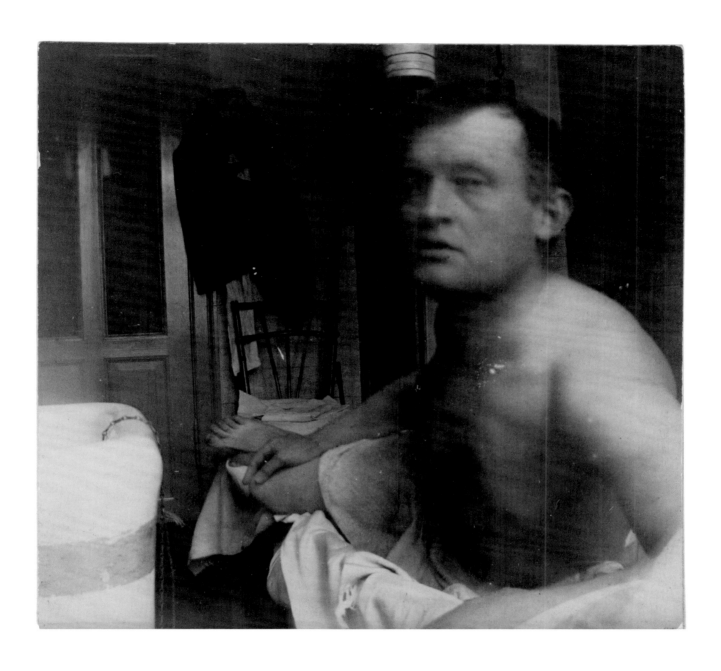

28
**Self-Portrait at Dr Jacobson's
Clinic in Copenhagen**
1908–9
Photograph, gelatin silver
print on paper
9.2 x 9.2
Munch-museet, Oslo

29
**Self-Portrait 'à la Marat' at
Dr Jacobson's Clinic in Copenhagen**
1908–9
Photograph, gelatin silver
print on paper
8.1 x 8.5
Munch-museet, Oslo

30
**Self-Portrait with Housekeeper
at 53 Am Strom in Warnemünde**
1907
Photograph, collodion print on paper
8.9 x 8.9
Munch-museet, Oslo

31
**Rosa and Olga Meissner on
the Beach in Warnemünde**
1907
Photograph, collodion print on paper
9 x 8.9
Munch-museet, Oslo

32
**Self-Portrait with Rosa Meissner
on the Beach in Warnemünde I**
1907
Photograph, collodion print on paper
8.9 x 8.7
Munch-museet, Oslo

33
**Self-Portrait with Rosa Meissner
on the Beach in Warnemünde II**
1907
Photograph, collodion print on paper
8.5 x 8
Munch-museet, Oslo

34
Edvard Munch's Exhibition at Blomqvist's in Kristiana
1902
Photograph, collodion print on paper
9.4 x 9.3
Munch-museet, Oslo

35
Edvard Munch's Exhibition at Blomqvist's in Kristiana
1902
Photograph, collodion print on paper
9.6 x 9.3
Munch-museet, Oslo

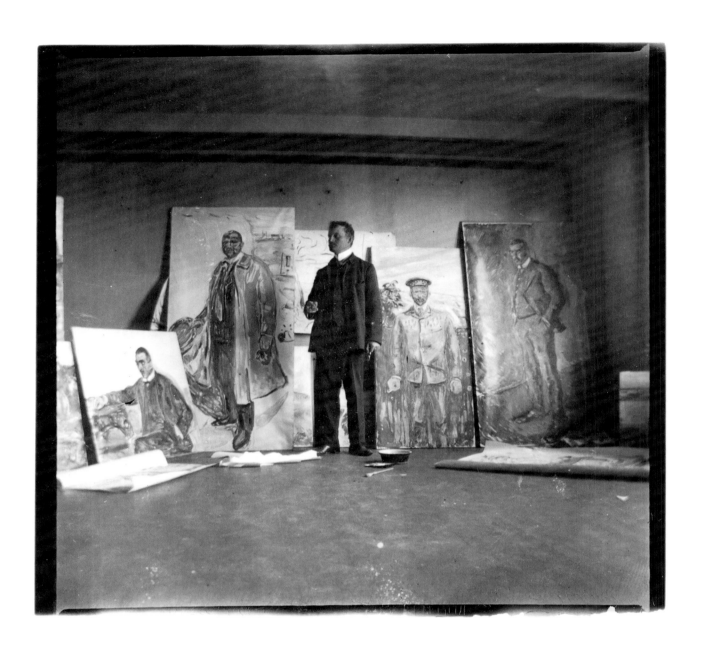

36
**Self-Portrait in the Studio at
Skrubben in Kragerø**
1909–10
Photograph, gelatin silver print on
paper
9 x 9.4
Munch-museet, Oslo

37
**Self-Portrait at 53 Am Strom
in Warnemünde**
1907
Photograph, gelatin silver
print on paper
9 x 9.4
Munch-museet, Oslo

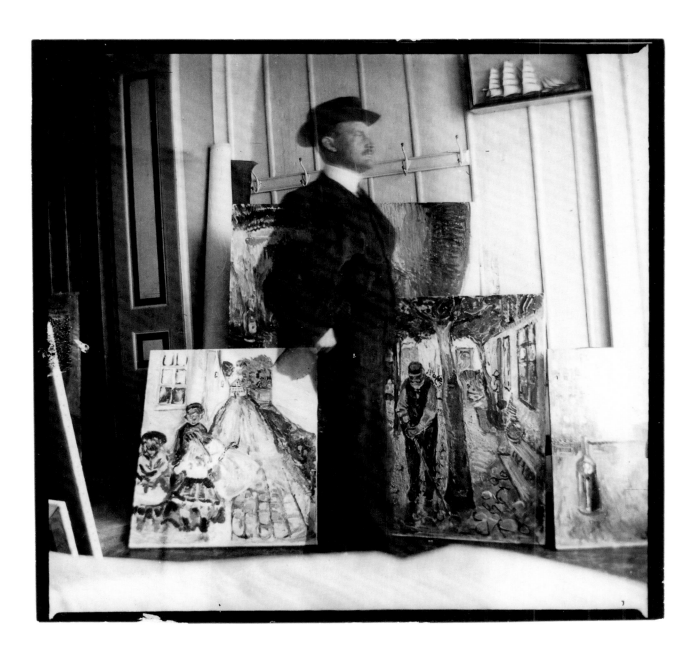

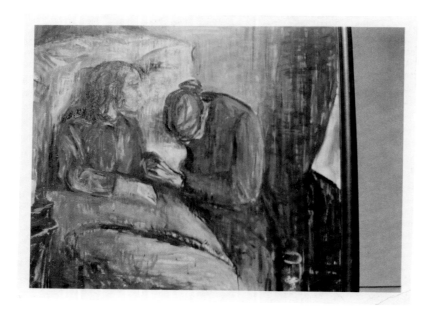

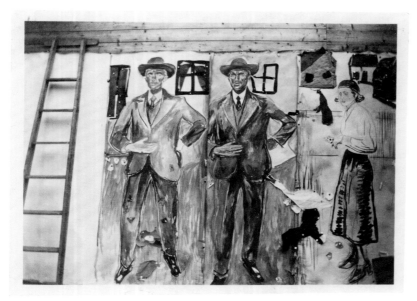

38
The Sick Child, Ekely
c.1930
Photograph, gelatin silver
print on paper
8.6 x 12
Munch-museet, Oslo

39
The Splitting of Faust, Collage in
the Outdoor Studio at Ekely
1932
Photograph, gelatin silver
print on paper
8.5 x 11.3
Munch-museet, Oslo

40
Double Exposure of 'Charlotte
Corday', Ekely
c.1930
Photograph, gelatin silver
print on paper
11 x 8.8
Munch-museet, Oslo

41
The Girls on the Bridge in the Yard
of 30B Pilestredet in Kristiana
c.1902
Photograph, collodion print on paper
10 x 9.7
Munch-museet, Oslo

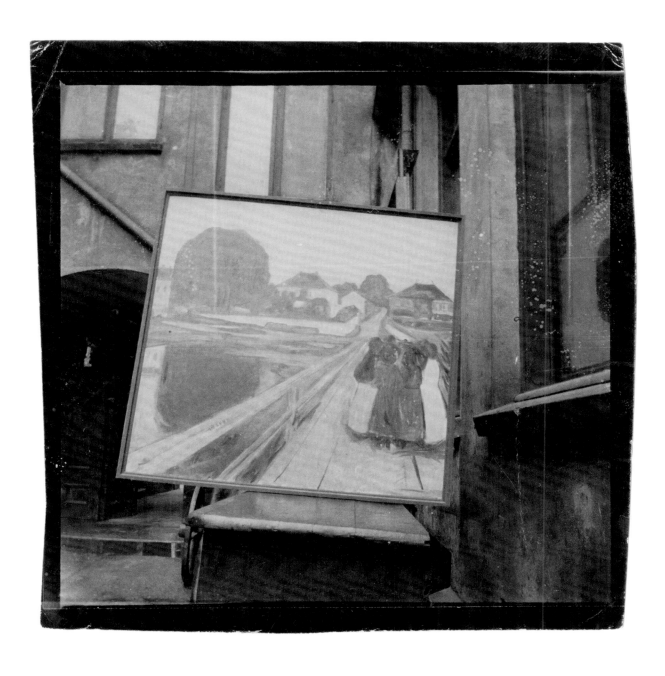

42
**The Yard of 30B Pilestredet
in Kristiana**
c.1902
Photograph, gelatin silver
print on paper
8.9 x 9.2
Munch-museet, Oslo

43
**The Yard of 30B Pilestredet
in Kristiana**
c.1902
Photograph, gelatin silver
print on paper
9 x 9
Munch-museet, Oslo

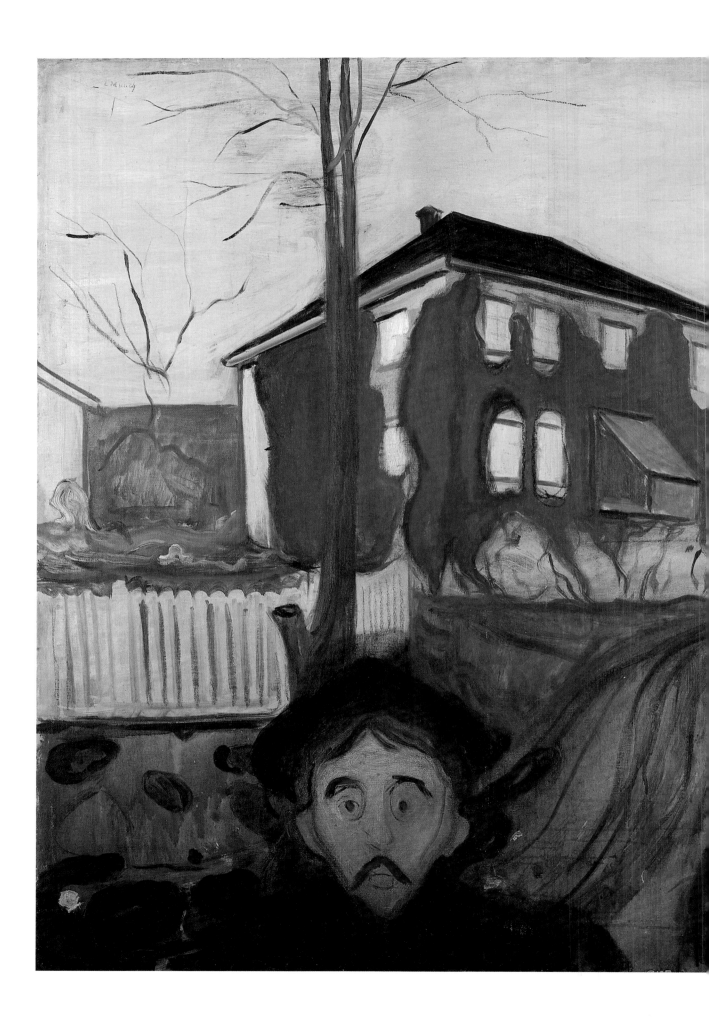

OPTICAL SPACE

The handling of space in Munch's paintings is highly unusual. In many instances his compositions rest on one or two diagonal structural lines heightening the perspectival effect; on an expansion of space from what is near into the distance; on prominent foregrounds that are often cut off by the frame; and on a movement of the figures towards the front of the picture. This way of painting has learned the lessons of the nineteenth century, from impressionism, from japonisme, from the use of the camera obscura and from photography. But it also integrates visual schemes characteristic of the twentieth century, such as those established by the illustrated press and cinema, with their images of moving crowds, and figures or horses rushing towards the camera. If Munch uses this dramatic and energetic method of composition so often, it is because he is trying to intensify the relationship between the picture and the viewer as much as possible.

Red Virginia Creeper
1898–1900
Oil on canvas
119.5 x 121
Munch-museet, Oslo
(no.52)

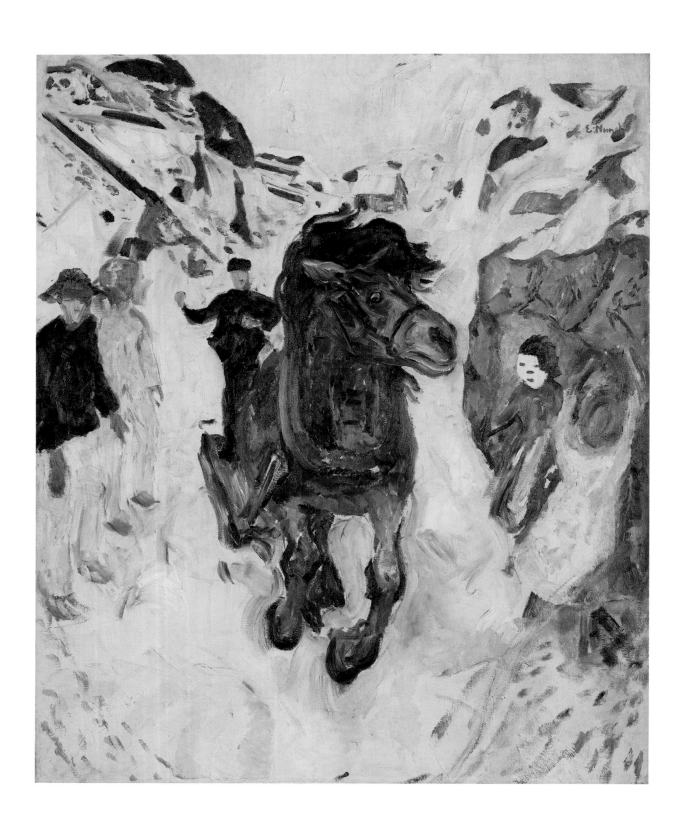

44
Galloping Horse
1910–12
Oil on canvas
148 x 120
Munch-museet, Oslo

Clément Chéroux

Depth of Field

He loved spatial effects ...
Rolf E. Stenersen[1]

The publication of a painter's catalogue raisonné always provides a chance to reassess his body of work. It offers an opportunity to add a more *quantitative* analysis to the more traditional *qualitative* approach. The concern for completeness inherent in such an undertaking, the accumulation of reproductions upon one single base, and the chronological organisation of the publication, allow for the frequency of choice of a motif, or of a way of painting, to be measured, thus identifying stylistic consistency. The recent publication of the complete works of Edvard Munch allows for this to be verified once again.[2] When consulting the four thick volumes assembled by Gerd Woll, it appears clear that in the 1880s and 1890s, or rather in the first two decades of his career, the Norwegian painter very often had recourse to the same way of representing pictorial space. In many examples – *Music on Karl-Johan, Melancholy,* and even *The Scream,* the composition rests, in fact, on a diagonal structural line that crosses the surface of the picture and heightens the perspectival effect, on prominent foregrounds that are often cut off by the frame, on a see-sawing ground that seems to have been painted from a slightly elevated viewpoint, and finally, on an expansion of space between what is near and what is further away.

There are many ways of explaining this recurrence, the first and most obvious of which calls upon the influence of impressionism. Research undertaken as part of the preparation for the 1991 exhibition *Munch and France* at the Musée d'Orsay showed that the Norwegian painter had a good grasp of impressionist painting.[3] At the beginning of his career, he heard older painters talk about it at length: Christian Krohg, who himself had spent a long time in France, and Erik Werenskiold, who in 1882 published a landmark article in *Nyt Tidsskrift* on 'the impressionists'.[4] Subsequently, during many visits to Paris in 1885, 1889–90, 1891, 1892, 1896–7, 1898 and 1903, Munch had various opportunities to see canvases by Gustave Caillebotte,

Edgar Degas and Claude Monet in particular. He was therefore very familiar with their methods of constructing pictorial space: the repeated use of diagonals, the fragmentation of bodies by the frame, the effects of high-angled viewpoints and the expansion of the space between the foreground and background, and so on. His own daring compositions of the 1880s and 1890s came about partly due to this knowledge. A work such as *Rue Lafayette,* with its very pronounced diagonal, seems even to directly pick up the perspectival construction of *A Balcony, Boulevard Haussmann* 1880 by Caillebotte.[5]

The original qualities of the impressionists' compositions themselves are often explained by the sudden arrival of Japanese prints in Western visual culture, in Paris in particular. Having been rediscovered in the mid-1850s by the engraver Félix Bracque-mond, they occupy an important place in the aesthetic debate of the second half of the nineteenth century. This was marked by some highlights, such as the Universal Exhibition of 1878 and the publication of *Artistic Japan* by Siegfried Bing between 1888 and 1891, as well as the publication of Edmond de Goncourt's monograph on Hokusai in 1896.[6] Munch himself had plenty of opportunities to admire Japanese prints during his trips to Paris, and more likely, in the summer of 1888 on a visit to Copenhagen, where Bing was showing his collection. Arne Eggum adds that in 1885, Karl Madsen, an art historian and editor of the Danish art review *Kunstbladet,* published a study on Japanese prints in which he analysed their strange perspective effects, their exaggeratedly close foregrounds, and their expansion of space.[7] Whether through direct contact with Japanese prints, through their assimilation by impressionism, or even through Vincent van Gogh, Munch seems to have been sensitive to this aesthetic. In 1903 a review of one of his canvases on display at the Salon des Indépendants in Paris at least noted the influence of japonisme on his painting, critici-sing him for a 'Hokusaï-like [sic] realism'.[8]

In his book, Madsen also noted that the spatial distortions of Japanese prints, as strange as they may appear at first glance, were no less accurate than a perspective viewpoint.[9] The use of precision instruments, such as the camera obscura or the camera lucida, allowed this to be verified, as they produced similar effects of spatial expansion. It was, moreover, through studying and reinterpreting in their own way the laws of Western perspective determined by tools like these, that Japanese artists such as Hokusai and Hiroshige, arrived at such curious compo-sitions. It is not one of the lesser paradoxes of these aesthetic exchanges between East and West, that having suggested to the European artists of the second half of the nineteenth century that they integrate typically Japanese methods of composition into their painting, they themselves had been widely influenced by a European system of representation. For art historians, the perspective effects inherent in the use of dark or light chambers provide another explanation as to the impressionists' compo-sitional innovations. Kirk Varnedoe showed clearly that the alleged distortions observed in the pictures of Degas or Caillebotte, in fact, correspond to a strict application of the rules of an optical instrument.[10] In Norway, in the early 1880s, *The Mender of Nets,* a picture by Krohg that displays consider-able disproportion between the figure located in the foreground and the one in the background, had triggered major controversy. The artist defended himself by arguing that his composition was scientifically accurate because he had realised it with the assistance of a camera lucida.[11] Studying with Krohg at the time, and according to Eggum, using these optical instruments himself for some of his preparatory studies, Munch was therefore fully aware of their perspective effects. The repetition in his paintings from the 1880s and 1890s of some of these effects can also be explained in this way.

Photography, which allows for images from the camera obscura to be fixed, is, by force of circumstance, determined by

Fig.26
Underwood & Underwood
Narrow path along the
rockface beside Oifjord lake
Stereoscopic proof
*Norway Through the Stereoscope:
Notes on a Journey Through the Land
of the Vikings*, New York 1907
Preus Museum, Horten

the same laws of perspective. Recording them in a lasting
fashion on paper makes them even more obvious. Since the
1960s, several art historians have shown how great the impact
of the advent of photography was on the compositional
methods of two or three generations of painters from the
second half of the nineteenth century, and on the impressionists
in particular.[12] It is true, by way of reducing such a long and
complex discussion to the needs of this study, that the perspec-
tival effects claimed by Degas, Caillebotte, van Gogh, and also
by Munch, are surprisingly close to those produced by stereo-
scopic photography (fig.26), or rather in 3D, which developed
from the 1850s and 1860s, then experienced a second phase of
keen interest in the 1880s and 1890s.[13] Manuals intended for
those using stereoscopy specifically recommended introducing
very pronounced diagonal lines into their images, as well as
prominent foregrounds, in order to accentuate the effect of
binocular relief as much as possible. 'The conditions for
executing stereoscopic views are parti-cular', as was written
in one of these publications dating from 1886,

> ... foregrounds that must very often be avoided in a single
> proof due to the detrimental importance of the role they
> play, are, conversely, to some extent indispensable here. This
> perspective that was shocking at first (flat photography)
> rediscovers its truth in stereoscopic proofs that restore it to
> us intact: the overlapping of various planes that provide the
> effect of a backdrop in an ordinary proof, conversely
> provide the impression of distance and remoteness.[14]

At a time when he was using these very marked composition
effects, Munch was not yet taking photographs himself. He
could not, however, have failed to see the stereoscopic proofs
that were very widely disseminated at the time, as postcards
would be in the twentieth century, in very popular locations
such as boulevards, amusement parks and holiday resorts.

False Pictorial Perspective. *Correct Pictorial Perspective.*

Accelerated perspectives, shifts in the picture plane, the presence of diagonal structural lines, prominent foregrounds cut off by the frame; the system of composition used most frequently by Munch in the last two decades of the nineteenth century is as marked by impressionism and japonisme as by the instrumental vision of a light, dark or photographic chamber. It would be a mistake to attribute a predominant influence to any one of these visual sources. It is much more likely that the register of spatial representation adopted by Munch is the product of the intersection of several of these influences, of the assimilation of one by the other, or rather the combination of all of them. When analysing the surprising construction of a picture by Paul Gauguin, *The Vision of the Sermon* 1888, Varnedoe writes,

> 'the composition here is taken from Degas, the line quality owes a lot to Daumier, the oblique branch comes from a print by Hiroshige ... Innovations such as this often have just that kind of patchwork nature. They do not look like a spaceship from Mars, with a mysteriously seamless form never seen before. Instead they look like the machine that the Wright brothers built, pieced together from parts lying around a workshop.'[15]

It is exactly the same for Munch. His system of composition in the 1880s and 1890s looks less like a spaceship and more like Wilbur and Orville Wright's *Flyer.*

With the new century, Munch would accentuate these optical effects even further. The stretching of space between the foreground and the background increases (no.52). Bodies are often depicted in foreshortening (nos.47 and 54). The painter uses more counterpoint perspectives, placing faces and parts of bodies at the edge of the picture in order to increase the feeling of depth in the pictorial space (nos.45, 46, 52). By always painting the horizon line relatively high up the canvas, he raises

his overhanging viewpoint slightly further (no.51). His compositions are frequently crossed by tree-lined paths, streets or roads that sink into the canvas, with the help of, not one, but two very pronounced diagonal lines (nos.45 and 46). Beyond the accentuation of perspectival effects already used in the previous decades, Munch also develops new pictorial strategies. His painting now seems more liquid. He plays more on the transparency of bodies, such as, for example, for the *Workers on Their Way Home* (no.51), in which the pavement along which they move is revealed by their feet. In this work, as in others, the outline of the bodies is not always completely delineated; the line hesitates deliberately and repeats itself, as if concerned with not fixing the human figure in too static a pose.[16] This is undoubtedly the painter's most striking stylistic development. In the 1880s and 1890s, his figures seem petrified, seated on a rock, motionless at the water's edge, gripped by fear, by an embrace (nos.14 and 16), or by melancholic contemplation. In the twentieth century, the beings he represents in outdoor scenes are most often in motion. They come forward towards the viewer, sometimes staring right at him.

Again, it would be a mistake to attribute Munch's evolution to a single cause. Several different kinds of factor come into play. Contrary to the claims of a persistent myth according to which Munch was a recluse, preoccupied only by his personal malaise, the painter was not completely impervious to developments in the art of his time. According to Eggum, his visit to the Sonderbund exhibition in Cologne in 1912, where cubism and futurism were very well represented, was at the origin of his new experiments with perspective, viewpoint and the effects of transparency.[17] When analysing *Workers on Their Way Home* from 1913–14, Gerd Woll also explains that the three figures in the foreground are not depicted from the same viewpoint.[18] The worker on the left is painted from an angle located approximately at the level of his chest. The one in

Pl. IV.

Gravure extraite de l'article
LES PETITES MÉSAVENTURES D'UN DÉBUTANT
(*Photo-Magazine*, n° du 13 novembre 1904.)

Thirteenth Trial.—Stubbs arranges his Cravat to
Captivate Pretty Girl.

Fig.27
Anonymous photographer
**'False Pictorial Perspective –
Correct Pictorial Perspective'**
from A.J. Anderson, 'Perspective
in Photography', *The Amateur
Photographer*, 24 April 1902, p.333
Collection Société française
de photographie, Paris

Fig.28
Anonymous photographer
**'Les petites mésaventures
d'un débutant' ['A beginner's
misadventures']**
L'Année photographique
1904, pl.IV, p.64
Collection Société française
de photographie, Paris

Fig.29
**Example of a classic photographic
error**
Engraving published in *Harper's
New Monthly Magazine*
1856, p.430
Private Collection, Paris

the centre, with a paler face, is seen from a gaze located above
his head, while the one on the right is seen from a high angle.
These altered viewpoints, combined in a simultaneous depiction
on a single painted surface, explicitly echo the research of the
cubists. The perspective of the picture, reinforced by highly
visible diagonal composition lines, and the jerky breakdown of
the movement of the marchers as suggested by the multiplication
of dark silhouettes in the background, also serves to increase
the energy of the work. The viewer is no longer contemplating
the advancing crowd from a distance, he finds himself caught up
in the movement. As well as for the futurists themselves,
explains Woll when citing their 1910 manifesto, this is a
question of placing 'the spectator in the centre of the picture'.[19]

Beyond cubism and futurism, some new ideas introduced by
Munch in his twentieth-century paintings can be explained by
his practice of photography.[20] It was in 1902, in Berlin, that the
painter began to take photographs. He did not receive any kind
of real training in using a camera and his images therefore bear
obvious traces of his amateurism. Roughly framed, his subjects
– most often self-portraits – are regularly cut off at the edges of
the image (nos.24, 28, 30 and 31). Usually working indoors, he
lacked light and therefore had to use long exposures. However,
as he did not have a remote release or timer, he was obliged to
press the button then position himself in front of the lens. As he
was moving for a part of the time while the image was being
imprinted onto the film, the background appears transparent
through his body, while his outlines are usually shaky, doubled
or multiplied (nos.24, 30, 37, 97, 100–3). At the time, for reasons
of immediacy as well as handling, the trend for manufacturers
of photographic material was to reduce the size of cameras
intended for amateur use. They were therefore fitted with small
lenses and consequently of short focal length, or rather 'wide
angle', which had the distinctive feature of stretching distances
between the different planes of the image and, according to one

commentator on the Russian director Sergei Eisenstein, of giving the impression that the thing being photographed 'was emerging from itself'.[21] Journals and manuals intended for amateurs were full, at the time, of illustrations denouncing these distorting effects, usually through the use of a figure with outstretched arms or a horse captured along its entire length (figs.27 and 28).[22] The Kodak camera that Munch was using at the time was particularly disparaged by professionals due to its distortions that were typical of wide-angled lenses. Given that he had to position himself very near his camera in order to be able to release the button easily, Munch increased these distortions all the more, as is well demonstrated by his self-portrait 'à la Marat', taken in 1908 or 1909 in Copenhagen (no.29).

One of Munch's pictures allows us to understand that he had fully picked up on these specifically photographic distortions. In 1906, during a visit to Germany, he painted the portrait of Felix Auerbach, a professor at the University of Jena (fig.30). Some months later, in an exchange of letters between Munch and Auerbach, mention is made of retouching the hand, which appeared disproportionately large in relation to the face. It should be noted that this had been the most common criticism of photographic portraits since the mid-nineteenth century (fig.29). '… The lens enlarges and deforms all the projecting parts [… this distortion is] very obvious in the hands, feet and knees, when they are not located on the same plane',[23] wrote one critic in 1856 for example. In 1904, an article for amateurs again advised 'taking care that the hands of the model are not spread out too far forwards, at the risk of seeing them reproduced in the photograph with the dimensions of "beaters".'[24] Fully aware of these exaggerations through having seen them for himself in his own shots, Munch asked Auerbach's wife to have her husband photographed in the same position as his painted portrait (fig.31). Comparing the painting and the photograph, and noting the correlation between the two,

Munch eventually did not retouch his canvas: 'I've decided not to modify the portrait of your husband,' he wrote to Anna Auerbach. 'I am afraid of ruining the picture. The hand is in the foreground and the relationships are the same in the photograph.'[25] This proves then that the artist was not merely fully aware of the inherent distortions in photographic perspective, but that he claimed the right to incorporate them into his paintings.

Beyond Munch's photographic experiments, we must also consider the other images to which he had access and their potential impact on his pictures. During the first decades of the twentieth century a new form of outdoor photographic portrait appeared in the majority of European cities. Photographers, known in some countries as 'surprisers', would position themselves in places where people would stroll past, then jump out suddenly – by surprise, hence the name – in front of those walking past, take their photograph, then offer to sell them their portrait (fig.32). In order to satisfy their customers, these street photographers would strive to capture them one foot in front of the other, in a pose that was both graceful and energetic. Jacques Henri Lartigue, who, in 1910, was amusing himself by photographing the elegantly attired in the Bois de Boulogne, clearly notes in his journal the difficulties of the practice: 'I know how to roughly judge the distance well. What is more difficult is that *her* [the female passer-by's] foot should be just in front at the correct moment in which to focus.'[26] In Kristiania, this practice of a walking portrait had been well known since when, in the mid-1890s, Carl Størmer had created such images on the city's principal thoroughfare, Karl-Johan Avenue.[27] From the second decade of the twentieth century, these photographs taken on the major boulevards, at racetracks and popular strolling spots, in short wherever respectable society tended to show itself off, were regularly published in the social columns of illustrated newspapers. A ripped-out page

Fig.30
Felix Auerbach
1906
Oil on canvas
83.8 x 76.2
Private Collection

Fig.31
Anonymous photographer
Portrait of Felix Auerbach
1906
Photograph, gelatin silver
print on paper
16.5 x 11.2
Munch-museet, Oslo

Fig.32
Anonymous photographer
Pedestrians in Paris
c.1910
Private Collection, Paris

of the *Aftenposten* newspaper survives in Munch's papers, which includes the reproductions of some photographs taken by Størmer (fig.39).[28] No other known documentary source attests to the painter's interest in this new form of moving portrait. The appearance in his paintings, however, from the second decade of the 1900s onwards, of figures with one foot in front of the other, particularly in the portrait of Thorvald Løchen (no.55), shows that he had fully understood the dynamic potential of these images.

The iconography of the human figure in motion is also particularly present in the illustrated press in the second decade of the twentieth century. This is for two reasons. Firstly, this decade corresponds to the progress in processes of photomechanical printing and to the boom in the illustrated press. Old-fashioned engravings had been progressively replaced in the newspapers by increasingly numerous photographs. It was exactly at this time that the concept of the illustrated magazine, in which the image takes precedence over the text, was developing and would go on to govern the entire publishing economy. At that time, the layout designers of these magazines looked, above all, for strong and dynamic images that could draw the reader's eye, such as photographs of figures walking towards the lens. The more there were, the greater the guaranteed effect. A moving crowd, procession or parade thus became one of the great visual archetypes of these first years of the photographic press. Siegfried Kracauer has clearly shown that newspapers and films of the period had given in to 'the mass ornament', or rather to the decorative nature of the motif of the crowd.[29] It should also be said, and this is the second reason accounting for the proliferation of these images of figures in motion in the press, that the period was particularly conducive to the creation of these kinds of images.[30] Between the increase in workers' demonstrations, marches by strikers and the mobilisation of soldiers during the First World War, there was a legion of

Fig.33
Anonymous photographer
**Paris: Firemen I: The
carriages going past**
Catalogue Lumière no.778
1896–28 November 1897
35 min, black and white silent film
Collection Association
Frères Lumière, Paris

Fig.34
Louis Gasnier
Direction: André Heuzé
Production: Pathé Frères
The Runaway Horse
1908
6 min 40 sec, black and
white silent film

Fig.35
Thomas A. Edison Inc.
Production: James White
Charge of the Boer Cavalry (no.2)
1900
33 min, black and white silent film

Fig.36
Anonymous photographer
The Octave's Final Procession
1911
3 min, black and white silent film
Centre national de l'audiovisuel,
Luxembourg. Cinémathèque
de la Ville de Luxembourg

Fig.37
Lumière
Coming Out of the Factory (III)
Catalogue Lumière no.91–3
15 August 1896
40 sec, black and white silent film
Chemin Saint-Victor,
Montplaisir, Lyon
Collection Association
Frères Lumière, Paris

Fig.38
Anonymous photographer
Mercier Champagne? Factory
1907
9 min, black and white silent film
Centre national de l'audiovisuel,
Luxembourg. Cinémathèque
de la Ville de Luxembourg

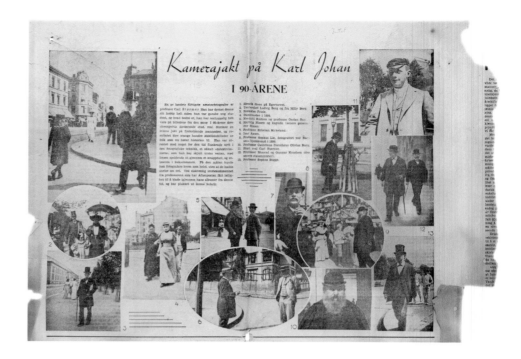

opportunities to photograph the movement of crowds. Ludvig Ravensberg recounts in his journal that Munch's living room was littered with magazines.[31] The stacks of illustrated journals that have been kept in the archives contain many of these images of moving crowds (fig.40). He would undoubtedly go on to remember them when painting his masterpiece of the second decade of the 1900s: the *Workers on Their Way Home.*

Workers on the march was also a favourite theme of films of this period, for the contextual reasons that have just been mentioned, but also for other reasons on which we must dwell for a moment. Historians who have worked on the first decades of cinema have clearly shown that the repertoire of subjects was particularly stereotyped, in the same way as methods of filming.[32] This was not just because local cameramen were usually content to reproduce what had been successful for their competitors, but also because the need for this essentially fairground show to appeal, combined with the desire to best show off what the medium was capable of, significantly determined the range of potential subject matter. Certain motifs, such as the arrival of a train at a station, a raging sea, a galloping horse (figs.33–5), or a moving crowd (fig.36), responded perfectly to this dual requirement. This is the reason why, wherever films were shown in Europe, cameramen of different nationalities filmed such scenes. If the motif of leaving the factory (figs.37–8), with its workers moving towards the camera, became a sort of standard repeated by many cameramen, it was not just because it recalled the first ever film by the Lumière brothers, but because, filmed and then distributed locally, these sequences allowed the workers to appreciate all the virtues of the moving image, in particular that of recognising themselves. Several accounts by those close to Munch – Rolf E. Stenersen, Ludvig Ravensberg and Hugo Perls – bear witness to the fact that, in the first three decades of the twentieth century, the painter often went to the cinema, both alone and in company, sometimes even with his dogs, in order to watch the news, European and American feature films, Charlie Chaplin films, and so on.[33] Pål Hougen, former director of the Munch-museet, wrote in 1969: 'Munch was a passionate cinephile; he could go to the same programme at the cinema on several consecutive evenings: in a second-rate Western, a horse – always the same one – would run backwards and forwards, frightening those who were not familiar with the new medium, or a locomotive would rush through a narrow gorge towards the audience.'[34] We should not therefore underestimate the impact that the cinema could have had on his painting, particularly on a work such as *Workers on Their Way Home.*

Historians have many accounts at their disposal that cast light on audiences' reactions to cinema. The scientific chronicler Henri de Parville wrote the following in 1896: 'A tapestry-maker was coming towards us on her galloping horse. One of my neighbours had fallen so far under the spell that she leapt to her feet and did not sit down again until the carriage had turned and disappeared.'[35] For his part, the Russian writer Maxime Gorky notes:

> Carriages roll right over you from the back of the screen, people loom forwards, children play with a puppy, the leaves on the trees stir, cyclists tear along – and all that, coming from the picture's vanishing point, moves quickly, approaching the edges of the picture before disappearing outside it, then reappearing and moving away into the depths, shrinking … A passenger train comes towards you out of the distance – watch out! It rushes forwards, as if shot from some enormous canon, it dashes straight at you, almost knocking you over; the station master runs along the train. The silent locomotive noiselessly approaches the very edge of the picture … he public nervously move their seats – any minute that machine of iron and steel seems as if it will have to leap into the darkness of the room, only to crush everyone …'[36]

Fig.39
'Kamerajkt pa Karl Johan'
Aftenposten
1910s or 1920s
Page from Munch's personal papers
Munch-museet, Oslo

Fig.40
'I Krig med Samfundet'
Krig & Fred
16 May 1912
Page from Munch's personal papers
Munch-museet, Oslo

It does not seem to matter much whether the cinema audience really had been frightened by what they saw, or if they over-played the panic, as if on a roller coaster; or if this is a myth developed from the outset in order to try to convince people of the extraordinary power of illusion of the new medium.[37] What is essential to understand, on the other hand, is that the first reception of the Lumière brothers' invention was in part built on the idea that they had succeeded in designing an image that jumped up like a jack-in-a-box. The cinema took an image to a level of achievement that had never previously been attained; an image that tirelessly came out of the frame and burst through the screen. A projected image, which was not content to move towards the audience, but that, quite literally, threw itself at it (fig.41). There is no doubt that this was what attracted Munch to the spectacle of cinema. In any case it is this that is shown very clearly in some of his most important pictures of the second decade of the twentieth century, *Galloping Horse, Murder on the Road* and *Workers on Their Way Home* (nos.44, 46 and 51). When in 1927 the painter purchased a small amateur camera, he did not fail to film life in the streets, the passing of the tramways and horse-drawn carriages, a friend walking towards the camera, or himself approaching the lens as if he wanted to pass over to the other side of the looking glass (fig.1 and nos.84–5).

In the twentieth century, Munch therefore continued the research into the representation of pictorial space that he had undertaken in the previous century. The artist intensified the compositional effects he had already tried out in the 1880s and 1890s. However, he also integrated new suggestions that take into account as much the experiments of cubism and futurism as the development of photography, the illustrated press and cinema. The challenge still consisted in intensifying as much as possible the relationship between the work and the viewer.[38] In the twentieth century, as in the nineteenth, it was therefore

still about locating 'the viewer in the centre of the picture', to
pick up on the formula used above. The methods of achieving
this differ noticeably, however. The system of composition used
by Munch at the end of the nineteenth century had a tendency to
deepen the canvas, thus producing the effect of absorbing the
viewer. That which he develops after 1900 encourages the
projection of the work towards whomever is looking at it. The
use of perspectival distortions characteristic of wide-angle lenses
has the effect of making the shapes depicted come out of them-
selves. The movement of figures towards the front of the picture,
the slight tremble of their bodies, and the transparency of the
parts of their bodies in the greatest motion provide an increasing-
ly strong impression that they are about to propel themselves out
of the canvas. By opting for a system of composition that is more
centrifugal than centripetal, Munch turns the perspective on its
head. In this way he puts himself at the heart of this 'major shift
in the relationship between painting and beholder'.[39] identified
by Michael Fried as the foundation of modern painting. It is true
that by choosing a scopic scheme that distances itself from the
traditional perspective dominant since the Renaissance, in favour
of a way of addressing the viewer that had been established by
photography, the illustrated press and perhaps cinema in
particular, Munch displays great modernity.

Translated by Laura Bennett

Notes

1 Rolf E. Stenersen, *Edvard Munch: Close-Up of a Genius*, Oslo 2001, p.41.

2 See Gerd Woll, *Edvard Munch: Complete Paintings. Catalogue raisonné,* London 2009, 4 vols.

3 See Arne Eggum and Rodolphe Rapetti (ed.), *Munch et la France,* exh. cat., RMN, Paris 1992.

4 Ibid., p.38; Kirk Varnedoe, 'Christian Krohg and Edvard Munch', *Arts Magazine,* vol.53, no.8, April 1979, pp.88–95.

5 See Eggum and Rapetti (eds.) 1992, p.103.

6 See Henri-Alexis Baatsch, *Hokusai,* Paris 1985.

7 See A. Eggum, *Munch and Photography,* New Haven and London 1989, pp.45–6.

8 Marius-Ary Leblond, 'Noël chinois. Ed. Munch', *La Grande France,* May 1903, p.273. Munch's library included a book on later oriental art: Otto Fischer, *Die Kunst Indiens, Chinas und Japans,* Berlin, Propyläen-Verlag, 1928. I would like to thank Helle Christine Aaneland for having brought this document to my attention.

9 See Eggum 1989, p.46.

10 See K. Varnedoe, *Au mépris des règles. En quoi l'art moderne est-il moderne?,* Paris 1990, pp.25–99; K. Varnedoe, Peter Galassi, 'Caillebotte's Space', in K. Varnedoe, *Gustave Caillebotte,* New Haven and London 1987, pp.20–6.

11 See Eggum 1989, pp.14–22; Patricia G. Berman, 'The Urban Sublime and the Making of the Modern Artist', in *Munch Becoming 'Munch': Artistic Strategies, 1880–1892,* Oslo, Munch-museet, 1998, p.142.

12 Van Deren Coke, *The Painter and the Photograph: From Delacroix to Warhol,* Albuquerque 1964; Aaron Scharf, *Art and Photography,* London 1968. For a review of these two works, see K. Varnedoe, 'The Artifice of Candor: Impressionism and Photography Reconsidered', *Art in America,* January 1980, pp.66–78; K. Varnedoe, 'The Ideology of Time: Degas and Photography', *Art in America,* Summer 1980, pp.96–110.

13 See Françoise Reynaud, Catherine Tambrun, Kim Timby (ed.), *Paris en 3D. De la stéréoscopie à la réalité virtuelle, 1850–2000,* Paris Musées and Booth-Clibborn Éditions, Paris and London 2000.

14 Albert Londe, *La Photographie moderne,* Paris 1886, p.591.

15 See Varnedoe 1990, p.89.

16 Munch had already experimented with this in a drawing and a lithograph from 1895 entitled *Tingel-Tangel.*

17 See Eggum 1989, pp.156–7.

18 See G. Woll, 'Now It Is the Time of the Workers', in G. Woll, Per Bj Boym (ed.), *Edvard Munch Monumental Projects, 1909–1930,* exh. cat., Lillehammer, Lillehammer Art Museum, 1993, p.72.

19 Ibid. See Umberto Boccioni, Carlo Carrà, Luigi Russolo, Giacomo Balla, Gino Severini, 'Manifeste des peintres futuristes' (1910), reproduced in Giovanni Lista (ed.), *Futurisme. Manifestes, documents, proclamations,* 'L'Âge d'homme', Lausanne 1973, p.164.

20 See A. Eggum, 'Munch's Experiments as an Amateur Photographer, 1902–1910', in Eggum 1989, pp.94–148.

21 See Sergei Eisenstein, *Cinématisme, peinture et cinéma,* Brussels 1980, p.83.

22 See A. J. Anderson, 'Perspective in Photography', *The Amateur Photographer,* 24 April 1902, p.333; 'Les petites mésaventures d'un débutant', *L'Année photographique,* 1904, p.64.

23 See Marcelin, 'À bas la photographie!!!' *Journal amusant,* no.36, 6 September 1856, reproduced in André Rouillé, *La Photographie en France. Textes et controverses. Une anthologie, 1816–1871,* Paris 1989, p.259. On this issue, see also Van Deren Coke, 'Photographic Exaggerations of Face and Figure', in *The Painter and the Photograph,* Deren Coke 1964, pp.180–7.

24 C. Chaplot, 'Les surprises de la perspective', *Photo-Magazine,* 1904, p.73.

25 Undated letter from Edvard Munch to Anna Auerbach, Munch-museet archives, Oslo, MM N 2171-04. I would like to thank Ophélie Sitbon for her translation from the German. For this portrait, see Eggum 1989, pp.89–91; Ruth Kish-Arndt, 'A Portrait of Felix Auerbach by Munch', *The Burlington Magazine,* March 1964.

26 Jacques Henri Lartigue, *Mémoires sans mémoires,* Paris 1975, p.80. On this issue, see Marianne Le Galliard, *L'Élégance photographique dans l'oeuvre de Jacques Henri Lartigue de 1910 à 1914,* post-graduate art history dissertation supervised by Michel Poivert, Université Paris-I, 2006, pp.15–17.

27 See Jonas Ekeberg, Harald Østgaard Lund (ed.), *80 Millioner Bilder. Norsk kulturhistorisk fotografi, 1855–2005,* Oslo 2008, pp.142–5. The originals are kept at the Norsk Teknisk Museum in Oslo.

28 'Kamerajakt pa Karl Johan', *Aftenposten,* unknown date (c.1910–20), and article kept in the painter's archives at the Munch-museet, Oslo. I would like to thank Helle Christine Aaneland for having brought this document to my attention.

29 See Siegfried Kracauer, *Das Ornament der Masse. Essays,* Frankfurt-am-Main 1963. French edition: *L'Ornement de la masse. Essais sur la modernité weimarienne,* trans. S. Cornille, Paris 2008, pp.60–71.

30 See Daniel Arasse, 'La meilleure façon de marcher. Introduction à une histoire de la marche', in Maurice Fréchuret, Thierry Davila (ed.), *Un siècle d'arpenteurs. Les figures de la marche,* exh. cat., RMN, Paris 2000, pp.35–61.

31 See Ludvig Ravensberg, *Journal,* Munch-museet archives, LR 536, 7 January 1910, and LR 377, 17 April 1910.

32 See Nancy Mowll Mathews, Charles Musser (ed.), *Moving Pictures: American Art and Early Film, 1880–1910,* Manchester (Vermont) 2005.

33 See Stenersen 2001, pp.130–1; Ludvig Ravensberg, *Journal,* Munch-museet archives, MM LR 554, 19 and 23 November 1914; Hugo Perls, *Warum ist Kamilla schön?,* Munich 1962, pp.22, 30, 31, see also pp.196–7 of this catalogue. I would like to thank Ingebjørg Ydstie, Lasse Jacobsen and Angela Lampe for providing me with this information. On this issue, see also Dieter Buchart, 'Edvard Munch. Du "traitement de cheval", de la photographie et du film muet en tant qu'expression de la peinture moderne du xxᵉ siècle', in *Edvard Munch ou 'Anti-Cri',* exh. cat., Pinacothèque de Paris, Paris 2010, n.p.

34 See Pål Hougen, 'Edvard Munch and the Munch Museum', *Papers from the 10th AICA Congress at Munch-Museet,* Oslo, 29 August 1969, p.12.

35 Henri de Parville, quoted by Georges Sadoul, *Histoire générale du cinéma, t. I: L'Invention du cinéma, 1832–1897,* Paris 1948, p.294.

36 Maxime Gorky, 'Le cinémato-graphe Lumière', *Odesskie novosti,* 6 July 1896, reproduced in a translation by Valérie Pozner, in *1895, Revue de l'Association française de recherche sur l'histoire du cinéma,* no.50, December 2006, pp.121–2.

37 On this issue, see Charles Keil, 'The Story of Uncle Josh Told: Spectatorship and Apparatus in Early Cinema', *Iris: A Journal of Theory on Image and Sound,* no.11, Summer 1990, pp.63–76; Tom Gunning, 'An Aesthetic of Astonishment: Early Film and the (In)Credulous Spectator', *Art & Text,* no.34, 1989, pp.31–45.

38 See Uriel Halbreich and Dorothy Friendly, 'The Characteristics of Tension-Provoking Composition and Lines – as Represented in Munch's Paintings', *Confinia Psychiatrica,* vol.23, no.3, 1980, pp.187–92.

39 Michael Fried, *Esthétique et origines de la peinture moderne, t. I: La Place du spectateur,* Paris 1990, p.62.

45
New Snow in the Avenue
1906
Oil on canvas
80 x 100
Munch-museet, Oslo

46
Murder on the Road
1919
Oil on canvas
110 x 138
Munch-museet, Oslo

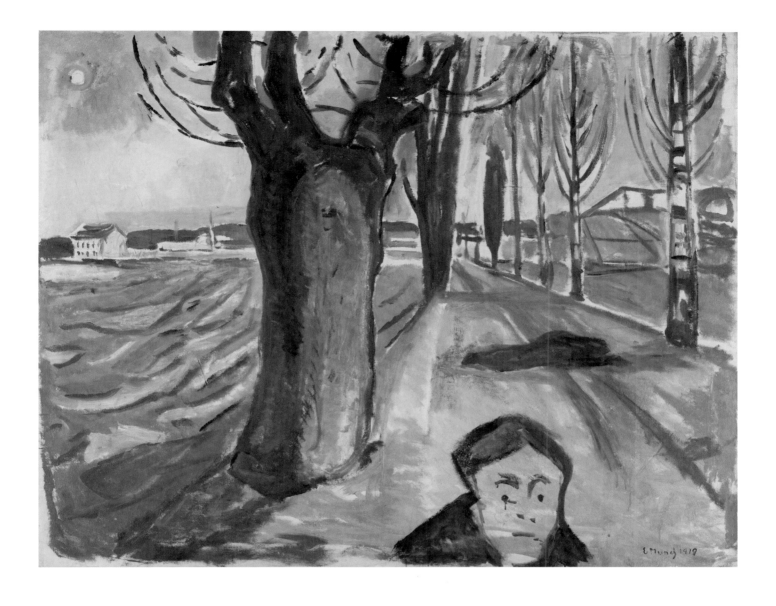

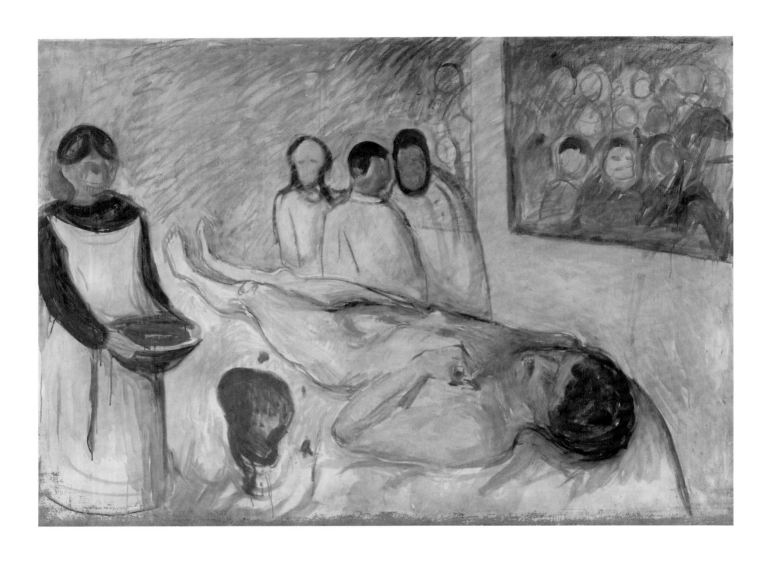

47
On the Operating Table
1902–3
Oil on canvas
109 x 149
Munch-museet, Oslo

48
The Yellow Log
1912
Oil on canvas
129 x 160.5
Munch-museet, Oslo

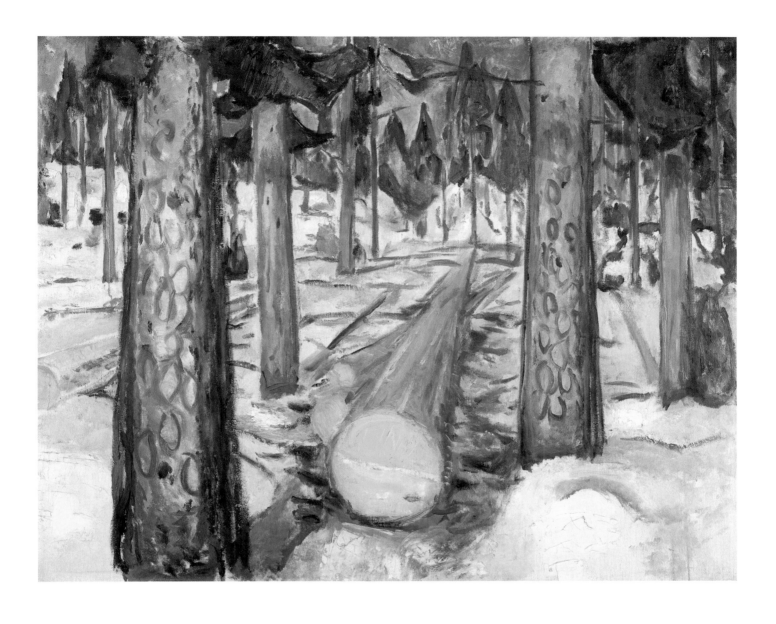

49
Workers on Their Way Home
1918–20
Watercolour, crayon and charcoal
on paper
57 x 78
Munch-museet, Oslo

50
Landscape and Dead Bodies
c.1912
Watercolour and charcoal on paper
56.4 x 77.7
Munch-museet, Oslo

51
Workers on Their Way Home
1913–14
Oil on canvas
201 x 227
Munch-museet, Oslo

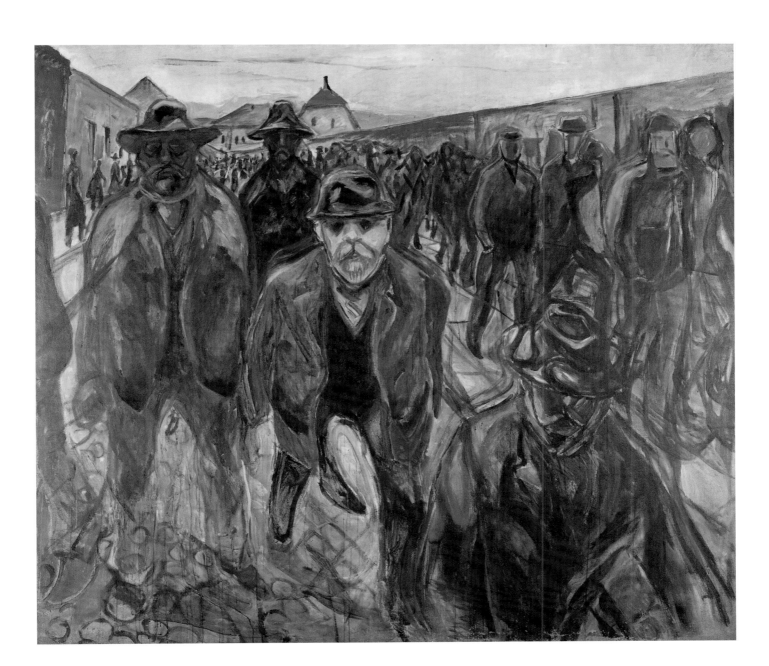

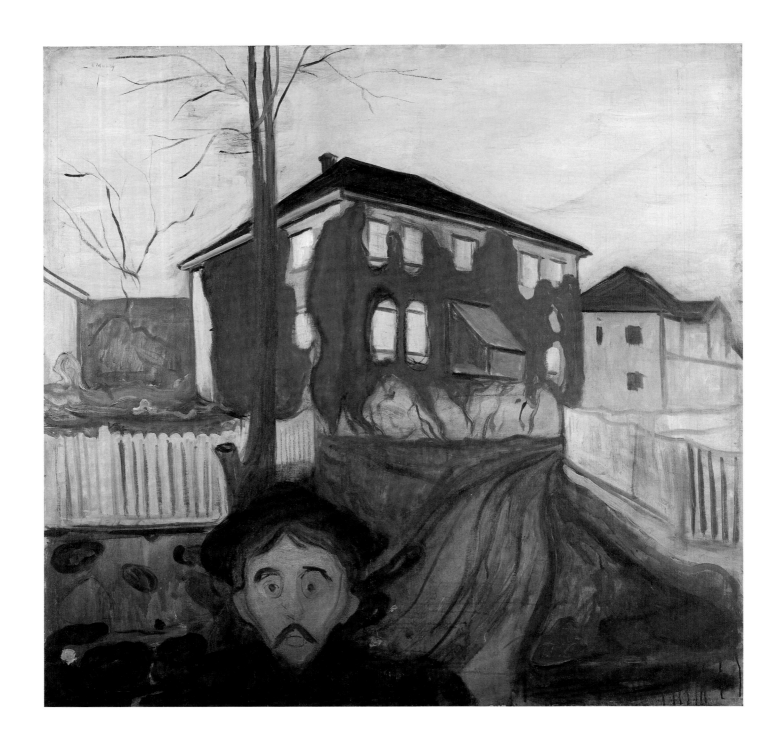

52
Red Virginia Creeper
1898–1900
Oil on canvas
119.5 X 121
Munch-museet, Oslo

53
Street in Åsgårdstrand
1901
Oil on canvas
88.5 X 114
Kunstmuseum Basel, gift from
Sigrid Schwarz von Speckelsen and
Sigrid Katharina Schwarz, 1979

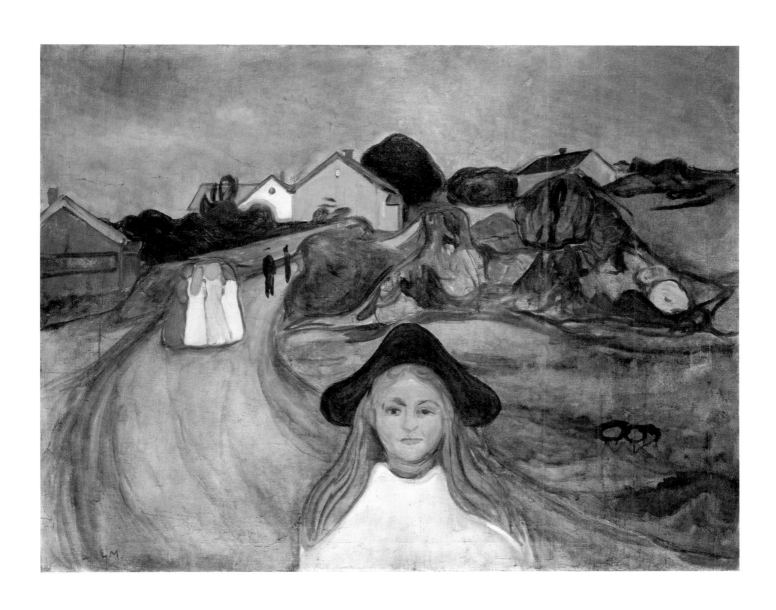

54
John Gabriel Borkman:
Borkman in the Snow
(Act IV)
1916–23
Charcoal on paper
48 x 65
Munch-museet, Oslo

55
Thorvald Løchen
1917
Oil on canvas
199 x 119
Munch-museet, Oslo

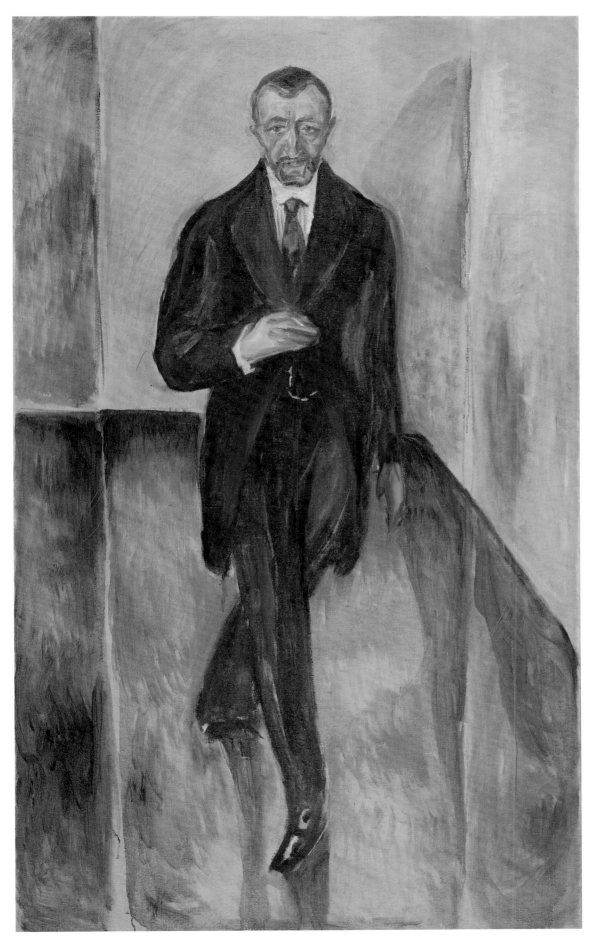

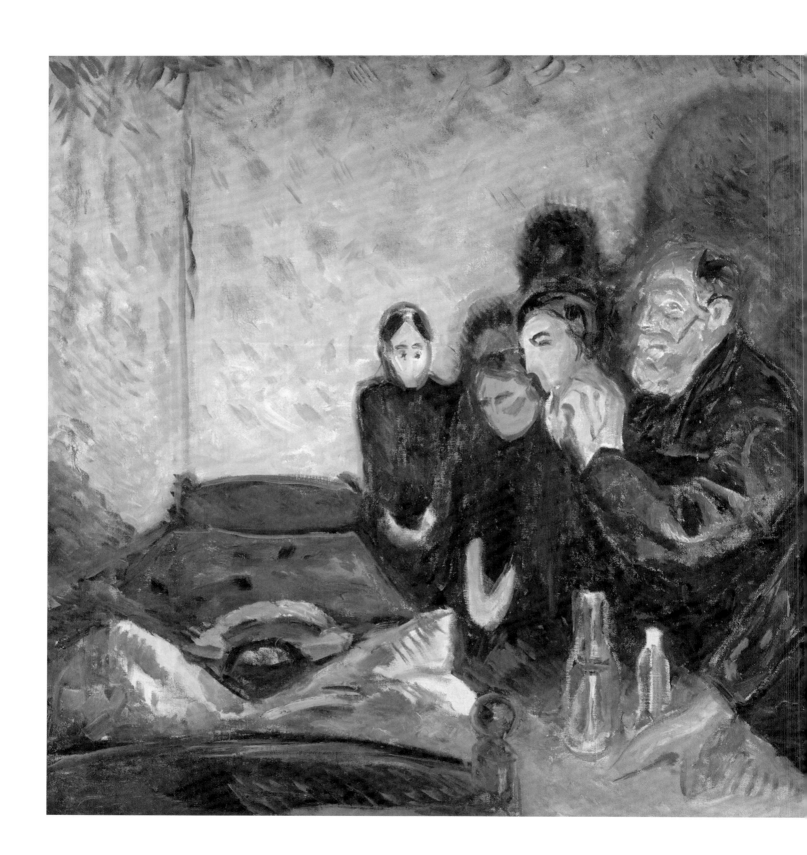

ON STAGE

In the 1890s, Munch lent a certain theatricality to the scenes he depicted, in terms of the placement of figures and their hieratic poses that are frozen and often frontal. This tendency intensified under the influence of August Strindberg, who he spent time with in Berlin in the 1890s, and Max Reinhardt, for whom he carried out some stage designs and a decorative frieze in 1906 and 1907. Strindberg and Reinhardt championed the idea of an intimate or chamber theatre (Kammerspiele), in which the distance between the actor and the audience is minimised in order to facilitate emotional empathy. For them, the stage space had to resemble an enclosed room from which a side wall had simply been removed, in order to open it up to the audience. This is exactly the device exploited by Munch in *The Green Room* series, started in 1907, therefore immediately after his collaboration with Reinhardt, with the aim of encouraging the projection of the viewer into the pictorial space.

Fig.42
Death Struggle
1915
Oil on canvas
140.3 x 182
Statens Museum for Kunst,
Copenhagen

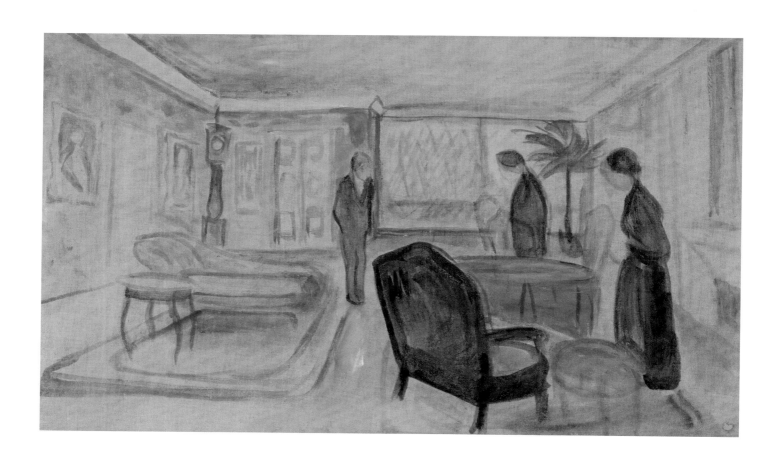

56
Set Design for Henrik Ibsen's *Ghosts*
1906
Tempera on canvas
60 x 102
Munch-museet, Oslo

Fig.43
**The Inner Hall of the Kammerspiele,
Berlin**
From *Mitteilungen der Berliner
Elektrizitätswerke*
1927, vol.2
Archiv des Deutschen Theaters, Berlin

Angela Lampe

Munch and Max Reinhardt's Modern Stage

'We would like to open our new little theatre, which you have already heard about from us, with a production of *Ghosts*. It would give us the greatest pleasure if you would be so kind as to agree to create a sketch for the stage decor.'[1] Thus, in the late spring of 1906, Edvard Munch and Max Reinhardt, the founder of the Kammerspiele in Berlin, embarked on their ground-breaking collaboration.

This invitation to the Norwegian artist was part of Reinhardt's declared strategy of 'not merely finding the best possible artist for each piece, but in fact finding the only possible artist'. When the decision was made that the inaugural production should be the play *Ghosts* by Henrik Ibsen, who had only recently died – a 'physically concentrated' drama with just five characters that was the 'perfect vehicle for chamber music on the stage'[2] – it seemed that only his compatriot Munch, the painter of the 'modern soul', could be considered for this task. That Munch was far from unknown in Berlin since his scandalous exhibition in 1892, and had influential champions such as Walther Rathenau and Harry Graf Kessler, may also have informed Reinhardt's selection. However, Munch, who was in Weimar at the time, did not immediately agree to this request. It proved necessary to ask him both in person and by letter, and it was only when Reinhardt also offered him the chance to decorate one of the public areas in the theatre – eventually leading to the creation of the Reinhardt Frieze – that Munch finally agreed in July 1906.

Besides his natural shyness, nervous disposition and growing problem with alcohol, Munch's hesitation may also have been due to the fact that he had no experience of stage design. At the time his only creative work for the theatre consisted of illustrations for programmes for two Ibsen plays, *Peer Gynt* (1896) and *John Gabriel Borkman* (1897), which he had made in Paris for the symbolist Théâtre de l'Oeuvre. A lithograph by Munch, with a monumental portrait of Ibsen

beside a lighthouse (fig.44), demonstrates how little interest he had in the contents or the mood of the drama. His illustration was more of a general homage to his famous compatriot, who had honoured him with a visit to his controversial exhibition in Oslo the year before.

During an exhibition in Stockholm in 1894 Munch had become acquainted with Aurélien Lugné-Poe, the founder of the Théâtre de l'Oeuvre, which led him to hope that he might benefit from the French symbolist's enthusiasm for Nordic theatre by gaining a foothold in Paris and being able show his work there. However, as his stage designer for *Peer Gynt,* Lugné-Poe chose Munch's friend and fellow Norwegian Frits Thaulow, who was to provide 'realistic pictures' of the North. Not long before that, in an interview in *Le Figaro,* Ibsen had complained that there was too much symbolism and mysticism at the Théâtre de l'Oeuvre.[3]

It may have been this sequence of events in Paris, or Munch's lack of confidence regarding this unfamiliar task, that prompted him, having at last accepted Reinhardt's proposal, to start by writing to his friends in Norway asking them for views of fjord landscapes and typical Norwegian interiors. Munch's designs were to be as authentic, as naturalistic as possible. Reinhardt had sent him a long account of the interior in *Ghosts,* including a highly detailed description of the main room in the play, the salon of Mrs Alving; at the same time he also asked Munch for sketches of the most important furniture, wallpaper patterns, wood panelling and windows. Having sent off his first sketches, it seems that Munch went to Berlin himself, to attend the rehearsals and to paint the 'mood sketches' Reinhardt had also asked for. The idea was that these innovative images should help the director and the actors develop their roles. On 23 October 1906 Munch's friend Ludvig Ravensberg wrote from Berlin:

'Munch and I are sitting here in a café on Unter den Linden. We were at the Deutsches Theater this morning and watched

the first rehearsals for *Ghosts* … He has also painted a whole series of scenes from *Ghosts* (15 in all), which are to be hung in the theatre. Munch has shown the figures in different poses, expressing what is happening in their minds, most are hugely atmospheric; the actors have been studying these intensely, with the result that besides being the arranger, Munch is now also an instructor.[4]

It was the first time that Munch was so closely involved in a stage production, and he wrote to Ravensberg: 'I am really curious to see how *Ghosts* will turn out, because I have never done anything like that – all the advertisements include the line "after designs by Edvard Munch"' (fig.45).[5] The opening on 8 November 1906 was a triumph. On the strength of this, Munch received an official invitation to create stage designs for the next Ibsen production in March 1907 – *Hedda Gabler,* directed by Hermann Bahr. But this time the critics slated the production, albeit less for Munch's stage sets than for Bahr's conventional direction. Towards the end of 1907 Munch's collaboration with the Kammerspiele came to an end with the dedication of his frieze. Munch's health was affected. The technical demands of the work on the frieze, the pressure to meet the deadline, lengthy financial negotiations and the sheer difficulty of the task had all taken a considerable toll on him. When Gustav Schiefler, his confidant and a collector of his work, asked him in 1914 if he would create designs for a Strindberg production at the Thalia Theater in Hamburg, the artist simply side-stepped the question.[6] He never again worked in the theatre.

Munch's work for the Kammerspiele was both the highpoint and the endpoint of his involvement with stage dramas. Yet this collaboration has received scant attention with regard to its impact on his art in the years to come. Instead, the main focus has been on analyses of his stage designs with regard to the plotline of *Ghosts,* with particular emphasis on the great

Fig.44
Programme for *John Gabriel*
Borkman **by Henrik Ibsen,**
illustrated with a lithograph by
Munch
1897
21 X 32
Munch-museet, Oslo

Fig.45
Programme for *Revenants*
by Henrik Ibsen
Archiv des Deutschen Theaters, Berlin

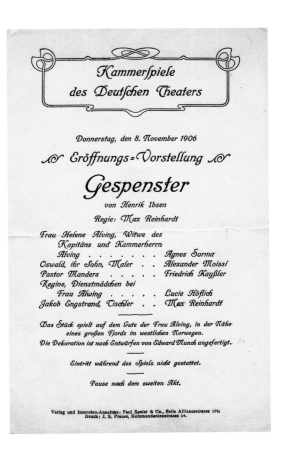

affinity between the kindred spirits Munch and Ibsen, whose plays were a source of motivic inspiration to Munch throughout his life.[7] But when he arrived at the Kammerspiele in Berlin, in that winter of 1906–7, the Norwegian artist had his first experience of a modern, intimate stage, where the greatest care was taken with the lighting, to create particular effects, and with the colours, which were used to convey different moods. In addition to this, Munch became acquainted with a young, visionary theatre director who was already introducing new approaches and methods. The painter was intensely involved in two productions. By the time he finished the frieze, he had spent over a year in that innovative theatre. His art could not and would not remain unaffected by this experience.

'The intimacy of a modern art of the soul'

At the opening of Reinhardt's Kammerspiele, the critics were united in their praise: 'It was only in the small space that Herr Reinhardt has created for his Kammerspiele that we could have seen this. There is nothing here of current theatrical fads. No stucco, no balconies, no stark footlights. A room that holds three hundred people and the stage right in front of you, at almost no distance. Exactly what Strindberg wished for in 1888 (in the Afterword to his inspired tragedy *Miss Julie*), he may not even have dared dream of such intimacy'. So wrote the renowned critic Maximilian Harden in admiration.[8]

Siegfried Jacobsen was equally effusive in the theatre magazine *Schaubühne*: 'Every detail counts. The auditorium is no wider than the stage, nor is it lower than the stage; it is not separated from it by an orchestra or a prompter's box and hence it easily creates an incomparable sense of containment and intimacy. You feel, no matter which row you are in, that you could reach out to the stage. Even the figures in the background of a scene are closer to us than those at the front edge of the apron elsewhere. Not a single breath is lost.'[9]

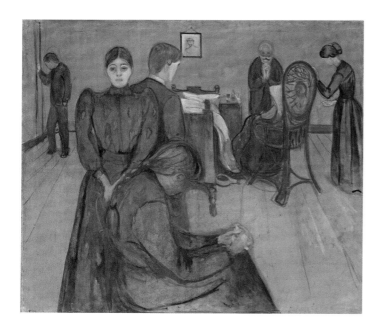

Reinhardt's intimate theatre fascinated the public. The stage no longer separated from the auditorium cast a spell over the audience, which often found itself deeply moved. Harden reported that those who were not sitting too far back could see the movements of the actors' nostrils and cheek muscles and sometimes had the uncomfortable sensation of 'committing some indiscretion'.[10] That might explain why the audiences at the Kammerspiele remained silent and did not even clap.[11] Clearly Reinhardt had succeeded in realising his vision of the ideal theatre:

> But it is not only a matter of shifting the stage into the auditorium and having representational sets, it is also a matter of stamping out that entirely outmoded custom of regarding the stage and the auditorium as two strictly separate realms. Any opportunity to create the closest possible connection between the actor and the auditorium has to be seized. The spectator must not have the impression that he is merely an uninvolved bystander; on the contrary he has to be persuaded that he is personally connected with what is happening onstage and that he has a part in the unfolding of the action.[12]

Reinhardt was not the first to have the idea of a small stage close to the audience. Ever since the late 1880s dramatists and theatre professionals had been preoccupied with an 'aesthetic of intimacy'.[13] The ground had been paved by August Strindberg, who outlined his idea of a new intimate theatre in 1888 in his preface to *Miss Julie*. Above all, he insisted that there should be 'a small stage and a small auditorium', with neither footlights nor an orchestra pit and with the stalls raised up. The stage should simply be a room with one wall missing. In the darkened auditorium, the spectators should be able to enter into 'modern psychological dramas' without being disturbed by intervals. Although Strindberg himself had not yet used the word

'intimate', from this point onwards theatre critics increasingly referred to intimacy as a modernist phenomenon.[14] The first 'intimate theatre' was opened in a private Munich apartment by the writer Max Halbe in 1895, with a production of a Strindberg play.[15] Similar projects in Nuremberg and Vienna, with the same name, also opened, and the numerous cabaret venues that were springing up all over Europe – such as *Le Chat Noir* that opened in Paris in the 1881–2 season – were also an offshoot of this new intimate theatre movement.[16]

But ultimately it was Max Reinhardt who founded the first institutional 'chamber theatre', in keeping with Strindberg's vision, when he extended the Deutsches Theater by converting the neighbouring dancehall into the Kammerspiele. The auditorium, with twenty rows on a shallow rake, could accommodate 346 people. The stage – 7.4 metres high by 8.10 metres wide by 13.5 metres deep – was separated from the auditorium only by an extremely low step (fig.43). The intention was that the audience should be able to follow the action as though seated in their own living rooms.[17] As early as 1901 Reinhardt had already wanted a small intimate stage in order 'to play certain classical works with all the intimacy of a modern art of the soul' (*Seelenkunst*). He had a vision of what he himself described as 'chamber music for the theatre'.[18] Strindberg was able to realise his own dream of an intimate stage only twenty years after he had first formulated his idea. In November 1907, one year after the Kammerspiele, Stockholm opened its Intima Teatern, although it had to close again just three years later for financial reasons.

There is nothing in Munch's biography to suggest that he ever visited Strindberg's Intima Teatern. However, it is not improbable that he will have been familiar with the contents of the preface to *Miss Julie*. Shortly after his arrival in Berlin in October 1892, Munch became personally acquainted with the Swedish author, who had also just arrived in the city. In the

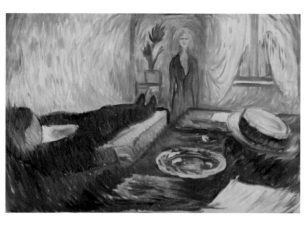

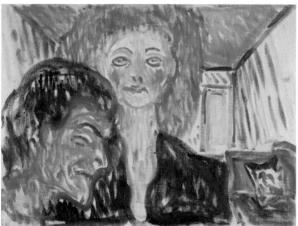

Fig.46
Death in the Sickroom
1893
Tempera and crayon on canvas
152.5 x 169.5
Nasjonalmuseet for kunst,
arkitektur og design, Oslo

Fig.47
Murder
1906
Oil on canvas
69.5 x 100
Munch-museet, Oslo

Fig.48
Hatred
1907
Oil on canvas
47 x 60
Munch-museet, Oslo

coming months they and other Scandinavian, German and East European artists and intellectuals met on an almost daily basis in a small wine bar, which Strindberg named Zum Schwarzen Ferkel (The Black Piglet). It soon became a favourite intellectual and literary venue in Berlin.[19] That same year, in April, the Freie Bühne – taking its lead from the Théâtre Libre in Paris – had presented the German première of *Miss Julie*, and a year later the Residenztheater in Berlin mounted very successful productions of one-act plays by Strindberg. That the concept of intimacy was discussed by the patrons of the wine bar, Zum Schwarzen Ferkel, is evident from a publication by the German author Max Dauthendey on the 'Kunst des Intimen' ('The Art of Intimacy') in 1893, which he exemplified by citing Munch's work. It also seems that Dauthendey had the idea of founding an 'intimate theatre' in Berlin, where the audience would not be separated from the stage by a four-square frame, so that they could have the feeling of witnessing an intimate event.[20]

Munch first created an intimate theatrical situation of this kind in *Death in the Sickroom* (fig.46), of which he painted several variants in Berlin in 1893 and which is constructed like a scene on a stage.[21] The floor sloping slightly downwards opens up a pictorial space, in which Munch positions the actors in this private drama – the death of his sister Sophie in 1877 – as though on a stage, seemingly arrested in mid-flow. The fact that Munch portrayed his siblings as grown adults and not as the children that they were when their sister died reinforces the effect of a theatrical re-enactment. The space is dominated by a high-backed wicker chair, in which the patient is sitting, and the statuesque figure of his sister Inger. As before, in the famous portrait of a year earlier, she stands directly facing the viewer. But now the girl sitting sideways on a chair forces her back towards her brother (Munch himself), who connects this group of three figures with the back of the room. The compositional structure leads the viewer's eye from the front edge of the

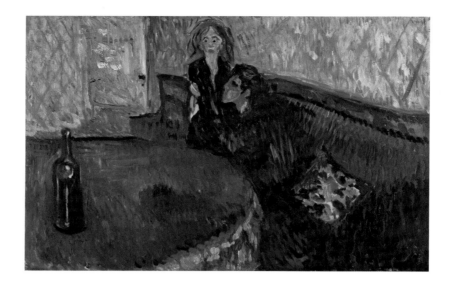

picture into the depth of the space, to where the real tragedy is unfolding, hidden behind the chair back. Munch's interest in this painting seems to be less in the representation of death than in positioning the grieving figures in the space in such a way as to draw the viewer into the situation – both optically and in terms of its meaning.

Having experienced the impact of performances at the Kammerspiele, Munch engaged with a new vigour and much more intensely than before with depictions of figures in interiors (fig.47). What began with different versions of *Death of Marat* in 1906 – a hieratic female figure stands, lost, by a bed with the foreshortened body of a man lying diagonally across it – came most effectively to fruition in a group of paintings that Munch collectively entitled *The Green Room*.[22] Munch painted this group of around ten works in the summer of 1907 in the small Baltic spa town of Warnemünde, just a short train journey away from Berlin. He had taken refuge there to gather his strength again and to explore new avenues in his art.[23] The core of this cycle, which is deeply influenced by Munch's traumatic relationship to Tulla Larsen, consists of the paintings portraying the situation in a room with green wallpaper: *Hatred* (fig.48), *Jealousy* (no.57), *To the Sweet Young Girl* (no.59), *The Murderess* (no.58) and *Desire* (fig.49).

For the first time Munch painted scenarios, recalling his set design for *Ghosts* (no.56), in a rectangular room with a ceiling and side walls: a narrow, green-barred peep stage with a rear entrance, a massive table and a Biedermeier sofa. The protagonists are not just confined in this space, they seem wedged into it. In the brothel-like interior of *To the Sweet Young Girl* the side walls seem to be drawing in towards each other and squeezing the actors up against the front picture edge, where the low viewpoint gives them an almost monumental air. The same applies, all the more so, to the two huge heads in the painting *Hatred*, seen in close up and almost filling the entire

pictorial field. The pictorial structure of *Jealousy* works in a rather different way. In this case it is not the oppressive proximity of the actors, but the intense stare from the detached-looking face that transfers the suffering of the jealous man to the viewer. Munch first used this motif in 1895, but now introduces part of a table into the viewer's field of vision. In the paintings *Murder* and *Desire*, Munch gives the table even greater prominence: in effect it extends the pictorial space out into real space. Particularly in the case of *Murder*, these scenes are set up as if the viewer were sitting at the table watching what was happening. It is interesting to see that in two instances Munch includes clearly identifiable figures in the background, stepping onto the 'stage' from the rear, as in *To the Sweet Young Girl*. Their positioning tallies perfectly with Jacobsen's description of the stage where even the figures in the background appeared to be very close.

The motif of the narrow rectangular space again has an important structural role in the variants on *Weeping Woman* (nos.65, 67–71), with their gentler, brown-red hues, which Munch also included in his Green Room cycle. Munch henceforth repeatedly returned to the idea of statuesque, isolated figures facing forwards in a low-ceilinged pictorial space, particularly in his depictions of couples and relationships, as in *Man and Woman* (no.61) and in the later painting, *The Artist and His Model* (no.62). In both cases the viewer seems to be invading the actors' privacy, despite their rigid, unwelcoming poses as though they were trying to ward off the viewer's illicit gaze. Munch in effect re-creates the paradox of Reinhardt's intimate theatre.[24] For all the intentional sense of community between actors and audience, the nature of that kind of staging – with isolated actors, controlled gestures and long pauses – generates another kind of distance. The viewer regarding Munch's figures has exactly the same experience. Their proximity is strictly a *mise-en-scène*.

Fig.49
Desire
1907
Oil on canvas
85 x 130
Munch-museet, Oslo

Fig.50
The Bohemian's Wedding
1925–6
Oil on canvas
134.5 x 178.5
Munch-museet, Oslo

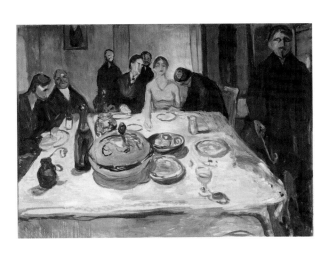

Mood Space – *Stimmungsraum*

Today, in Reinhardt's study, he showed me an oil painting by the famous Norwegian artist Edvard Munch. It is of a room, dominated by a big black armchair [no.56]. The room is intended as a set for Ibsen's play *The Ghosts*, the first production at the Kammerspiele, which is finished now. Munch's picture, painted in his usual manner, provided me with very little detailed information on the design, as I told Reinhardt. 'That may well be,' he replied, 'but the armchair says it all! Its black conveys everything about the mood of the play! And the walls of the room in Munch's painting! They are the colour of gum disease. We have to try to find wallpaper in exactly this tone. It will put the actors in the right mood! To come fully into its own, facial expression needs space that is modulated through form, light and, above all, colour.'[25]

This last sentence from the memoirs of Ernst Stern, Reinhardt's long-term artistic advisor, sums up the avant-garde director's aim, that is to say, to set the mood in the space by means of colour, which he regarded as a fundamental feature of stage design. The intention was to create a highly expressive overall atmosphere that derived less from Ibsen's text than from visual and painterly elements.[26] Munch's evocative paintings were the key to this. They were to set the mood for different scenes in *Ghosts*, which the spectator would later experience during the performance.

The idea of engaging an artist to provide inspiration and to set the mood was entirely new in the theatre. Hitherto artists such as Maurice Denis, Édouard Vuillard and Paul Sérusier had only ever designed programmes or stage sets. This new role could have arisen in part from the fact that, around 1890, modern dramatists such as Ibsen and Strindberg were already starting to include detailed instructions concerning stage design

in their scripts. In the same way that the interior lives of the characters, their nature and their state of mind were at the core of the dramas of the day, the look of their domestic surroundings also became increasingly important. Interiors were not just the external framework for a person's life, they were 'externalisations' of their occupants. In other words, the inner life of the modern individual was expressed in the interior where he left his mark.[27] In order to give visible form to this in Ibsen's play, Reinhardt needed a like-minded artist. As it said in the invitation sent to Munch: 'We believe no other artist could capture the nature of Ibsen's family tragedy as effectively as you ...'[28]

However, Reinhardt was not prepared to rely solely on the artist's intuition and took the precaution of sending Munch detailed notes on the interior in *Ghosts,* setting out his own idea of moods and atmospheres. Thus the high-ceilinged main room for Mrs Alving was to have 'something serious, simple, almost ascetic about it, but also something of the rough sensuality and brutality of the deceased chamberlain ... At the same time, this space should have secrets, dark nooks and crannies.' Reinhardt left Munch in no doubt as to the importance he attached to the hitherto undervalued interior, for it constituted 'a large part of the many things that are written between and behind the lines in an Ibsen play and not only frames the action but also symbolises it'.[29] He also described how he wanted to generate these moods, that is to say, with sophisticated lighting that made use of both moving shadows and different colours in the light from the window at the back of the stage. It was Munch's task to translate these ideas into evocative scenarios (fig.52).

Although no images have survived, it is clear from contemporary reviews that this innovative, forward-looking collaboration between artist and director was a success. Julius Bab was full of praise: 'There really were spooks in the scenery designed by Edward Munch, the great super-realist painter and compatriot of Ibsen. In the desperate final scene, when Mrs Alving ran behind her son past the lamp, shadows as big as houses flew along the walls, as though she were pursued by demons.'[30] The critic of the *Berliner Börsen-Zeitung* wrote: 'We breathed the air of desperation', 'felt their burning fear', and saw human beings run hither and thither 'like captive animals'.[31] Scarcely any critics could resist the intensity of this production of *Ghosts*, which was on the programme of the Kammerspiele for over three months.

Munch had the idea of placing a huge pitch-black armchair (not specified in Ibsen's play) with its back to the front of the stage (no.56), like the high-backed chair in his early painting *Death in the Sickroom*. Reinhardt immediately recognised the ominous effect of this prop, with the black symbolising the hopelessness of the situation in the drama. In subsequent compositions – for instance in *The Green Room* series – objects take on a noticeably more dramatic role.[32] In *Desire* (fig.49) the massive table and the long, empty sofa underpin the loneliness of an anxious couple who seem to be at the mercy of powerful external forces. In another painting from this series, there is no escape for the *Murderess* (no.58), penned in by furniture. Some years later, we see a similar use of props in the vertical format *The Bohemian's Wedding* of 1925 (fig.50), where the huge dining table literally forces the wedding guests into the background. At the time variable scales and optical distortions were very much part of the vocabulary of expressionist theatre, which first started to come into its own in Germany in 1917.[33]

The powerful visual impressions that Munch encountered in Reinhardt's theatre set the Norwegian artist's pictorial space in motion. To Arne Eggum it becomes much more active and suggestive after Munch's time at the Kammerspiele.[34] In effect it turned into a theatrical space. Settings and the props become actors in the pictorial drama. Clearly inspired by the moods of Reinhardt's theatre, Munch now introduced strongly coloured and strikingly patterned wallpapers into the rooms he was

Fig.51
Death Room
c.1915
Gouache on paper
49.2 x 63.5
Munch-museet, Oslo

Fig.52
**Stage design for *Les Revenants*,
by Henrik Ibsen**
1906
Tempera on unprimed canvas
60 x 102
Munch-museet, Oslo

Fig.53
Oskar Kokoschka
**Mörder, Hoffnung der Frauen III
[Murderer, the Hope of Women]**
Cover of *Der Sturm*
14 July 1910, Year 1, no.20
Centre Pompidou, Bibliothèque
Kandinsky, Paris, Fonds Destribats

painting. Expressive backgrounds of that kind had not played a part in his earlier work. The grid-like diamond pattern heightens the oppressive atmosphere of the Green Rooms, from which there is no escape. The only door is always either shut or blocked by another figure. The erratic execution of the patterns on the walls accentuates the agitation of the figures locked into these spaces. The air is filled with nervous tension.

Between 1914 and 1916 yet more highly expressive pictorial backgrounds appear in Munch's work. In *Puberty* (no.60) he created a later variant of one of his major works from the 1890s. The earlier bare grey wall behind the girl is now replaced by a background with bright red spots, which also reappears in two new versions of *Death Struggle* (fig.42). Above all in the latter painting, the dramatic mood is further heightened by the intense interplay of light and shadows. The members of the grieving family look as though their faces are lit from below, by stage footlights. The shadows cast upwards give them a demonic look – a lighting technique in fact used in the Kammerspiele.[35]

That Reinhardt continued to use footlights, which Strindberg openly scorned, underlines the complexity of his role in the history of the theatre, somewhere between naturalist and innovator. He was not a revolutionary like Adolphe Appia or Edward Gordon Craig,[36] just as little as Munch was an expressionist artist in the spirit of Oskar Kokoschka, who wrote the ecstatic one-act play *Mörder, Hoffnung der Frauen (Murderer, the Hope of Women)* in 1907, created a provocative illustration of the theme (fig.53) and later had Paul Hindemith set it to music. Both Reinhardt and Munch had their roots in naturalism. Yet, as we see from the scenarios in *Ghosts,* they increasingly imbued the realistic basis of their work with psychological and internal meaning – until the stage became the locus for a wholly modern mode of expression.

Translated by Fiona Elliott

Notes

1 Letter from Felix Hollaender to Edvard Munch, n.d., Archive of the Deutsches Theater Berlin.

2 Arthur Kahane, 'Wie Munch zu Reinhardt und ans Deutsche Theater kam', *in Berliner Tageblatt,* 28 October 1926. Translation in this catalogue, p.119.

3 On this see Geneviève Aitken, 'Edvard Munch und das französische Theater', in *Munch in Frankreich,* ed. by Sabine Schulze, exh. cat. Schirn Kunsthalle, Frankfurt am Main, Ostfildern 1992, pp.242ff.

4 Facsimile letter with drawings from Munch to Christian Gierløff in ibid., *Edvard Munch selv,* Oslo 1953, unpaginated, German translation in Hans Midbøe, 'Max Reinhardts Inszenierung von Ibsens "Gespenstern" in den Kammerspielen des Deutsches Theaters Berlin 1906. Ausstattung Edvard Munch', in *Maske und Kothurn. Internationale Beiträge zur Theaterwissenschaft,* Vienna, Cologne and Graz 1978, vol.24, p.47.

5 Letter to Ludvig Ravensberg, n.d. (mid-October), Munch-museet, Oslo.

6 Letter to Munch from Gustav Schiefler, 30 November 1914, in Arne Eggum (ed.), *Edvard Munch/Gustav Schiefler. Briefwechsel,* vol.1: 1902–1914, Hamburg 1987, p.481.

7 See, importantly, Ingrid Junillon, *Edvard Munch. Face à Henrik Ibsen: impressions d'un lecteur,* Louvain 2009; see also Joan Templeton, *Munch's Ibsen: A Painter's Visions of a Playwright,* Seattle 2008; Ulf Küster, 'Gespenster. Gedanken zum Theatralischen bei Edvard Munch', in *Edvard Munch. Zeichen der Moderne,* ed. Dieter Buchhart, exh. cat. Fondation Beyeler, Basel, Kunsthalle Würth, Schwäbisch Hall, Ostfildern-Ruit 2007, pp.32–4.

8 Maximilian Harden, 'Theater', in *Die Zukunft,* vol.58, Berlin 1907, as cited in Midbøe 1978, p.23.

9 Siegfried Jacobsen, in *Die Schaubühne,* no.46, 15 November 1906, as cited in Hugo Fetting, *Von der Freien Bühne zum politischen Theater,* vol.1, Leipzig 1987, p.322.

10 Harden 1907, as cited in Peter W. Marx, *Max Reinhardt. Vom bürgerlichen Theater zur metropolitanen Kultur,* Tübingen 2006, p.75.

11 Account by Harry Graf Kessler in his diary entry for 20 November 1906, as cited in Marx 2006, p.76.

12 Max Reinhardt, 'Über das ideale Theater', 1928, in ibid., *Ich bin nichts als ein Theatermann. Briefe, Reden, Aufsätze, Interviews, Gespräche, Auszüge aus Regiebüchern,* ed. Hugo Fetting, Berlin 1989, p.465.

13 See, Marianne Streisand, *Intimität. Begriffsgeschichte und Entdeckung der 'Intimität' auf dem Theater um 1900,* Munich 2001, pp.133ff.

14 Ibid., p.141.

15 Ibid., pp.271–88.

16 Ibid., p.301.

17 Nikolaus Bernau, 'Wo hing Munchs "Lebens-Fries"? On the Construction of the Kammerspiele and its Most Famous Embellishment', in Roland Koberg, Bernd Stegemann and Henrike Thomsen (eds.), *Max Reinhardt und das deutsche Theater. Texte und Bilder aus Anlass des 100 jährigen Jubiläums seiner Direktion (Blätter des Deutschen Theaters, n°.2),* Berlin 2005, p.71. Unfortunately only one photograph has survived of the auditorium, which was redesigned several times over the years. Of the early productions, there is only one stage shot of Wedekind's *Frühlingserwachen* in November 1906; unfortunately no photographs of the production of *Ghosts* are known to have survived. With grateful thanks to Karl Sand at the Archive of the Deutsches Theater Berlin for this information and for his generous help with my research.

18 Max Reinhardt, 'Über ein Theater, wie es mir vorschwebt', 1901, in Reinhardt 1989, pp.75–6.

19 On this, see Uwe M. Schneede, '"Aus der Erinnerung und mit der Phantasie". Skandinavien in Berlin – Munchs "zweite Heimat"', in *Munch und Deutschland,* exh. cat. Nationalgalerie, Staatliche Museen zu Berlin, Ostfildern-Ruit 1994, pp.12–19.

20 See Peter Krieger, *Edvard Munch. Der Lebensfries für Max Reinhardts Kammerspiele,* exh. cat. Nationalgalerie, Staatliche Museen Preußischer Kulturbesitz, Berlin 1978, p.14. There is some uncertainty here concerning the reliability of the source.

21 See also Aitken 1992, pp.237ff.

22 See, importantly, Arne Eggum, 'The Green Room', in *Edvard Munch, 1863–1944,* exh. cat. Lilejevachs Konsthall, Kulturhuset, Stockholm 1977, pp.82–100.

23 On this, see Arne Eggum, 'Munch und Warnemünde', in *Munch und Warnemünde,* exh. cat. Kunsthalle Rostock, Munch-museet, Oslo 1999, pp.25–45.

24 Streisand 2001, pp.306ff.

25 Ernst Stern, *Bühnenbildner bei Max Reinhardt,* Berlin 1955, as cited in Midbøe 1978, p.31.

26 On this, see Marx 2006, pp.70–1.

27 Streisand 2001, pp.169ff.

28 Letter from Felix Hollaender to Edvard Munch, n.d., Archive of the Deutsches Theater Berlin.

29 Max Reinhardt, *Anmerkungen für das Gespenster-Interieur,* n.d. (probably August 1906), Archive of the Deutsches Theater Berlin.

30 As cited in Streisand 2001, p.320.

31 *Berliner Börsen-Zeitung,* 10 November 1906, as cited in Midbøe 1978, p.67.

32 On this, see also Junillon 2009, p.307.

33 On this, see Gerhard Köhler, 'Zum Raum wird hier der Schmerz. Das expressionistische Theater als Gesamtkunstwerk', in *Gesamtkunstwerk Expressionismus,* eds. Ralf Beil, Claudia Dillman, exh. cat. Institut Mathildenhöhe Darmstadt, Ostfildern 2010, pp.174–80.

34 Eggum 1977, p.94.

35 On this, see Streisand 2001, pp.319ff.

36 Midböe 1978, p.36.

How Munch Came to Reinhardt and to the Deutsches Theater

The new home for the Kammerspiele had just been finished, the difficult task of finding a name had been achieved in all-night sittings, with no one of course predicting how soon it would be on every German speaker's lips, and the ceremonial opening was almost upon us. After much thought, Ibsen's *Ghosts* had been chosen as the inaugural work. Physically concentrated, with just five characters, it provided the perfect vehicle for chamber music on the stage, with its quintet of five noble instruments. The cast had already been engaged: Sorma, Moissi, Höflich, Reinhardt and Kayssler. But as yet there was no painter: in accordance with Reinhardt's principle of not merely finding the best possible artist for each piece, but in fact finding the only possible artist, it had to be Edvard Munch. Very much his own man, he was hard to persuade; in the end he gave in when he was faced with an opportunity that no painterly spirit could resist. He was offered the chance to decorate one of the public areas at the Kammerspiele exactly as he liked. Thus, as a wonderful by-product of the *Ghosts* commission, Munch painted the series of paintings that later became known as the Reinhardt Frieze. Unlike other painters, Munch's work for the performance of *Ghosts* did not consist of set designs and figurines; instead he made two or three paintings of different situations in the play. And I have heard Reinhardt declare a hundred times that no other painter ever provided him with such powerful and rewarding inspiration as Munch did in these paintings. And in that remarkable production Reinhardt did indeed manage to perfectly translate the indescribably affecting attitudes and atmospheres of the painter's vision into the reality of the stage.

As it happens, later on Munch was again asked to work on the décor for a production of another Ibsen play at the Kammerspiele – *Hedda Gabler,* directed by Hermann Bahr. I remember that amongst other things Munch designed, for General Gabler's daughter, very effectively and appropriately, an interior of wonderful, genuine old Norwegian peasant furniture, which he personally found and bought for us in Norway. However, when the items arrived in Berlin it turned out that genuine old Norwegian peasant furniture is damnably similar to a lot of what was spreading through Germany at the time in the guise of Jugendstil. And since it is less than likely that the forefathers of ancient Norwegian farming folk had stolen the colours and forms of their household goods in Munich, it must have been the other way round – food for thought for the ethnographers. Still, once Munch had put the finishing touches on them, these items were positively resplendent and Mrs Hedda Tesman was much to be envied for her room.

That is why Edvard Munch was in the Deutsches Theater on a daily basis – living with us, working during the day and drinking of an evening or painting his *Ghosts* pictures and his cycle. Sometimes he spent a long time in my office sitting very still, motionless, saying practically nothing to anyone and apparently neither seeing nor hearing what was going on around him; he seemed lost in thought and not a flicker passed across his face. What was going on behind those iron features? What was working away behind that strange, iron brow? Yet all it took was some quite small thing and he would come to, and he would brighten up and laugh – simple, happy, childlike laughter. In himself he was always equally friendly and yet somehow reserved, with a Nordic stiffness, aloof, impenetrable. He always remained a stranger, an enduring enigma. He was part child, part wild man, with an almost animalistic primitivity and the innocence of a Parsifal. And yet there was also that immense complexity, the deep secrets that he understood. You need only take a look at his paintings: where would you find another such as he? So wholly a man that he both experienced woman and suffered with woman? He was sometimes laughably obstinate, not looking around him, not listening to right nor to left, untouched, unmoved by praise or condemnation; but behind this obstinacy there was a titanic, wholly unyielding will set on its own path like a sleepwalker. And there was a will to freedom that seemed to defy any limitations society might devise, a will that could only have been born and flourished in what was ultimately true solitude.

Arthur Kahane
Berliner Tageblatt, 28 October 1926

Translated by Fiona Elliott

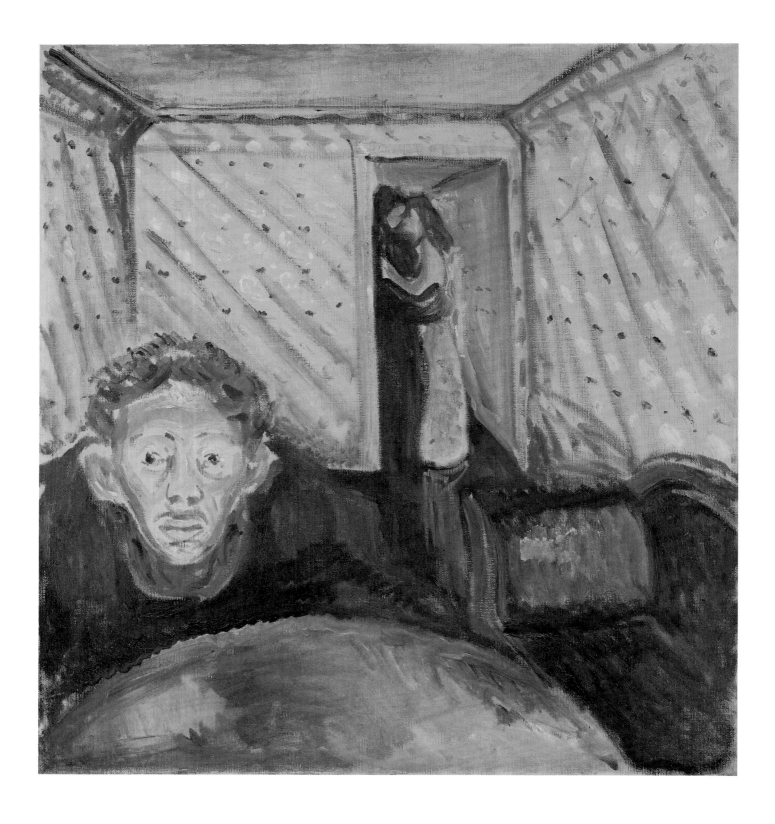

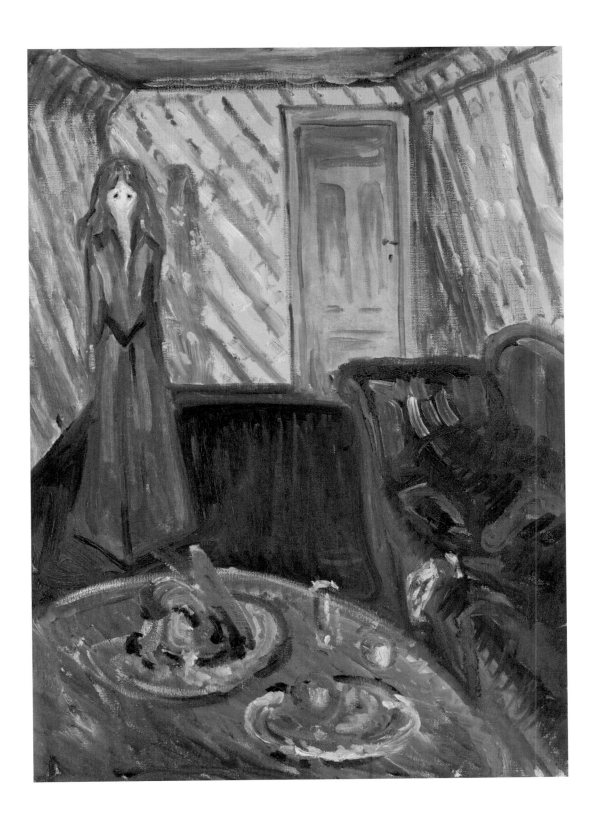

57
Jealousy
1907
Oil on canvas
89 x 82.5
Munch-museet, Oslo

58
The Murderess
1907
Oil on canvas
89 x 63
Munch-museet, Oslo

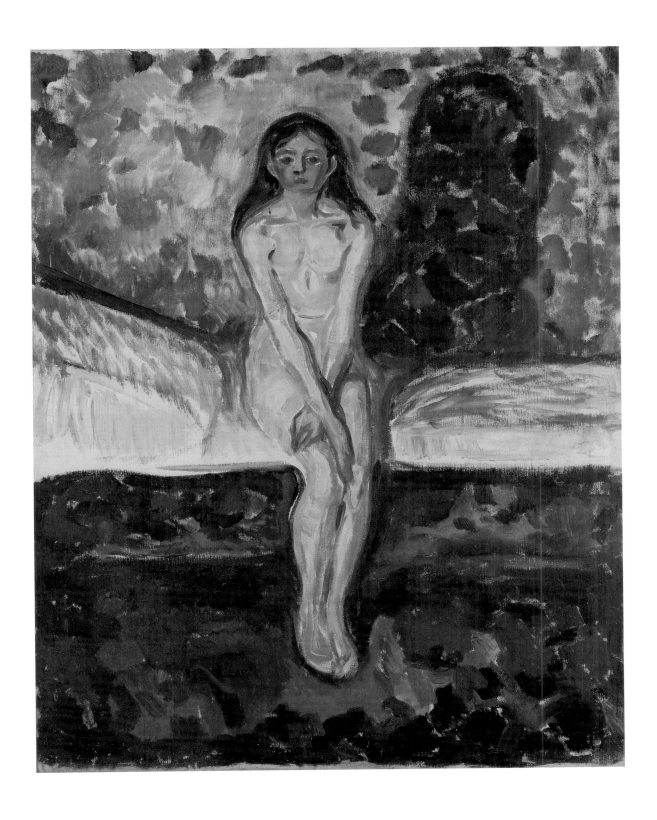

59
'Zum Süssen Mädel'
[To the Sweet Young Girl]
1907
Oil on canvas
85 x 130.5
Munch-museet, Oslo

60
Puberty
1914–16
Oil on canvas
97 x 77
Munch-museet, Oslo

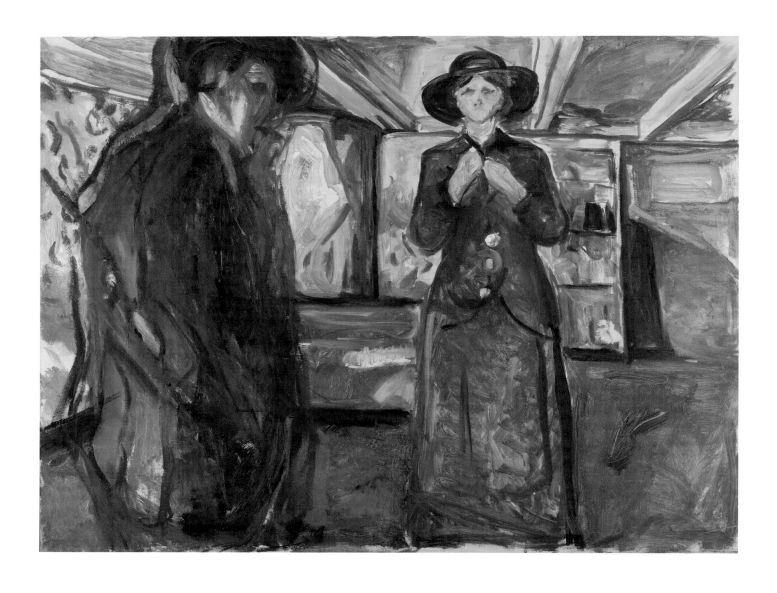

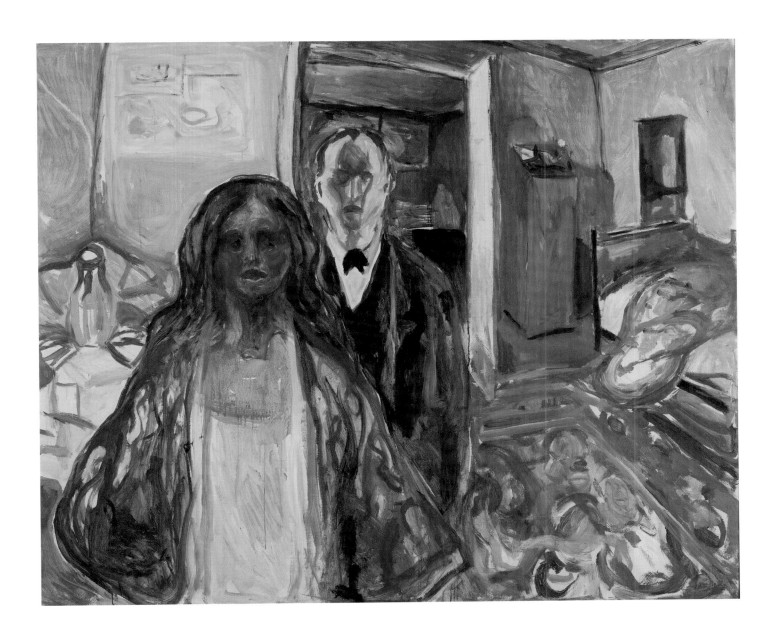

61
Man and Woman
1913–15
Oil on canvas
89 x 115.5
Munch-museet, Oslo

62
The Artist and his Model
1919–21
Oil on canvas
128 x 153
Munch-museet, Oslo

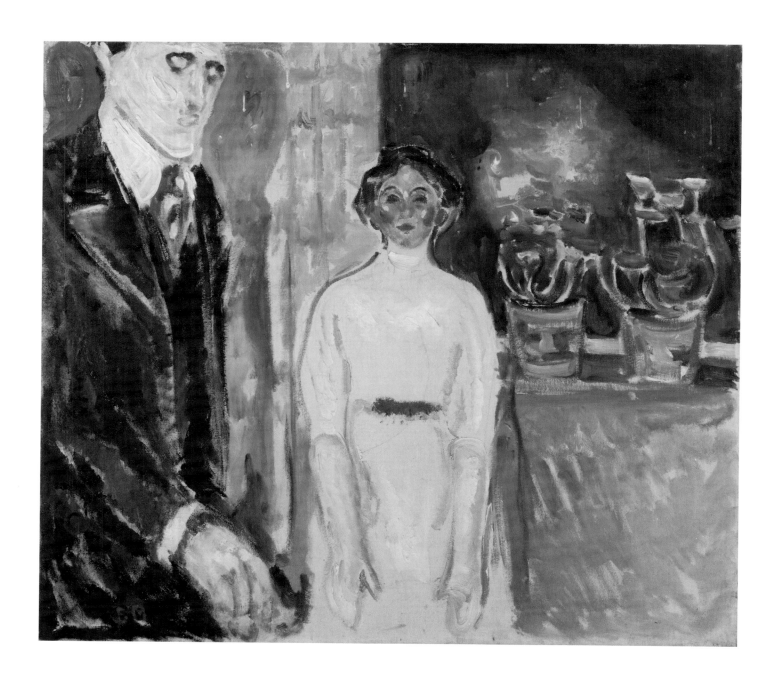

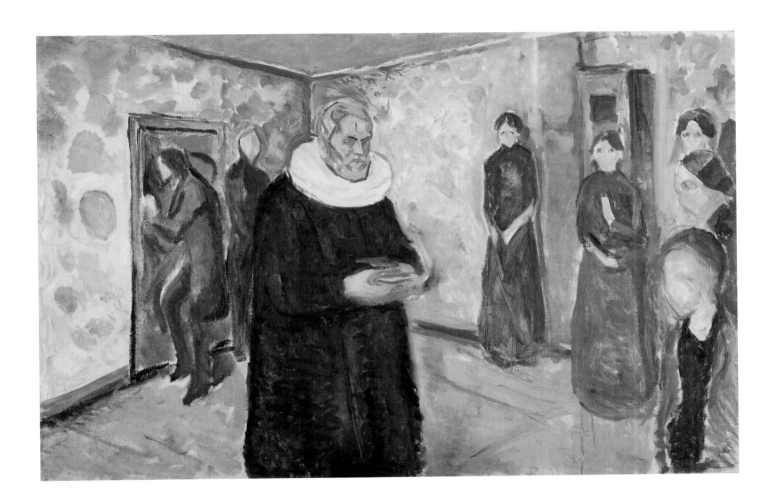

63
**Man and Woman by the
Window with Potted Plants**
1911
Oil on canvas
91 x 100
Munch-museet, Oslo

64
Sacrament
1915
Oil on canvas
120 x 180
Munch-museet, Oslo

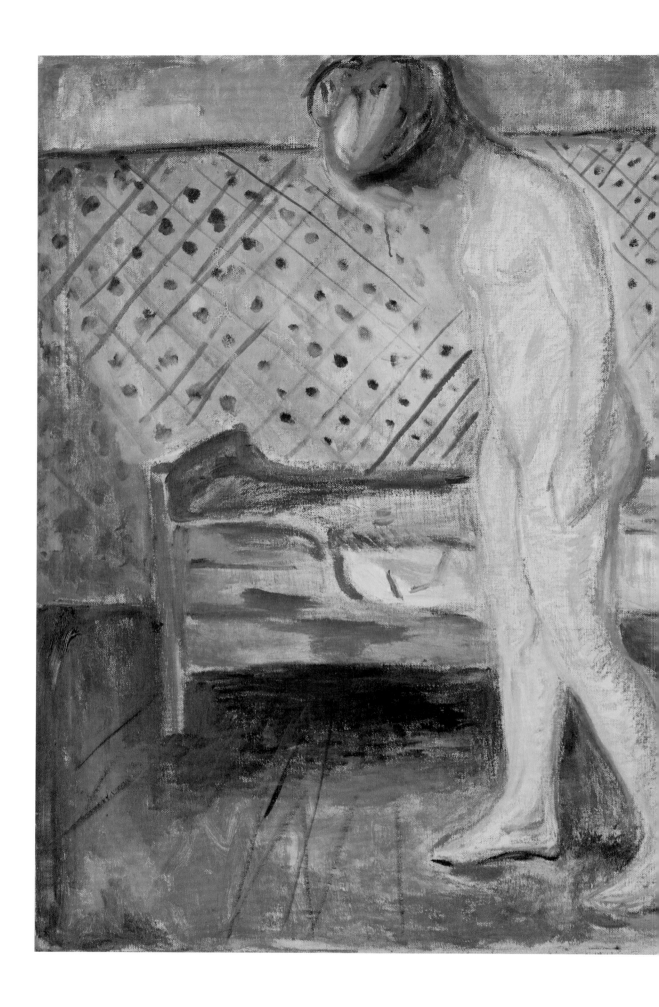

COMPULSION

In 1907, while he was painting *The Green Room,* Munch was also working on another motif, that of a nude woman standing weeping in front of a bed. In a relatively short period of time he painted six versions of it and created several drawings, a photograph, a lithograph and a sculpture. This is an altogether different form of repetition than when the painter returns to a picture years later in order to suggest a different version of it. There is in this repetition, through the range of all the media that he was using at the time, a kind of compulsion that expresses his obsession with the subject. No one knows exactly what this motif meant to him: a primitive scene, an erotic memory, an archetype of despair that he would try to simplify as much as possible by repeating it, as he had done with *The Scream, Melancholy,* and *The Kiss*? Doubtless it meant much more than that because he had planned to use the sculpture of the *Weeping Woman* for his own tombstone.

65
Weeping Woman
1907
Oil on canvas
121 X 119
Munch-museet, Oslo

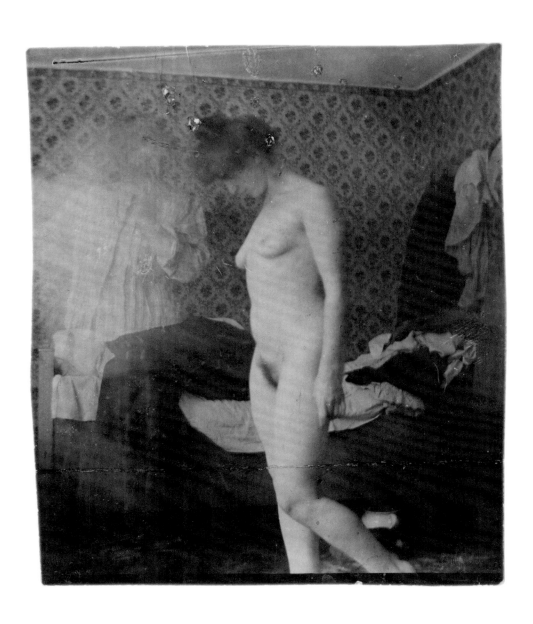

66
**Rosa Meissner at the Hotel
Room in Warnemünde**
1907
Photograph, gelatin silver
print on paper
8.7 x 7.3
Munch-museet, Oslo

Arne Eggum

'The woman, he must weep'

From the autumn of 1906 and for more than a year, the workshop in the basement of the brand new Kammerspiele Theatre in Berlin served Edvard Munch as a studio. Max Reinhardt, the director of the theatre, had commissioned him to create a series of pictures to be used for the set design of *Ghosts* and *Hedda Gabler* by Henrik Ibsen, as well as a frieze to decorate one of the foyers. The inaugural play, *Ghosts*, set up according to Munch's scenographic sketches, was an artistic success and formed a cornerstone in the history of modern German theatre. After Munch had also contributed to the set design of *Hedda Gabler,* the frieze was completed a year later. On 29 December 1907 he showed it to his friend Gustav Schiefler, who had just published a catalogue of his engravings, and to the painter Emil Nolde. Schiefler recorded Munch's explanations in his journal. The frieze depicted informal scenes in Norway's small coastal towns, of the kind where young people get together to talk and dance. However, after everyone else has left, a woman in a red dress is seated alone, 'plunged into a deep melancholy. "The woman, he must weep," our interpreter explained to us.'[1] The figure mentioned picks up on that of the engraving *Melancholy* (1898; fig.54), although different in that her position has been reversed and she is weeping. This is often how a new title is born in Munch's work, from a stroke of inspiration. That the artist should, however, use the masculine gender for 'woman' ('*der Weib*' in German, instead of '*das Weib*') is not trivial and reveals, in one way or another, his perception of the gender relationship.

Munch spent time in Warnemünde from mid-June 1907. He was commissioned to create a copy of *The Sick Child* (painted in Paris in 1896) for his important new patron Ernest Thiel. At the beginning of September, he brought two models from Berlin, Rosa and Olga Meissner, known to us from the fascinating double portrait of *Two Sisters* 1907. In Warnemünde, Rosa posed alone for another picture, *Weeping Woman,* also known

as *Nude Young Girl* (no.65). Once finished it was exhibited at the Salon Clematis in Hamburg, several months before Munch's meeting with Schiefler and Nolde at the Kammerspiele. In a letter to Munch dated 30 October 1907, Schiefler says: 'I found many things I liked a great deal among your Warnemünde pictures. The nude young girl, standing and graceful, is exquisitely fine. My wife never grows tired of it.'[2]

A nude figure standing in front of a bed readily brings with it, whatever the title of the picture, an underlying erotic motif. *Weeping Woman* is an exception; on the contrary it exudes something sorrowful and sad. If the woman had been elegantly dressed, the scene could have been interpreted as a variation of the theme of the Annunciation, with a carefully made bed symbolising the forthcoming birth, rather than an invitation to love. We recognise moreover the heavy wooden bed of Munch's famous mortuary scenes. We see it on the wide floor panels in *Death in the Sickroom* (fig.46, p.112), or in very close-up perspective in *By the Deathbed*. This emphasised huge wooden bed was possibly inspired by the picture *The Room in Arles* 1888 by Vincent van Gogh, which Munch would have been able to study at his leisure in Theo van Gogh's gallery in Paris. The object itself comes from the artist's family home, however.

In his scenographic pictures for *Ghosts*, Munch had devised a wide armchair on which the character Osvald would sit down to die in the final scene. The armchair would stay empty in all the preceding scenes, making it a major dramatic element. In *Weeping Woman* the relationship of tension between the figure and the room's empty bed is in the same vein. On the other hand, there are obvious parallels between the bowed head of the mother in *The Sick Child* and that of the *Weeping Woman*. However, if the mother's suffering in *The Sick Child* is contained and hidden, that of the *Weeping Woman* is a life force that takes hold of the individual. *The Sick Child* refers very specifically to ancient funerary reliefs, in which death is represented

through a farewell to the living. Our *Weeping Woman* is alone; at home, her suffering is expressed as an existential absence without any depiction of its source.

A sorrowful feeling of oppression weighs down upon a number of Munch's major works. Bereavement was a common theme in the secular avant-garde art of the early twentieth century, in Picasso's Blue Period for example. In *Evocation* 1901, the Spanish artist depicts the wake over the body of his friend Casagemas, whose soul rises up to heaven. Some of his pictures, such as *Life* 1903 or *Two Sisters* 1902, offer resonances with Munch's melancholic works. Picasso frequented the Franco-Nordic milieu in Paris, where Munch was known as the most anarchic Scandinavian character.

The face of the *Weeping Woman* is of a crimson red and with brushstrokes so wide that her features disappear. Her broad hairstyle is an eruption of flaming red tones. Munch used the same palette for the red hair of *The Sick Child* in the two reworkings painted simultaneously in Warnemünde.

In the funereal scenes of the 1890s, Munch's figures are often treated in contrast as the faces are either blood red or pale green, a feature that is particularly evident in the watercoloured lithographs. These can be seen in the light of the remarkable and lucid book by the Danish physiologist C.G. Lange, *The Emotions* (1885), which, in the chapter entitled 'Sadness', analyses the phenomenon according to which some people express suffering with a flushed face, and others through pallor. For one group the blood vessels flood the skin; for the other the blood flows back into the body. According to Lange, these are natural physiological reactions that are not at all pathological.

These ideas, developed in partnership with William James, were christened 'the James-Lange theory of emotions' by the scientific press. In 1899, Lange continued his study in a new publication that was just as accessible and devoid of customary

Fig.54
Melancholy
1898
Woodcut
33.5 x 42.5
Munch-museet, Oslo

pedantic jargon, *Bidrag til Nydelsernes Fysiologi som Grundlag for en rationel Aestetik* (*Contributions to the Physiology of Pleasure as a Basis for a Rational Aesthetic*).[3] One of his principal theories was that emotions are transmitted from one person to another through the simple perception of their visual or oral manifestations. The concept of 'sympathetic anguish' that he develops is particularly important to symbolism (Arnold Böcklin and Max Klinger). Lange's theories solidly support Munch's subsequent formulation, according to which the subjects of his paintings were above all representations of human emotions – of 'what is human' – rather than of physical objects. However, the question of the visual representation of human suffering, and primarily that associated with the breakdown of a relationship, was also the central issue in the best-known work by Søren Kierkegaard, *Either/Or*, celebrated at that time across Germanic Europe. The first, very accessible, German translation had appeared in 1885, and the fourth edition of the book was under way when Munch was painting *Weeping Woman*.

What is more, it was a friend of the painter, Max Dauthendey, who had been the first to publish separately the 'Diary of a Seducer', an extract from *Either/Or*. In the spring of 1904, a few months before Munch's important exhibition in Copenhagen, Kierkegaard's niece, Henriette Lund, published *My Relationship to Her*. The book included letters from Kierkegaard to Regine Olsen at the time of their engagement, and selected extracts from his private archives. Kierkegaard broke off the engagement, and his philosophical reflections about this break-up formed the central axis of *Either/Or*. Munch, who had experienced similar difficulties at the end of relationships, wrote in February 1929, when he was organising his literary notes: 'As it is now almost a year and a half since I have read Kirkegård from time to time – when in a strange way everything seems to have been lived before – in another life – I am going to try to draw a parallel between my life and that of Kirkegård.'

As a frontispiece to *My Relationship to Her*, an engraved portrait of Regine Olsen by Emil Bærentzen, dating from the engagement (1840), depicts her with her head slightly leaning at an angle. In his papers Kierkegaard often referred to Regine as a 'young girl', or rather 'a little girl'. In one of his letters he wrote to her: 'And sometimes when you lower your head with sadness, he knows that your soul is generous.'

A chapter of *Either/Or* entitled 'Shadowgraphs. A Psychological Pastime' covers the visual arts. Referring to the famous treatise by Gotthold Ephraim Lessing, *Laocoon* (1766), narrator 'A' states: 'Whatever then is to be an object of artistic representation must have that quiet transparency in which the inner reposes in a corresponding outer.'[4] After his stay in Dr Jacobson's Copenhagen clinic for a nervous illness between 1908 and 1909, Munch confided in Ludvig Ravensberg: 'There is something in my pictures that I cannot overcome, something that is always transparent and ghostly.' The artistic representation of suffering makes up the central issue of the 'Shadowgraphs' chapter. According to 'A', 'sorrow is reserved, silent, solitary, and seeks to retire into itself'.[5] It is perceived visually, however, and, anticipating James-Lange, Kierkegaard formulates the theory thus: 'There are those so constituted that when affected their blood rushes to the skin, making the inner movement outwardly visible. Others are so constituted that the blood flows inwards, seeking the ventricles of the heart and the inner parts of the organism.'[6] This phenomenon is further illuminated by the use of the concept of 'reflected sorrow', from which the source is absent: 'Seeking its way thus inwards, it finds at last an enclosure, an innermost recess where it thinks it can stay, and now it begins its monotonous movement. Like a pendulum in a clock, it swings back and forth and cannot find rest.'[7] And further on: 'And deep inside, in its little nook, sorrow lives like a well-guarded prisoner in an underground gaol ... It walks up and down in its enclosure ...'[8]

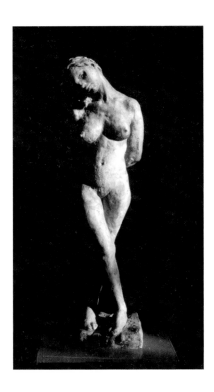

Fig.55
Gustav Vigeland
The Sleepwalker
1909
Plaster
172 x 42 x 38.5
Vigeland-museet, Oslo

Fig.56
The Murderess (The Death of Marat)
1906
Oil on canvas
110 x 120
Munch-museet, Oslo

However, the comparison with the pendulum allows us to notice that our *Weeping Woman* is not stationary. In fact, she could easily be seen as a sleepwalker on the point of falling forwards, her movement suspended. From this point of view she is fundamentally inaccessible. Gustav Vigeland, who, like Munch, also had Ernest Thiel as a patron, sculpted a statuette in 1907 that he called *The Sleepwalker* (fig.55), a standing nude with tilted head, reminiscent of a Rodin. It is one of his most beautiful female figures. Ragna Stang, the first curator of the Vigeland Museum, made the link between the sculptures dealing with gender relationships that he created during this period and the theme of the irremediable solitude of the sexes, as it is effectively staged in the play by Gunnar Heiberg, *The Tragedy of Love* (1904).

Munch had an unusually virulent reaction to this major play in the history of Norwegian and Germanic theatre. When it was put on for the first time at the Nationaltheatret in Kristiania on 16 January 1905, the painter was in Prague for an important exhibition. He was feted within the Mánes art association as an avant-garde anarchist, and had one of the most beautiful women in Bohemia as his guide to the region. It was from this place of residence that he reacted with understandable violence to what he considered a defamatory and provincial attack from Kristiania. He was convinced that he was being targeted in the guise of Erling Kruse in Heiberg's play. In the final act, the character of Karen Kruse, speaking of Erling's (therefore of Munch's) inability to love, admits: 'I stand here like a stranger to myself – like a cold stone within which my soul is freezing … I alone. Naked. Without a ribbon even … You wished to see me stripped. Now you see me. Shamelessly stripped. Without modesty. Everything laid bare. Do you see me now? Can you see the strumpet?'[9]

Nor is the motif of the *Weeping Woman* devoid of connections with the painting *The Murderess (The Death of Marat;*

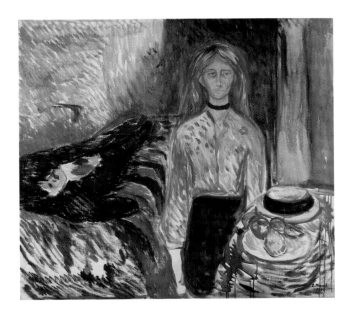

fig.56). In Heiberg's play, the murderous essence of love is evoked through certain lines: 'That love kills … always … someone. One or the other.' After Karen's suicide: 'Is it not more beautiful that love kills than that it dies?' If we interpret *Weeping Woman* in the light of *The Tragedy of Love,* something of the hysterical stands out from it, something excessive. It seems as if her head is in turmoil. It is possible that Heiberg was directly inspired by the twelfth chapter of Otto Weiniger's book, *Sex and Character* (1903). The concept of hysteria is studied here in all its facets, and reference is made among others to Ibsen's characters Rita and Hedda.[10] Those searching for sources of inspiration for the one-act play by Oskar Kokoschka, *Mörder, Hoffnung der Frauen* (*Murderer, the Hope of Women,* 1907) should focus primarily on *The Tragedy of Love* by Heiberg, which spread like wildfire through German-speaking theatres. From a stylistic angle, however, the stage paintings by Alfred Jarry of the destructive anti-hero Ubu are another preliminary milestone to Kokoschka's short play. In any event, the bloated figure of Ubu was a clear source of inspiration for the caricatures Munch made of Gunnar Heiberg, depicting him alternately as a toad or a pig. Jarry's absurdist theatre rejuvenated the Parisian artistic community. Jarry gave his revolver to Picasso as a gift (he also obtained his manuscripts after Jarry's death in 1907). *Ubu the King* (1896) also inspired the absurdist play *Den frie Kjaerligheds By* (*The City of Free Love*), which Munch wrote as an acerbic response to *The Tragedy of Love.* When Munch was working on the set design and drew a poster for the production of Ibsen's *Peer Gynt* at the Théâtre de l'Oeuvre in Paris in 1896, Jarry, who was then the artistic secretary at the theatre, was making his debut as an actor in the role of the Troll. The *succès de scandale* of *Ubu the King,* which deals with the blind instinct of destruction, immediately followed *Peer Gynt* in the same theatre. Beneath a drawing of a scene of *The City of Free Love,* Munch wrote in November

1906, 'At the Court of Uby [sic] the King'. Munch's play was inspired by Jarry's play and, similarly, had obviously been intended to be performed with puppets.

One of Munch's set designs for *Hedda Gabler,* late in 1906, shows the character of Hedda as a dark, ghostly figure, with her head typically bent forwards (fig.57). She faces Thea, whose blonde hair radiates across the room. At the end of Act II, the scene depicts the preceding moment when Hedda 'passionately embraces' Thea and launches at her: 'I think I must burn your hair off after all.' (The link between the image and this line has been established by Peter Krieger in his important study, *Edvard Munch. Der Lebensfries für Max Reinhardts Kammerspiele,* 1978.[11]) This is the only drawing made by Munch for this play that offers a visualisation of the relationship between two characters. When studying *Weeping Woman* from this perspective, it becomes obvious that the woman's head is indeed the source of physical light in the room. Only the light from this 'burning' head explains the trembling shadow cast on the ground. This observation makes the absurd dimensions within the picture easier to grasp. The space of the room becomes less obvious, and its walls appear like the wings of a theatrical stage that has been erected in the first appropriate place. The woman seems disproportionately large in relation to the room and the bed. Her head pushes the ceiling back, and we can appreciate how Munch manipulated and stretched the play of perspective in order to create an oppressive 'iconic' space. Seen in this way, the composition reproduces an existential anguish that we perceive, along with C.G. Lange, to be 'sympathetic anguish'.

A comparison of Munch's picture with popular depictions of the Annunciation showing Mary with her head lowered in front of a very commonplace bed – even in the most beautiful artistic representations, such as that by the baroque painter Orazio Gentileschi – clearly shows the extent of the tension in Munch's figure, despite her sleepwalking nature. If she wakes up, we are

expecting an hysterical eruption rather than a loving embrace. Like Mary in Dante Gabriel Rossetti's *Annunciation* 1849–50, *Weeping Woman* is also fed by the concept of the anguish of puberty. In the versions of Munch's picture *Puberty*, from the early 1890s, the naked body of the young girl is outlined vertically in a hidden cross shape, the horizontal line of which is created by the rough plank of wood that frames the bed. Her chest is flat, without breasts – just as in *Weeping Woman*.

Munch photographed Rosa Meissner (no.66) in a pose similar to that of *Weeping Woman*. We can see that she has clearly outlined, well-formed breasts, firm thighs, marked abdominals, strong arms and a muscular neck. If, as is generally accepted, Rosa was the model for *Weeping Woman,* Munch transformed her athletic and slender body in this picture, reducing her breasts and making her stockier and more 'ordinary'. Also noted in the picture is the unusually marked pubis, which once again offers links to the equivalent area of Picasso's *Dryad* 1908, a masterful 'female nude' moving inescapably forwards with her left hand transformed into a deadly axe.

The position of the head is identical in the photograph and the painting. The head in *Weeping Woman*, however, droops in a gesture traditionally inherited from the famous *Expulsion of Adam and Eve from the Garden of Eden* (1424–8) by Masaccio, while Rosa 'poses' openly. In the photograph the bed is in obvious disarray, and the model, seen close up through a lens possibly placed on a table, plays a more neutral role in the space.

If we search contemporary art for female figures with a similar physique, naturally our focus falls on Paul Gauguin, who Munch considered to be the greatest artist of his time. In *Man with an Axe* (fig.58), the principal figure is a woman with typical characteristics of the Pacific Islands, closely resembling the model in *Manao Tapapau* painted in the same year, 1891. Gauguin wrote in *Before and After*: 'What distinguishes the Maori woman from all others, and makes one often mistake

her for a man, is the proportions of her body.'[12] He describes her 'large shoulders … her narrow hips … her broad arms … her enormous thighs … her huge knees and inside … the leg, from hip to foot, [which] offers a pretty, straight line'.[13] I am convinced that when Gauguin wrote these lines he was thinking about *Man with an Axe*. The pure young girl lifts 'heavenward' a typically French axe, stained with blood. The handle of the axe and the head are seen from two opposing perspectives, thus providing a symbolic and heraldic dimension. If we interpret 'Man' as a 'human being', that is, not necessarily masculine, the picture then assumes a conception of the matriarchal society in which woman, not man, is the primordial being. Alfred Jarry, who loved to cultivate the androgynous gender, and throughout his life was a close friend of Rachilde, the author of *Monsieur Vénus*, paved the way to an erroneous interpretation of the sex of the figure with his well-known poem '*Man with an Axe*, after and for P. Gauguin'.

Even more visible are the features shared between Munch's *Weeping Woman* and the central figure picking fruit in Gauguin's symbolist masterpiece, *Where do we come from? What are we? Where are we going?* 1897. Incidentally, the title comes from a French translation of the book by Louis Büchner, *Die Stellung des Menschen in der Natur in Vergangenheit, Gegenwart und Zukunft. Oder: Voher kommen wir? Wer sind wir? Wohin gehen wir?* (1868), published in French in 1870 with the title *L'Homme selon la science, son passé, son présent, son avenir, ou D'où venons-nous? – Qui sommes-nous? – Où allons-nous?* The first part of this book, 'Where do we come from?', deals with the fundamental role of the axe for man at the dawn of civilisation ('Man') (*Der Mensch*), and the third part, 'Where are we going?', develops the question of female emancipation in the chapters 'Woman' (*Die Frau*) and 'Marriage' (*Die Ehe*).

Another reason, perhaps more profound, for the choice of this title was also its connection to the book by Barthélemy

Fig.57
Set design for Henrik Ibsen's
Hedda Gabler
1906–7
Gouache on unprimed board
41.5 x 71
Munch-museet, Oslo

Fig.58
Paul Gauguin
Man with an Axe
1891
Oil on canvas
92 x 70
Private Collection

Prosper Enfantin, *Life Eternal: Past, Present, Future*, from 1861. Enfantin was a close friend of Gauguin's anarchist grandmother, Flora Tristan, and he exerted a strong influence over her, and, through her, on Gauguin himself. Chapters 31 to 36 are particularly, in my eyes, not merely of crucial importance for interpreting the androgynous aspect of Gauguin's art, but also for an overall understanding of his Tahitian project from 1891 to 1898.

Many authors have identified an hermaphrodite element in this figure from Gauguin's masterpiece, which I personally struggle to see. Other examples, however, of masculine women do exist in art, such as the painting *Hermaphrodite* from circa 1800, attributed to Anne-Louis Girodet de Roucy-Trioson, which shows a figure without a penis, with a dark, clearly marked pubis, and an unquestionably masculine chest. However, that the picture's central figure should be devoid of sexual aura is an observation that opens up new horizons.

Munch found a rich theoretical introduction to the contemporary debate on sexual roles in Otto Weininger's book *Sex and Character* (the author had tried to publish the first eleven chapters, which made up his doctoral thesis, under the title *Eros and Psyche*). Drawing, among others, from the work of Ibsen, the issue had been inspired by a performance of *Peer Gynt* at the Nationaltheatret in Kristiania in 1902. Weininger analysed all the contrasts existing between 'Mann und Weib', including the psychological ones. With reference to Plato's *Symposium*, he alleged that primordial man must have been a hermaphrodite, '*Mannweib*'. Strindberg showered praise on the book; he saw it as a work of genius, and Munch read it, using his faithful .22 calibre pistol as an eloquent bookmark.

In the photograph of Rosa Meissner taken by Munch (no.66), developed before or after *Weeping Woman*, her sister Olga can also be discerned, like a transparent, ghostly figure. She looks ahead, unlike her sister, who appears in profile, as in

the painting *Two Sisters*. This spiritualist dimension becomes apparent in another version of *Weeping Woman* (no.67). I will refer from now on to the version discussed above as the 'primary' version (no.65), and those to come as, rightly or wrongly, 'secondary'.

A version in the Munch Museum, probably from 1907, resembling a watercolour due to its fine pictorial layer, is, from a thematic point of view, the most interesting secondary version (no.67). The woman here has a much slimmer and more slender silhouette, and her head, as in the photograph, is contained within the 'natural framing' of the room. In a tightened composition, the body is, as in the photograph, cut off above the feet, and the legs have blended into one another. This secondary version features a much more rapid technique, and is perhaps a study for the primary version. In the former, the woman really burns like a spiritualist flame, reflecting much more openly its occult references than the primary version. The yellow, translucent tones echo the famous works of William Blake, such as the feminine *Vitruvian Man* and the masculine *Vision of God*, which, it should be said in passing, approach the viewer in the same way as the figures in Munch's *Bathers*, the work that occupied him primarily during the late summer of 1907 in Warnemünde.

When Munch first painted the study for *The Sick Child* in 1886, spiritualist photography was all the rage in Kristiania, and this portrait study made its mark, before it was partially repainted between 1892 and 1896, and greatly restored much later. In mid-July 1907, Schiefler noted that Munch was fond of 'mysticism', harboured 'transcendental ideas', and could really see the aura around people. Munch explains this with references 'to the astral body of theosophy' and to 'Hertzian waves'.[14] One of his literary notes of the period reads, for example: 'Do spirits exist? We see what we see – because our eyes are made that way – who are we? – an accumulation of forces in motion – a light

that burns – with a wick – internal flames – hot – external – and again an invisible flame – that is felt.'[15]

A radically simplified version of the composition of *Weeping Woman* (no.69), in which the bed has disappeared, is handled with long parallel vertical streaks, in yellow-green tones. Some other works, such as *Cupid and Psyche*, *The Death of Marat* and *Consolation*, are worked in the same way that had, for Munch, resonances with nascent cubism in Paris. Here (no.69), the woman, as in the 'spirit' version (no.67), is framed at her lower legs and has a tactile, sculptural quality.

It seems possible to date some further versions of the motif of the *Weeping Woman* to 1908–9 (Woll M 775 and 829). They reveal a new direction in Munch's art, which could be defined as a heightened and violent extension of fauvism, linked with contemporary French and German painting. One version (Woll M 829) can now be found at the Landesmuseum in Münster. It constitutes a more literal reworking of the primary version, without the motif of the clothing hanging on the wall. The Swedish collector Klas Fåhræus bought the picture from Munch during a visit to Kragerø, and wrote to him on 21 April 1912: 'The weeping woman looked particularly good in the electric evening light, beautiful like a Frisian Venus painted by a Nordic Titian.' This version also recalls the *Bathers* by Paul Cézanne from 1905.

The other version from 1908–9 (Woll M 775) was purchased by Rolf Stenersen, a patron and close friend of Munch's since the 1920s. It returns to the 'spirit' version (no.67) in an 'expressionist' way. It includes the clothing hanging conspicuously from a hook on the wall, where we might expect to see a crucifix instead (the photograph of Rosa Meissner – no.66 – confirms that clothes really were hung up above the bed). In addition, the green 'shadow' in the primary version, to the left of the room where Olga Meissner 'materialises' in the photograph, is painted here in broad strokes in a complementary red-brown colour.

Fig.59
Paul Gauguin
Oviri
1894
Ceramic
75 x 19 x 27
Musée d'Orsay, Paris

In 1904 or 1905, a German doctor warned Munch that he only had a few years left to live if he did not give up his considerable fondness for alcohol. Munch did not manage this completely and it is understandable that he should then become interested in tombstones in 1907. In his journal from that year, Schiefler recorded a conversation on 6 August with Munch about the engravings *Funeral March* and *The Urn*: 'He designed *Funeral March* firstly as a funerary monument for a mother.'[16] In his book *Im Männlichen Gehirn* (*Inside Man's Brain*, 1973), Gösta Svenaeus made the link in a convincing way between *The Urn* and Gauguin's ceramic self-portrait in the shape of an urn, which Munch could have studied in Copenhagen in 1893. After his stay in the Copenhagen clinic in 1909, Munch always described Gauguin as a 'painter and sculptor', not as a painter and engraver. After the important Gauguin exhibition in Paris in 1906, it was well known that his ceramic work, *Oviri* (1894; fig.59), had been designed for his own tombstone, and a version does now decorate his tomb on the Pacific island of Hiva Oa. The formal handling of the word *oviri*, and its location right at the bottom, also echoes the word *enfantin* on the tombstone of the writer Barthélemy Prosper Enfantin in the Père-Lachaise cemetery in Paris.

In a 1907 drawing, undoubtedly a first sketch for Munch's small statue, *Weeping Woman* (no.75), we see a woman standing in front of an unmade bed that now, perhaps, does symbolise a tomb. A beautiful young woman in mourning, her head bowed, is a classic motif in funerary sculpture. Thanks to Munch's correspondence with Dr Max Linde, who had in his time unquestionably the largest collection of Rodin sculptures, we know that Munch had been working with plasticine since 1903. Unfortunately, everything he was able to make before *Weeping Woman* is now lost. The statuette must have been created from plasticine either in 1907 or 1909. The exceptionally hard coating had been modelled by experienced hands. (Munch had a plaster

version of the statuette carried out in 1914, and a bronze cast in 1932.) Strindberg's statuette *Weeping Boy* from 1891 (fig.60), which was initially intended to depict a praying boy and was transformed 'by coincidence' into a crying boy, may have been a direct model.

The idea of using the motif of a nude woman for a funerary sculpture, with her face completely hidden by her hair – as in the wood engraving *Melancholy* from 1898 – may have been suggested to Munch by the picture *Grief* 1902 by Anna Ancher. She depicts herself naked, kneeling before a cross in a cemetery, opposite her mother dressed in black, a group that is analogous, therefore, to the motif of *The Sick Child*. Note that Munch's picture *The Smell of the Cadaver* (MM M 34, Woll M 248), from the late 1890s, depicting a body lying on a rough wooden bed and exuding a pestilential stench, has so much in common with Ancher's *Funeral* from 1883 or 1888 that it cannot be accidental.

Munch reuses the figure of *Weeping Woman* in *Chemistry*, one of the panels for the festival hall of the University of Oslo, painted between 1914 and 1916. With a sculptural form, quite close to the late statues of Gustav Vigeland that decorate the bridge of the Vigeland Park in Oslo, she is collecting in a cup a vital liquid poured by a monumental masculine figure. The scene is painted in a typically theosophical palette, which we know initially through the book by Charles Webster Leadbeater, *Man Visible and Invisible* (1903). The subject obviously refers to one of the final extracts from the tale of Amor and Psyche in Apuleius' *Metamorphoses* in which Mercury, messenger of the Gods, takes Psyche up to heaven: 'And he held out to her a goblet of ambrosia and said: Drink, Psyche, and mayest thou be immortal. Cupid will never escape your chains, and together you shall be united in marriage for all eternity.'

In Munch's painting, *Harvesting Women*, which can also be found in the University of Oslo festival hall, the woman standing with raised arms echoes the central figure of Gauguin's masterpiece *Where do we come from? What are we? Where are we going?* Here, the woman has passed the age of puberty and her blooming body is built for motherhood.

One further variant (no.70) exists of the primary composition of *Weeping Woman*, created in a radically extended format (174 × 59.5) allowing Munch to integrate it into the narrower panels of the university festival hall, close to *The Sun*. In 1909 he planned *Towards the Light/The Human Mountain* as the theme of the central panel. Tone Wikborg, director of the Vigeland Museum for several years, has analysed the subject in the light of Ibsen's play, *When We Dead Awaken*, particularly in the description of the final, damaged version of the group sculpted by Rubek,[17] *The Day of the Resurrection*.

Munch's *Weeping Woman* statuette, on the other hand, may evoke the description of the original work by the sculptor Rubek in which Irene, his model, alone 'on the stool', 'figured in the likeness of a young woman, awakening from the sleep of death'.

A lithograph created during Munch's stay in the Copenhagen clinic, *Weeping Nude*, returns to the figure of the occult version of *Weeping Woman* (no.67), modifying it. It should be interpreted as a new sketch for a funerary sculpture. It is now clear that her feet and calves have 'taken root together', transforming her into a dryad. Munch compared men to trees several times in his literary notes, and the work can therefore be considered as a sketch for a wooden tomb sculpture. Can *Oviri*, Gauguin's funerary sculpture, shed light on Munch's intentions? It is certainly not impossible.

If we pick up on the play on words/syllables/ideas conceived by Alfred Jarry in *Minutes of Sand: Memorial*, published in October 1894, and we interpret *oviri* as *où – iri* from a cosmic Franco-Latin angle, we find as a result '*va être*', an absurd portmanteau word that, in French, reflects a depersonified version of 'Where are we going?' If, on the other hand we read

Fig.60
August Strindberg
Weeping Boy
1891
Gilded plaster
20 high
Modelled and cast at Djursholm,
Sweden in Autumn 1891, by
August Strindberg: Strindberg's
copy, of an edition of five
Private Collection

ov as *ou*, without an accent and meaning 'or' in French, then we start to doubt that it is leading us anywhere. Let us join the two interpretations together simultaneously from the same angle, and we get an *Either/Or* that is Kierkegaardian. In Gauguin's funerary sculpture the question is posed visually, without Kierkegaard's irony but in a savage and uncontrolled manner, an 'oviresque' manner. From this point of view, Munch poses a similar question in the lithograph *Weeping Nude*, although it is sorrowful in its own way.

Viewed from the front, Gauguin's *Oviri* is very violent. Her face seems inspired by Odilon Redon's *Cactus Man* from 1881, but also resembles that of the woman in *Omega Weeping*, one of the lithographs making up *Alpha and Omega*, Munch's visual tale inspired by Jarry on the theme of the birth and death of love. Gauguin referred to *Oviri* as *The Killer*. In a primitive fashion she breaks the neck of her animal offspring. In the same way, in *Alpha and Omega*, Alpha is slaughtered by the descendants of Omega, those animal bastards that called him 'daddy'. *Oviri* reveals the legacy of Indian totems in the giant reptile under the murderess's leg that is trying to bite us; the woman in the sketches for the funerary sculpture *Weeping Nude* in turn plants her healthy roots into the ground. Hamadryads, such as those shown on a well-known mosaic from Pompeii, are also depicted in this way.

The back of *Oviri*, the shape of which recalls that of an occult spirit, is interesting in itself. We can sense a trace of it in another late work, Rodin's *Draped Torso of the Age of Bronze* 1916. Gauguin's *Oviri* reflects both, or more exactly alternates between, the aggressive and the spiritualist sides of the painted versions of the motif *Weeping Woman*.

Munch created a lithograph with the reversed motif of the occult version of *Weeping Woman* from 1908–9, which was bought by Rolf Stenersen and later dated by him to 1906. It was, as with many of the later lithographs, originally intended

Fig.61
Weeping Nude
1906
Charcoal on paper
58 x 39.5
Munch-museet, Oslo

to be coloured in by hand. In this way Munch was able to create works that were easy to sell, while revisiting, and sometimes completely reinterpreting, his earlier motifs. In the lithograph the bed is unmade as if having been used by a couple, a possible echo of Munch's conversations with Stenersen. A watercoloured print (no.72) also shows the clothing as having been retouched into a strange black, sepulchral 'silhouette', which could be interpreted as a man leaving the room – through the wall, as if he were the devil himself. When Munch printed this lithograph in 1930, Stenersen was writing *God natt da du* (*Nighty-Night Then!*), the first Norwegian 'dadaist' book, which was banned due to its erotic content.

Stenersen wrote *Edvard Munch: Close-Up of a Genius* during the Second World War when he had taken refuge in Sweden. The book is fed by more than twenty years' worth of Stenersen's conversations with Munch. Like the artist, Stenersen had the profoundest contempt for the petit-bourgeois observance of rules and regulations. He depicts the painter as a lively and absurd personality, far removed from bourgeois conventions. Stenersen, ever the sensualist, also notes his impressions of Munch's pictures. For example,

> A vision he has often portrayed is a nude woman standing by a bed. In some of the pictures, her body is attractive – posed in a flood of light against a dark, spotted wall. In most of them, however, she is ugly and finished despite her youth. Her position is the same in all these pictures – she is moving away from a bed, her head bowed, arms limply at the sides, her hair covering her face – these are the things he remembers.[18]

Translated by Ingrid Junillon and Laura Bennett

Notes

1 In German in the text: 'Der Weib muss weinen, sagte erklärend unser Interpret', Arne Eggum (ed.), *Edvard Munch–Gustav Schiefler. Briefwechsel I, 1902–1914,* Hamburg 1987, no.368, p.266.

2 Ibid., no.353, p.260.

3 Carl Georg Lange, *Bidrag til Nydelsernes Fysiologi som Grundlag for en rationel Aestetik*, Copenhagen 1899.

4 Søren Kierkegaard, *Ou bien... ou bien...*, trans. from the Danish by F. and O. Prior and M.H. Guignot, Paris 1943, p.132.

5 Ibid., p.133.

6 Ibid.

7 Ibid., p.134.

8 Ibid.

9 Gunnar Heiberg, *La Tragédie de l'amour*, 1904, trans. from the Norwegian by P. Groth and S. Flour, in *Les Oeuvres libres*, no.147, Paris, September 1933.

10 'Rita', character in *Little Eyolf* (1896), 'Hedda', heroine of *Hedda Gabler* (1891).

11 Peter Krieger, *Edvard Munch. Der Lebensfries für Max Reinhardts Kammerspiele*, exh. cat., Berlin 1978.

12 Paul Gauguin, *Avant et après*, Taravao 1989, p.75.

13 Ibid., p.76.

14 Eggum 1987, no.334, p.250.

15 MM T 2704, Oslo, Munch-museet, p.24.

16 Ibid., no.340, p.254.

17 The protagonist in Ibsen's play, Rubek is a famous sculptor who tries to reconnect with Irene, who inspired the work that made him famous.

18 Rolf Stenersen, *Edvard Munch: Close-Up of a Genius*, Oslo 1969, p.57. First edition, in Swedish, Stockholm 1946.

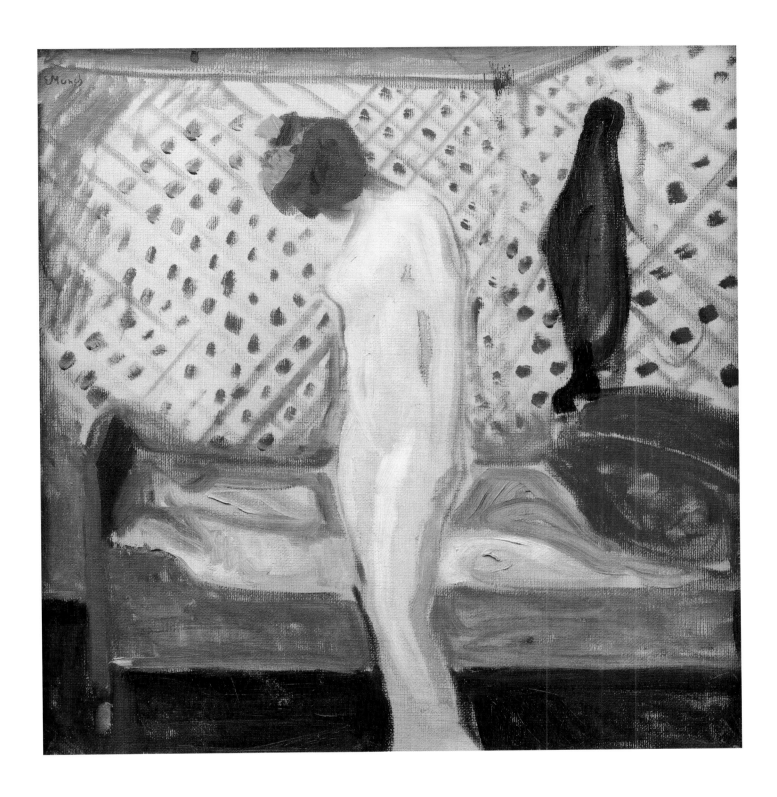

67
Weeping Woman
1907–9
Oil and crayon on canvas
110.5 x 99
Munch-museet, Oslo

68
Weeping Woman
1907–9
Oil on canvas
63 x 60
The Stenersen Collection,
Bergen Kunstmuseum

69
Weeping Woman
1907
Oil on canvas
103 x 87
Munch-museet, Oslo

70
Weeping Woman
1907
Oil on canvas
174 x 59.5
Munch-museet, Oslo

71
Weeping Woman
1909
Oil on canvas
88.5 x 72
Westfälisches Landesmuseum für
Kunst und Kulturgeschichte, Münster

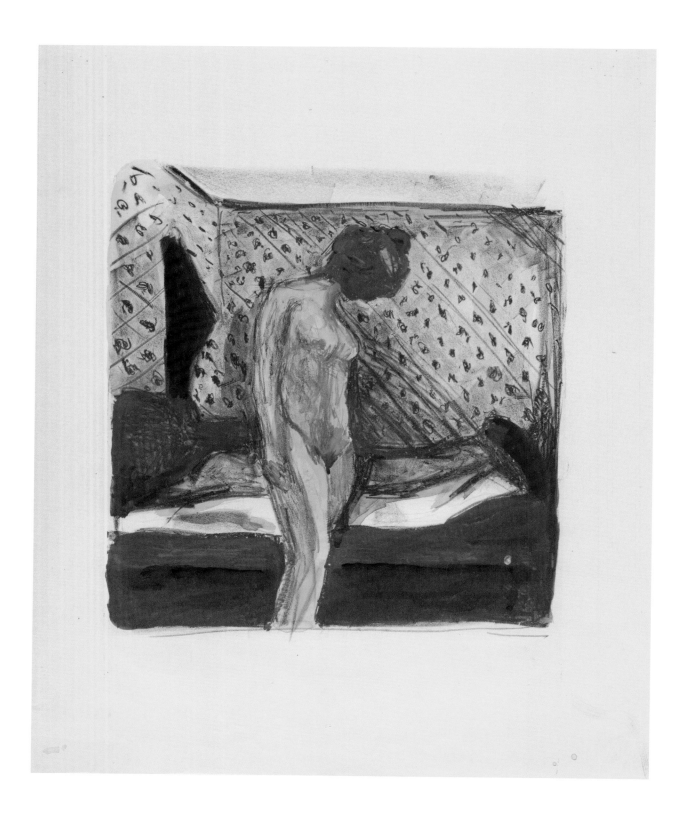

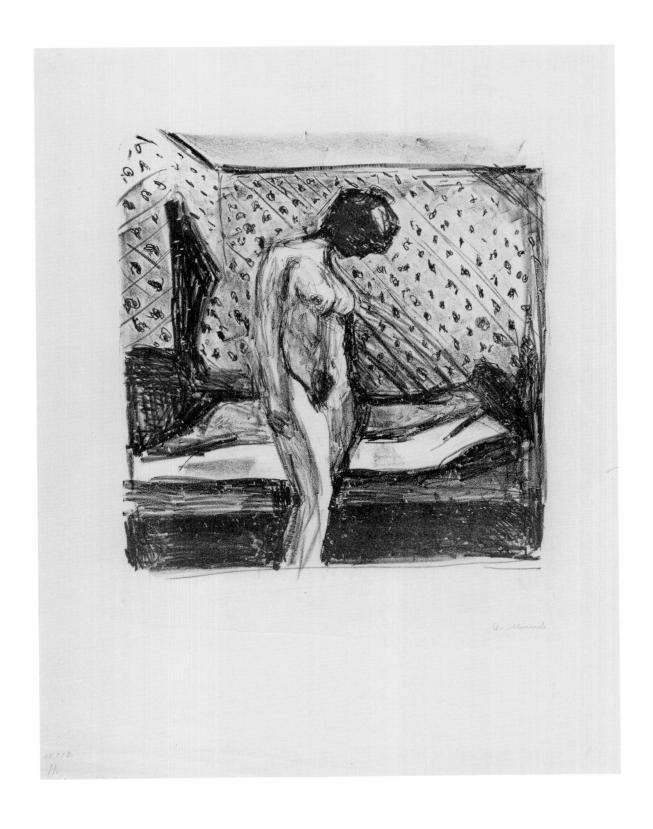

72
Young Woman Weeping by the Bed
1930
Lithograph
40 x 36.2
Munch-museet, Oslo

73
Young Woman Weeping by the Bed
1930
Lithograph
40 x 36.2
Munch-museet, Oslo

74
Interior with Small Sculptures at Ekely
1931–2
Photograph, gelatin silver print on paper
8.1 x 13.9
Munch-museet, Oslo

75
Weeping Woman
1907
Bronze
38.2 x 27.5
Munch-museet, Oslo

It was a dark
children's room –
our maids and other
maids played with us
they traipsed back and forth
back and forth facing each
 other and sang
a song that was so
sad. Finally
a girl was
left quite alone
and no one wanted to have
anything to do with
her; the young boy who
had given her the ribbon
and the ring was also gone
and so I had to run to her and take her
hand and comfort her
 It was winter and we sat all day
in the windowsills looking
 out. Across the street
lived a husband and wife who
 fought constantly
and once while they were quar-
 relling the devil came
up behind them and stood laughing.
 He had large horns on his
 forehead and he had
horses' hooves and a tail
 and he was black
all over his body. Once he
finally wanted to capture
 them with his claws
and drag them into hell.
That is why he smiled so.
 They could sometimes see
ram's hooves in the evening when
it was dark in the next room
– it was the devil
he wanted to capture them
 when they were
bad and did not want to go to bed but
if they kept to god he could
not touch them. –

Translated by Francesca M. Nichols

Mai Britt Guleng

Repetition in the Writings of Edvard Munch

*Repetition and recollection
are the same movement, just
in opposite directions, because
what is recollected has already
been thus repeated backwards,
whereas genuine repetition is
recollected forwards.*
Søren Kierkegaard [1]

Fig.62
'Den illustrerte dagbok'
[The Illustrated Journal]
c.1889–90
MM T 2761, p.3 recto
Munch-museet, Oslo

In *Repetition* by Søren Kierkegaard, the narrator Constantin Constantius tries to make the memory of a visit to Berlin reappear, returning there with the intention of reliving the same experiences. He then discovers that he cannot recollect the feelings and events of the past; and yet this attempt provides him with new experiences. The realisation that past events cannot be re-created identically leads him to reflect on what it is that makes repetition possible? What does repetition imply in an epistemological and ethical sense? He discovers that repetition makes the past and the future evolve in a dynamic relation-ship: 'The dialectic of repetition is easy, because that which is repeated has been, otherwise it could not be repeated; but precisely this, that it has been, makes repetition something new.' [2] This dynamic relationship between repetition and recollection may serve as an introduction to Munch's literary writings.

Fragment and Integrality

Munch drew inspiration for his literary output from his past, as a number of his writer friends were also able to do. Hans Jæger, August Strindberg, Ola Hansson and Emanuel Goldstein, among others, initiated him into the issues that were in vogue at the time, such as naturalism and decadent literature, as they were perceived within the international artistic milieu. They urged him to use his own experiences, and to direct his attention towards the spiritual life of the modern individual in order to create a new kind of literature. One of the ways of achieving this consisted in transcending traditional genres and using a fragmented form, reflecting the psychologically disintegrated individual.

In his text entitled 'The Illustrated Journal' from c.1889–90 (fig.62), Munch tried to observe these recommendations; as indicated by the title, drawings accompanied the theme in a sketch book. [3] It is not easy to follow a narrative thread in 'The

[only parts are legible]

– Have you ever loved? –
– Never in this way – Not even
kissed –
I have dreamt about it more
than once – I undressed her
on the wedding night –
– I search for her as well –
But she must be
the light as well as the goal
– She must inspire –
and make the flame shoot out –

[…]
– Sexual urges must be satisfied

Translated by Luce Hinsch
and Laura Bennett

Illustrated Journal'. Even though the text is reminiscent of a brief novel or a short story, it has so little of the epic about it that it appears more like a collection of fragments.[4] Its incompleteness affects the action, the characters and the theme itself. The spatial and temporal dimensions remain vague in every scene.

The essence of the work recounts a love story between a young painter, Nansen, and a married woman, Mrs Heiberg, from passionate beginnings to the (unexplained) end of their liaison, an intense moment of despair and self-loathing for the young artist. The narrative focuses on describing the emotional evolution of the characters: firstly intoxication, then moments of jealousy and remorse, and finally the destructive and irrational collapse of love.

The term 'journal' is used for the simple reason that the text contains obvious allusions to events in Munch's life. The love story between Nansen and Mrs Heiberg can be explained by Munch's first romantic relationship with a woman two years his senior, during the summer of 1885.[5] Per Thomas Andersen saw in this a kind of 'performative biographism'.[6] This emphasis on autofiction can also be found in Munch's painting. In it he closely links the artistic theme to his personal experiences, childhood memories and adult life. He often incorporates members of his family, friends and personal enemies into his compositions in a recognisable way, even including himself. Munch borrowed the figure of Nansen from the *roman à clef* by the Norwegian writer Herman Colditz, *Kjærka* (*The Church*), published in 1888, the characters of which are drawn from Kristiania's bohemian milieu. In this case it is Munch who is referred to by Colditz's Nansen, a sensitive young man who allows himself to be possessed by visual phenomena.[7] Through the intertextual use of the same name in 'The Illustrated Journal', Munch gives identity and character to his own literary figure 'Nansen'.

The relationship between fiction and reality is ambiguous. Several scenes from 'The Illustrated Journal' were later rewritten

Fig.63
Handwritten note
MM N 625
Munch-museet, Oslo

Fig.64
Elskov [Love]
Page 85 of Munch's notebook (MM T 2782), showing the marks of two paperclips where the note MM N 625 (fig.63, opposite) was attached
Munch-museet, Oslo

in loose note form and in other sketchbooks, which also have Mrs Heiberg as their subject matter. Munch worked on the words, grammatical forms and the point of view of the narrator. Sometimes, the main character was called Nansen, sometimes Brandt. In total, around forty-five texts are about the relationship between Mrs Heiberg and Nansen/Brandt. None of them can be considered a kind of 'final version' or clear rendering of these stories, but some of them show fewer corrections or crossings-out than others.[8] However, the variations are not just linked to the style, but also to small differences in the plot. The storyline, revealed in the form of conversations or moments of introspection, has no fixed definition; on the contrary, it is subject to experimentation and modifications. Evidently, although the plot may have been based on real events in Munch's life, these have been reworked in the texts.

'The Illustrated Journal' has no clear epic structure and it is marked by breaks in the plot and stylistic changes, features that bring Munch even closer to a branch of literature of the period. Such fragmentation is found, for example, in Arne Garborg, whose *Trætte Mænd* (*Tired Men*) was published in 1891. According to the author's introduction, this book is the sum of a series of notes and impressions scribbled on envelopes and scraps of scattered paper, which together make up a novel. Munch's text also recalls, in a striking fashion, the novel by Ola Hansson, *Sensitiva Amorosa* (*Sensitive Love*), another collection of fragments published in 1887. Munch and Hansson explore certain shared themes: a complicated romantic life; the fundamental isolation of the individual; destructive love; a constant yearning for the indefinable; and the disgust for life that can be felt by an individual in despair.

Transformation: Reuse and Collage of Texts

When Munch died, hundreds of disorganised notes and notebooks were discovered. The documents lay scattered about but some were mounted into collages that, in most cases, respected a certain logic in terms of content, their author probably wanting to see them merge into new narrative plots. Some of these resemble the plot of 'The Illustrated Journal'.

This collage technique is used in notebook MM T 2782 (figs.63–4). This contains some texts, and on certain pages, which are sometimes completely blank, Munch has added titles: 'Engraving', 'Childhood', 'April', 'June', 'Philosophy', 'Feelings', 'Moods', 'Memories of Youth', 'Love', 'Passion', '1915', 'Madness'. Other pages contain notes in their margins relating to very ordinary everyday things (lists and accounts for the most part), which have very little to do with the reflections contained in this notebook.[9] Despite the differences due to the context of the writing, to the arrangement of the ideas, and to the presence in these leaves of new themes ('Philosophy', 'Madness'), many similarities appear between this notebook and 'The Illustrated Journal'.[10] The unfinished project comprising all the notes in the notebook also shows features in common with 'Kunnskapens tre på godt og ondt' ('The Tree of Knowledge of Good and Evil'), a volume begun in 1934–5 and later abandoned. This is a thick folio volume into which Munch stuck drawings and engravings, embellished with texts written using different-coloured inks. On the first page of 'Kunnskapens tre' a green hill is drawn upon which animals are grazing during hay-making (fig.65), a pastoral motif firmly anchored in the imagination of Munch, who was both painter and poet.

Drawing on the Past

The relationship between memory and imagination was a very fashionable theme in Munch's immediate aesthetic surroundings. For Scandinavian readers, an important source of reflection on this subject was the influential article by the Danish art historian Julius Lange entitled 'Studiet i Marken. Skildreriet. Erindringens Kunst' ('Field Studies. Description.

Fig.65
Edvard Munch
Drawing from 'Kunnskapens tre på godt og ondt' [The Tree of Knowledge of Good and Evil]
MM T 2547, 1r
Munch-museet, Oslo

The Art of Memory', 1889), in which the author attacked artists who only work 'in the field', who stick with what is before their eyes, to the detriment of feelings and thought.[11] Artists should first delve into their personal experiences, and then create, starting from 'what was once called the imagination', but which was nothing other than, according to Lange, one of the faces of memory.

The idea that imagination was connected to memory responded to a classic perception of memory, which enjoyed considerable success with the aesthetic theories of romanticism.[12] Imagination was not perceived as an arbitrary dream-world but as something that had been learned, observed or experienced. Memory involved not just the ability to store memories, experiences, thoughts and knowledge, but also the ability to recall them (recollectio) advisedly.[13] The imagination rested therefore on everything that had been experienced, dreamed of, or learned from fiction or reality; the artist was exercising his will and reasoning over this material. Charles Baudelaire saw the imagination as 'the queen of all faculties', with its constructive qualities, its critical capacities and its gift for reviving a stale subject with new ideas and new images: 'The whole visible universe is nothing but a storehouse of images and signs, to which man's imagination will assign a place and relative value; it is a kind of pasture for the imagination to digest and transform.'[14]

On several occasions Munch asserted that his many repetitions were attempts to re-create 'the original intention' of an earlier experience. His artistic praxis consisted in multiple revisions of the same situation, motif or event. Every time he rewrote a text, however, he also changed the sense of the story; this is why each text has a different effect on the reader. In this way his repetitions can be considered as artistic retouching, the aim of which is not necessarily to return to something authentic and original. They may instead have many other purposes:

reorganisation, development, improvement, citation, distortion, self-reference, contradiction, experimentation.

The fact that repetition could provide results very different from the initial image was therefore an idea Munch reflected on. In the draft of a letter addressed to Johan H. Langaard, then secretary and librarian of the Oslo Nasjonalgalleriet, Munch protested against the 'accusations' of self-plagiarism that had been levelled at him when he offered several versions of the same canvas, as was the case with *The Sick Child*. He insisted that this approach had nothing to do with copying. When he returned to the same subject, it was always for genuine artistic reasons, to re-immerse himself in the motif and to redo 'the colours and lines, as well as the conception'.[15] In order to bolster his defence Munch relied on the great authority of the *Schöpfungslieder* by the poet Heinrich Heine. In this work Heine played on the poet's resemblance to God in his role as creator. After having created the sun, oxen, lions and men, God himself copied his creations: he created the stars, calves, cats and monkeys.

Munch made the German poet's metaphor his own. Beyond any similarities between his works (of which a detailed examination is sufficient to show the differences), the fact remains that the artist created them. Even if the ox and the calf, man and the monkey are more or less related, they are not identical. The poet and the painter proceed in this way, taking a memory that is 'projected into the future' as their starting point, through repetition.

Translated by Jacques Privat and Laura Bennett

Notes

1 Søren Kierkegaard, 'Repetition: An Essay in Experimental Psychology by Constantin Constantius' (1843), in *Repetition and Philosophical Crumbs*, trans. M.G. Piety, Oxford 2009, p.[9].

2 Ibid., p.25.

3 See Edvard Munch, 'Den illustrerte dagbok', Oslo, Munch-museet, Munch archives, MM T 2761. The text is reproduced in its entirety in Mai Britt Guleng (ed.), trans. from the Norwegian by Francesca M. Nichols, *eMunch.no. Text and Image,* exh. cat., Oslo, Munch-museet, 2011, pp.239–74.

4 See Per Thomas Andersen, 'Edvard Munch and the Literary Fragment', in Guleng 2011, pp.157–66. For Andersen, the fragment points to prose poetry and aphorism in particular, but he also views it as a formal concept in novels and stories.

5 The figure of Mrs Heiberg was, in fact, inspired by Andrea Fredrikke Emilie (Milly) Thaulow (1860–1937), who was married to Carl Thaulow, brother of Frits Thaulow and a captain in the health service of the Norwegian navy.

6 Andersen, 'Edvard Munch and the Literary Fragment', in Guleng 2011, p.166, n.7.

7 See M.B. Guleng, 'Edvard Munch and the Source of Creativity', in Jan Åke Pettersson (ed.), *Kjærlighetens strand. Edvard Munch og Åsgårdstrand,* Tønsberg/Lillehammer/ Oslo, Haugar Vestfold Kunstmuseum/ Lillehammer Kunstmuseum/ Labyrinth Press, 2010, pp.21–37.

8 These drafts are partially written in a sketchbook, and partly on loose sheets. Some of them are illustrated with drawings.

9 The sixty-five notes scattered throughout the notebook are now registered under the numbers 609–665 and MM T 2903–2908.

10 See the childhood memories MM T 2903. Maybe Munch used the notebook MM T 2782 as a synopsis for 'Kunnskapens tre på godt og ondt' ('The Tree of Knowledge of Good and Evil')?

11 See Julius Lange, 'Studiet i Marken. Skildreriet. Erindringens Kunst', *in Nordisk Tidskrift for Vetenskap, Konst og Industri,* 1889.

12 This theory of imagination was supported at the time by the aesthetic work of the leftist Hegelian Friedrich Theodor Vischer, *Aesthetik, oder Wissenschaft des Schönen, zum Gebrauche für Vorlesungen,* Reutlingen/Leipzig 1846–57.

13 On this classic perception of memory, see Henning Laugerud, 'Memory Stored and Reactivated: Some Introductory Reflections', in Arne Bugge Amundsen (ed.), *ARV: Nordic Yearbook of Folklore,* vol.66, Uppsala, The Royal Gustavus Adolphus Academy, 2010, pp.7–20.

14 Charles Baudelaire, 'Le gouvernement de l'imagination', *Salon de 1859,* in *Curiosités esthétiques,* Paris 1962, pp.328–9.

15 E. Munch, draft of a letter to Johan H. Langaard, MM N 1787, n.d., Oslo, Munch-museet, Munch archives, trans. into English in this catalogue, p.52.

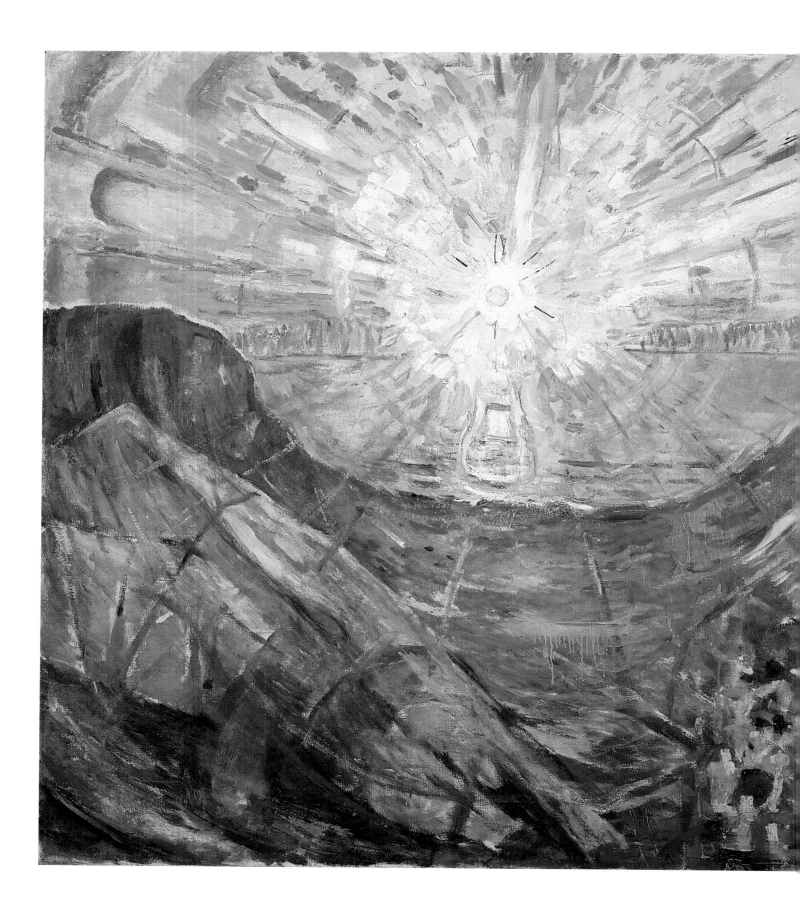

DEMATERIALISATION

Munch belonged to a generation of artists whose imagination was profoundly marked by a culture of radiation – from distant echoes of mesmerism to a belief in the curative powers of the sun, including the discovery of X-rays, radioactivity and wireless telegraphic waves. The painter himself underwent an X-ray in 1902 and was treated with electricity between 1908 and 1909. His archives contain many leaflets for treatments with rays and light therapy, and his paintings bear traces of this fascination with radiation. He uses transparency effects typical of X-rays, as if he could now see through opaque bodies. He paints the iridescence of the sun's rays against the light, and the colourful vibrations of shadows. His stroke seems to want to adjust to the undulating frequency of light. It begins to vibrate and dilute, sometimes to the point of flirting with abstraction.

76
The Sun
1910–13
Oil on canvas
162 x 205
Munch-museet, Oslo

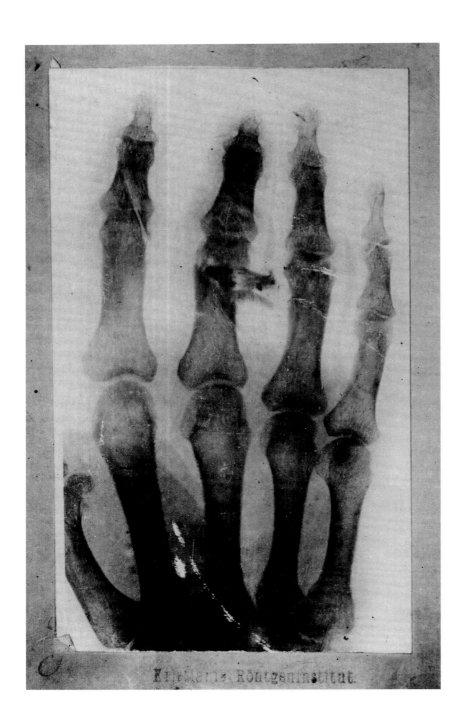

Fig.66
Kristiania Röntgeninstitut
X-ray of Munch's hand
1902
Munch-museet, Oslo

Pascal Rousseau

Radiation: Metabolising the 'new rays'

Enjoy the sun –
like plants that turn
their leaves towards the light
Edvard Munch

Filled with flickers, shadows and ghosts, Edvard Munch's painting is inhabited, if not obsessed, by the enigma of sight, his acutely sensitive eye seeing a hallucinated vision of reality. This physiology of perception tackles a series of obstacles, all of which are empirical surveys in the field of the retina, including residual image, peripheral vision, focusing and centring, distortion and blindness, even the most troublesome effects of ocular disease, illustrated by the famous series of sketches on *Distorted Vision* (1930; see nos.115–30). Munch explores his own sight in order to get up close to these organic phenomena, in a direct continuation of Goethe's *Naturphilosophie*. He not only examines the workings of the retina; he also tests out its limits as Goethe was able to do, followed also by the physiologist Jan Evangelista Purkinje, in their experimental analysis of after-images, sometimes at the risk of blindness. The eye does not just look at a light with the risk of what is visible overflowing into an excess of sensation; it is immersed in a world of vibrations, which extend far beyond the solar spectrum and reach a physical field of waves that expand further and further. In December 1895, Wilhelm Röntgen publicised his work on the mysterious X-rays, very quickly feeding an imaginary world of resonances, to the extent of creating what is referred to by Linda Dalrymple Henderson as 'Vibratory Modernism'.[1] Munch realises that the eye can perceive beyond the limited scope of its organology, while the new rays seem to be evidence of far subtler states of matter, making the boundaries between the physics of the 'infinitely small' and psychic life more permeable. All this leads him towards an aesthetic of the dematerialisation of forms into the surrounding ether, where the limits of the body blend together within the flow of thoughts equipped with a morphogenetic power, 'ideoplasty'. This (electro)magnetic understanding runs through all of Munch's work, up to his final pictures, which are inhabited by bodies of light and other crystalline auras that anticipate the bright future of the species.

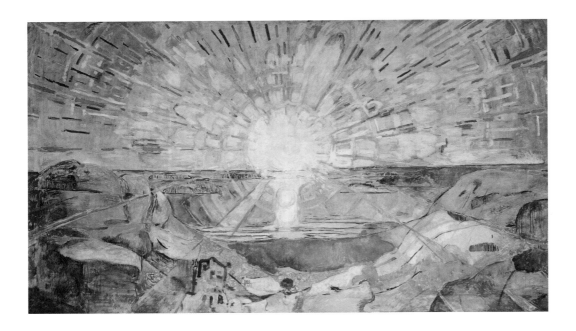

Solar Ecstasy: Edvard Munch's Dazzled Eye

Although Munch's early paintings conversely instil a romantic darkness, a search for twilight ambience and the dreams of sleepwalkers, solar landscapes begin to appear very quickly in his work (*Beach* 1889), however, thanks to contact with the legacy of impressionism. In this friction between light and dark Munch rediscovers Goethe's perception, according to which shapes only appear to us in the temporalised contrast of values. Colours are no longer the result of a simple Newtonian deconstruction of light, but of a conflicting tension between light and darkness that provides colour with an unprecedented formal power (value contrast, colour formation, appearance of shape): 'From these three elements we construct the visible world, and thus, at the same time, make painting possible, an art that has the power of producing on a flat surface a much more perfect visible world than the actual one can be.'[2] Seeing is no longer a passive function of the eye that faithfully records what is real, but a productive activity that appears over time. It passes through all the nuances of light and shade with, at the origin of this vitalist approach to perception, the principle of a 'physical' identity between the eye and the light source, the legacy of a long philosophical tradition. The eye is not only in 'affinity' with the light but in conformity with it: 'Light devotes itself to an organ that becomes its fellow, and in this way the eye is created by the light, so that the interior light comes to meet the exterior light.'[3]

The eye itself is a resting light (*Ruhendes Licht*), in a latent state, which asks only to be activated by the slightest external stimulation (ray of light or pressure of the eye). This specific activity of the eye, far from remaining a poetic metaphor of creation, is confirmed in this period by recent discoveries in opthalmoscopy, such as those carried out by a physiologist who would attract the attention of Munch, Gustav Theodor Fechner, for whom an eye that is closed or plunged into complete

darkness itself produces a 'sort of fine luminous dust'.[4] This has, as its corollary, the idea of a link that is increasingly ambivalent, or rather, arbitrary, between the sensation and the perceived impression; the straightforward link between the outside world and sensation begins to break down, leaving room for a system of equivalences that is more open to the subjective will of the observer. This was analysed by Purkinje in his *Contribution to the Knowledge of Vision in its Subjective Aspect* (1819), in which he establishes a methodical classification of the different types of 'subjective' images (stroboscopic effects, physical pressure, galvanic stimulation, distortions, dazzling, etcetera),[5] the most creative manifestation of which would be consecutive 'after-images' following prolonged staring at a light source. Purkinje poetically names these 'blind images' (*Blendungsbilder*), which can be seen very early on in certain solar landscapes by Munch. We may think in particular of the *Sunset on the Quay* 1893–4, in which the view of the port on which a faintly outlined couple is strolling is flooded by an incandescent sky that takes on a strange centripetal undulating form, studded with green dots, similar to the many residual geometric shapes of the *Blendungsbilder*.

It is not just retinal occurrences that fill these dazzling landscapes, as if to better mark the subjective imprint of these hallucinatory visions, but polychrome infiltrations of rays across the whole solar spectrum that flood the electric atmosphere of Munch's skies. This is a direct influence of the laws of optics, based on a vision that is deliberately more cosmic. By way of proof comes the monistic analysis supported by Léon Arnoult in his *Treatise on Transcendental Visual Aesthetics* (1897), in which the author insists on the 'morphological identity of daylight and of the eye'.[6] This principle of the physiological adaptation of the organ to its source is the very impulse of the feeling of well-being. According to Arnoult, who was sensitive to Fechner's arguments, this allows for the

Fig.67
The Sun
1911
Oil on canvas
455 x 780
University of Oslo, the University
Festival Hall (the Aula)

Fig.68
Image of the body's aura
From Charles Leadbeater, *L'Homme
visible et invisible*, Paris, Publications
théosophiques, 1903, p.116, pl.XXVI
Private Collection

definition of an optimisation criterion for harmonious intoxi-
cation: 'The most harmonious light-shape is the spherical
light-shape.'[7] The maximum pleasure will be obtained by the
'hemispherical' dispersal of all the colours in the spectrum
across the canvas: 'A polychromatic pigment surface, in order
to be harmonious, must theoretically be composed of a colour
variety equivalent to that which shows the totality of the rays
visible in the normal solar spectrum, in such a way that the
projection of the activities of multiple rays traces an evenly
hemispherical figure in space.'[8] This harmonious 'totality' was
at the heart of Goethe's *Theory of Colours*. For him the eye
instinctively 'delights' in being confronted by all the colours
of the spectrum because it recognises the work of Nature in its
entirety: 'The eye especially demands completeness and seeks
to eke out the colourific circle in itself.'[9]

The monumental version of *The Sun* (1911; fig.67 and see
fig.68), which has pride of place in the lecture hall of the
University of Oslo, is the most striking manifestation of this.
This huge seafront landscape is brought to life by a multitude
of coloured beams that infect the entire panorama; even the
outline of the rocks in the foreground conforms to the arc of
the circle of the sun's oculus. The many sketches reaffirm this
choice, the large preparatory version on canvas in particular
(450 × 772 cm), now kept in the Munch-museet and painted in
the studio set-up outdoors. Here, the entire space is enlivened
by concentric circles that not only show the entire range of the
colour wheel but also very obviously suggest a hemispherical
surface, as if trying to merge the motif and the organ of sight.
The idea of a functional identity between the light source and
the retina is fully played out, because, just like Goethe, Fechner
and Purkinje, Munch wants to access the mystery of the
'chemical' transformation of the impression (light) into
sensation (energy). As Shelley Wood Cordulack has been able
to show,[10] Munch consulted books on ocular physiology for

Fig.69
Ingeborg with her Hands behind her Back
1912–13
Oil on canvas
84 x 69
Munch-museet, Oslo

Fig.70
Ilustration of an 'aura'
From Albert de Rochas,
L'Extériorisation de la sensibilité,
Paris 1895
Private Collection

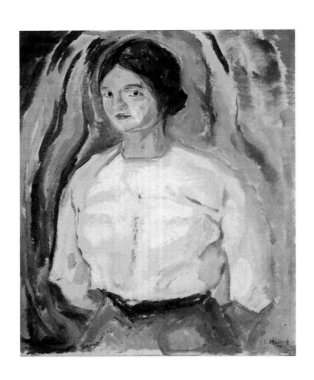

this, and was especially interested in the nerve flow in the epithelium. In particular, he found in these the establishment of an electro-chemical pattern by the retina, which, at that time, was quickly associated with photoelectric activity on the incandescent surface of the sun, the 'photosphere'. An examination of the activity of the eye reveals the transformation of light rays into nervous energy, but also an association of this 'retinal electricity' with activity on the surface of the sun, which allows us to see.[11] This is an 'organic coherence' for which Munch was deliberately searching in the footsteps of Goethean solar mythology. Light here is only an externalised manifestation of magnetic waves that animate the world on all levels, according to a vibratory and protoplasmic model, of which he found confirmation in his reading of biological monist philosophy.[12]

Cerebral Ecstasy: Astral Body and Mental Aura
We are not just setting our sights on the analogy between the eye and the sun here, but the correspondence between cosmic animation (the *Natura naturans* of romanticism) and the psychic activity of the individual. In order to do this we need merely to extend our field of vision to an extra-retinal sensitivity, attributed by occultist and fluido-magnetic traditions to 'hypersensitives', sleepwalkers and other visionaries. Theosophy reinvented the study of these at the turn of the century, when experimental psychology inclined towards stages of consciousness (from Frederic William Henry Myers's 'subliminal self' to Joseph Grasset's 'subconscious') and modified states of consciousness (from hypnosis to marijuana-induced delirium). The period looked favourably on this staging of consciousness and body, which it readily associated with a graduated scale of states of matter, and of the clairvoyance of the mind. We can better understand the invasion of dumb-founded stares and somnambulic bodies in Munch's paintings. They are intermediary bodies, body/mediums muddling the

Fig. 2. — Couches enveloppant un sujet extériorisé.
Croquis exécuté par Albert I.

great polarities (life/death, here below/afterlife, matter/spirit); 'inorganic' bodies, to use Edgar Allan Poe's term in his famous *Magnetic Revelation* (1848).[13] Munch is fascinated by this culture of duplication, in which the physical shell is only the shadow carried by another, more ethereal, entity, of which he tries, through a mediumistic paintbrush, to convey the luminous essence. Examples of the duplication of the body abound in Munch's paintings; there are as many emblems of the internalised division of the subject (from schizophrenia to jealousy, from hallucination to the dual creator) as the sensitive presence of another phenomenal reality of the being. We might think in particular of the *Splitting of Faust* (1932–5; no.86) in which Munch depicts his friend, the philosopher Eberhard Grisebach, painted as an 'investigator' according to a letter by the latter, with a translucent doppelgänger beside him, the silhouette of which oddly recalls the many shots of the 'astral body' and their auras that filled the manuals of 'transcendental photography' in this period.[14]

We know that Munch was particularly interested in *Animism and Spiritism* (1895), the book by Alexandre Aksakof, director of the 'Psychische Studien' in Leipzig, devoted to a 'critical examination of mediumistic phenomena, especially related to hypotheses of nervous energy, hallucination and the unconscious'.[15] In response to the hypothesis put forward in *Spiritism* by Professor Hartmann, who interpreted the visible manifestation of 'spirits' as a pure hallucination, Aksakof proposed an interpretation of the mediumistic phenomenon of 'materialisation' as measured by the tangible evidence of photography. Munch encountered therein many cases of 'invisible doubles', of detailed analysis of 'the expansive action of nervous energy fighting against the cohesion of particles of matter', and its corollary, the 'penetrability of matter, or rather the dematerialisation and momentary rematerialisation of an object',[16] conveying an imagination of ubiquity and of the

physical externalisation of mental activity (figs.69–70). Numerous handwritten notes left behind by the artist reveal the persistence of these beliefs of a spiritualist persuasion in the interwar years when, at the same time, his photography was playing at extending exposure times in order to record a ghostly double wandering among the pictures in his workshop. For example, among others, this undated annotation returns to the inadequacy of our natural senses when faced with different levels of reality. Munch is talking about the possibility of an invisible spirit presence around us:

> Do spirits exist? We see what we see because our eyes are built to see in this way … If our eyes were made differently – for example, equipped with X-ray vision, we would only see our skeletons – our bone structure. And if our eyes were different again, we would be capable of seeing people in a different form. Why should other beings that are physically less substantial than us not exist, surround us and move around us. The souls of the dead, the souls of our loved ones or of demonic spirits.[17]

The souls of ancestors fill the many pictures dedicated to vigils for the dead, often in the soul-like and post-mortem shape of the mask (*By the Deathbed: Fever* 1893). These forms of spectral apparitions extend broadly to what are known, among circles of psychic studies, as 'telepathic hallucinations'.[18] On first sight, the reference to the X-ray image of the skeleton also confirmed the genre of the *vanitas*, via the phantasmagorical tradition of the *danse macabre* (*Death at the Helm* 1893). This 'X-ray vision' (fig.66) however, opens out towards an imagined performative extension of the eye, a new perspective of absolute transparency. Munch is in dialogue here with what Akira Mizuta Lippit has recently called a 'semiology of avisuality', born of the historical coinciding in 1895 of the discovery of X-rays by Wilhelm Röntgen (perceiving the body's interior),

the origins of psychoanalysis with Sigmund Freud (visualising
the interior of the psyche), and the precursor to cinema with the
Lumière brothers (projecting an image into the darkness).[19]
Munch penetrates into the meanderings of the mind by lifting
the veil of the body beneath the beams of the 'new rays'. For the
unusual thing about X-ray beams is not just that they penetrate
the privacy of the body, but that they also project it. X-rays take
part in this paradigm of projection (interior/exterior) that
should be linked here to a culture of 'the externalisation of
sensitivity', which, at the same time, animates the (meta)
physical analysis of hypersensitives.[20] As part of the mechanism
of this projection, they contribute to this optical transformation
of the referent into a sign, the body-medium itself becoming a
surface for inscription (writing on a sensitive film on which the
flow of hidden energy is recorded).

Exploring the spectrum of these infravisible vibrations (it
was not until 1912, with the work of the German physicist Max
von Laue, that the electromagnetic nature of these mysterious
X-rays was discovered), Munch is quick to make 'psychographs',
projecting the active world of thoughts onto canvas. Nothing
surprising in that. After word had spread about the first
experiences with X-rays (the famous X-ray of Berthe Röntgen's
hand was created on Christmas Day 1895), there was a rush to
believe in the possibility of seeing not just the 'structure' of the
body but also the active interior of the skull, the gestation of
the forming of thoughts (from 'Thoughts-Forms' to
'Thoughtography'). From January 1896, the *Revue scientifique*
begins to talk of 'psychophotography'.[21] After X-rays, why not
consider, as Hippolyte Baraduc and Commander Darget would
in France, V-rays (V for 'vital'), capable of registering the very
forms of ideation onto the photosensitive plate?[22] A gestalt of
ideation. This would become the major theme developed by the
gurus of theosophy, most notably Annie Besant and Charles
Webster Leadbeater (fig.71) in their book on *Thought-Forms*

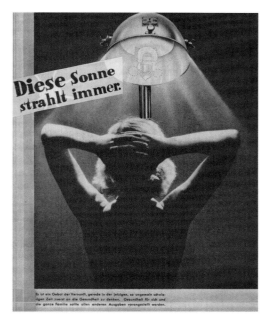

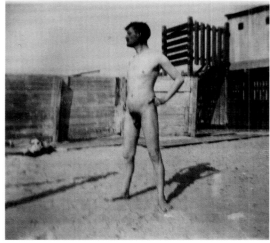

(1905),[23] with, as a frontispiece, a colour atlas established according to feelings and aspirations (yellow for the 'highest intellectuality', orange for 'jealousy', mauve for 'depression', etcetera).[24] A chromatology of desires, appetites and frustrations, with a range passing from desire to life, from life to death and vice versa. (It should be remembered that radiography closely affects this question of the reversibility of life/death, both therapeutic and lethal. Prolonged exposure to X-rays is fatal, the image that it produces in negative replaces the living body with an effigy of foretold death.)

This Orphic light, passing from hell to the sensory intoxication of life, runs through Munch's works. Sometimes funerary, it can be energising, in the naturist spirit of *Lebensreform*. We know from his archives that the artist, who liked to expose to the open air not only his canvases but also his own body (fig.73), immersed himself in many light-therapy treatments and collected, up to the 1930s, leaflets for sun chambers and other cures with artificial rays (fig.72). From *Promenade in Spring* 1917 to the final versions of *Alma Mater* 1940, Munch's landscapes are populated by translucent silhouettes that levitate in a chromo-luminous fairyland in which the artist takes care to link the body's exposure to the sun with the awakening of consciousness. In many bathing scenes, Munch plays on the dual status of the body; generous bodies, joyous thanks to the morality of their flesh, but also flooded with light, almost to the point of disappearing into the evanescence of the rays, liberated from all gravitational force. Instincts and mental ecstasy live side by side. Body and mind. In *Young Men Awakening in the Sun* 1910–11, a preparatory study for the small side panels of the University of Oslo lecture hall, we can witness this incorporated awakening of the mind, common to many painters of this period, from Fidus to Frantisek Kupka. This reflects the Dionysian (Nietzschean) idea of an illuminated mind in a healthy body (*Genies in the Sun's Rays*, 1914–16), but

also the reactivation of the fluido-magnetic traditions of a cosmic circulation of energies that Munch went in search of in Emanuel Swedenborg, and not forgetting Franz Anton Mesmer. A drawing that Munch created for the polychrome book project *The Tree of Knowledge* c.1916 evokes this cosmology in terms that clearly link magnetic polarity and ethereal vibration: 'Vibrations from the ether. Brain, heart, instincts. Earthly vibrations.'[25] This is a triad that picks up on theosophical scales. The heart, intermediary between earthly appetites and spiritual rapture, according to an analogical anatomy that includes the three states of corporeality: physical body/astral body/mental body.

Metabolisms: Crystal-Clear Vision and Desire for Immortality

What Munch shows us in the most solar of his canvases is not therefore just the instinctive pleasure of the completeness of the colours of the spectrum, but the radiant transfiguration of the body into an astral silhouette through the mere migration of thoughts into a mental space where everything is nothing more than vibrations in unison.[26] From the visible man to the ultimate body, the artist foretells the reign of clairvoyance.[27] This may have something to do with a biological desire for immortality, a possible exit from the 'cage of organs' to attain a body that has overcome the obstacle of death, a 'complete body that is nothing more than rays. In the footsteps of Edgar Poe, Munch tries to produce a radical anticipation of this angelic vision of life in the future, immersed in the ethereal sensorium of the purest thoughts, in which the body, skilled in 'magnetic revelation', would resemble a radiant brain:

A luminous body imparts vibration to the luminiferous ether. The vibrations generate similar ones to the optic nerve. The nerve conveys similar ones to the brain; the brain, also, similar ones to the unparticled matter that

Fig.74
New Rays
Study for the décor of the Festival
Hall at the University of Oslo
1912–13
Oil on canvas
229 x 111
Munch-museet, Oslo

Fig.75
Men Turning Towards the Sun
Study for the décor of the Festival
Hall at the University of Oslo
1914–16
Oil on canvas
444 x 169
Munch-museet, Oslo

permeates it. The motion of this latter is thought, of which perception is the first undulation. This is the mode by which the mind of the rudimental life communicates with the external world; and this external world is, to the rudimental life, limited, due to the idiosyncrasy of its organs. But in the ultimate, unorganised life, the external world reaches the whole body (which is of a substance having affinity to the brain, as I have said), with no other intervention than that of an infinitely rarer ether than even the luminiferous; and to this ether – in unison with it – the whole body vibrates, setting in motion the unparticled matter that permeates it.[28]

Dematerialisation in Munch's works is the tangible sign of a sublimation of the visible, in which the physiological adaptation of the new species to the revelations of the new rays is at stake.

The prism, which had provided Goethe with the optical division of the spectrum and its display of magnetic colours, becomes the philosopher's stone of this metabolic transubstantiation. This can be observed in the different preparatory versions for *New Rays* (fig.74), a work located as a lateral counterpoint to the triumphant *The Sun* at the University of Oslo. Two Adamic bodies are shot through by the new rays (radium X-rays, or rather the more unlikely 'N-rays' of Prosper-René Blondlot, which supposedly conveyed cerebral radiation, and so on). They plunge into a 'vibrating ether'[29] crossed by electromagnetic forces, proof of their 'immortality, in the sense of energy understood by Ernst Haeckel, the mentor of biological monism who Munch read attentively, as the principle of a 'conservation of substance'.[30] We would not be surprised to see this Adamic couple walking across a ground of polychrome crystals. The crystal really is the optical prism that diffracts light to flood the body-screens. It is above all the emblem of the 'high level of development' of the species to come, the crystal future of a Humanity that has passed through

death.[31] *In The Tree of Knowledge*, Munch had decided to set aside a page, now lost, for the 'Land of Crystal'. This is what we find beneath the glass roofs of the University of Oslo, resonating closely with Haeckel's transformist aesthetic, which rightly associated the power of creation of these new forms with the process of 'crystallisation'.[32] The light of *New Rays* embodies the metabolism of this glorious body ('We will not die'[33]), the body of Art itself, which sings of the absolute unity of phenomena and is solely capable of defeating and sublimating the oppressive weight of earthly passions.

Translated by Laura Bennett

Notes

1 Linda Dalrymple Henderson, 'Vibratory Modernism: Boccioni, Kupka and the Ether in Space', in Bruce Clarke, L. Dalrymple Henderson (eds.), *From Energy to Information: Representation in Science and Technology, Art and Literature*, Stanford, CA, 2002, pp.126–49.

2 J.W. von Goethe, *Traité des couleurs* (1810), trans. from the German by H. Bideau, Paris 1993, p.80.

3 J.W. von Goethe, *Goethes Werke*, vol.XIII, Hamburg 1962, p.324.

4 Fechner quoted by Marcel Foucault, *La Psychophysique*, Paris 1901, p.52. Gustav Fechner also adopts the solar analogy of the eye ('We can already consider our eye . . . like a solar creature on earth. It lives within and through the sun's rays, and therefore also has the shape of its brothers from the sun itself.') in his *Comparative Anatomy of Angels: The Little Book of Life after Death*.

5 Nicholas J. Wade, Josef Brozek, Jiri Hoskovec (eds.), *Purkinje's Vision: The Dawning of Neuroscience*, Mahwaj, NJ, 2001.

6 Léon Arnoult, *Traité d'esthétique visuelle transcendantale fondé sur la fixation des grandes lois des trois hypostases de l'objectivité visuelle, scientifiquement ramenées à une unité, à la première forme*, Paris 1897, p.129.

7 Ibid., p.212.

8 Ibid., p.216.

9 Goethe 1810, p.104.

10 Shelley Wood Cordulack, *Edvard Munch and the Physiology of Symbolism*, London 2002.

11 Gaston Planté, 'Les taches solaires et la constitution physique du soleil', *La Nature*, 153, 6 May 1876, pp.353–4.

12 On the influence of biological monism in Munch's work and thought, see the article by Robert Michael Brain, 'How Edvard Munch and August Strindberg Contracted Protoplasmania: Memory, Synesthesia and the Vibratory Organism in Fin-de-Siècle Europe',

Interdisciplinary Science Review, vol.35, March 2010, pp.7–38.

13 In *Magnetic Revelation*, a short story translated by Baudelaire, Edgar Allan Poe features a dialogue about the future of the 'ultimate' body, the body in the afterlife, which he tells us can be sensed by magnetised people and other visionaries, the only ones capable of going beyond the physiological limits of a natural vision, going beyond the surface of the 'shell' or the fleshy husk of 'rudimental' bodies: 'For when I am entranced, the senses of my rudimental life are in abeyance, and I perceive external things directly, without organs, through a medium which I shall employ in the ultimate, unorganised life . . . Organs are contrivances, by which the individual is brought into sensible relation with particular classes and forms of matter, to the exclusion of other classes and forms. The organs of man are adapted to his rudimental condition, and to that only' (Edgar Allan Poe, *Révélation magnétique* [1848], trans. from the English by Ch. Baudelaire, Bayonne 1994, p.30).

14 Anonymous, *La Photographie transcendantale. Les êtres et les radiations dans l'espace,* Paris, Librairie nationale, n.d.

15 Alexandre Aksakov (director of the 'Psychische Studien' in Leipzig), *Animisme et spiritisme: Study of a critical analysis of mediumnic phenomena, particularly in relation to theories of 'nervous force', 'hallucination', and the 'subconscious', in response to the publication by Dr Ed. von Hartmann, entitled 'Le Spiritisme'*, Paris 1895.

16 Ibid., pp.87 and 90.

17 Undated manuscript, MM T 2704, Oslo, Munch-museet.

18 E. Gurney, F. Myers and F. Podmore, *Les Hallucinations télépathiques*, Paris 1891.

19 Akira Mizuta Lippit, 'Modes of Avisuality: Psychoanalysis – X Ray – Cinema', in *Atomic Light (Shadow Optics)*, Minneapolis, MN, 2005, pp.35–59.

20 Albert de Rochas,

L'Extériorisation de la sensibilité. Étude expérimentale et historique, Paris 1899.

21 Anonymous, 'Psychophotographie', *Revue scientifique,* January 1896, p.25.

22 On the adventure of these 'thought photographs' in the harmony of fluid conceptions, see Clément Chéroux, 'La photographie des fluides. Un alphabet de rayons invisibles', and Andreas Fischer, 'La Lune au front. Remarques sur l'histoire de la photographie de la pensée', in *Le Troisième Oeil. La photographie et l'occulte,* exh. cat., Paris 2004, pp.114–25 and 139–46.

23 Annie Besant, Charles Webster Leadbeater, *Les Formes-Pensées*, Paris 1905.

24 The impressive orangey background of *Self-Portrait against Red Background* 1906 should be noted in this respect, picking up the obsessive theme of jealousy, as well as his *Self-Portrait with Hand* 1911, in which the painter depicts himself, deep in thought, surrounded by haloes of colour denoting the emotional range of his feelings.

25 E. Munch, 'The Tree of Knowledge', quoted in Poul Erik Tøjner, *Munch: In His Own Words*, Munich 2001, p.109.

26 'A thought may be generated by the consciousness, cause vibration in the mental body, then in the astral body, set up waves in the ether and then in the dense molecules of the physical brain; by these brain vibrations the physical ether is affected, and the waves pass outwards, till they reach another brain and set up vibrations in its dense and etheric parts. By that receiving brain, vibrations are caused in the astral body and then in the mental bodies attached to it, and the vibrations in the mental body draw out the answering quiver in consciousness' (A. Besant, *Le Pouvoir de la pensée. Sa maîtrise et sa culture,* Paris 1911, pp.46–7).

27 Charles Webster Leadbeater, *L'Homme visible et invisible. Exemples de différents types d'hommes tels qu'ils peuvent être*

observés par un clairvoyant exercé, Paris 1903.

28 Poe 1848, p.31.

29 'Only a few years ago the cosmic ether was to the majority of scientists an imponderable something . . . All this was changed when Heinrich Hertz (1888) demonstrated the nature of electrical energy, by his beautiful experiences establishing the conjecture of Faraday that light and heat, electricity and magnetism, are closely related phenomena of one single set of forces, and depend on transverse vibrations of the ether . . . It is the vibrating ether we see' (Ernst Haeckel, *Le Monisme. Lien entre la religion et la science. Profession de foi d'un naturaliste,* Paris 1897, pp.17–18).

30 'Immortality in a scientific sense is conservation of substance, therefore the same as conservation of energy as defined by physics . . . The cosmos as a whole is immortal . . . At our death there disappears only the individual form in which the nerve-substance was fashioned and the personal "soul" which represented the work performed by this. The complicated chemical combinations of that nervous mass pass over into other combinations by decomposition, and the kinetic energy produced by them is transformed into other forms of motion' (ibid., p.26).

31 Edvard Munch refers explicitly to this crystalline transformation of dead bodies in a letter from 1906 to Gustav Schiefler, quoted by Cordulack 2002, n.37, p.122.

32 Haeckel 1897, p.16.

33 E. Munch, 'The Tree of Knowledge', in Tøjner 2001, p.115.

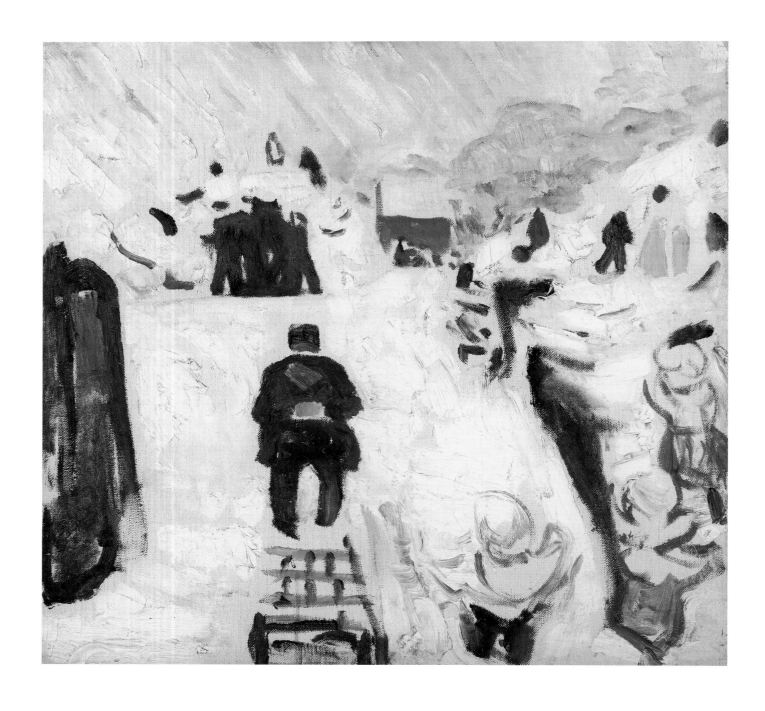

77
Man with a Sledge
1910–12
Oil on canvas
77 x 81
Munch-museet, Oslo

78
Children in the Street
1910–15
Oil on canvas
92 x 100
Munch-museet, Oslo

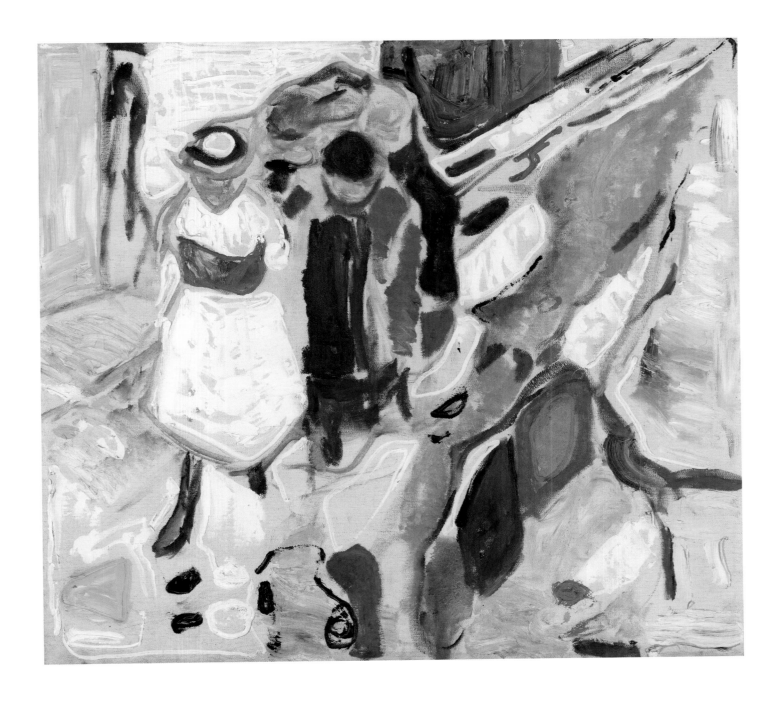

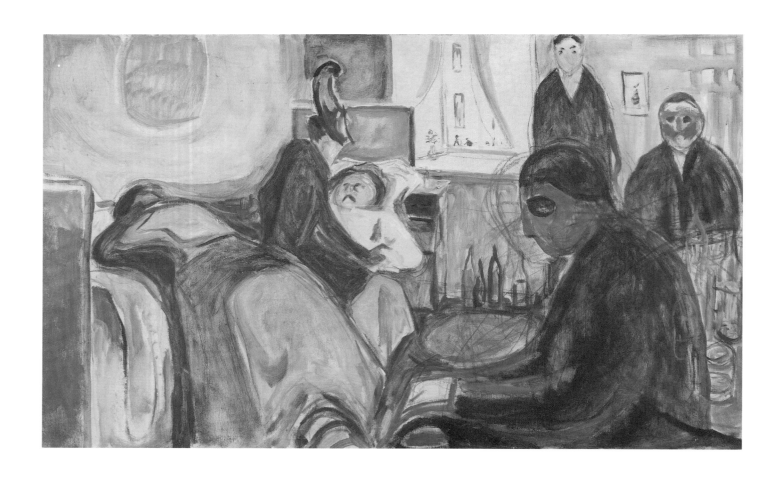

79
The Death of the Bohemian
1925–6
Oil on canvas
65 x 104
Munch-museet, Oslo

80
Women in the Bath
1917
Oil on canvas
72 x 100
Munch-museet, Oslo

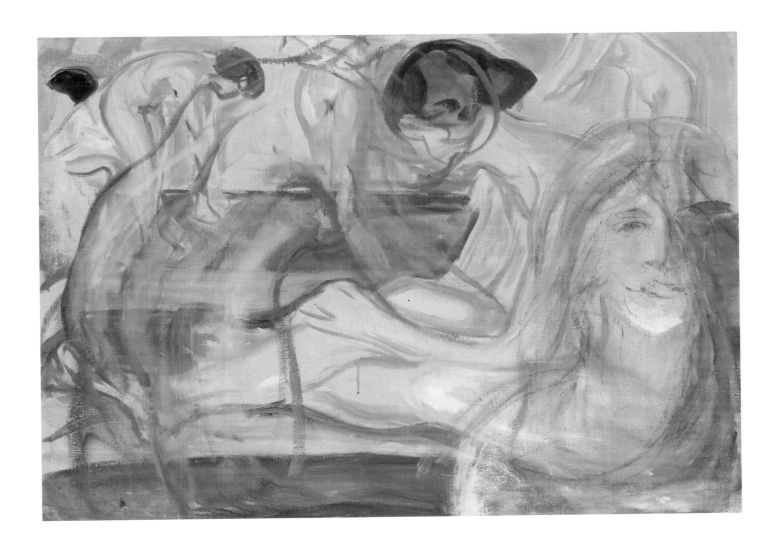

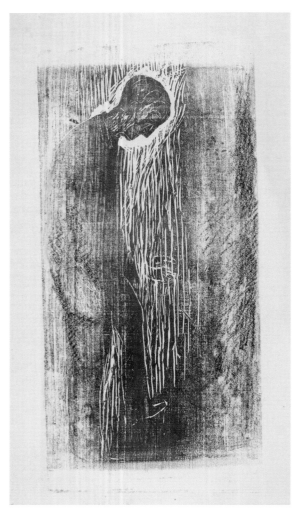

81
Kristian Schreiner, Standing
1943
Woodcut
70.1 x 34.7
Munch-museet, Oslo

82
Kiss in the Field
1943
Woodcut
40.5 x 49
Munch-museet, Oslo

83
Starry Night
1922–4
Oil on canvas
120.5 x 100
Munch-museet, Oslo

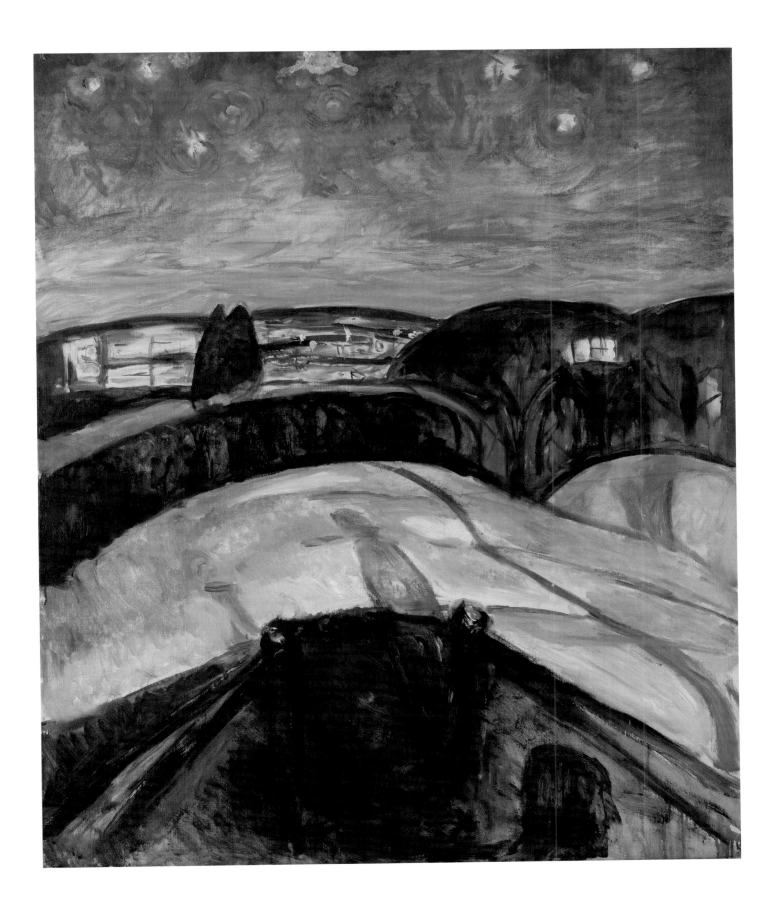

Edvard Munch
Notes

13

1927 [J̶a̶n̶ Pure style [?]
1928
A̶s̶

Everything is motion – everything is alive
in stone – in crystal – in air in
man (Already noted 20 years ago
In the earth – and the planets – and the atoms
and their planets –
– The earth – is the earth an inert
sphere – that turns around the sun –?
The earth has this beautiful
spherical shape – from which in springtime
greenery bursts forth – nourishing
humans and animals – sending
fire through its volcanoes – ?
The earth follows its orbit in quite
wide space around the sun as
Man moves across the surface
of the earth –

15

The earth is a living atom with
its own will and mind – it
breathes and its breath settles
as clouds just above it – it
breathes and storms rage
over the earth – its blood
is boiling lava –
Should not the earth have a mind
and will – turning
so proudly in space
around the sun – and does the sun not
have a will and mind sending
the immense masses of light into
space – that follows its orbit
in a multitude
of millions of celestial bodies?

17

1928 February
I reread my notes
written in the course of the previous almost
 40 years
We are in another time –
That was the age of
realism – when it was necessary to believe in
a non–God – It was in fact
a faith like any other – many
who lived and died with this
belief found
tranquillity and peace in it – because a belief
 is
a belief –
One had made discoveries
that were earth-bound and practical
Railways – Steamships –
steam power – Darwin taught
the short earth-bound truth
about individuals evolving towards
improvement – But there were also other
discoveries that pointed towards more pure

19

phenomena and to other forces –
Electricity – the telephone –
I think about the ideas
that occupied me at that time –
The planets in space and
now the atoms –

Kollman television –

Electricity was an
invisible power – which indicated its presence
 only
by its power – but it remained connected to
 the earth
– it had to pass through the wire
– Then came the wireless transmission
of electricity – waves
passing through matter – passing through

21

space –
Thought could be transmitted through space
– X–rays were discovered
– t̶h̶r̶o̶u̶g̶h̶ bodies –
The radio

> Note, MM T 2748–13–21,
> 1928
> Oslo, Munch-museet

16–4–29
The wavy line that dominates
my early paintings and prints –
corresponded to the premonitions I had
about waves in the ether
– to the feeling of contact
between bodies (The separation and
two beings – the hair became wavy lines
and the connection between lovers)
At that time wireless telegraphy
had not yet been discovered

> Note, MM T 2748–37
> 16 April 1929
> Oslo, Munch-museet

49

4–5–29
Lately I have been thinking
about the following – what
we see and feel we
see and feel because
we have the devices
sight hearing and touch that are made for this
are limited – if we had
other more sensitive – or better adapted
 organs
we would see and feel differently –
– A tree is not a
trunk with branches and roots – in reality
it has another shape –
in truth almost round – surrounded
by a ball-shaped casing – thereby
I claim on the other hand
that the earth is not really round –
but it also has a differently shaped core
(let us imagine it like this [sketch]
a core with branches

50

Likewise the shape of the earth is anything
but round – it is surrounded by the
 atmosphere
and the ether – which make up part of the
 earth
and can take the shape of a sphere [sketch]
It is the same for us –
We are surrounded by a casing
which let's say has
a round shape –
In this way we do not live
on the earth but we move around
in the earth
(Compare my drawing
from 1909 in my journal man
and his circles – and his periphery –
The periphery cuts into the waves
of the ether and of the earth)
After these reflections today I read
Plato – the soul
Recently I have
flicked through Plato for the first time – It
 was
a revelation – like Kierkegaard –
To my great surprise he writes
these surprising words about the earth (read
 today)
He says that in reality

51

we are not moving around on the earth
but we live in a cavity of the earth –
like the animals
on the sea bed. He
touches on relativity – and
thinks that air is part of the terrestrial mass
– but that it seems lighter to us because
of the senses we have.

> Note, MM T 2748–49–51
> 4 May 1929
> Oslo, Munch-museet

63

January 1̶9̶2̶3̶0̶ 1930
I read in the newspaper today

about new discoveries – or conclusions –
'matter is made up of waves in the ether'
It is some years ago now that I said
to my friends and also noted in my journal
 that everything
is in motion that even the stone is alive
I maintained that the nature of matter
(and for example its hardness) depends
on the nature of the movement (speed or
nature)

65

I have long claimed that the earth
is also a living being –
a round ball it is said –
Why do we know that it is
round or that the planets are round –
The Ancient Greeks (Plato I think) thinks
that the earth is the core of a body
– that it is surrounded by several spheres
 – the
closest being the atmosphere –
What shape do these spheres take?
We only see the round shape
of these planets with the eyes we have.
– But what about the rays?
Everything is probably round –
Human beings and what they radiate
and all of life – [sketch]

 Note, MM T 2748-63-65
 January 1930
 Oslo, Munch-museet

February 1930
On the radio today I heard
a lecture about light waves
and matter –
The lecturer emphasised that according
to the latest conclusions
matter is like light
made up of waves –
That is exactly what I wrote
in my journal 20 or 30 years ago
that everything is in motion
and that the flame of life can be found even in
 stone
It is just about different
as movements –
The lecturer maintained
that the electrons in atoms
should be considered
movements – He also mentioned
electric charges
at the same time – (everything is fire, fire is
motion)
– The nature of motion has given its form
and nature
to matter

 Note, MM T 2748-67
 February 1930
 Oslo, Munch-museet

June 1930
– It is better to paint
a good unfinished picture than a poor
finished picture –
Some people think that a picture

is finished when as many details as possible
have been put into it
– A line can be an accomplished work of art
– Whatever one paints should be done
with determination and sensitivity
– It is useless to.....add
indifferent and mediocre things to it –
A picture should not be contrived
or devoid of sensitivity –
It can be poor and contrived if
it is done with sensitivity – and with
awareness – Like in music when one uses

 Note, MM T 2748-99
 June 1930
 Oslo, Munch-museet

III

When you mention *The Frieze of Life* and
the various pictures
that are referred to as symbolic or literary
you must remember that at the same time,
 there was
a coordinated artistic tradition
– These paintings mark steps
towards the latest mural paintings and those
for the University Festivity hall –
I searched for simplification which
I have always done – There was construction
 in iron
(as now in concrete) – the Eiffel tower
 – There was
the tight curve that was later relaxed in Art
 Nouveau –
The undulating line had its origin in the
 discovery
and premonition of the existence of new
 forces in
the atmosphere – One sensed radio waves and
contact from man to man
(Separation: I symbolised communication
between separate beings)

IIII

with the help of the long undulating hair
(in The Frieze of Life) The long hair is
a type of telephone cord)
Woman's simplified clothing today
is it not the result of an attempt at simplifica-
 tion in art
of that time. And also of functionalism –
It is however a question of simplification and
 this idea
had already been presented by Van de Velde
 among others
Do you not see a resemblance between The
 Dance
of Life and the rhythm and movement of the
 dances of
the last 20 years? Alltogether in
The Frieze of Life?
Are there not points of convergence between
the movements of the groups and the
 costumes and lines
in the Frieze of Life with those of youth
 recently –
By the way – soon I have to think about
 making
a decision about The Frieze of Life and the
 other

large friezes. I know that I should not expect
 to sell
much and I am prepared to have to stop work –
I can hold on for one more year but then I
 will have to roll up all
my canvases –
I can of course take photographs and
 drawings of my projects
I have also dreamt of creating a park with
 mural decorations
out here –

Your devoted
Edvard Munch

 Note, MM T 43
 c.1935
 Oslo, Munch-museet

Translated by Luce Hinsch
and Laura Bennett

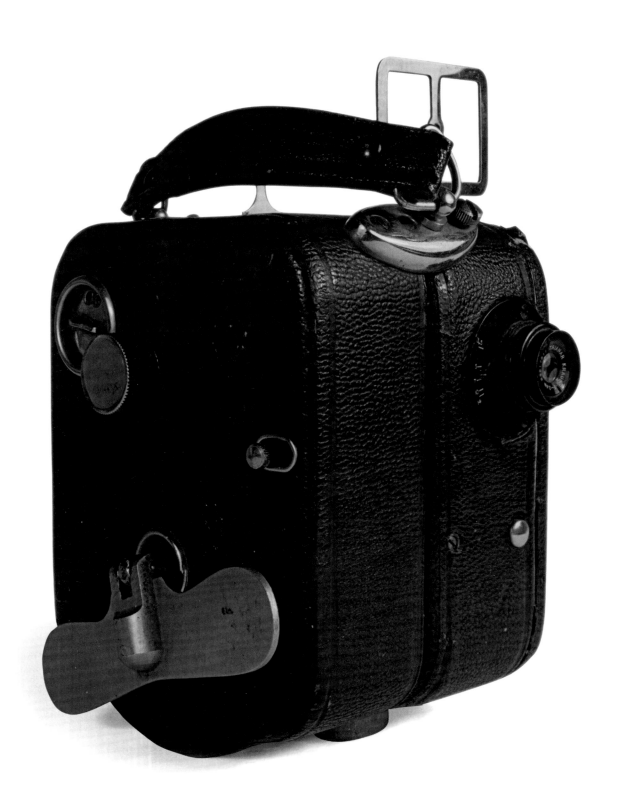

Amateur Filmmaker

Several accounts bear witness to the fact that, in the first decades of the twentieth century, Munch liked to go to the cinema regularly to watch current affairs, European and American feature films, Charlie Chaplin films, etcetera. In the 1910s his friend Halfdan Nobel Roede opened several cinemas in which some of Munch's works hung on the walls. In 1927, while visiting France, the painter purchased a small 'Pathé-Baby' amateur film camera. In the 5 minutes and 17 seconds that have survived, we can see his fascination with urban life. In both Germany and Norway, he films the movement of pedestrians and the passing of a tram or a cart. He watches a woman waiting at the corner of the street, then briefly follows her. He asks a friend to walk in front of the camera, surreptitiously captures the image of his aunt and his sister, and then puts the camera down in front of himself leaning in towards the lens, examining it intently as if he wants to see through to the other side of the looking glass.

Fig.76
Munch's Pathé-Baby camera
Munch-museet, Oslo

Fig.77
Anonymous
Paladsteateret Cinema
11 x 22.7
Oslo City Archive

Fig.78
Anonymous
Halfdan Nobel Roede
c.1927
10.8 x 7.9
Nasjonalbiblioteket, Oslo

Ingebjørg Ydstie

The Cinema-Art Galleries of Halfdan Nobel Roede

The friendship between Edvard Munch (1863–1944) and Halfdan Nobel Roede (1877–1963), composer, collector, theatre and cinema director and manager, sheds light on a new but interesting part of the artist's strategy for spreading the word about his art (fig.78). Roede exhibited works by Munch and other well-known artists in his elegant cinemas and theatres in Kristiania (now Oslo). When Roede opened his first cinema, the Kosmorama, on 8 January 1911, Munch's prints were hanging on the walls. On leaving the opening, the painter, caught up in a moment of excitement while he was returning to his home in Hvitsten, jumped off the train at Ski station and called the *Dagbladet* newspaper.[1] He wanted to compete with his friend by opening a cinema in Hvitsten, where he had just settled and purchased the Nedre Ramme property on the coast. The following day, half the press reports were devoted to this whim. Munch was intending to improve on Roede's electric piano with his brand-new gramophone, and wanted to screen the film *Da Toms bukser ble vaade* (*When Tom Wet His Trousers*) to the sound of the languid voice of Caruso. The project, of course, came to nothing, but Munch skilfully succeeded in bringing a fair amount of sensation to the undertaking, thanks to this free publicity in a national newspaper. For his part, Roede provided proof of his artistic calibre. He had employed well-known pianists, such as the Pole Ignacy Jan Paderewski (1860–1941), and the Hungarian Ernö Dohnányi (1877–1960). *King Lear*, an 'arthouse film' with 'the finest actor in Italy in the lead role', was billed, followed by *Anna Karenina*, and an assortment of extracts from films served as a 'standard cinematic dessert'. The Kosmorama was a success. In the spring of 1911, Munch noted to his cousin Ludvig Ravensberg, 'Roede is earning an enormous amount of money with his cinematograph.'[2]

Fig.79
A.F. Johansen
**Ida Roede and her portrait
by Munch, Kragerø**
1910
Munch-museet Archive, Oslo

Fig.80
A.F. Johansen
Munch painting *The Sun*, Kragerø
1911
From a newspaper in Gustav
Schiefler's correspondence
Munch-museet Archive, Oslo

Fig.81
A.F. Johansen
**Much and friends in his open-air
studio, Kragerø**
1910
From left to right: the governess Stina
Krafft, Munch's relative Ludvig
Ravensberg, Halfdan Nobel Roede,
the painter Lars Fjeld?, Ida Roede,
Edvard Munch
Munch-museet Archive, Oslo

Cinema and Art Gallery

Arthouse films were a relatively new concept that Roede, like
his competitors, used at leisure during the commercial launch of
his business. Their origins were to be found in French arthouse
films, which, from 1908 onwards, depicted the great novels and
dramas, with roles given to well-known actors. In 1904,
Kristiania had its first permanent projection hall. There, as
elsewhere, the prospect of profits made the cinema an attractive
investment opportunity and competition was fierce. It was
common to emphasise the prestige and modernity of the equip-
ment in the advertising patter. Architect-designed buildings
with elegant interiors became part of a strategy aimed at
improving the standing of cinema, presenting it as a genuine
alternative to the theatre. It was with this in mind that Roede
launched his Kosmorama as a modern and sophisticated
'Munch gallery'.

The verdict of the *Ørebladet* newspaper on Roede's innova-
tion was scathing. That the city's 'bourgeois' and 'senior
officials' ventured into 'the profound darkness' of the cinema
for laughs, 'was known to everyone'.[3] But that the city's upper
crust should attend the opening of the Kosmorama 'in broad
daylight' was new. 'The National Theatre can pack its bags! …
It will not be long before the cinema has caused it to close its
shutters.' Who would now care to read a long novel when it could
be 'wonderfully summed up in an immediate representation'?

Birth of the Friendship and Collaboration Between Roede
and Munch

The urbane Halfdan Roede came into Munch's life in the spring
of 1909, a rich art collector at a time when the painter was in a
delicate financial situation. In the late autumn of 1908, Munch
had suffered a severe nervous breakdown. His friend Emanuel
Goldstein had him admitted to Dr Daniel Jacobson's private
clinic in Copenhagen, where he immediately began working

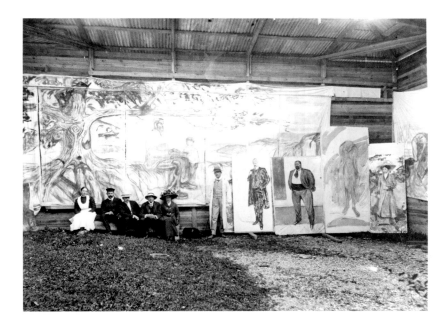

again. Given the cost of his care, however, he needed to continue to sell and exhibit all the more. Munch commandeered his friends as business agents. His cousin Ludvig Ravensberg intensified his role as personal assistant. In Norway, the brothers Halfdan Nobel and Wilhelm Roede soon joined the circle of the famous artist's supporters. Munch wrote to Ravensberg from the clinic: 'A thousand greetings from me to the wonderful knights of art, the Roedes – I am looking forward to being able to greet them one day and to seeing my works.'[4] It is difficult to determine the extent of the Roede brothers' Munch collection, as it is to establish what each of them owned, but we know that it included, among others, the masterpiece on display here, *Two Human Beings: The Lonely Ones* 1905 (no.18), and *Rue de Rivoli* 1891.

In March, Munch noted that he was starting to regain control of his 'bouts of nerves' and asked Ravensberg to look for a 'farm with a garden' for him, by the sea, where he could work and receive friends.[5] Munch wanted to return home. The choice was Kragerø, a small seaside resort on the southwest coast of Oslofjord. In the late summer of 1910, Roede asked Munch to paint the portrait of his wife Ida, and this commission marked the occasion of their first meeting (fig.79). Munch was working furiously at that time for the competition for the university lecture hall, the decorations for which would make up his principal research in the years between 1909 and 1916 (fig.80). In this photograph (fig.81), we see him in his outdoor studio, flanked by his housekeeper Stina Krafft, Ravensberg of course, and by Ida and Roede, as well as the craftsman Lars Fjeld (?). Behind them we can see, nailed to a wall of planks, a monumental sketch of *History*, the panel that had received the best reception from the lecture-hall competition jury. The portrait of Ida can be made out on the extreme right; the corpulent man is Munch's jovial friend, Christen Sandberg, who, the following year, would take on one of the main roles in

a silent film by Roede, *Under forvandlingens lov* (*Under the Law of Change*).

The pace of the days spent at Kragerø was in keeping with the Roedes's extravagant lifestyle. Ravensberg's journal gives a good overview of the guests' stay.[6] Champagne breakfasts and fine dining in a local hotel, rounding off the evening in celebratory fashion with fireworks. Ravensberg noted that 'the master' was 'in an excellent mood', but abstained from drinking, in line with Dr Jacobson's orders, toasting with alcohol-free beer. This was the same year in which Roede threw himself headlong into the film industry. He bought the Internasjonalt Filmkompagni production company, increasing the capital by 50,000 kroner.[7] Between 1911 and 1912 he produced five films and directed four. During the second decade of the twentieth century, he opened four cinemas in Kristiania.[8] In all probability it was during this visit that the idea came to him of a cinema that would also be an art gallery, with Munch as his 'sparring-partner'.

Edvard Munch never documented his first cinematic experience, but when he established contact with Roede, the cinema was already firmly rooted in his free-time pursuits. He had bought himself a motorboat at Kragerø, and his friend Jappe Nilssen provides evidence of his adventures in the fjord, visiting small neighbouring coastal towns to go to the cinema. Boy, the small Gordon Setter that ran between the legs of the guests in the summer of 1910, was also a cinema-going companion (fig.82).[9] If he barked, the eccentric Munch would get up and leave, concluding that he was not enjoying the film. August Strindberg, who had been one of the painter's closest friends in the 1890s, formulated a point of view on the culture of modern cinema in 1909 that may have been shared by Munch:

> This modern invention known as cinema was well in tune with the times, and was terrifically successful. It is democratic; all the seats are of the same quality, the same price, no tips. And for a very modest price, you can choose your own

free time during the day for a little distraction, a brief
moment for a story, or for pure entertainment.[10]

While Munch was contributing to Roede's gallery-cum-cinema,
Strindberg was opening himself up to realising his theatrical
works on-screen.

Roede as Producer and Director of Cinema

Under forvandlingens lov (*Under the Law of Metamorphosis*)
was billed as 'the first Norwegian arthouse film',[11] and is the
only production by Roede to have survived almost intact. The
film is a drama about jealousy, in which Camillo and Francesca
discover that their respective spouses are lovers. They put their
unfaithful partners to sleep and lock them in a cage until they
get tired of one another; the couples then find happiness again.
The film provides us with a glimpse into a frivolous world
marked by luxury and debauchery. The narrative is presented in
the form of a series of tableaux characteristic of the narrative
technique during the early days of cinema. While the unfaithful
spouses in the cage recover their minds, the other two go on a
spree; we then see them in a theatre somewhere abroad.
Munch's close friend, Christen Sandberg, played a major role in
the film. Munch's graphic work also found a place in Roede's
scenography. The double portrait of the couple Anna and
Walter Leistikow is given a prominent place on the living-room
wall in one scene in the film (figs.83–4).[12]

In 1914, Roede opened a new architect-designed cinema on
the city's main artery, Avenue Karl-Johan. The Paladsteateret
(Palace Theatre) had long been considered the most elegant
cinema in the capital, but, this time, the walls were decorated
with prints by Paul Gauguin (fig.77).[13] Ravensberg helped
Roede with his art purchases on several occasions, on the advice
of Munch. In 1915 the *Aftenposten* newspaper described the two
cinemas as follows: 'We have often noticed the artistic sense of

the director, Roede. The prints by Munch on the walls of the
Kosmorama and the delightful etchings by Gauguin at the
Paladsteateret have long offered the public an insight into the
aesthetic inclinations of the director.'[14] Roede had bought and
rebuilt the Dioramalokal from the naturalist painter Otto
Wilhelm Peter, who was very popular in the 1890s. He would
later repeat this strategy of moving into a well-known enter-
tainment location. The modern appeal of film became part of a
coherent continuum with the illusionistic technique of
Diorama; in addition, the room had also previously been used
as both a cinema and an exhibition space for art. Munch had
held a major exhibition there in the spring of 1910. The opening
of the Paladsteateret was as spectacular as that of the
Kosmorama, with five hundred guests, in an 'exceptionally
tasteful cinema' fitted with an 'agreeable lighting system' and a
'fine orchestra'.[15] In 1917, Roede bought two new cinemas at the
Tivoli in Kristiania, a popular place for entertainment. The
Rådhusbiografen (The Town Hall Cinema) succeeded the old
Festivitetslokale (Festivities Hall) (yet another site that had
been used by Munch for his solo exhibitions);[16] it displayed
nude studies by Munch and pictures by other artists on its
walls. The gallery-cinema also received criticism, however: 'It is
vulgar to hang works of art in cinemas,' wrote the painter Carl
Dørnberger in 1918 to Gunnar Heiberg, a former bohemian
companion of Munch who had long since become one of his
sworn enemies.[17]

The Reinhardt Frieze in Roede's Cabaret

In 1919, Roede bought the Black Cat cabaret, located in Tivoli
since 1912. After a spectacular renovation, the place was
renamed Den Røde Lykte (The Red Lantern). Remarkably, this
is where Roede set up the frieze that Munch had created for
Max Reinhardt's experimental theatre in Berlin. Munch
attended the installation in person.[18] In 1914, Roede had also

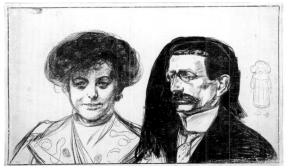

purchased the panels for La Goulue's Booth at the Foire du Trône in Paris, by Henri de Toulouse-Lautrec, which found an appropriate home in the cabaret. The panels had been painted in 1895 following a commission from Louise Weber, a dancer at the Moulin-Rouge with the stage name of La Goulue, when she was trying to establish herself on an open-air stage in the amusement park, La Foire du Trône (fig.85).[19] Other works of art were also hung in the theatre.[20] In 1923, Den Røde Lykte began to lose money and had to close.[21] Munch was relieved to know that the Reinhardt frieze had been removed from the smoky atmosphere of the cabaret.[22]

Plans for a Cinema Museum, the Cinema Law of 1913 and the Munch Museum in Tøyen in 1963

The collector Rolf Stenersen, Munch's biographer, was a close friend of both men. In the 1920s, Roede and Stenersen had two plans to create a Munch museum, based on their own collection, combined with a cinema company. At the time, Munch was discussing with Jens Thiis, director of the Nasjonalgalleriet (National Gallery), the possibility for an extension to house a Munch museum.[23] In his correspondence with Stenersen, Munch made several objections to the museum-cum-cinema project, as much because it ran counter to a project on a national scale as because the collections of his friends were not representative enough of his work.[24] Munch deplored Roede's efforts and added that 'with the museum upstairs and the cinema on the ground floor there is a greater risk of fire'. Munch was now very tired of being dragged into short-lived art-cinema projects. Neither Roede nor Thiis managed to bring their museum projects to fruition.

In 1926, Roede's company was affected by the Norwegian cinema law passed in 1913.[25] This established a national body for censorship but also introduced a municipal operating concession. When the Labour Party obtained a majority on the

straks ringet
et. En under-
noget spor for

ed for, at det
dere, som har

ar.

H. E. Ber-
tember 80 aar.
talen 12te sep-
student 1859
Efter nogen
som advokat-
ist, var han i
ged i Kristi-
ede han som
ladet« 1869—
evisor i aarene
hekbankdirek-
ret 1898 blev
i Kristiania,
fratraadte i

tifterne i Nor-
han var for-
vor han nu er
er ogsaa en af
kvindesagsfor-
gsaa i nogen

omtrent fem gange saa stor som den
gamle. Den er henved 6 meter bred

rian forueller:
— Torsdag den 11te begynder vi.

Direktør
(forhandlin;

Nordens mu
tallet (plus 20
dage sat hvera
stiania.
Skandinavisk
blev stiftet i 1
den danske di
n o v e r.
Igaaraftes bl
kel modtagels
seets restaurar
dag og torsdag
seumsmænd dro

**"Det lykkelig
paa Tro**

»Aftenposte
i Trondhjem t
Igaar gik »D
som premiere

Et av Toulouse-Lautrecs billeder, som skal pryde salen.

Fig.85
**Newspaper drawing of a painting
by Henri de Toulouse-Lautrec, in
Roede's cabaret, 'The Red Lantern'**
From *Aftenposten*, 9 September 1919
Nasjonalbiblioteket, Oslo

Oslo municipal council, Roede's operating rights were repealed. Oslo kommunale kinematografer (Oslo Municipal Cinemas) took over, their profits flowing directly into the municipal coffers. After the dissolution of the union with Sweden in 1905, Norway was, in short, a very poor country. The anti-capitalist cinema law allowed for the financing of cultural centres and sports stadiums in the country for years, and contributed to Norway's socially democratic state-welfare system. Roede sold the majority of his collection after 1926, on the art market, but he and Munch remained friends throughout their lives.[26] On his death in 1944, Munch bequeathed his estate and his entire collection to the City of Oslo. Ironically, it was revenue from Oslo's municipal cinemas that financed the construction of the Munch-museet in Tøyen, which opened in 1963.

Translated by Ingrid Junillon and Laura Bennett

Notes

1 *Dagbladet*, 9 January 1911; the article 'Kinorevy' in the *Aftenposten* of 7 October 1915 is the first definite source for dating the presence of Munch's graphic works at the Kosmorama, but it is reasonable to think that they were already in place in 1911.

2 Undated letter from Munch to Ravensberg, Oslo, Munch-museet, MM M 2883. Munch explains that he has just sold *Bathers* to the Athenaeum in Helsinki, which confirms the 1911 date; see Gerd Woll, *Edvard Munch. Samlede malerier. Catalogue raisonné*, Oslo 2008, no.766, 4 vols.; English trans., *Edvard Munch, Complete Paintings. Catalogue raisonné*, London 2009.

3 *Ørebladet*, 9 January 1911.

4 G. Woll (catalogue raisonné) identifies ten pictures as belonging to the collection of H.N. Roede, but it counted on even more. From the correspondence between Munch and Ravensberg (Oslo, Munch-museet, MM N 2882, 2939, 17 March 1909; MM N 2886, sealed on 22 October 1912), it emerges that Munch sold *Starry Night* (1900–1, Woll no.478, currently Folkwang Museum Essen) to Roede in the spring of 1909, at a better price than he had offered to the director of the Nasjonalgalleriet, Jens Thiis. See also H.N. Roede in a letter to Munch dated 30 September 1910, in which he thanks him for the sale of two paintings; in a letter to Ravensberg, dated 21 January 1912, Munch notes: 'My pictures are hanging superbly at Roede's house' (Oslo, Munch-museet, MM N 2884). The breadth of H.N. Roede's graphic collection is more difficult to establish.

5 Letter from Munch to Ravensberg, Copenhagen, 17 March 1909, Oslo, Munch-museet, MM N 2866.

6 Ravensberg's journal, 1–9 September 1909, Oslo, Munch-museet, MM LR 541.

7 On H.N. Roede and the history of the origins of Norwegian cinema, see Gunnar Iversen, 'Under forvandlingens lov – spillefilm og pioner i Norge', *Historie*, no.3, 2004; G. Iversen, 'Den første pionertiden, Norsk Filmproduksjon, 1911–1919', in G. Iversen, Ove Solum (eds.), *Nærbilder. Artikler om norsk film-historie*, Oslo 1997, pp. 11–25; G. Iversen, *Z Filmtidsskrift*, no.3, 1992.

8 Elin J. Siggerud, 'Kinoarkitektur i Kristiania, 1912–1928. Kinematografteater og stumfilmtid', MA Thesis, Oslo 2007, provides a good summary of the development of cinema in the capital.

9 Jappe Nilssen, Erna Holmboe Bang, *Aldri skal du vite. Brev fra Jappe Nilssen til en svensk vennine*, Oslo 1948, p.130; 'Boy var sjefen', *Moss Magasinet*, no.16, 2000; for a general look at Munch's relationship with his dogs, see also Magne Bruteig, 'He Is a Genuine Animal Lover! On Munch and His Dogs', in Karen E. Lerheim, Ingebjørg Ydstie (eds.), *Munch & Manning: Between the Clock and the Wall*, Oslo, Munch-museet, 2006, pp.83–105.

10 Agneta Lalander, 'Strindberg och stumfilmer', in A. Lalander and Marianne Landqvist (eds.), *Strindberg och stumfilmen*, Stockholm, Strindbergmuseet, 1995, p.2.

11 See note 7.

12 G. Woll, *Edvard Munch: The Complete Graphic Works*, London/Oslo, Munch-museet, 2001, no.196. This print in particular, with Indian ink wash, behind Leistikow's head, was inventoried at the Munch-museet in 1985 as having belonged to the collection of the art historian Harry Fett.

13 In the postcard of 22 January 1910 (Oslo, Munch-museet), Ravensberg explains that he is in Copenhagen with Roede to buy works by Paul Gauguin; Roede owned a total of two paintings by the French painter: *The Embroiderer* 1880 (Stiftung Sammlung E.G. Bührle, cat.170) was in his possession from 1914 to 1926; *Still Life with Fruit Bowl* 1880, painted after a still life by Cézanne, was bought from his son Pola

Gauguin by Roede in 1919, Christie's (www.christies.com, 15 January 2011). Pola Gauguin, who had settled in Norway, contributed to the interest in his father's art in the country. It is not known when Roede bought the graphic works by Gauguin.

14 'Kinorevy', *Aftenposten*, 7 October 1915.

15 *Dagbladet*, 29 September 1914; *Ørebladet*, 20 September 1914.

16 *Ørebladet*, 27 September 1917; in her catalogue raisonné, Gerd Woll does not identify any nudes as having belonged to Roede.

17 Bjørn Lijestad, *Carl Johannes Andreas Dørnberger. Maler og musketér*, Vestby, Vestby Kunstforening, 1989, p.22; Roede also decorated his establishments with works by Munch's former teachers, Christian Krohg and Frits Thaulow.

18 *Aftenposten*, 6 October 1934, see also *Aftenposten*, 18 October 1923; 9 September 1944; and 13 February 1976. In an undated note (draft of a letter for an unknown recipient?, Oslo, Munch-museet, MM N 403) Munch explained that the Reinhardt frieze had been hung at the Black Cat, Roede's cabaret, Den Røde Lykte (The Red Lantern).

19 *Aftenposten*, 9 September 1919. According to the article, the works by Toulouse-Lautrec and Munch were hung on red walls. I would like to thank the Musée d'Orsay for the following references: *Beaux-Arts*, 15 March 1929, and Charles Bellet, 'De la Foire au musée', *L'Archer*, April 1931.

20 *Aftenposten*, 11 September 1919.

21 Ibid., 18 October 1923.

22 See note 18.

23 Letter from Munch to Thiis, Oslo, Munch-museet, MM N 2074. Munch seemed quite sceptical about Thiis's project; see for example Munch-museet MM T 2703 and MM N 2074.

24 Letters from Munch to Stenersen, Oslo, Munch-museet, MM PN 957, MM PN 2932, MM PN 178; Rolf Stenersen, *Edvard Munch. Nærbilde av et geni*, Oslo 1946, p.140.

25 Øyvind Samuelsen, *Kinoloven av 1913. Kupp for åpen scene?* (Masters thesis, summarised in English), University of Bergen, 2009.

26 Letter from Munch to H.N. Roede, dating from 30 December 1943, in which he thanks his friend for his good wishes on his 80th birthday, Oslo, Munch-museet, MM PN 879.

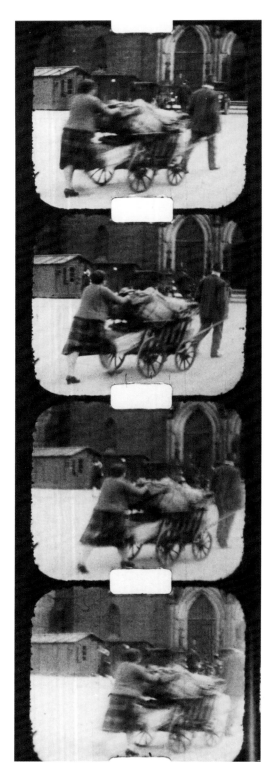
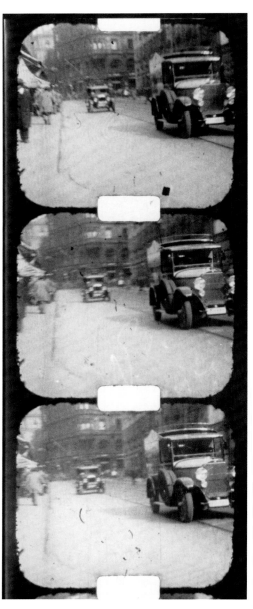

François Albera

Munch the Filmmaker, a Recalcitrant Amateur

84
Stills from a film made with a Pathé-Baby camera in Dresden, Oslo, Aker
1927
5 min 17 sec, 9.5 mm black and white silent film
Munch-museet, Oslo

85
Stills from a film made with a Pathé-Baby camera in Dresden, Oslo, Aker
1927
5 min 17 sec, 9.5 mm black and white silent film
Munch-museet, Oslo

How should the four 9.5 mm films made in 1927 by Edvard Munch with his 'Pathé-Baby' film camera be best understood? Given that so little is known about his relationship with film, it would surely be excessive to include him among the visual artists, his contemporaries, on whom film left its mark in one way or another (Georges Braque); those who were interested in it (Marcel Gromaire, Kazimir Malevich); tempted to use it (Léopold Survage); occasionally converted, even (Fernand Léger, Francis Picabia); with a certain insistence (Man Ray, Lázló Moholy-Nagy); or who went all out and adopted the medium (Hans Richter). Nowhere did Munch express a stance on cinema, 'the 7th art', in the same way as the artists, writers, architects and musicians who gathered around Ricciotto Canudo, or 'anti-art' in the manner of the dadaists; they were concerned with a potential confrontation with the new medium, a pursuit of pictorial research from the point of view of the moving image, or simply the inspiration they could draw from it. His paintings and engravings were obviously made in the era of the mechanical image, of the reproduced image, and one may encounter particular themes and motifs, particular constructive traits, in his canvases with this mass imagery. But how can a distinction be made between what may have come from photography or from film? There is evidence, in fact, of Munch's long-lasting relationship with photography; he practised it, studied it, helped his sister Inger to master it, and used it. The same is not true of film.

Of course he went to the cinema, and was linked, in the second decade of the twentieth century, with a producer, distributor and operator (Halfdan Nobel Roede[1]), but a link between Munch the viewer and Munch the practitioner of cinema remains conjectural. Moreover, with the exception of any future discoveries, this 'filmic oeuvre', we should remember, refers to these four films of a dozen or so metres and just a few minutes, filmed in Dresden, Oslo and Aker during the

189

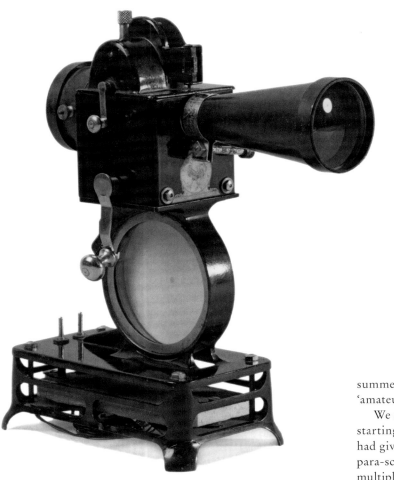

Fig.86
Munch's Pathé-Baby projector
Munch-museet, Oslo

summer of 1927, shortly after he had bought (in Paris) an 'amateur' film camera and projector (figs.76 and 86).

We should therefore take this amateur approach as our starting point. Munch became part of a movement that cinema had given rise to since its birth – so it was considered in all its para-scientific, literary and animated extrapolations, which multiplied during the second half of the nineteenth century. It then hatched out in the mid-1920s, continuing to develop and becoming an important part of film production over the course of the twentieth century. We should begin with the 'ordinary man' purchasing a 'Pathé-Baby' film camera. An amateur. That this amateur should have been an artist, also using the related medium of photography, and that he watched films made during the period and was interested in them (the 'Pathé-Baby' projector also allowed you to watch large-production films in the home on a reduced format[2]), would all have undoubtedly influenced his filmic practice, however brief it was. Therefore, the differences should be established between the recommended and widespread use of his camera and his own use, by striving to draw a distinction between hesitations, beginner's mistakes and deliberate choices. Unless these are the same thing …

The Film Camera for All

The amateur has not had much luck attracting the interest of specialist cinema 'scholars': historians, theorists, semiologists, aestheticians …[3] He has, however, given rise to extensive literature, both specialist and for the general public: *The Encyclopaedia of Images: The Cinema*, a 64-page booklet published by Librairie Hachette in 1925, devotes one of its four chapters to 'Amateur Cinema' (alongside 'Cameras', 'Making Films' and 'Applications of Cinema'). Even before the question of 'cinematic art' arose, the manufacturers of recording and screening equipment had the general public in mind, the family, in order to distribute their machines throughout society as a

whole. Watching films in your 'living room' (broadcast live, as Albert Robida had imagined, like consulting a book from your bookcase), and filming one's nearest and dearest, are the commonplaces of representations in the medium, and of its potential. Technological obstacles were continually 'overcome by science-fiction writers (in 1895 in *The Helix Island*, Jules Verne lists all the future domestic and social applications of image and sound technology), and by commentators less bound by the artistic model (Léon Moussinac, René Barjavel). These obstacles would later be resolved by miniaturisation and mass production.

So, on 17 April 1897, for its Easter edition, *Le Gaulois* (a newspaper in which Raymond Roussel published his works in serial form on Sundays) showed a drawing on its front page of a giant egg containing twelve 'surprises', which subscribers could win if they sent in the postage strip surrounding their copy within the allotted time. The 'lots' included a house that could be dismantled, a bicycle, a dining-kit, a steam tricycle, garden gymnastics apparatus, a renewable one-year pass for a variety show, a seventeen-volume Larousse dictionary and a Lumière Cinematograph.

'Everyone knows how to take photographs and can quickly learn how to operate a cinematograph', it was claimed. Nothing could be simpler. The Cinematograph had only recently begun to appear (December 1895). It was both a spectacular and scientific curiosity, its somewhat magical powers had been evoked here and there – it disrupted the accepted relationship between space and time. Cinematographs were already growing in number, however. Despite the Lumières' commercial policy of refusing to sell the device in order to control its use, it was immediately recognised as a means of recording, of memory, of communication within the reach of everyone. On the model of photography, it too was the 'democratic art', and substituted the 'photographic paradigm' with its own.[4]

It is not obvious to our modern eyes that the handling of the film camera did indeed offer the convenience of which the newspaper boasts. The device, which provided the three functions of shooting, developing and projecting, was not fitted with a viewfinder. It was activated with a handle and therefore required the use of a stand and a projective demarcation of the frame. However, despite this, and the brevity of the strips, *Le Gaulois* listed a series of subjects that could be achieved by the amateur: a comic scene, an interesting movement, a ball, a meeting, a seaside scene, a comedy scene in a castle, a mort, hunting scenes in water, the hunt's quarry, a village wedding, a train station monument, a pilgrimage, and so on. 'What is there that cannot be reproduced with a film camera? And in the evening, the developed shots will be shown on canvas, moving just like reality.'[5]

In 1907, after never-ending attempts by Gaumont-Demenÿ, comes the 'amateur "Kino" cinematograph', and, in 1912, the Pathé company, an industrial and commercial 'empire' involved in gramophones and cinema, continued this idea of 'home cinema' with the 'Pathé-Kok'. This was a dynamo projector allowing well-off members of the public to view edited films in a reduced format (28mm) on non-flammable film in their living rooms. The Kok amateur film camera was also perfected in the wake of the projector. The costs of the film and the laboratory expenses made this device difficult to afford, however. Ten years later, Charles Pathé divided up his 'empire': the gramophones and gramophone equipment on one side, Pathé Consortium Cinéma for distribution and operation; Pathé Cinéma for the production of the film itself, and the manufacture of devices for filming and projection. He did not give up selling in large numbers, however, the gramophone proving to be lucrative by nature. At Christmas 1922, he launched the 'Pathé-Baby', a device intended to project small-format films at home. This involved exploiting the stock in the production 'houses' on a

private level, once the films had been written off in the cinemas. Its success was considerable. As well as families, schools and Catholic youth groups became the major players for this medium. *L'Informateur photo* from March 1924 states that 'if we were still in the age of fairytales, we would all, young and old, have to put the Pathé-Baby into the realm of dreams'. It was understood both as an instrument of popular science and as something with which children could be trusted, it was so easy to use.

As in the case of the 'Pathé-Kok', a filming device for amateurs was quickly added to the projector, perfected by the manufacturer, Pierre-Victor Coutinsouza. *L'Informateur photo* praised this in turn; it was a film camera that could be used 'without the basics of photography, at a low cost and in a simple and practical way'. The device was small, compact, light and could be reloaded easily, and in broad daylight, thanks to its casing system. Although it only included a clear viewfinder, it was fitted with an 'extra-bright' lens, which did not need to be focused from 1.5 metres to infinity. Finally, it was cheaper than its predecessors (385 francs).

The Boom in Amateur Cinema
In the wake of the 'Pathé-Baby', there was a boom in amateur cinema. This phenomenon was favoured within the artistic field itself, allowing the protected status of the other arts to be challenged by the 'newcomer', either from the viewpoint of destroying established aesthetic values (as in the case of the avant-garde) or from a modernist perspective of rebuilding a 'new outlook'. The interest in these new processes, new media, new recipients and 'non-professional' uses combined in a way that turned the 'canons' on their head. This movement towards amateurs was also as clearly borne out in the USSR (in the Proletkult movement, then winning over the literary, photo-graphic and cinematographic avant-garde around the LEF, which advocated factualism and the 'deprofessionalisation' of

art) as in Germany, from the point of view of Bauhaus and the modernist movements, and of social movements, trade unions and parties of the extreme left. In France the cinephile review *Cinéa-Ciné pour tous* (*Cinéa-Ciné For All*) regularly devoted articles to the phenomenon, focusing on its technical and economic dimensions, but not exclusively. There was a secret hope for a shift in themes and styles prompted by amateur practitioners who did not have a string of artistic certitudes acquired from the fine arts, literature or the theatre. Pierre Henry proclaimed in 1927, that with the 'Pathé-Baby' 'the amateur photographer now has his equal in a film camera'. On the one hand, 'what has been created up to now with a Kodak and a photo album will take on a different and startling life with the moving image';[6] on the other,

> amateur filmmaking opens the door to curious future interpreters of photogeny, to future operators, to future directors, to artists who, maybe tomorrow, will provide a new impetus to this art that is still searching for its path. Is it not clear that the great filmmakers of tomorrow will not be defectors from literature, the stage or many other careers, but rather, amateur filmmakers …[7]

Munch as Filmmaker: Instructions for Use
A technician from the corporate La Cinématographie française did, however, put somewhat of a damper on the enthusiasm of the writer from Cinéa: 'Amateur cinema has provided great hope, but it seems that it is experiencing a period of slight crisis that is impeding its evolution.' In addition to the price of the film, which made it 'impossible to envisage an intense populari-sation of amateur cinema', there were technical difficulties facing the amateur, and its instructions for use were also far from expressive. 'Clever retailers believed that turning the handle in any conditions and in any way was enough,' protested A.P. Richard. 'This unfortunate mistake has only produced

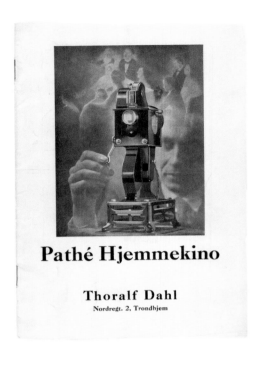

Fig.87
**Cover of the *Pathé Home-Cinema*
catalogue**
1920s
Norsk Teknisk Museum, Oslo

disappointing results. It is high time every purchaser of the device was provided with a reliable guide telling him what to do and what not to do', a handbook containing 'more than just sales pitches'.[8]

This talk of expertise overlapped and, in part, contradicted the words of the manufacturer who also had a 'technical' aim, that of the device's instructions for use, and furthermore, of its manufacturing policy and supplying accessories. So the 'dictatorship of exposure time' deplored by Richard was tackled by Pathé within the scope of mastering the camera. In addition to explanatory tables, they suggested a device, the posograph, a calculation board intended to determine the exposure time of the aperture and the speed of rotation of the handle. Information was 'entered' on one side about the weather, filming location and nature of the intended subject, while on the other side the figure recorded was then to be transferred to the ring of the lens. This device detailed all the possible situations; before the photoelectric cell it was a convenient way to calculate this parameter.

The 'sales pitch' is the promotional advertising talk ('the moving image within everyone's reach', 'making a film with the Pathé-Camera is as simple as photographing anything with the simplest modern camera'[9]) introducing a set of instructions. These set the standards, facilitating the task of the amateur operator but also encouraging conformity to a certain type of representation deriving from the pictorial and photographic tradition, to an ideal of stability and length of the image, to a measure of contrasts and distances. In this respect the expert-technician, just like the manufacturer, induced an aesthetic with the very wording of their advice and steps to follow. Would Munch, who took care to study photographic manuals some years earlier, comply with this prescriptive discourse?

The 'Pathé-Baby' film camera model that he acquired was the second from the brand, created between 1925 and 1926, and was fitted with an auxiliary mechanism for driving the film with a spring (fig.76).[10] Heavier than the handle model, on the one hand it avoided the inherent jerks and vibrations common to the former, unless it was being used with a stand, but on the other it prohibited manipulating the speed of rotation of the handle by slowing it down in the event of an immobile subject (portrait) so as to increase the exposure time. As indicated by the patent, this mechanism, in fact, 'ensured the driving of the film at a uniform speed along its entire length'.[11] This model still did not have an optical viewfinder, but a simple frame located at the front of the device with a marker in its centre, a small hole, which had to be adjusted to the one located near the operator's eye (the peephole) when focusing, after having placed the camera against the cheek 'taking care to hold it in a vertical position'.

The strictly defined shooting release came with warnings: 'From that moment do not move the device, except if it is necessary to follow the subject. Avoid any kind of very rapid movement which would give a blurred image.' And there were the recommendations: 'We recommend filming several scenes on the same film in order to avoid "excessive length", but the subjects must all have the same lighting, as the films are developed in their entirety, and lighting differences on the same film cannot be caught during development' (my emphasis). Finally, it was indicated that 'if the operator wants to appear in the film', he just needs to place the camera on a very stable stand and release the spring while positioning himself in front of the camera.

The subjects that Munch tackles appear to be in keeping with the defined 'programme' for amateurs. We even find the urban views, traffic, trams, carts and passers-by of the Lumière Cinematograph, as well as landscapes, houses, portraits of loved ones, a skit and a self-portrait. However, from the outset, he transgresses the 'technical' recommendations, adopting

a method of filming that is above all gestural, in contrast with the advocated stillness; following things that are moving or portraying panoramas of buildings and urban spaces. He grapples with the prescribed standards, not just in terms of stability, but also clarity, distance and luminosity. Each brief shot makes a sudden movement, sometimes there and back, similar to the 'shots' of a kaleidoscope, the paradoxical telescope which, far from allowing you to 'see better' as a telescope should, opens onto the imaginary, as Charles Baudelaire would say. To the reproduction of things 'as they should be', to the embalming of times past, to all these memorial, archival, entertaining or wonderful functions, was added that which finally made such analogue and familiar representations possible, the mechanism of deception (everything is based on a perceptive illusion: movement, depth, colour, scale, sound), in particular the homology of this mechanism, along with that of perception itself, and of the psyche specifically. Félix Le Dantec wrote: 'That which you call your life is a series of successive momentary lives, similar to the images of a film camera ...'[12] The film camera, with the discontinuity of its millions of shots capturing the appearance of external movement, of the 'life' of the streets, squares and trains, of smoke and waves, was understood, by psychologists and philosophers of knowledge and of the psyche, at the dawning of the twentieth century, as the model for the inner life. At least, an inner life that 'hectic' modern life had restructured in keeping with just that discontinuity, with jerks, pauses and flutterings. The screen was a reconstruction of the visible world in the guise of the psyche, of the waking dream, of recall.

Should we then attribute some of the effects that these four films have on us to the editing? Within the frame, the relationship that develops between an inscription ('Marie') and the comings and goings of a 'passer-by', pursuing her in the following image, taken from a window; or the destructive framing that reduces

Albert of Saxony to his spurs, hooves and the underbelly of his bronze horse? Editing in the planning, editing in the camera or assembly after the films had been developed; 'objective chance' in the simple rough-cut of the Nerlien laboratory in Oslo? Associations are created precisely because of these gestures that defy the representative order, when overexposure 'burns' the image or when shadow drowns it, when the overly 'quick' movement smudges it from one shot to the next.

Moreover, this plays out in the tension between Munch's likely 'clumsiness' and the energy that he puts into capturing the dynamics of the world around him, something that both underlies and surpasses all representative design. Something Malevich called the 'added element'.[13] At the very same time that Munch was learning about film, in fact, Malevich, commenting on *Man with a Movie Camera* by Dziga Vertov (1929), welcomes its importance in the fact that it is not so much about reproducing moving objects (as Walter Ruttmann was able to do in *Berlin, die Sinfonie der Großstadt*), but their dynamic power, this power that can be felt 'outside the objects themselves ...'[14]

Translated by Laura Bennett

Notes

1 See the article by Ingebjørg Ydstie, 'The Cinema-Art Galleries of Halfdan Nobel Roede', on p.181 of this catalogue.

2 The 'Pathé-Baby' catalogue soon included a large number of titles and was constantly being updated (192 in 1922 and more than 4,000 at the start of the 1930s), from *The Three Musketeers* by Henri Diamant-Berger and *The Wheel* by Abel Gance, to 'Boireau' and Chaplin comedy films, animations by O'Galop, Robert Lortac and others (*Félix the Cat*), plus many documentaries, religious films intended for youth groups in particular.

3 With the notable exception in France of Roger Odin, who devoted a 'pioneering' study to it in 1979 ('Rhétorique du film de famille', Revue d'esthétique, nos.1 and 2, 'Rhétorique, sémiotique', Paris, 10/18), then a book that he edited, *Le Film de famille, usage privé, usage public* (Paris 1995), and finally an issue of *Communications* ('Le Cinéma en amateur', no.68, 1999).

4 See François Brunet, *La Naissance de l'idée de photographie*, Paris 2000.

5 *Le Gaulois*, 17 April 1897, p.1.

6 Pierre Henry, 'Le cinéma d'amateur', *Cinéa-Ciné pour tous*, no.85, 15 May 1927, pp.26–7.

7 ibid., no.86, 1 June 1927, pp.14–15. These final comments echo those of Franz Roh: 'The Werkbund exhibition [*Film und Foto*, 1929], the most important event of recent years in the visual domain, showed almost no professional photographic productions, so often petrified into conventional mannerism. There, once again, we have proof of the fact that it is precisely the outsiders, free from any prejudice, who often create the required progress and rejuvenation in the most varied areas of life, art or science. And in this way, this new flourishing of the photographic art also belongs [... to] the neglected history of the overall productivity of amateurs' ('Mécanisme et expression', *Foto-Auge*, repr. Paris 1973, p.8).

8 A.P. Richard, 'L'opinion d'un technicien', *Cinéa-Ciné pour tous*, no.92, 1 September 1927, pp.24–5 (reproduced from La Cinématographie française).

9 Formulas used in Pathé-Baby advertising (n.d, collection of Cinémathèque française, equipment department).

10 Pathé would later put a third model of the motocamera on the market, in which the motor was integrated into the strengthened case. A single wind of the movement was sufficient for the running of an entire film, 'the device is constantly ready to work'.

11 Patent no.608.815, 'Cinematographic device perfected for filming', Pathé Cinéma Company, application dated 30 December 1925, granted on 30 April 1926 (collection of Cinémathèque française, equipment department).

12 Félix Le Dantec, *Le Conflit. Entretiens philosophiques*, Paris 1901, p.166.

13 Something that disturbs and disrupts an established norm (of perception, of representation) and provokes the creation of new forms tending towards a new norm (see Kazimir Malevich, 'Introduction à la théorie de l'élément ajouté en peinture' [1923–6], in *Écrits*, Paris 1975).

14 Ibid., 'Les lois picturales dans les problèmes du cinéma', *Kino i Kultura*, no.7/8, 1929; French translation in *Cinémathèque*, no.8, 1995.

Hugo Perls
Memories of Oslo

By March 1913 all the preparations had been made and the journey could begin. In the meantime, Munch had written a letter to us: 'Dear Mr Perls, At 10 o'clock on Tuesday morning Consul Sandberg – you know him (the man in the large portrait) – will be at the station in Moss. My horse will take your cases to Arnesen. Twenty-six hours to Christiana, one hour to Moss.' And there he was, a giant in a tiny station … Consul Sandberg and the two of us set off, and soon we were at a guest house called Arnesens Hotelett … No sooner had we arrived than Mr Munch appeared and greeted us like old friends. Would we like to come to his 'castle' after lunch, at around one o'clock? …

'Shall we get to know each other?' asked Munch, which was our dearest wish. If possible – we normally made a point, on principle, of not becoming personally acquainted with painters, in order not to lose any last remaining iota of objectivity. But this would do our principle no harm, since we already loved Munch's paintings. The 'castle' was horseshoe shaped, about four metres high, with forty windows and endless rooms all leading off one long corridor, facing the courtyard on one side and the garden on the other. By way of furniture there was a table and two chairs, a bed and a chair in the bedroom and two brass candelabras. We were already in the studio, a small two-windowed room with excellent light and the deep window niches of old buildings. 'Stop,' said Munch, as Käte paused by the window niche, fetched a chair for her, one for himself, a large canvas – and started to paint her. First the eyes, then the nose, then the mouth, then the hair and suddenly the dress. Forty-five minutes later the sketch was there. No pencil, no charcoal, no drawing – colour, colour and colour! We talked about 'form and colour', so often used as a book title in those days. Munch, the master draughtsman, said: 'Here's the colour on my palette, I take a brush and some paint, and there, almost having a face.' No form without colour, the form derives from the colour; form and colour are not opposites, but they do not complement each other, either; without colour there is no form; that was Munch's very reasonable and welcome opinion.

He talked about Berlin, he loved that city. 'They tried throwing me out.' And he told the story of his first exhibition at the Architektenhaus in Berlin in 1892, which had to be closed after only a few days because of

the 'silly general public'. He told us about the tavern Zum Schwarzen Ferkel (The Black Piglet), an old wine bar in Dorotheenstrasse, which I happened to know because I had dictated my law thesis in the house next door. He was delighted that I had seen Strindberg's *Wave*, on the wall above the sofa in one of those ancient rooms. 'I have a drink there with the great man.' Soon it grew dark and he could no longer go on painting. We agreed to meet again the next morning, at nine o'clock. But then he appeared at supper, ate some sweet cream with us and then apologised for having completely forgotten to tell us that there was a film-screening that evening in the building next to ours. 'We must see new film.' He bought four tickets, one of which was for 'lady' dog. 'If dog gets bored, she starts barking and we leave.' The dog was called Muff. 'She is lady, and if dog gets fat like a muff … so I just call her Muff from the start' …

Our nine o'clock meeting was postponed until ten … Munch painted, made 'a tour of the garden', painted again, and I took a closer look at the floor in the next room. Strewn on it were piles of Munch's most beautiful print experiments, brush proofs, the rarest mezzotints, mostly on card-like paper or thin card. 'These are some of my best things.' 'You have to seeing all my castles, we have to going to Oscarstrand, Krageroe and Hvitsten.' When I asked to see his paintings, he became serious and anxious, but he promised to show us three paintings in the afternoon. So we returned and all went together to a kind of open barn, climbed up some steps, and there, standing in neat wooden pigeon holes, in two rows, one above the other, were hundreds of paintings. I hoped the moment had come to look at one, but Munch stepped in: 'This is bookcase, I need it for my studies.' There were portraits of Holger Drachmann and Helge Rohde, of Strindberg and Ibsen, of Jacobsen and Gunnar Heiberg. There was *Madonna* and *Jealousy* and *Man in the Moon*. Unforgettable! Munch was happy when the visit to his bookcase was over. 'Tomorrow at nine.'

On the dot, as the cream was served, Mr Munch appeared, 'lady dog' again didn't bark during the Chaplin film, the piano player played his two pieces all evening, as before, which I still can't get out of my ear, the upright piano was old and out of tune, which didn't bother Muff. The petroleum lamp burnt until four in the morning, again, the mysteries of the world were not systematically solved, they just flew around in the air. Munch was so pure, innocent, unspoilt, not even an allusion to anything that might be taken the wrong way! … 'The prophet means nothing in Kristiania'; it turned out that the museum had twenty-three paintings but there were barely any of his prints in the Kabinett, the collection of prints and drawings. Munch had come up with a plan. He suggested that the next day, after the sitting, we should all go to Kristiania to the Kabinett and peruse, perfectly innocently, the three hundred sheets that he had offered to the director. 'Then you

cause confusion, say, you want to buying it, he has had them so long and never say yes. If you say, you are wanting it, he will say yes.' But the plan completely misfired. For I had seen scarcely thirty sheets, when I asked Munch, entirely seriously, to let me have them all … 'You know, now I must to write my name 300 times, that will be taking long, between two signatures must to drink cup of coffee' …

Munch was a wonderful man! The self-portraits from all the various periods of his career show his outward appearance. But in these pictures you don't see that Munch was capable of the heartiest laughter. When he was with friends he possibly didn't always have the friendliest smile on his face, but his eyes smiled when his heart wanted them to. And there was always a certain reserve and shyness about him, although that had nothing to do with his painting. Because the painter can only be an optimist, he creates a new world; if he weren't doing that he couldn't be sure that it would be beautiful …

Munch's way of expressing himself, witty and boyish, seemed to be in keeping with my picture of his spirit. His literary time appeared to be over, he was no longer painting impressions that had formed in his mind from a thousand things he had seen. But he was still preoccupied with old feelings from the 1890s. The paintings he had made earlier were a help to him in this, which was why he couldn't part with them. He wasn't painting any new ones in that style, but he did often copy the old ones. Some time around 1925, when a friend of mine fell in love with *Melancholy* from a reproduction, I asked Munch if there were any chance that my friend could have it. Munch said he would copy it. That was also how the Dresden versions of *Spring* and *The Sick Child* came about, which he first painted in 1896. One version from 1926 was not a commission from an art lover, it was just his own desire to revisit the motif and to see how it would turn out. It turned into an expressionist painting. After thirty years his way of dealing in his mind with what he had seen has changed so much that, apart from the motif, there was no resemblance with the much more impressionist result of his first concept. Munch didn't try to copy his earlier style – it wouldn't have worked. The collectors – of which there were not many – thought they had acquired an early painting. But they were wrong. They only had an early motif of Munch's on the wall. Although, now, over thirty years after the last version of *The Sick Child*, it is easier to see that than in those days. He used to date the later versions of an old motif with the year when he had worked on it. And I always use that to defend Munch against the occasional claim that he only parted with 'copies' and kept the 'originals' for himself.

By his prime, Munch already has something about him of J.J. Rousseau's 'lonely wanderer', who – like him – deliberately put as much distance as possible between himself and his own body. He didn't drink another drop, he lived the healthy life of a Norwegian

peasant, only without ploughing the fields. In the icy winter his decorative paintings for the Great Hall at the university were set up outside, with a long ladder leading up to them. He needed the light above the trees. When I saw the high, airy scaffolding, I thought of Michelangelo, painting the ceiling of the Sistine Chapel, and told him so. He replied: 'I am not lying on my back.' In four weeks, Munch said not a single thing about his body, he was spirit and soul, wit and humour. His profound sensitivity gives us a sense of his state of mind when he painted *The Scream*, *Anxiety*, *Vampire* and *Jealousy*. Until just after 1905 all those things were seen in a single head, which appeared in a landscape, with all its internal dislocation; it seems that later on we still see in the lines of the trees and rocks something of what was previously in the faces. Then Munch became a balanced, often merry, spirit, above corporeal matters, who was always serious, even if his abandoned, external gaiety was not perhaps immediately comprehensible to outsiders. In Munch's case, being in a 'good mood' did not mean that there were not also deeply human or social issues in his cheerful paintings, his cheerful hours. Often what he said about things was like the sugar-coating on a pill. He saw everything individually, he never generalised a case. He saw people and fates, not nations with good or bad qualities, with wrongful or rightful national constitutions. He could not have been further from politics …

The decorative paintings for the university could have been a serious worry. In the ante-spring of 1913 Munch did not yet know how vexing the unclear, perhaps not yet even certain, commission from the university would be. And then there were also his own artistic reservations. As soon as he started to paint, he forgot the commission or non-commission, and any misgivings were swept away by the serious joy of creation …

For half an hour we stood gazing at the paintings, as though in silent meditation. Then we went into the ugly little house, with its many nooks and crannies, which some much too 'artistic' man must have built in the 1890s. It was nothing but angles, projections, towers, gables and roofs. Even the cock and weathervane hadn't been forgotten. The previous owner had furnished the house; Munch didn't do that sort of thing. Wherever you went, you were afraid of bumping into something, Jugendstil was already casting a shadow ahead of itself. That morning, Munch had very kindly given me twenty of the most beautiful prints from the floor of the room next to the studio in Moss, as a reward for playing my part so well – too well – in Kristiania. Here in Hvitsten there was one room that Munch had cleared out to make some space. And again there were proofs of prints spread out on the floor. This time I was allowed to choose. I had to admit, in all humility, that he made the better choices. Those forty prints were to become the basis of a collection of 325 sheets, which in the end contained barely any prints from the Kabinett and certainly no editions. I was forced to sell

because of the First World War …

When Munch visited Berlin, he usually stayed at a hotel near the Stettin Station, where the trains from Scandinavia arrived. It was the Hotel Nordland, he felt at home there, in that godforsaken place, where there was nothing for Munch. 'You know, the doorman was so arrogant, had never time for me. I said to doorman, you want to earning three marks? – Yes, I do, Mr Munch; suddenly he is knowing my name. I say, come, and we go to photographer next door and are photographed on a picture postcard.' When Munch was leaving the hotel, he gave the doorman a thaler and a sealed envelope. In it was the picture postcard, on which Munch had written: 'This is what artist looking like, this is what doorman looking like.' …

The next day there was a surprise. I came in from the garden and showed Käte something in the garden from the window where she was busily 'sitting'. When I turned round, Munch cried, 'Standing still, one moment!' He returned with a canvas and before we knew it there was the beginning of the double portrait. In the absence of a third chair, we now both stood, until first the first and then the second double portrait was finished. 'You know, I am painting your wife again.' And everything started for the second time. 'We are calling your wife "Penitent Magdalena" and you together "She is travelling to Norway, he to Italy".' And then Käte's second portrait led to a third. 'Have you just a dress, and that is blue?' 'Green goes with red, have you a green dress?' Käte had a green dress and a whole array of colours, because we also had an inestimable treasure in our bags, a passport to Russia. Our intention was to visit Käte's dearest friend in St Petersburg, which seemed simple from Stockholm. But when our month in Moss was up, Käte was so exhausted and tormented by her longing to see the children that we postponed St Petersburg and Moscow for another time. That other time came very late, and not at all for Käte.

The afternoon was also a success. Munch joined us for coffee and offered to sign the sheets. There was no need for the 299 cups of coffee, that was just another of his many, good-natured teases. Still, it did take until well into the evening because there was so much to say about the making of these lithographs and etchings. It turned out that when he was working, Munch would have something in mind that would work better in one technique on paper than in another. So he wouldn't decide to do a series of zinc etchings, for instance. The technique would arise from what he had in mind. This was how he arrived at new techniques or variants on old ones, if the subject needed it. He cut large pieces of wood away and created contrasts between black and white that were hitherto quite unknown. Under the etching, *The Three Witches*, he wrote in English 'When shall we three meet again?' We were all three already thinking about our departure and about seeing each other again. After

we had eaten, the four of us – the fourth was Muff – we went to see the new film that we had almost missed. It wasn't a Chaplin film. Even so, 'lady dog' didn't bark, so the film was good, and the tireless music-maker played the same two pieces, alternately, as in the Chaplin film …

Two paintings and 340 prints went to the carriers. Munch took us to the station. 'Saying farewell is so hard, God bless you both!' In Kristiania we went to the Grand Hotel with the café where Munch had painted Ibsen. In the evening we went to a cinema, it was dark. When the lights went up, there all around us on the walls were thirty very beautiful early prints by Munch. I rushed to the cashier's desk, would they consider selling the prints? 'Oh, no!'

I left the cashier my visiting card. Five months later a letter arrived from an official receiver, I set off, and three days later returned home with a most precious burden.

Hugo Perls

Extracts from *Warum ist Kamilla schön? Von Kunst, Künstlern und Kunsthandel*, Munich 1962, pp.19–31.

Translated by Fiona Elliott

THE OUTSIDE WORLD

Posterity has left us with an image of Munch as an introspective artist: solitary, reclusive and exclusively preoccupied with depicting the torments of his angst-ridden soul. In the twentieth century, however, his painting is highly engaged with the wider world. He often paints from life, inspired by things he has seen or various news items he has read about in the newspapers. When fire ravages a neighbouring house, he rushes over to paint it. He bears witness to the execution of communists in Finland and to scenes of panic in Oslo after the declaration of war. He is interested in the social demands of the working classes. He clearly understood that the illustrated press and cinema would establish new forms of narration. In order to recount his disagreement with the painter Ludvig Karsten, he uses a distinct sequence of scenes and picks up on a principle that was widely used in the early days of cinema for obvious photogenic reasons, the contrast between a black character and a white character.

86
The Splitting of Faust
1932–5
Oil on canvas
100 X 117
Munch-museet, Oslo

Aasgaardstrand. Lindenbergs Bad

Fig.88
**Postcard from Munch
to Curt Glaser**
Munch-museet Archive, Oslo

Fig.89
Melancholy
1893
Oil on canvas
86 x 129
Munch-museet, Oslo

Munch's Postcards

How can we explain why the correspondence left behind by Munch when he died included a series of postcards that show strong similarities with some of his works? Studying this collection opens up an interesting perspective on Munch's art and the visual culture of his period.

An apparently limited field of study, such as Munch's use of postcards, brings up several interesting issues. We will develop three different approaches: firstly, the influence of Munch's landscapes on the photographic representation of these locations, through examples of postcards of Åsgårdstrand (this village perhaps being the most well-known reference in his work); followed by Munch's use of postcards as a tool and possible source of inspiration; and finally the use made by the artist of the postcard's photographs in his correspondence.

The Influence of Munch's Pictorial Motifs on Postcard Publishing

'On the other hand my pictures from Aasgaardstrand [sic] and Kragerø are good publicity for the towns', wrote Munch in one of his notes.[1] In fact, the small resort of Åsgårdstrand, on the Oslofjord, had acquired worldwide fame after the series of pictures *The Frieze of Life* had travelled to several international exhibitions. Similarly the coastal town of Kragerø became famous when Munch used the surrounding landscape for many motifs, including *The Sun* (no.76), for the decoration of the festival hall at the University of Oslo. For the art historian Ingebjørg Ydstie, 'Munch was aware that he had also given something back to the physical landscapes he depicted in his art; publicity – which was valuable.'[2] For those familiar with Munch's art, gazing at Åsgårdstrand and its landscapes would, to a great extent, be marked by Munch's motifs and experienced through his prism. Several postcards contained in the Munch-museet archives clearly show that the artist constituted an aesthetic model for travelling photographers taking pictures of

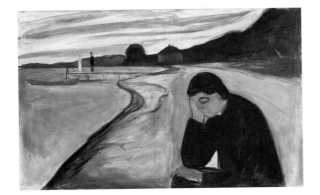

 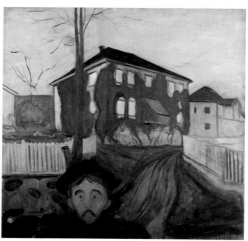

Fig.90
**Postcard from Munch
to Curt Glaser**
Munch-museet Archive, Oslo

Fig.91
Red Virginia Creeper
1898–1900
Oil on canvas
119.5 x 121
Munch-museet, Oslo

Fig.92
**Postcard from Munch
to Gustav Schiefler**
Munch-museet Archive, Oslo

Fig.93
The Girls on the Bridge
1927
Oil on canvas
100 x 90
Munch-museet, Oslo

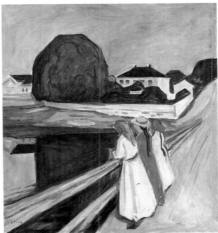

Åsgårdstrand in the 1920s.[3] Three cards in particular demonstrate tangible similarities with certain pictures by Munch. The first, sent by the artist to his sister Inger in 1926, shows a section of shoreline with a boat approaching a jetty (fig.88).[4] It is easy to see the resemblance here to a version of *Melancholy* 1893 (fig.89), although the photograph does not seem to have been taken on the same beach as the one used by Munch for his picture. The second shows the Kjøsterud residence,[5] which played a major role in many of the painter's works (fig.90).[6] One could argue that Kjøsterud was a preferred motif for photographers wanting to reproduce an image of Åsgårdstrand. However, if a comparison is made between the card and Munch's painting *Red Virginia Creeper* 1898–1900 (fig.91 and no.52), the resemblance is striking; the composition is almost identical. Finally the third shows a pier in Åsgårdstrand (fig.92),[7] in which the composition is the same as *Girls on the Bridge* (fig.93 and no.21). It is true that this does not deal with a bridge but with a pier, and that the three young girls have given way to two men, walking away with their backs to the viewer. The perspective of the pier is nonetheless similar to that used by the artist in his painting.

These postcards were issued after Munch's pictures had become world famous, and those that are dated are from the 1920s. These examples show how the artist's motifs had gradually become integrated into popular culture. A postcard of Elverum addressed by Munch to his aunt, Karen Bjølstad, also reveals the imprint that the painter had succeeded in leaving, more generally, on the collective reception of the Norwegian landscape. By comparing it with the motif of *The Voice*, developed over several versions, one can see that the photograph imitates Munch's view (figs.94–5). The dark foreground, punctuated by column-like tree trunks, and the lighter sea in the background, make up the backdrop for many of the artist's famous pictures. Although the postcard photographs were subject to the stamp of Munch's landscapes, the plays of influence could, however, also work in the opposite direction; landscape views and other photographic subjects constituted a source of inspiration for the artist.

Postcards, Sources of Inspiration for the Artist
Munch rarely cited his sources of visual inspiration, and although it is probable that he used postcards as models, he refrained from referring to the fact. However, some of his motifs display notable similarities with contemporary publications. An initial example is the picture *Avenue Karl-Johan* 1885–6, in which the similarities with particular picture cards of the period have been identified by the art historian Arne Eggum in his monograph *Munch and Photography*: 'Munch had apparently been studying the subject from the same place as had so many photographers before him. None of his contemporary naturalist colleagues made serious attempts at such a banal view of Karl Johan Street.'[8] By getting close enough to the photographers of his time to adopt the same initial perspective, Munch was clearly laying claim to his position as a modern artist, determined to tap into popular culture and its methods.

A somewhat later example is the series of posthumous portraits of the philosopher Friedrich Nietzsche (in 1906–7). Here Munch used postcards issued by the Nietzsche archives in Weimar. The resemblance between one photographic portrait of Nietzsche and a sketch in the Munch-museet is also very striking,[9] although Munch distanced himself from this composition in the final portrait, which bears the stamp more of portraits of the philosopher by other artists, than of postcards. Munch used photographs for several other portraits, even though it was exceptional at that time to have one's portrait officially issued on a card.

We also find examples of photographs serving as a source of inspiration, or as artistic material, in depictions of workers. In

Edvard Munch: Monumental Projects, 1909–1930, the art historian Gerd Woll highlights in this respect: 'Photographs at this time show laboring gangs building the railways and highways. They show an astonishing likeness to Munch's workers, posing proudly and self-consciously for the photographer, heavy pick-axes hanging from their shoulders or resting on the ground as if they were elegant walking sticks.'[10] In his article 'Edvard Munch og norsk samtid, 1909–1933' ('Edvard Munch and the Contemporary Norwegian Milieu, 1909–1933'), Frode Sæland cites a fascinating example of a photograph of this kind.[11] A postcard kept in the archives of the Munch-museet, addressed to Albert Kollmann but never sent, clearly illustrates the 'striking resemblance' pointed out by Gerd Woll. It is entitled 'Snow drift on the Bergen railway line' and shows a team clearing snow from the railway, with shovels in hand. The intense contrast of the dark silhouettes against the white snow, and the powerful and dynamic energy of the image, recall several of Munch's motifs depicting workers in the snow (figs.96–7).

In other cases, Munch sent postcards before or during the creation of a motif, similar to a photograph, although we are unable to establish how much he was fuelled by it in the course of the process. The view of the driveway in front of the Kaiserhof Hotel (fig.99), which Munch sent to his faithful cousin Ludvig Ravensberg, is very similar to the lithograph *Forest in Wiesbaden* 1921–2 (fig.98).[12] The composition is marked by the play of light and shade created by the tall trees along the path, and by the linking of the leaves that recalls a vaulted ceiling with the trunks as the columns, an effect that is stronger in the lithograph. According to the postmark, Munch sent this card on 11 May 1922, around the same time that he was creating the lithograph. We can also cite the postcard sent from Warnemünde on 17 November 1907, the view of which resembles the setting for the picture *Mason and*

Mechanic, dating from 1907–8. Many examples can be found of this kind in which Munch refers to the flood of images from popular culture.

The Use of Postcards in Munch's Correspondence

Images played an important role in Munch's correspondence. The artist illustrated his letters; created cards using his own drawings, photographs or hectographs; or drew on printed postcards, the photographs on which seemed themselves to take on an important meaning in his correspondence.

Munch sent postcards depicting locations from which he had drawn his motifs, or of which the photograph showed some kind of relationship with his own visual world, initiating thereby an early form of the art of appropriation. Nor was it rare for him also to receive a response with a significant motif. In this way, a correspondence could sometimes evolve into a dialogue of images, with a hint of humour. Munch sent these cards carrying visual quotes to his close friends, collectors and art dealers, recipients who would easily understand the allusion. One of his friends, the German judge Gustav Schiefler, occupies a special position in this respect. As well as works of art, he also collected postcards and corresponded with famous artists. It is highly probable that Munch had seen the collection and been encouraged to contribute to it.[13] The correspondence between Munch and Schiefler, which has been published, shows some amusing cases in which Munch chose a postcard for its recipient in the knowledge that he would enjoy it as a connoisseur. A view of Ekeberg, postmarked 27 August 1913, for example, shows a boy leaning against a parapet contemplating the fjord at sunset;[14] an amusing reference to *The Scream* by the artist (fig.130, p.261).

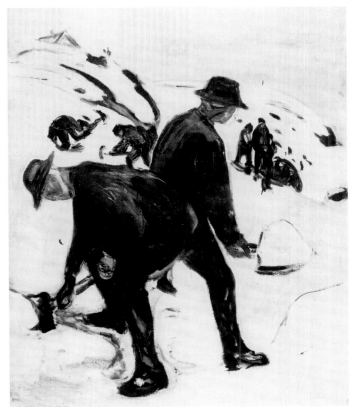

Fig.94
The Voice
1893
Crayon on paper
41.5 x 50
Munch-museet, Oslo

Fig.95
**Postcard addressed to Karen
Bjølstad, Nordstrand,
but not sent**
Munch-museet Archive, Oslo

Fig.96
**Postcard to Albert Kollmann:
'Snow drift on the Bergen
railway line'**
Munch-museet Archive, Oslo

Fig.97
Snow Shovellers
1913–14
Oil on canvas
151 x 128
Whereabouts unknown, formerly
at the Nationalgalerie, Berlin

205

Fig.98
Forest at Wiesbaden
1921–2
Lithograph
49.5 x 38
Munch-museet, Oslo

Fig.99
Postcard from Munch to Ludvig Ravensberg: photograph of the Kaiserhof Hotel at Wiesbaden
11 May 1922
Munch-museet Archive, Oslo

Signed, Edvard Munch

Recollections of Munch's pictures in the postcards of the time attest to the fact that his works had now become part of popular culture. We can see this as the first step in the process of iconisation of his subjects, something that has continued to intensify since. The extremely famous motifs by the artist have been reproduced countless times, transformed and hijacked. Andy Warhol interpreted them (fig.14, p.38), and we find resonances of them in the black and white films of Alfred Hitchcock.[15] Hollywood even drew inspiration from the figure in *The Scream* for the mask of the killer in the 1996 horror film *Scream*. Munch's use of photographs and postcards, however, reveals that although popular culture was able to feed off his painting, it could also attract his attention and provide a source of inspiration for several motifs that still stand out today as absolutely and uniquely his.

Translated by Ingrid Junillon and Laura Bennett

Notes

1 Note MM N 288, quoted by Ingebjørg Ydstie, 'Åsgårdstrand in Munch and Munch in Åsgårdstrand: Landscape as Meaning and Context', in Jan Åke Petterson (ed.), *The Shore of Love: Edvard Munch and Åsgårdstrand*, exh. cat., Tønsberg and Lillehammer 2010.

2 Ibid., p.59.

3 Carl Normann was one of the most famous postcard photographers in Norway. The Munch-museet holds several postcards from his publishing house. See among others Randi and Arne Normann, 'Carl Normann, Norges store kortpioner', in *Norsk Fotohistorisk Årbok, 1983–1984*, Oslo 1984.

4 Postcard (ed. Johan Eriksen) sent by Edvard Munch to his sister Inger Munch, 2 March 1926, Munch-museet, MM N 1116.

5 Unsent postcard, addressed to Professor Curt Glaser, Munch-museet, MM N 2240.

6 See among others the two pictures of *House with Red Virginia Creeper* (Woll nos.438 and 439).

7 Unsent postcard, Munch-museet, MM N 2241.

8 Arne Eggum, *Munch and Photography*, New Haven and London 1989, pp.28–9.

9 The use of photographs in the genesis of the portraits of Friedrich Nietzsche and his sister Elisabeth Förster-Nietzsche is dealt with in the book by Arne Eggum, ibid., pp.84–5.

10 Gerd Woll, 'From the Aula to the City Hall', in G. Woll (ed.), *Edvard Munch: Monumental Projects, 1909–1930*, exh. cat., Lillehammer Bys Malerisamling 1993, p.66.

11 Frode Sæland, 'Edvard Munch og norsk samtid, 1909–1933', in Åshild T. Halvorsen et al., *Arbeidets sjel*, exh. cat., Rjukan, Norsk Industriarbeidermuseum, 1996.

12 Postcard from Munch to Gustav Schiefler, facsimile in the Munch-museet collection.

13 Eggum 1987, p.151. For a more in-depth description of the postcard collection of Gustav Schiefler, see Gerhard Schack, *Postkarten an Gustav Schiefler*, Hamburg 1976.

14 Postcard from Munch to Gustav Schiefler, facsimile in the Munch-museet collection.

15 See for example Robert Boyle's preparatory sketches for *The Birds*, in Dominique Païni, Guy Cogeval (eds.), *Hitchcock and Art: Fatal Coincidences*, exh. cat., Montreal, Montreal Museum of Fine Arts, 2000, p.351.

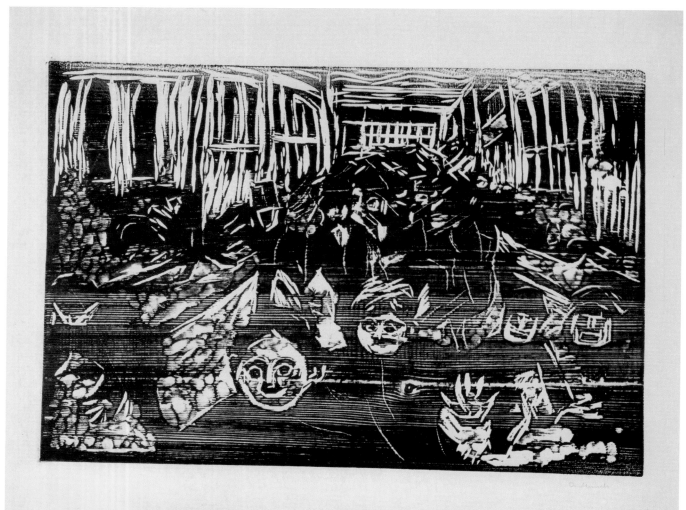

Lasse Jacobsen

History, Events and Stories

Over the course of history, most large towns in Norway have suffered terrible fires, including Oslo (Kristiania).[1] Entire areas were destroyed, usually the poor neighbourhoods and workers' districts with narrow streets and wooden buildings. In turn, in 1879, a powerful fire devastated the newly built suburb of Balkeby in Kristiania, although the housing had been intended for the families of better-off workers, and urban planners had designed wider streets precisely to prevent the spread of fire. On Friday 13 June 1879, the young Edvard Munch, fifteen years old, recounted the event in his journal, demonstrating precocious maturity and a particular fascination:

> Two fire sirens went off this evening. I ran with Andreas and Laura to Balkeløkken, where the fire had started. As almost all the houses are made of wood, the flames spread very quickly. The fire started at 4 p.m. and, less than three hours later, fifty-one houses have been reduced to ashes. Balkeløkken [Balkeby] is one of the poorest areas of Kristiania, and the victims are extremely distressed. Several people were injured and one man is missing. It is thought that his charred skeleton has been found.[2]

When, many years later, visiting Bergen in February 1916 for an exhibition, Munch was able to see the ruins of the fire that had devastated the city centre some weeks earlier, destroying 380 buildings and leaving almost 2,700 people homeless. The area must have looked like a battlefield, and it was perhaps with the war raging in Europe at the same time in his mind that Munch created two lithographs of the ruins of Bergen, and a more allegorical one entitled *Fire and Naked People*.

Fire in Grønland
Munch granted an interview to the national newspaper *Verdens Gang* in October 1919, on the occasion of his exhibition at the Blomqvist Gallery. Mention was made of the large fire that had

87
Panic in Oslo
1917
Woodcut
38 x 54.6
Munch-museet, Oslo

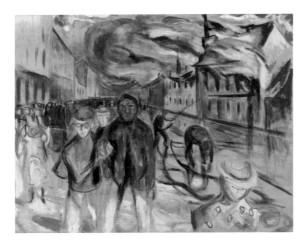

raged in Kristiania two weeks previously: 'You were in Grønland, Mr Munch. Did you draw? – Yes. Yes, when such an occasion presents itself, you can become more famous than in thirty years of painting. But the picture is not ready for the exhibition. It is still at home.'[3]

On 18 September the same newspaper had put the dramatic events of the previous day on its front page:

Eleven houses were on fire, as well as warehouses worth several million kroner. Fortunately, there were no casualties on this occasion. The fire started at around 11 in the morning at the Linnerud og Breiens joinery. The fire may have been caused by a spark from one of the electrical motors located in the basement flying off onto a neighbouring pile of sawdust and shavings; everything burst into flames instantly.

The fire spread quickly to the neighbouring building, the factory's warehouse, in which wooden boards were piled up. Driven by the strong southerly wind, the flames quickly licked through an avenue of very dry wooden houses, which were soon completely ablaze. Munch was living in his property at Ekely at the time, in the Aker district, on the outskirts of Kristiania. It was a few kilometres away from the working-class area of Grønland, located in the city centre in the area known at the time as Old Oslo. It is likely that Munch, noticing the clouds of smoke blown over the city by the wind, rushed to call a taxi in order to see the fire at first hand. The report in *Verdens Gang* reconstructs the course of events in a rather literary and vivid manner: 'The enormous, thick clouds of smoke rose up, sometimes even concealing the crowd that had assembled to witness this impressive spectacle. From time to time the sun broke through, illuminating the scene with a gaudy glow. But almost immediately the smoke and flames invaded the sky once again.' Munch took a sketchbook out of his pocket and made

some small sketches of the tragedy. Two of them are more highly worked. One shows the crowd moving forward towards the viewer, with the inferno and the smoke clouds in the background, in a composition that is reminiscent of the 1917 engraving, *Panic in Oslo* (no.87). The other reconstructs the struggle against the fire as seen by the onlookers; a composition later reworked in a lithograph and in a more successful coloured drawing. The painting mentioned in the interview is a synthesis of these two sketches (fig.100). The figures in the foreground coming towards the viewer allude, nevertheless, to a scene of the event that Munch may have seen, but which does not appear in the sketches. In the meantime, he probably followed the newspaper accounts with great interest. The *Verdens Gang* journalist continued his description of the fire:

It sparkles and crackles; the fire hoses gush and then fall back, wriggling like thick maggots in the flaming streets … Was anyone injured? A fireman, covered in soot, emerges, staggering from the smokescreen. His clothes are dripping and his face is bleeding. He has enough strength left to reach the pharmacy, however, where he is given attention before returning to the fire.

In the picture, Munch has depicted the injured fireman appearing suddenly from the sea of flames.

Among the many spectators, there were photographers and illustrators as well as journalists. Anders Beer Wilse, a famous photographer of the period and an acquaintance of Munch, was also there. He took a series of photographs that seem strangely bland and do not reflect the tragedy of the situation. We can see plenty of smoke, but very little fire, and it is noticeable that the flames were retouched during the developing process (fig.101). Several newspapers published photographs the day after the event, as well as a number of lithographed sketches, which offered an even more dramatic representation including

unusual, foreshortened perspectives, intense light contrasts, powerful flames and clouds of smoke, wind and movement.

The House is on Fire

On 31 August 1927, a sunny late-summer morning, a fire broke out at Abbediengen manor, a few hundred metres from Munch's property. The manor was one of the historic residences in the Aker district, which at the time bordered Oslo to the east and the west. Since 1916 it had belonged to the engineer and industrialist Sigurd Rønne, who lived in the main building with his family. Rønne and Munch knew each other well. According to the three surviving reports, the two fire stations close to Vestre Aker were called at 9.47 a.m. when the blaze started, while a third call was made to the central station in Oslo. The teams were on the scene within minutes. The reports differ slightly as to the course of events, but together provide a detailed description: when the firemen arrived the two floors of the main building were on fire. However, the flames were contained, bit by bit, in the south wing. Ladders were set up on three sides of the building and the fire hoses were unrolled. A petrol can exploded on the upstairs balcony, but the fire was quickly brought under control and the intervention lasted for only a few hours. The interior of the house was completely destroyed.

The *Aftenposten* newspaper provided a full account of the events in its evening edition, illustrated with a photograph. The journalist, who had interviewed the servants, attributed the fire to a short-circuit: 'While the maids were cleaning in the smoking room, using an electric vacuum cleaner, an explosion could be heard and one of the curtains suddenly was ablaze. The carpets also caught fire, and the whole room was immediately filled with smoke. The fire spread quickly throughout the house, and was fuelled by an abundance of wood.' Munch, in his sixties, could well have been one of the first neighbours to

rush over, after having seen the smoke or heard the shouts and the sirens. A relative of Rønne later confirmed that he had helped. The national *Dagbladet* newspaper recounted the following day that 'the inhabitants were able, with the help of neighbours, to rescue various things … In the beautiful autumn day, a crowd of spectators had gathered, mainly women, children and adolescents, to watch this terrible and fascinating spectacle, and to occasionally lend a hand to the work.'

In his memoirs of Munch, Rolf Stenersen recounts that 'a summer day, when a fire raged near Munch's home, he came running with his canvas and paint box and took up position so close to the spot that the fireman had to ask him to move. "Can't you see I'm working?" Munch complained. "And couldn't you possibly wait a minute or two with that hose over there? You don't want me to paint only smoke, do you?"'[4] This juicy anecdote, typical of Stenersen, is unlikely to reflect what really happened. No other sketch or drawing is to be found elsewhere. Munch must have partially relied on his visual memory, and a closer look at the photograph of the fire published that evening in *Aftenposten* (fig.102) shows features in common with the picture (no.89). The shapes of the clouds of smoke are identical, as is the ladder to the left of the entrance and the play of shadows on the porch. An examination of the spectators seen from the back in the photograph suggests that Munch used several of these figures in his pictures, such as the woman in the cloche hat in the right foreground, or the figure in the left-hand corner, who is reproduced in exactly the same position and with the same framing. We also find the young man with his hands in his pockets, slightly further to the left in the photograph. Munch probably went to the site the day after the fire to paint the house and gardens on the broad canvas from further back, and accentuated the perspective. He added the scene of the maids fleeing in horror from the house after having inadvertently caused the blaze.

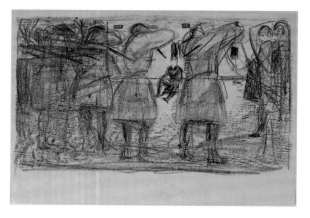
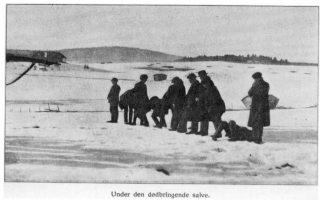

Under den dødbringende salve.

Abbediengen was rebuilt after the fire by the famous architect Arnstein Arneberg, who had designed Munch's first studio in Ekely in 1919. The painter supposedly later offered to sell the painting to Rønne, claiming that 'never did the place look more picturesque!', but the engineer apparently declined the offer.

Panic in Oslo

When the First World War was declared, Edvard Munch was living in the Grimsrød manor house in Moss, about fifty kilometres south of Kristiania. His friend, the journalist Christian Gierløff, says of Munch in his memoirs: 'Every day, before breakfast, he would stroll to the station at Moss, buy an assortment of newspapers and magazines and stuff them in his overcoat pockets.'[5] There is little doubt that Munch would have been worried by the news of the war in Europe. Most newspapers and many weekly magazines in particular published photographs from the front, as well as drawings and illustrations relaying the military action in a more detailed and dramatic way. When Munch went to Kristiania in November 1914 to see some art exhibitions, he took the opportunity to go to the cinema to see reports about the war. The mental and emotional effect that the news of the conflict had on him can be felt in a letter sent several months after the declaration of war, from the idyllic town of Hvitsten by the Kristiania fjord: 'Here there is only sea, forest and pure air. It is good not to read anything about the war for a few hours.'[6]

During those years of conflict he created a series of graphic works linked to the war. In a letter to Gustav Schiefler dating from October 1922, he gave a clue as to one of the motifs: 'I made *Panic in Oslo* after some unrest in a Christiania street.'[7] In this wood engraving (no.87), a crowd of figures with anxious and grimacing faces move towards the viewer, surrounded by modern buildings in the background and along both sides of the street. The image dates from 1917 but a similar motif can be found in an engraving from 1915 entitled *Panic*. A group of people, smaller this time, moves along a country road in rural surroundings.

It is likely that the motif's source can be found in the disturbances shaking the capital and other towns across the country after the declaration of war. A newspaper records on 3 August, 'Black Monday' as it would soon come to be known: 'The war has filled the city with terror, has gripped it with horror and has taken people's reason. Yesterday, Kristiania witnessed a wave of panic; people became obsessed by the war and its potential repercussions on everyday life. It was a rainy and hopeless grey autumn day, and there were only damp streets and exhausted faces to be seen. People imagined that there would soon be shortages in the city, and all the grocers were under siege by those creating stockpiles.' Similar stories were reported in other Norwegian towns, night-time break-ins and the storming of shops, so much so that the army had to intervene in several locations to restore calm. Similarly, several banks in Kristiania saw long, restless queues of customers who had come to withdraw their savings or to change their notes into gold. The context of the scene has a dual meaning, however. Munch deliberately related the motif, perhaps in order to make it more universal, in the background of Henrik Ibsen's historical drama, *The Pretenders*, which he was illustrating at the time in the same expressionist vein. The play's plot takes place in the thirteenth century, against a backdrop of civil war: in Act IV, the population of medieval Oslo is forced to flee before the onslaught of the enemy army.

Execution

Munch wrote on one print of the lithograph *Execution* (fig.105) from 1929, the words 'Execution of communists in Finland',[8] thus directly linking the subject matter to the events of the

bloody Finnish civil war in 1918. Following a political crisis, punctuated by strikes, unrest and terrorist attacks, the conflict had arisen between the civilian government that had fled Helsinki and the radical Socialists who had led the revolution and established an independent government in the capital. The government in exile quickly recruited a large army among peasants and young bourgeois intellectuals, called the 'hunters' or the 'whites'. The Socialists raised their own troops among the red guards and the Russian revolutionary forces, the 'reds'. The 'whites' quickly went on the attack and succeeded in taking the capital after four months. Eight thousand 'red' soldiers were executed after more or less cursory trials, and ten thousand of them were killed in prison camps. News of the war in Finland and its sinister mass executions marked public opinion in Norway, all the more so because it was a neighbouring country. The motif of execution must have seemed both tempting to Munch, as well as challenging due to its recollections of well-known pictures by Goya and Manet. In an exhibition catalogue from 1918, Munch made a small sketch depicting an execution. The firing squad, with backs turned, occupies the foreground, while the victim sits down, against the wall in the background. The same motif appears in a larger charcoal drawing (fig.103).

Munch also returns to the motif more than ten years later, perhaps after having leafed through old magazines and illustrated books of the war years. One day in the autumn of 1918 he bought a book, two copies to be exact, which included a large collection of photographs of the Finnish civil war. The book had been published in the summer of 1918 and sold for the benefit of 'disabled veterans, widows and orphans' of the 'white' army from the West. It includes the photograph of an execution that appears summary; the victims are lined up on a snowy field, and only the barrel of one of the firing squad's rifles can be seen (fig.104).

The photograph was taken just a few seconds after the shooting. When looking at the line of victims, it appears that Munch picked out certain figures and used them in the same poses in his lithograph, such as the man standing stiff with fear, with his hands on his head; the figure lying to the side, with his knees in the air; and the figure slightly further down the line, seen from the back (fig.105). Photographs and drawings of this kind could be found in several weekly magazines. The photograph of an execution in Serbia, published in the English magazine *The Graphic* in November 1914, recalls Munch's engraving, as much due to the composition and diagonal framing as to the building with two rectangular windows. The final composition of the lithograph is very different to that of the 1918 drawings and is closer to a photograph or a journalistic drawing. The head and the arm of the soldier holding the weapon, as well as the hand drawing the sword in the foreground, gives the viewer a feeling of being both a witness to the cruelty and a member of the firing squad.

The Murderer
The pictures *The Murderer* from 1910 (fig.106) and *Murder on the Road* from 1919 (no.46) cannot actually be linked to a specific event or crime. In the 1910s, 1920s and 1930s, newspapers regularly recorded events that had taken place, not just in the capital but also in other towns in Norway and in the countryside, such as murders sparked by passion or emotions, heinous crimes, or what were discreetly known as 'family tragedies'.

There is, however, an old story about a murderer that may shed new light on this unusual motif in Munch's work. One day, in the early 1930s, Munch visited the town of his birth, Løten, about one hundred kilometres north of Oslo, to see the place of execution of the murderer Kristoffer Nilsen Svartbækken (1804–1876). The artist wanted to get a feel for the gloomy

Fig.106
The Murderer
1910
Oil on canvas
94.4 x 154.4
Munch-museet, Oslo

Fig.107
Newspaper sketch of Munch's
Murder on the Road 1919
Morgenposten, 3 October 1919
Munch-museet, Oslo

forest and the sinister atmosphere of the place. It is likely that he had been interested in Svartbækken since his youth. The murderer has retained his place in Norwegian criminal history as the last victim of capital punishment carried out during peacetime. It was customary that the execution be carried out at the scene of the crime, and the scaffold was set up in a field on the outskirts of Løten in February 1876. Svartbækken was a well-known bandit at the time; he had spent several years in prison for crimes of gain and mail robbery. His robberies and violence were notorious, and many believed he had several murders on his conscience. One cold winter's night in March 1875, he assaulted a nineteen-year-old boy who was returning home by sleigh along the Løten road. Svartbækken had spoken to him at an inn earlier in the evening, and had then planned the murder. The boy was killed by blows from an axe and the murderer took everything of value, even his clothes. He was identified by witnesses from the inn and a search party was sent out for him. When he was arrested, the boy's purse and clothes were found among Svartbækken's possessions and he was convicted of robbery and murder. The execution, by beheading, took place on 25 February 1876. Almost three thousand people came to attend the macabre event. Munch was thirteen years old at the time and his family was living in Kristiania. It is likely that, along with his school friends, he followed the articles and stories about Svartbækken and his execution with terror and fascination, a fascination that perhaps had its origins in his childhood. Late in life, Munch recalled the memory of his father telling his young children frightening tales and stories.

Then, in 1909, the young painter Henrik Sørensen, who had studied with Matisse in Paris the previous year, exhibited his expressionist picture *Svartbekken* [sic] at the autumn exhibition in Kristiania. In his picture Sørensen depicted the murderer dressed in black, sitting near a smoking bonfire, frightened and hunched up, almost blending into the darkness of the forest in expressionist colours. The picture was widely commented upon and discussed at the exhibition, and the older painter Christian Krohg praised it in an article. The art historian Marit Werenskiold notes that Sørensen's picture 'is closer to Munch's form of expressionism than to Matisse's more aesthetic art'.[9] The picture was purchased in 1911 in Bergen by the patron Rasmus Meyer, who also acquired a series of Munch's major canvases in the same period. It is now counted as a masterpiece of Norwegian art history. It is possible that the publicity surrounding Sørensen's picture encouraged Munch to create *The Murderer* the following year in 1910. At the time the artist was looking for new subject matter and compositions, and in his painting he chose quite a different perspective of the motif, responding in a certain way to Sørensen's picture. The murderer is depicted in dark clothing, in the harsh light of day, just before or just after the crime. Occupying the entire centre of the composition, on a road, he comes dangerously close to the viewer. His face is a shapeless mask of a highly expressive green colour, and the autumnal landscape could be located anywhere in southern Norway, near the coastal town of Kragerø, where Munch lived at the time, or in the town of his birth, Løten. In 1919 the painter returned to the motif in a slightly different composition in *Murder on the Road* (no.46).

Munch kept these pictures, which attracted attention when they were exhibited. When *The Murderer* was displayed in Kristiania in June 1914, the newspaper *Tidens Tegn* printed a drawing publicising the picture, and the 'unpleasant work' was given a relatively long review. It is possible that the attention given to the subject matter was due to a brutal murder that had taken place some days earlier on Avenue Karl-Johan, the main thoroughfare in Kristiania. A famous lawyer had been killed in broad daylight by three revolver shots fired at close range by a former client. When *Murder in the Lane* was exhibited in 1919, two different drawings of it were printed in the newspapers

Edvard Munch.

Trods Munch er blandt dem som | av Ideer og Skjønhet.
utstiller meget ofte er Forventnin- | Det er vistnok saa at Munchs
gerne og Spændingen like stor for- | Billeder trænger en viss Forkla-
an hver ny Ophængning. — Og al- | ring, det vil si den Forklaring som
drig har han skuffet. Han griper | bare Kjærlighet til Kunsten og op-
og holder en fangen med Geniets | rigtig Studium kan gi. Men den
ubendige Kraft fra første til sidste | som først forstaar ham er blit lyk-
Billede. Hans Kunst hører hjemme | kelig beriket, er indladt i den mer-
i en merkelig Verden for sig, fuld | kelige Verden.

(fig.107), although, for all that, it was not subject to a review. This depiction of an almost archetypal murderer was clearly a potential 'tabloid' illustration .

As this study shows, some shared features can be found between the pictures mentioned and the subjects. Actual events, history and stories, and Munch's ideas and compositions are interwoven. Destructive fires can be read and experienced as a metaphor for war; contemporary war scenes are linked to a theatrical play and to other representations of fear, all the while inspired by real events and contemporary sources. There may also be a youthful innocence and curiosity, which many people carry with them throughout their life, in this fascination with fires, war and military action, murder and criminals, for the world as it really is. This can also be applied to Munch's interest in technical innovations and methods of communication, such as the parlograph and the gramophone, radio and television, the camera and film camera, films and cinema. A prophetic remark in the draft of a letter to his friend, the Danish painter Jens Ferdinand Willumsen, in 1910, is significant in this regard: 'If I had been in possession of the not yet invented little remote telephonic device that one keeps in one's pocket, you would have received my message a long time ago.'[10]

Translated by Ingrid Junillon and Laura Bennett

Notes

1 In 1925 the Norwegian captal, known as Christiania since the reign of Christian IV, then Kristiania, returned to its medieval name of Oslo.

2 Edvard Munch, *Journal*, 1879, Oslo, Munch-museet, MM T 2925.

3 'Edvard Munch hos Blomqvist', *Verdens Gang*, 1 October 1919.

4 Rolf Stenersen, *Edvard Munch. Nærbilde av et geni*, Oslo 1945, p.71.

5 Christian Gierløff, *Edvard Munch selv*, Oslo 1953.

6 Letter from Munch to Gustav Schiefler, n.d. [December 1914], in *Edvard Munch – Gustav Schiefler. Briefwechsel*, Hamburg 1990, vol.1, letter no.639, p.484. Gustav Schiefler wrote the first catalogue raisonné of Munch's graphic works. The correspondence between Munch and Schiefler is written in German [translator's note].

7 *Edvard Munch – Gustav Schiefler. Briefwechsel,* ibid., vol.2, letter no.697, pp.80–1.

8 Note in German 'Hinrichtung Kommunisten in Finland' [translator's note].

9 Marit Werenskiold, *De Norske Matisse-elevene*, Oslo 1972, p.75.

10 E. Munch, Draft of letter to J.F. Willumsen, n.d. [1910], Oslo, Munch-museet, MM N 2533.

88
Fire
1920
Lithograph
54 × 74
Munch-museet, Oslo

89
The House is Burning!
1925–7
Oil on canvas
80 × 135
Munch-museet, Oslo

Fig.108
The Fight
c.1916
Watercolour
Munch-museet, Oslo

Fig.109
The Fight
1916
Oil on canvas
100 x 67
Munch-museet, Oslo

Magne Bruteig

The Altercation with Ludvig Karsten

The relative isolation in which Munch lived after returning to Norway in 1909 did not prevent him from closely following the news through newspapers and his subscriptions to national and international magazines. Advances in printing techniques caused photographic and artistic illustrations, sometimes even in colour, to play an increasingly important role in the media. So, it seems obvious that a reader such as Munch, someone so sensitive to the impact of images, should have retained some of these, in a subconscious or conscious way, when choosing themes for his future compositions. Can we, through scanning what we know he read and might have seen in newspapers and magazines, find traces of influence or inspiration relating to specific works?

1905: Tooth and Nail

In that year the midsummer celebration at Munch's small house in Åsgårdstrand brought together the artist himself, an actor from the capital, Ludvig Müller, and a young colleague, friend and admirer, the painter Ludvig Karsten. What might have been a pleasant evening ended in a brawl between Munch and Karsten. Drunk, the two men went outside the house, grappled with one another and tumbled down the slope. Munch injured his left wrist, Karsten got a black eye, and his white suit was stained with blood. Munch staggered back into his house and locked himself in after violently slamming the door. Approaching one of the windows to try to calm things down, Karsten and Müller preferred to beat a prudent retreat when Munch shouted at them to leave and threatened them with a rifle.

This was neither the first nor the last time that Munch would quarrel with his surroundings. This event must have made a strong impression on him, however, as he returned to it many times over the following years and decades, in both words and images. Four canvases, an intaglio print and at least four drawings can be directly linked to this brawl. Additionally, in

his notes and some fifty drafts of letters to his friends and acquaintances, the painter tries to explain what really happened and attempts to find a justification for his acts. These documents reveal the two principal causes of this dispute, both of which threatened to undermine Munch's honour.

The month of June 1905 is not an insignificant date in Norwegian history. On 7 June the Norwegian parliament unilaterally terminated the union with Sweden. King Oscar II and the Swedish government threatened military invasion in order to re-establish the union. Norway responded by mobilising its military and volunteer forces. This is the crux of the problem; Munch did not volunteer, which was hardly surprising given how alcoholic, psychologically unstable and physically weakened he was at the time. He would have been a burden to any army. Karsten himself had enlisted, however. Proud of his bravery, he ventured to suggest that Munch was too cowardly to defend his country, that his dedication to the nation was in doubt, all the more so because at that time he had more or less permanently settled in Germany. 'Of course,' Munch wrote, 'this nervousness that I could not calm … was interpreted as anxiety about a possible war. I instantly felt that an opinion had been formed about me, that I was afraid of the Swedes.'[1]

The nationalist sentiment of a man who had flown the pure Norwegian flag (i.e. without the union symbol) at the Equitable Palast in Berlin in 1892 had clearly been called into doubt. Munch's pride found itself under attack.

This altercation was also linked to another dispute that had taken place some days earlier during a lunch in a hotel with friends, when Munch slapped a young woman, Inge Vibe.[2] The artist tried to minimise the impact of his behaviour by calling it a harmless joke, but the other guests, especially Karsten, saw things from a different angle. Munch, who made a point of coming across as a gentleman when ladies were present, was now seen as an uncontrollable and rude character. Such

accusations were particularly hurtful to Munch, coming, in particular, from those who claimed to be his friends, who ate from his table and drank his wine.

1916: The Aesthetics of War

The Fight (fig.109) shows the two figures on the slope below Munch's house; Karsten is wearing a white suit, while Munch is dressed in dark blue. The handling is coarse, like a sketch, the colours light and joyful. The grass around the figures, rendered quite abstractly in richly coloured tones, counteracts the melancholic atmosphere that might be expected in such circumstances, as does Munch's strange but nevertheless logical pose and Karsten's wide open eyes, expressing more surprise and astonishment than anger and pain.

Munch created an intaglio print with the same title (fig.108) around the same time as the painting. The principal features of the composition are retained but inverted, in keeping with the printing process. Once again, Karsten seems dumbfounded. Without the title, it would be difficult to understand the action depicted. If some provisions and wine had been added on the ground, the scene could have been interpreted as a picnic. The feeling of betrayal, humiliation and anger felt by the artist in 1905 has, eleven years later, given way to a calmer and more distanced attitude.

It is likely that Munch carried out a new pictorial reinterpretation of this event because the artistic potential of the brawl interested him. Compared to his earlier pictures, he pushes the abstraction further here in the painted version, in the depiction of the grassy slope. The simplified, almost naïve, silhouette of Karsten is an isolated case in Munch's work. The perspective he uses to represent his own reclining body attracts us into the space of the picture itself, and draws us into the action; the lower part, with the head, is almost seen from above, so much so that it creates an impression that we are standing just above

him. We can only just control our impulse to want to lean over
to help him get up. Such visual tricks aimed at involving the
viewer can be found in many of Munch's pictures, however this
variation is quite distinctive.

Another, quite unusual, element lies in the fact that this deals
with a real, dramatic and action-packed episode taken from the
artist's personal life. It does not have any symbolic value or
universal impact, nor appears to aspire to a universal declara-
tion. The physical act is at the heart of the composition. Where
does this new artistic direction of Munch's in 1916 come from?
It is difficult to provide a definite response to this question. The
painter was undoubtedly very preoccupied by the First World
War that was raging in Europe at the time, as evidenced by his
subscriptions to French, English and German magazines
(*L'Illustration*, *The Illustrated London News*, *The Graphic*,
The War of the Nations, *Illustrierte Zeitung*, *Simplissimus*), in
which the conflict was a recurring subject.

It goes without saying that the tussle with Karsten was not
an act of war comparable to the fighting taking place on the
continent. As we have seen, however, this brawl was connected
to the military mobilisation, and, in addition, Munch had a
tendency to interpret his own conflicts as an ongoing battle
with a clearly identified enemy.

All the magazines mentioned provided plentiful illustrations,
photographs as well as drawings. The illustrators in particular
depicted events in close-up and provided dramatic and striking
descriptions of the acts of war. Although there is no specific
motif in any of these magazines that may have served as a model
for Munch, all this war-like imagery undoubtedly prompted the
painter to create 'images of action' inspired by the dramas in his
own life. The 'trick' consisting in locating portions of a figure
entirely in the foreground of the picture, in order to give the
viewer the impression of being in it, appears in a large number
of wartime illustrations (fig.111).

A painting by James Clark (fig.110), reproduced a number of
times in *The Graphic* in 1915, depicts a dying, or already dead,
soldier in a position very similar to that of Karsten in Munch's
painting. It is unlikely that he would not have seen this picture.

It is difficult to define the importance of such visual stimuli
in Munch's work. In the series of drawings created around the
motif of the torpedoed ship, however, it is possible to identify
exact models of illustrations, especially in English magazines.

1932: Wild West in Åsgårdstrand?
In 1932, Munch returned once again to the 1905 brawl with
Karsten. We cannot know what led him to do so this time
either, but unlike in 1916, we know that he was staying in
Åsgårdstrand during the summer of 1932, in the company of
his model Hanna Selqvist. In an interview with the newspaper
Gjengangeren (*The Ghost*), on 12 June 1989, she recounts that,
wearing a white trouser suit, she posed seated on the grass
below Munch's house, in the role of Karsten. *The Fight* 1932
(no.90) resulted from this sitting. In order to carry out this
work, Munch probably returned to the 1916 print as a basis, but
he altered the position of the house and the distance between
the protagonists, as well as his own pose. In the etching,
appearing somewhat indolent, he was leaning backwards with
his elbows resting on the ground. In contrast, in this new
canvas, his body is stretched out and distorted, in a position
that seems very uncomfortable. The blood on Karsten's suit,
and the more jarring colour that surrounds the figures, creates
an overall effect that differs greatly from the print and the 1916
painting. To a certain extent, Munch is now getting closer to
his own ambiguous feelings connected to this event.

As we have already seen above, the 1905 event had remained
etched in the painter's memory, but it seems difficult to
determine what led him to paint a new version. None of his
written texts indicate that he was particularly preoccupied with

this story during the summer of 1932. What is more, no comparable events seem to have been cited or illustrated in the newspapers or magazines of this period.

The drawing in *Oslo Illustrerte* (*Illustrated Oslo*), no.24, 15 June 1932 (fig.112), with a person lying in a position almost identical to that of Munch in the etching, might well be unconnected. We know, however, that Munch bought this weekly magazine more or less regularly,[3] in a period that corresponds closely to the genesis of this painting. The fact of having seen this drawing may well have been enough to bring the 1905 event back to the surface, and to cause the artist to imagine a new version while he was once again at the 'scene of the crime', and had a model with him who could help with the 'reconstruction'.

With *Uninvited Guests* 1932–5 (no.91), Munch tackles a new sequence in the event.[4] As previously mentioned, Munch had threatened Karsten and Müller with a rifle to get them to leave. The work is dramatic; it retraces the moment in which the intensity of the situation was at its height. The man with the gun, Munch himself, is represented by nervous strokes and numerous outlines. Is he shaking with rage, nervousness or drunkenness? Munch recalls the episode as follows: 'Threatening – the finger on the trigger trembles nervously. Müller stands in front of Karsten and pushes him back. They leave – Was it just a threat? The hand on the trigger, fierce and insensitive – Would I have shot if they had not left – come towards me?'[5]

And what about *The Fight* 1932–5 (no.92)? Is this a third version of the scene with Karsten? Yes and no at the same time. The figure in white, in the blood-stained suit, unquestionably recalls Karsten after the dispute. No further quarrel between the two men on the road is recorded, however. On the other hand, Munch describes a meeting with Müller a few days after the altercation with Karsten:

There I met the actor Møller [sic] in front of Ingse's house. He stopped me – and came towards me. I saw a knife gleam in his hand – I thrust my hand into my pocket and took out a key, pretending to have a revolver – I pressed it against him firmly – what have you got in your hand, he said – I let him go – as I left I saw Miss Ingse at the nearby window.[6]

The composition of this picture is unusual and so similar to duels in classic Western films that one wonders whether this can be simply coincidental. We also know that Munch was occasionally a very enthusiastic cinema-goer, and that around 1930 the Western film genre was experiencing growing popularity, even in Norway, due in particular to actors such as Gary Cooper and John Wayne. It is, however, impossible to say with certainty that Munch had seen *A Holy Terror*, *The Bad Guy* and *The Big Trail*, which were some of the Westerns screened in Oslo's cinemas between 1931 and 1932.

An examination of the many magazines to which Munch subscribed, as well as the newspapers and weeklies that he could have read in the periods around 1916 and 1932, reveals some striking similarities with the depictions of the altercation with Karsten, although these cannot be linked directly to the artistic process with any certainty. If these media provided a sort of prime material for Munch's work, he reorganised them entirely, and integrated them fully into his own artistic language. As a general source of visual inspiration, they may, however, shed light on a number of his pictures, including *The Fight with Karsten*.

Translated by Jacques Privat and Laura Bennett

Notes

1 Oslo, Munch-museet, MM N 221.

2 Munch had painted Vibe's portrait two years earlier.

3 Even though he left behind a few copies of *Oslo Illustrerte*, for the most part they were insignificant issues – quickly absorbed and discarded – compared to the more serious journals to which he subscribed.

4 As Gerd Woll indicates in the catalogue of Munch's works dealing with his paintings, the date of this piece is a little uncertain. It is traditionally dated to around 1935, but by dating the picture to 1932–5, Woll broadens its possible origins to link its chronology with *The Argument* (Woll 1711). The same applies to *The Fight*.

5 Oslo, Munch-museet, MM N 666, p.33.

6 Ibid., p.34.

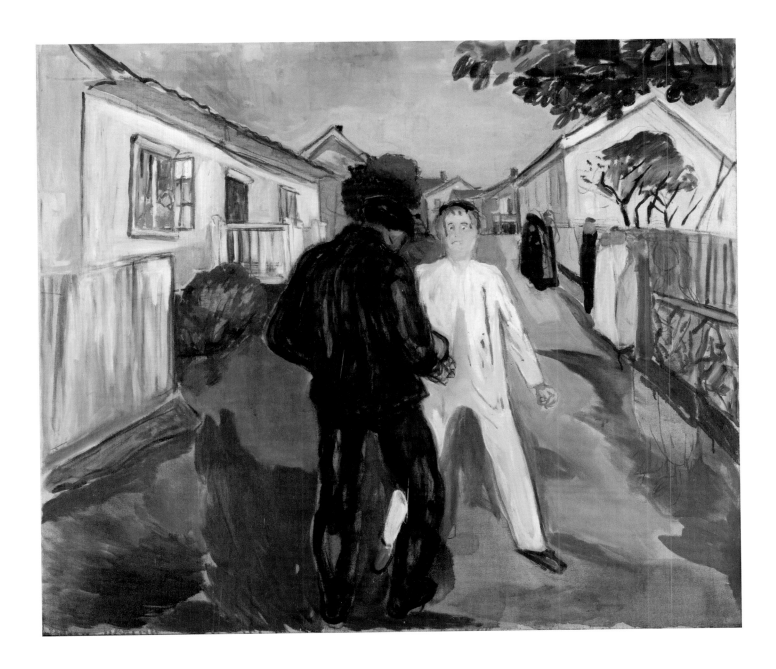

90
The Fight
1932
Oil on canvas
90 x 120
Munch-museet, Oslo

91
Uninvited Guests
1932–5
Oil on canvas
75 x 101
Munch-museet, Oslo

92
The Fight
1932–5
Oil on canvas
105 x 120
Munch-museet, Oslo

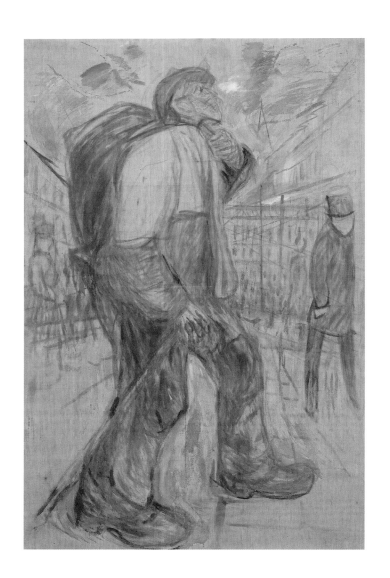

Fig.116
The Beggar
1909–10
Oil and charcoal on unprimed canvas
215 X 140
Munch-museet, Oslo

Fig.117
Workers in the Snow
1909–10
Tempera (?) and charcoal on unprimed
canvas
210 X 135
Munch-museet, Oslo

Gerd Woll

'Recording the waves emitted by society'

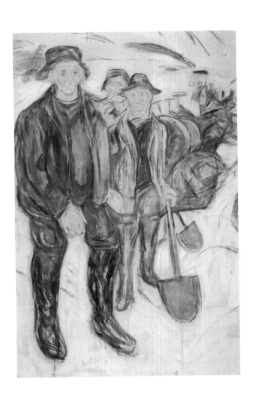

Edvard Munch opened a major exhibition at the Dioramalokal in Kristiania on 6 March 1910. The exhibited works included several decorative paintings intended for the Festival Hall of the Universtiy of Oslo, and some sketches for unspecified decorative projects, including two pictures entitled '*The Beggar* and *Workers in the Snow*, studies for decorations' in the catalogue (figs.116–17). The size and composition of these two works indicate they were more than mere genre scenes. It is also significant that they were listed under the same catalogue number and were therefore clearly seen as pendants.

For both these paintings, Munch used models found in his neighbourhood in Kragerø, where he had settled on returning to Norway in the spring of 1909, after a prolonged stay at Dr Jacobson's clinic in Copenhagen. Børre Eriksen, an old skipper who worked for him as a handyman, was the model for *The Beggar*, as well as for the old man in *History*, one of the sketches that Munch submitted for the central panel of the Festival Hall. There was very little in Børre Eriksen's life to link him with the life of a beggar or rag-and-bone man, even though, in the past, he had led a roving life on the seas. The biographical context does not then explain the choice of subject, although the unusual clothing of the man and his calm appearance no doubt inspired Munch. The model for the figure in *Workers in the Snow* was one of Munch's neighbours, Kristoffer Hansen Stoa. A labourer, Stoa was strong and heavy, and passionate about music and politics. He was committed to the labour movement and was described as a 'glowing red socialist'.[1] He may have inspired Munch to create a monumental rendering of a worker, himself appearing as a perfect example of the working class.

Munch had depicted beggars and workers in earlier pictures and the theme was not unprecedented in European art history. However, the combination of these two types, both of whom could be seen as a representative of the proletariat, the

social class that many thought was due to seize power, was something new. During the French Revolution, the Third Estate, peasants and the bourgeois, had taken power, but at the start of the twentieth century it was the Fourth Estate, the working class, who began to stand up for their rights.[2]

These two subjects may have arisen in Munch's mind during his clinic stay in Copenhagen between 1908 and 1909. In the French collections at the Ny Carlsberg Glyptotek, he was again able to see one of Jules Bastien-Lepage's masterpieces, *The Beggar*, which had been purchased by the museum in 1888 after an important exhibition of French art in Copenhagen. We know that Munch definitely saw this exhibition, and although Bastien-Lepage was not one of his favourites, the French painter nevertheless exerted a strong influence over Scandinavian artists in the 1880s. Moreover, the size, as well as the price, of the picture was quite enough to mark it out as a significant work.

The visit to the Ny Carlsberg Glyptotek may have also encouraged Munch to carry out a monumental representation of workers. The large sculptures by Constantin Meunier, *The Dock Worker*, *The Hammerer* and *The Sower*, had been erected outside the museum. Of course, Munch already knew Meunier well and his friendship with Henry van de Velde may lead us to think that he was also aware of Meunier's ambitious project for a *Monument to Labour*.[3]

Navvies, Railway Constructions and Industrialisation in Telemark

During this period Munch was living at Kragerø, a small town on the Oslofjord. He found the surroundings and people there very different from those of the large European cities. In Kragerø, fishing and shipping had always been the principal sources of income, and people were well informed about what was happening abroad. The Telemark region, where Kragerø was located, was going through a period of heavy industrialisation,

with Norsk Hydro as the leading company and driving force. The dynamism of the building industry attracted numerous labourers who came to work on the construction sites. Around 1910 the labour movement had a strong position in the Telemark. So-called Navvies, coming from Sweden, imported new theories on syndicalism and power to the workers. Munch may have got an idea about these theories from Kristoffer Stoa while he was posing for his pictures of workers. The first signs of Munch's new interest in workers appear in a notebook from the summer of 1909 (figs.118–20), in which he drew landscapes and scenes observed during a journey from Kragerø to Bergen. During the return journey, Munch and his travelling companion Ludvig Ravensberg took the recently opened railway line from Bergen across the mountains. An undated and unsent postcard showing the removal of snow from the line may be seen as a possible source for the pictures. The official opening of the last section of the line linking Kristiania and Bergen in November 1909 was a prominent national event.

While the figure of the beggar, planned as a monumental decoration, disappeared after the 1909–10 sketch, that of the worker became an area of research that Munch would exploit over several years, in a variety of versions. During 1910 he painted a new picture (fig.123), in which Kristoffer Stoa was the model for the main figure. The piece was presented as a major work during important exhibitions in Germany in 1912. The first was a solo exhibition at the Thannhauser Moderne Galerie in Munich, which had just hosted an exhibition of work by the Swiss painter Ferdinand Hodler. It was inevitable that many critics latched onto the thematic affinities between the two artists, and were particularly interested in Munch's monumental painting of the workers in their reviews of the exhibition.

From Munich the picture was then taken to the international Sonderbund exhibition in Cologne, where Munch was presented

Fig.118
Sketchbook
MM T 147–39r
Summer 1909
Crayon on paper
p.39 recto
Munch-museet, Oslo

Fig.119
Sketchbook
MM T 147–22v
Summer 1909
Crayon on paper
p.22 verso
Munch-museet, Oslo

Fig.120
Sketchbook
MM T 147–23r
Summer 1909
Crayon on paper
p.23 recto
Munch-museet, Oslo

as one of the most important modern artists, the equal of predecessors such as Paul Cézanne, Paul Gauguin and Vincent van Gogh. The latter was the main figure in the historical section, with 107 pictures on display; 26 works were shown by Cézanne, 25 by Gauguin and 32 by Munch. Younger artists, such as Pablo Picasso, Henri Matisse, André Derain, Pierre Bonnard, Ferdinand Hodler, Giovanni Segantini, Oskar Kokoschka and Egon Schiele, were also widely represented. Following this exhibition, Munch's picture was sold to the German art historian Curt Glaser.

Munch repeated the motif of the workers as a lithograph, a woodcut and even a sculpture. In 1913 he painted a new picture with similar subject matter, *Snow Shovellers*. The two men working back to back create a play of opposing forces, which is found again in the line-up in the background of the two first sketches of *Workers in the Snow*. This had already been noted positively in the introductory article to the Sonderbund exhibition in 1912.[4] In 1927, Munch donated the painting to the Berlin Nationalgalerie in appreciation of the magnificent retrospective it had dedicated to him, but unfortunately it was one of the works that the Nazis decided to get rid of ten years later. What happened to the painting thereafter remains unknown, but it is likely that it perished during the war.

From Bathing Men in Warnemünde to Workers in Kragerø
While he was painting *Snow Shovellers*, Munch also painted a new version of *Workers in the Snow*. The main group is more or less the same, but the line of men digging has given way to several smaller groups in different positions (fig.122). The position of the figures in the foreground, in all versions of *Workers in the Snow*, is very similar to that developed by Munch for the large *Bathing Men*, a picture painted in Warnemünde in 1907–8 using local lifeguards as models (fig.121). After having sold this work to the Ateneum in Helsinki, Munch painted a

new version, probably at the same time he was working on a new version of *Workers in the Snow*.

Bathing Men is a formidable homage to the nudity and strength of man. The sun, air and the sea were important motifs in the vitalist movement sweeping across Europe in the first decade of the twentieth century, to which Munch was, of course, not indifferent. Strength and physical energy were further hallmarks of this modern cult of health, which set itself up in total contradiction to the decadent lifestyle of the 1890s. Its influence is strongly felt in Munch's depictions of workers, who, in their dark working clothes, appear both as a compact group and as autonomous individuals, standing out against the white snow.

The play of light and shade is also glaring in the picture readily considered Munch's first depiction of workers, *Mason and Mechanic*, painted at Warnemünde in 1907 or 1908. The same colour contrast between the light and dark clothes is found in two pictures of the same genre and period: *The Drowned Boy* and *Worker and Child*. Their figures are easily recognisable as workers, even though they are not depicted actually working. Munch re-exploits this contrast in the late pictures such as *Black and Yellow Men in the the Snow*, painted in Kragerø between 1910 and 1912 (no.94).

In several drawings, Munch used groups of workers seen during the two summers spent at Warnemünde, and indications show it was during this period that he began to move towards a reality other than that of the personal anguish of the individual, or psychological intricacies. In the summer of 1908 he made a note of some interesting reflections on this topic:

A country's artists, its poets – are sensitive phonographs – they have received the noble and painful ability to record the waves emitted by society – Poets reproduce these waves as condensed extracts – when an artist is driven out of his country – at the same time the country drives out an enormous electrical force.[5]

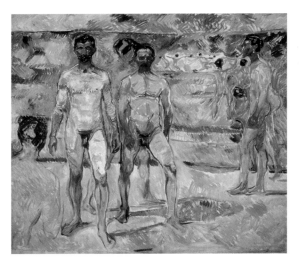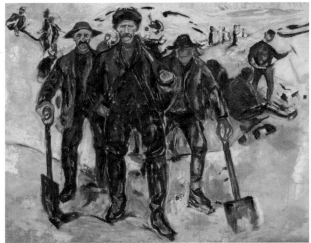

The note recalls the early days of Munch's career, under the influence of Christian Krohg and the naturalism that marked out Norwegian artists in the 1880s. Krohg's aesthetic manifestos were more or less a Norwegian variant of Émile Zola, particularly in their insistence that artists should paint images of their time. Similar points of view can also be found in the ideological leader of the Kristiania Bohème, Hans Jæger, who demanded that modern authors write about their own lives. These ideas played a very important role in Munch's artistic development, although he applied them in a highly personal way.

The Labour Movement on the Rise

The stride of the men in *Bathing Men* and *Workers in the Snow* indicates that they are moving forward, but their movement is ambiguous and could also be interpreted as a *contrapposto*. The main group in the scene of workers may recall many photographs of the period, in which working teams pose proudly for the camera.

Munch explored the representation of movement in several pictures painted in Kragerø between 1910 and 1912. In one of these, known as *Sailors in the Snow*, the figures come forward through the drifting snow (no.93), forming compact groups that perhaps recall the workers of Warnemünde. It is in *Galloping Horse*, however, in which the white horse seems to be rushing towards us, that the artist was best able to replicate movement (no.44).

The theme of the worker embodies this eruption of the new social class, with which Munch was undoubtedly fascinated. In *Workers on Their Way Home*, movement is expressed by the endless stream of men, in such a way that the viewer almost feels part of them (no.51). In addition to the linear perspective, several viewpoints are used to create a dynamic tension in the crowd. In order to accentuate the illusion of movement further, the men in the foreground are depicted with exaggerated foreshortening, and their legs are painted in an overlapping fashion. Arne Eggum points out that the disproportionate figure of the man in the centre is probably inspired by the movements and distortions of film.[6] It is interesting to note in this light that the film *Germinal*, based on Zola's novel, with a miners' strike as its central theme, was shown in Norwegian cinemas during the New Year celebrations of 1913.[7]

The naturalistic representations of strikes are another possible source of inspiration for Munch's picture, and it is not insignificant that in April 1913 a Norwegian newspaper reported that the Belgian government had distributed hundreds of thousands of reproductions of Hubert von Herkomer's picture, *On Strike* 1891, to warn workers about the consequences of the general strike taking place.[8] This may have led Munch to want to express another point of view about the issue. He had also been aware of Theodor Kittelsen's picture, *Strike* 1879, since his childhood; it had aroused a lot of attention when it was exhibited in Kristiania, and was later considered the first attempt in Norway at a picture with a social tendency. These preoccupations echoed the political climate in the country. The parliamentary elections of the autumn of 1912 had caused a minor earthquake in Norwegian politics. The conservatives had lost their majority in favour of the liberal left, while the Arbeiderpartiet (Labour Party) had obtained more than 26 per cent of the votes. Women were also granted the right to vote in 1913, and trade-union organisations strengthened their position across the country.

This scene of workers erupting in the evening from a factory at the sound of the siren indicating the end of the working day was not unknown to Munch. In his youth he lived in Grünerløkka, in the east of Kristiania, an area dotted with large factories along the river. In the 1880s he had rendered, both in drawings and small pictures, workers leaving for work early in the morning, or returning home in the evening.

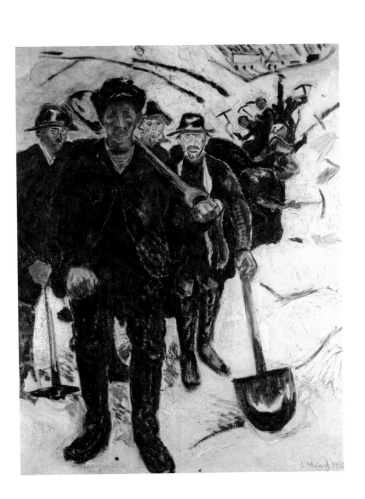

Neither the street nor the business of Munch's new scene of workers can be firmly identified, although it is possible that they were inspired by the glass factory, located close to the artist's house in Moss where he was living between 1913 and 1916, before moving to Ekely.

Even though the starting point for Munch's picture was probably prosaic – the stream of workers returning home at the end of their working day – it has acquired, thanks to its size, composition and handling, an otherwise symbolic significance. This motif, like others, exists in two versions, of which the one in the Munch-museet is the larger.[9] When it was exhibited in Kristiania in 1918, one of the leading Norwegian critics wrote that, with a little imagination, the picture could serve as an illustration of recent events in Russia.[10]

In 1916, Munch bought Ekely, a large estate on the outskirts of Kristiania, which would then become his permanent place of work and residence. The Eureka mechanic workshops located nearby employed many workers, and Munch carried out a large watercolour of men leaving at the end of the day (no.49). In 1920 he created a new version of *Workers on Their Way Home* using this factory as a backdrop (fig.125). The same year he also painted a superb picture with three men laying tarmac in front of Ekely (no.95), which was probably due to the fact he had undertaken the construction of a studio, completed in 1920.

The labourers busy working at his own estate allowed Munch to benefit from excellent models for new pictures on the theme of work and workers, a theme that he would return to nine years later when he had the studio completely rebuilt.

The Project for a Frieze of Workers, from the Freia Chocolate Factory to Oslo City Hall

In January 1921 the Freia chocolate factory called upon Munch to decorate the walls of its canteens. In addition to the twelve panels carried out, the artist also made sketches for six panels

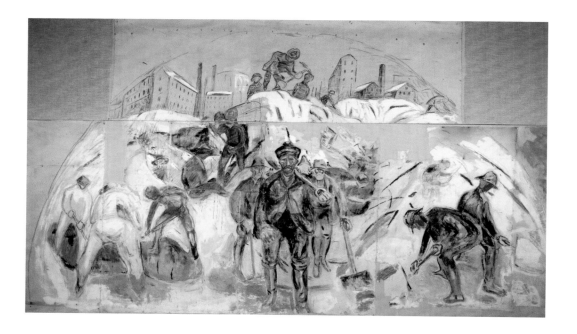

dedicated to the life and activities of workers, intended for a smaller dining room.[11] The frieze's central scene, a large horizontal painting, depicted the stream of workers leaving the factory. This frieze on the theme of workers was not realised at Freia, but a fresh opportunity presented itself in the late 1920s. Many people wanted Munch to decorate Oslo City Hall, which had been planned for several years. The painter was also undoubtedly interested in such a commission, and his sketchbooks and notebooks from the second half of the 1920s are full of ideas and drafts for such a decoration. They include, in particular, a new variant on the frieze of workers.[12] In 1929, however, Ekely saw the arrival of more labourers when Munch undertook the complete reconstruction of his studio. Once again, this event inspired him to create a series of scenes of men working on the building. Renderings of the construction works appear in sketches for the city hall decoration, and a major new thread in the concept slowly emerges, the construction of the building itself. These sketches demonstrate the ongoing themes of the demolition of the old slum in which the building was to be raised, and of the emergence of new modern buildings, including the city hall, designed as the central radiating motif.

Slowly, these ideas crystallised into a large composition in which the building site became the principal arena, and the scenes of demolition and construction were replaced by two compact groups of men at work (fig.124). On the left, the motif of *Street Workers in the Snow* from 1920 is recognisable, and *Snow Shovellers* on the right. Munch returned to *Workers in the Snow* for the central group, and painted a semicircular panel above all the figures, bringing the composition to a conclusion by creating links with the building site in progress in the centre of Oslo.[13]

The theme of demolition and reconstruction fitted in well with Munch's philosophy of life, as he had expressed it in his many earlier paintings; destruction or death are not only fertile ground for a new life, they are also its condition. We may also consider that the old bourgeois social order had been destroyed and replaced by new thoughts of equality and solidarity. In the wake of the First World War, social democracy was gaining momentum in huge areas of Europe and, in Norway, the Labour Party formed its first government in 1928, which was nevertheless short-lived. Against this backdrop, Munch's proposed decorations for Oslo City Hall were as modern as they were pertinent, although, sadly, they were never realised.

Translated by Ingrid Junillon and Laura Bennett

Notes

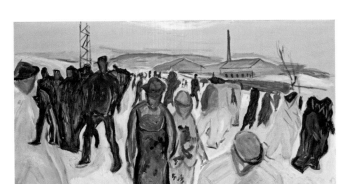

Fig.124
Workers on a Building Site
Sketch for the decoration of the Oslo
Town Hall
1931–3
Oil on unprimed canvas
340 x 570
Munch-museet, Oslo

Fig.125
Workers on Their Way Home
1920
Oil on canvas
79.5 x 138.5
Nasjonalmuseet for kunst, arkitektur
og design, Oslo

1 Hans-Martin Frydenberg Flaatten, *Soloppgang i Kragerø*, Kragerø 2009, p.76.

2 Classic Marxism did not include beggars in the proletariat class, but Munch was not a political theorist. It is likely that, for him, beggars and manual labourers embodied the strong and independent figures of the lower classes.

3 The monument remained unfinished on Meunier's death in 1905, but Van de Velde developed an architectural framework into which several of Meunier's sculptures were integrated, known as the 'Abbé Monument', completed in 1908.

4 H. von Wedderkop, *Führer nebst Vorwort, Sonderbundausstellung 1912*, exh. cat., Cologne 1912, p.48.

5 Oslo, Munch-museet, MM N 0170-01. The document can be consulted in full at www.emunch.no.

6 Arne Eggum, *Munch and Photography*, New Haven and London 1989, p.154.

7 This information is courtesy of Ingebjørg Ydstie, who carried out research after having seen enlargements of shots of this film at an exhibition at the Van Gogh Museum in the autumn of 2010. The theory that Munch may have been inspired by this film therefore implies that the picture, previously dated to 1913–14, was not painted before 1914. Munch was fiercely interested in films and often went to the cinema. See the article by Ingebjørg Ydstie on Nobel Roede in this catalogue, pp.180–7.

8 *Aftenposten*, 22 April 1913.

9 The Munch museum version (MM M 365) is generally considered to be the first, and dates from 1913–14, while the second, smaller, version is signed and dated 1914. This picture was sold to the Danish collector Tetzen-Lund, who donated it to the Statens Museum for Kunst in Copenhagen in 1928.

10 Jappe Nilssen, in *Dagbladet*, 19 February 1918.

11 It was not possible to carry out this section of the decorations at Freia; the six sketches are now kept at the Munch-museet. See Gerd Woll, Per Bj. Boym (eds.), *Edvard Munch: Monumental Projects, 1909–1930*, exh. cat., Lillehammer, Lillehammer Art Museum, 1993, pp.84–8.

12 Woll and Boym 1993, pp.89–105.

13 The composition consisted of a series of canvas fragments. These were reunited and lined on a new canvas in 1965, after photographs taken in Munch's studio.

93
Sailors in the Snow
1910–12
Oil on canvas
96 x 76
Munch-museet, Oslo

94
Black and Yellow Men in the Snow
1910–12
Oil on canvas
58 x 51
Munch-museet, Oslo

234

95
Street Workers in the Snow
1920
Oil on canvas
105 X 151
Fram Trust

96
Building Workers in the Snow
1920
Oil on canvas
127 X 103
Munch-museet, Oslo

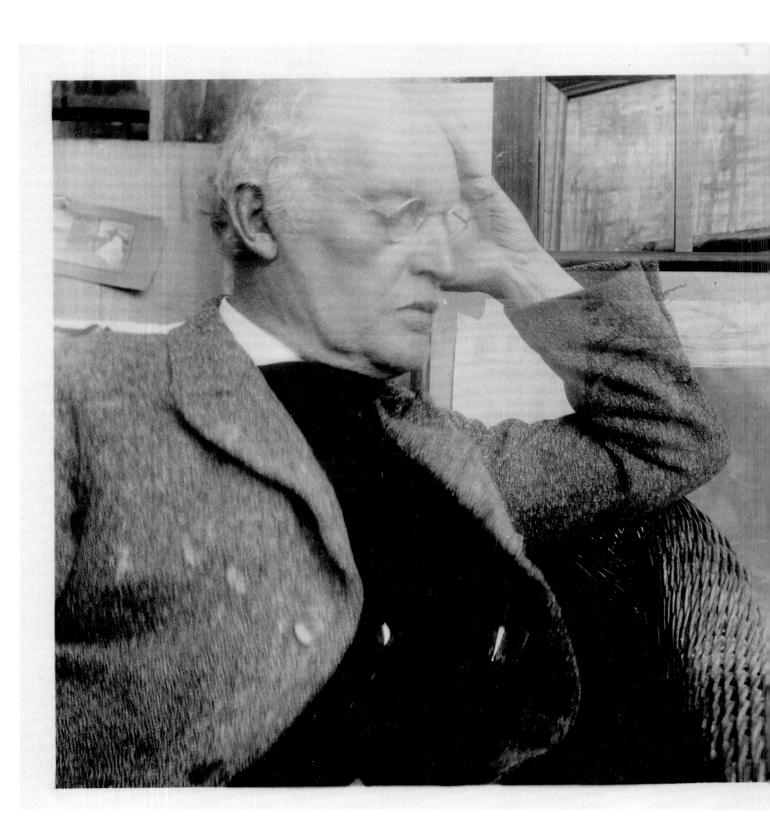

Drawing and Photography

In the late 1920s Munch began to take photographs again after a very long break, beginning with a series of self-portraits created in his studio. Playing with the effects of transparency using long exposures, in keeping with a principle he had already explored at the beginning of the century, the painter seemed to want to become one with his painting. He also took a further series of self-portraits outdoors. With a gesture that is common today, in the era of digital self-portraiture, the painter held his camera at arm's length, turning it around towards his face like a mirror. A connection must be made between this second series of self-portraits and a lithograph created at the same time. In fact, this was a response to a debate launched by the German magazine *Das Kunstblatt* about the respective qualities of photography and drawing, and their ability to render degrees of light and shade. At a time when Munch was suffering from severe problems with his sight, it is easy to understand that he felt the need to assess his tools in this way.

97
Self-Portrait in front of *The Family Tree*, Ekely
1930
Photograph, gelatin silver print on paper
8.6 x 11.2
Munch-museet, Oslo

98
Self-Portrait with Hat I
c.1930
Lithograph
20.2 x 18.5
Munch-museet, Oslo

Fig.126
**Illustration from Paul Westheim's
article, 'Gezeichnet oder geknipst?'**
Das Kunstblatt, 14th year, February
1930, p.42
Centre Pompidou, Bibliothèque
Kandinsky, Paris

Clément Chéroux

Drawing versus Photography

Art historians are quick to link the invention of the profile portrait to an anecdote told by Pliny the Elder in the volume on painting and colours in his monumental *Natural History*. In order to hide the affliction of King Antigonus, who only had one eye, the painter Apelles supposedly chose to portray him in profile. In this way, so Pliny the Elder wrote, 'what in reality was wanting to the person might have the semblance of being wanting to the picture rather'.[1] It is very tempting to link this episode from the mythology of painting to a series of photographic self-portraits in profile taken by Edvard Munch in 1930, shortly after a blood vessel in his right eye had ruptured, leaving him partially blind.

At that time, the painter had not long returned to photography after a considerable break. He had recently bought a camera for his sister Inger and shown her how to use it, encouraging her to take the plunge into photography. He had also bought himself a new camera, using it to increase his number of self-portraits, which can be divided into two groups. The first group was created in the studio, with Munch posing or moving around in front of his canvases. Playing with effects of transparency using long exposures, in keeping with a principle he had already explored at the beginning of the century, he seemed to want to *become one* with his painting. The other group of images, undoubtedly the more surprising, was taken outside the studio. The painter holds his camera at arm's length and points it towards his face. According to Arne Eggum, in May 1930 he suffered from a stroke that caused a haemorrhage in his right eye and led to the vision problems that would bother the painter until the end of the year.[2] Eggum writes that Munch created the series of outdoor self-portraits in the autumn of the same year.[3] Now, with the exception of a single image, in which the artist appears in three-quarter view, all the other self-portraits show him in profile. So much so that, if Munch had not photographed his right profile as much as his

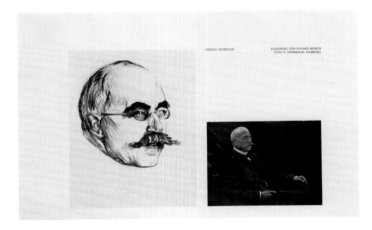

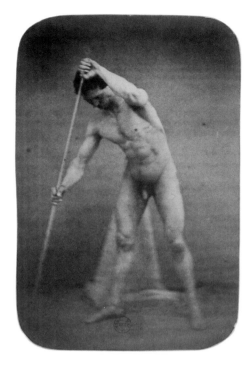

left, it would be tempting to believe that he was trying, just like Apelles, to conceal the afflicted eye.

The real reason behind the existence of this series of self-portraits is therefore to be found elsewhere. At the beginning of 1930, the German art historian and critic Paul Westheim was organising an unusual exhibition in Berlin. It was distinctive because it combined drawn, engraved and sculpted portraits by contemporary artists with photographs of their models. In its February 1930 edition, the German magazine *Das Kunstblatt*, of which Westheim was editor-in-chief, dedicated a considerable review to the exhibition, written by Westheim himself (see p.252) and including many reproductions.[4] Entitled 'Gezeichnet oder geknipst?' ('Drawn or Snapped?'), Westheim's article returned to the eternal question of the artistic status of photography, before tackling the no less recursive issue of resemblance in the field of portraiture. According to him, a portraitist who really wanted to be creative had to go beyond resemblance. 'If he is creative,' he wrote, '... he will try to conceive of what I call a portrait of essence. I mean, beyond the visual, he will also provide a concept, or at least an idea, of the spirituality of the subject that is to be portrayed.'[5]

Munch had several reasons to be interested in this exhibition. One of his engravings was on display and several of his German contacts, Gustav Schiefler and Curt and Elsa Glaser, were, to some extent, connected with the project. The painter subscribed to *Das Kunstblatt* and kept the issue with Westheim's essay in his archive, as well as the reproduction of his engraving that appeared in the article (fig.126) and had been sent by the German press cutting agency, to which he had subscribed. Munch's curiosity in the debate comparing drawn and photographic portraits even led him to draft some notes on the subject (see p.253). According to Eggum, these were intended to be published in the Norwegian magazine *Kunst og Kultur* (*Art and Culture*).[6] In the surviving draft, a document that is actually quite difficult to decipher and interpret, Munch seems to be in agreement with Westheim as to the need for the artist to go beyond resemblance. He is, on the other hand, much more confident than the editor-in-chief of *Das Kunstblatt* about the ability of photography to do this. Whereas Westheim doubts the possibility of transmitting the 'spirituality of the subject ... by mechanical means', Munch notes that 'mechanical production made by a judicious hand can provide good results'.

We can suggest then that Munch carried out this series of photographic self-portraits outside his studio in order to check what he was writing, or rather as accompanying illustrations for his forthcoming article in *Kunst og Kultur* (nos.108–14). This seems to be confirmed moreover by the existence of a self-portrait, probably drawn by Munch while looking at himself in the mirror, in which the painter's face is depicted in similar close-up, and with the same hat as in his photographs (no.98).[7] It is as if the artist had wanted to test out on himself the relative merits of drawing and photography in the field of portraiture. With these notes and this series of self-portraits, Munch is therefore responding to *Das Kunstblatt*. However, he is also involving himself in a longer-standing debate begun in the mid-nineteenth century by Eugène Delacroix.

In a text published in September 1850 in the *Revue des Deux Mondes* (*Review of Two Worlds*), the French painter wrote the following about the drawing technique of Marie-Élisabeth Cavé:

> The daguerreotype is more than just tracing, it is the mirror of the object. Certain details that are almost always neglected in drawings from life take on significant characteristic importance here, thus introducing the artist to a complete knowledge of construction. Light and shade take on their true character, that is to say the exact degree of solidity or softness, a very delicate distinction without which there can be no projection.'[8]

Fig.127
Eugène Durieu
Standing Male Nude Holding a Pole
1854
Salt paper print
16.5 x 10.8
Bibliothèque nationale de France,
cabinet des estampes et de la
photographie, Paris

Fig.128
Eugène Delacroix
Study of a Standing Man
1854
Pencil on paper
Detail of a page, 25 x 40.2
Musée Bonnat-Helleu, Bayonne

Notes

1 Pliny the Elder, 'De la peinture et des couleurs', *Histoire naturelle*, Paris 1833, book 35, no.20, p.21.

2 See Arne Eggum, *Munch and Photography*, New Haven and London 1989, p.174.

3 Ibid., p.163.

4 See Paul Westheim, 'Gezeichnet oder geknipst?' ('Drawn or Photographed?'), *Das Kunstblatt*, 14th year, February 1930, pp.33–7.

5 Ibid., p.36.

6 See Eggum 1989, p.172. The article was not published.

7 This lithograph is usually dated to 1927. Given its strong resemblance to the photographic self-portraits, we would now like to suggest a date of 1930.

8 Eugène Delacroix, 'De l'enseigne-ment du dessin', *Revue des deux mondes*, 15 September 1850, reproduced in Christophe Leribault (ed.), *Delacroix et la photographie*, exh. cat., Paris, Musée du Louvre/ Le Passage, 2008, p.154.

Some years later, Delacroix also tested photography's pre-disposition towards rendering the organisation of masses of light and shade more successfully than drawing. In 1854, along with Eugène Durieux, he organised several posing sessions in which one drew while the other photographed the same nude models (figs.127, 128).

Eight decades later, Munch renewed the experience of comparing the two media, except he did not need a photographer, or models. He himself was all that was required. The analysis of the images shows that it was precisely this issue of the definition of light and shade that was of interest to Munch. He photographed himself against the light, or conversely with his face leaning towards the sun, allowing his nose to cast broad patches of shadow onto his cheek, and his profile to project in a bright glow. On the lithographic drawing it seems apparent that he attempted to represent the masses of light or dark with their 'exact degree of solidity or softness', to pick up on Delacroix's words once again. In the manner of the French painter, but in a context of the debate revived by *Das Kunstblatt*, Munch tries here to evaluate the respective qualities of the hand and the lens in the creation of a portrait. It is easy to understand this approach from a painter whose vision was greatly diminished.

Translated by Laura Bennett

99
Self-Portrait in the Studio at Ekely
1932
Photograph, gelatin silver
print on paper
11.4 x 9
Munch-museet, Oslo

100
**Self-Portrait in front of Two
Watercolours I, Ekely**
c.1930
Photograph, gelatin silver
print on paper
11.5 x 8.8
Munch-museet, Oslo

101
**Self–Portrait in front of Two
Watercolours II, Ekely**
c.1930
Photograph, gelatin silver
print on paper
8.8 x 11.2
Munch-museet, Oslo

102
Self-Portrait in front of *Metabolism*, Ekely
1931–2
Photograph, gelatin silver print on paper
14.5 x 8.8
Munch-museet, Oslo

103
Metabolism **with Shadow Effects and Reflection, Ekely**
1931–2
Photograph, gelatin silver print on paper
14.5 x 9
Munch-museet, Oslo

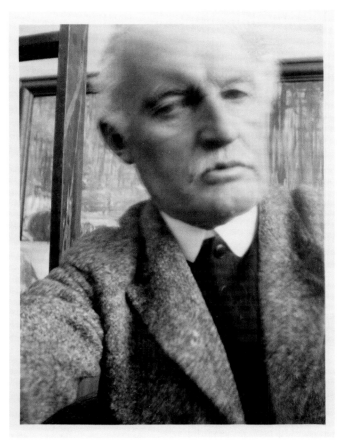

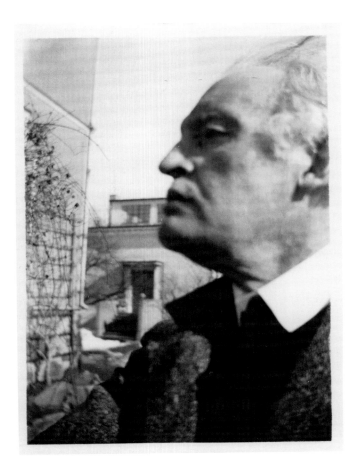

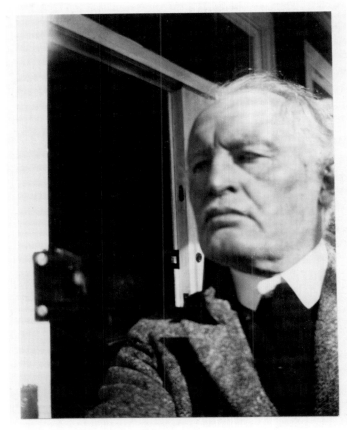

104
Self–Portrait in front of *Death*
of Marat **I, Ekely**
1930
Photograph, gelatin silver print on
paper (posthumous print from original
negative in O. Vaering's Archives)
11.4 x 7.8
Munch-museet, Oslo

105
Self-Portrait in front of *Death*
of Marat **IV, Ekely**
1930
Photograph, gelatin silver print on
paper
11.5 x 8.8
Munch-museet, Oslo

106
Self–Portrait in front of *Death*
of Marat **II, Ekely**
1930
Photograph, gelatin silver print on
paper
11.2 x 8.8
Munch-museet, Oslo

107
Self-Portrait in front of *Death*
of Marat **V, Ekely**
1930
Photograph, gelatin silver print on
paper
11.3 x 8.3
Munch-museet, Oslo

108
Self-Portrait with the Winter Studio
in the Background at Ekely
1930
Photograph, gelatin silver print on
paper
11.4 x 8.4
Munch-museet, Oslo

109
Self–Portrait on the Veranda
at Ekely
1930
Photograph, gelatin silver print on
paper
10.8 x 8.2
Munch-museet, Oslo

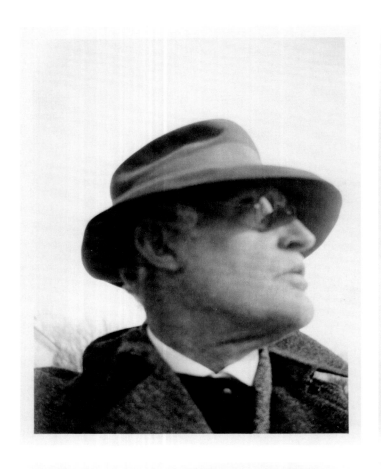

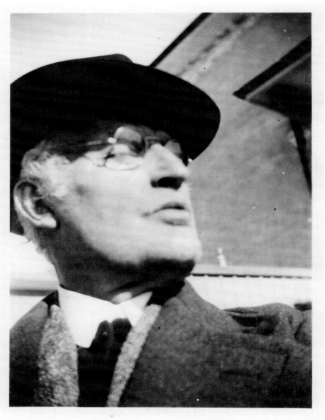

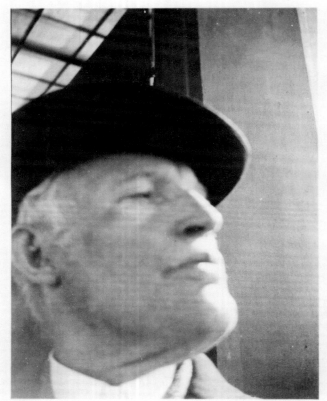

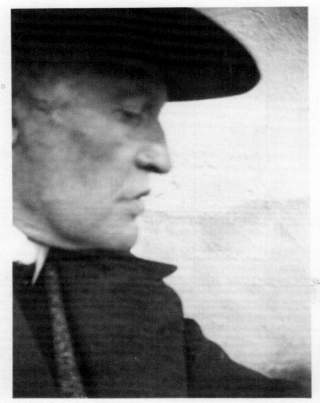

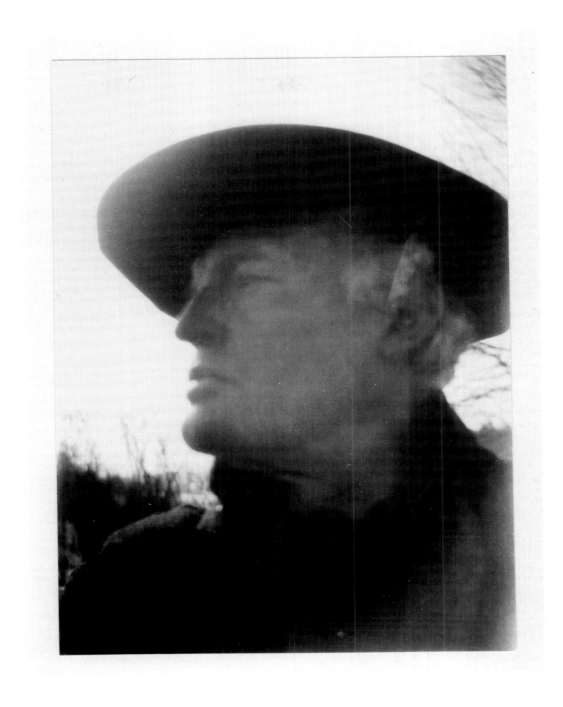

110
**Self–Portrait with Hat and Glasses
at Ekely**
1930
Photograph, gelatin silver print on
paper
11.2 x 8.8
Munch-museet, Oslo

111
**Self–Portrait with Hat outside the
Winter Studio at Ekely**
1930
Photograph, gelatin silver print on
paper
11.4 x 8.8
Munch-museet, Oslo

112
**Self–Portrait with Hat and Glasses
outside the Winter Studio at Ekely**
1930
Photograph, gelatin silver print on
paper
11.2 x 8.5
Munch-museet, Oslo

113
**Self–Portrait with Hat (right profile)
at Ekely**
1930
Photograph, gelatin silver print on
paper
11.2 x 8.6
Munch-museet, Oslo

114
**Self–Portrait with Hat (left profile)
at Ekely**
1930
Photograph, gelatin silver print on
paper
11.7 x 7.9
Munch-museet, Oslo

Paul Westheim
Drawn or Snapped? [1]

In February we will be presenting an exhibition of portraits in the public rooms of Reckendorfhaus: drawings, prints, some sculptures, each accompanied by a photographic image of the same subject. The artists represented in the exhibition include Munch, Thoma, Liebermann, Corinth, Matisse, Kirchner, Kokoschka, Meidner, Dix, Beckmann, Grosz, Grossmann, Kretzschmar, Nay, and the photographers Erfurth, Lerski, Riess, Yva, Stone, Hoinkis and more.

This assortment will, we do believe, raise some questions. (Which would be a gain: an exhibition that rouses the viewer. Rouses him to take this or that stance regarding the matter of the representation of living people, which constantly recurs as a new problem, again and again.)

It is our hope that one question, which has exercised artistic minds for so long – much too long! – that is to say, whether the photographic image is art, too, whether the painter can with justification look down from the heights of Olympus half in pity and half in scorn at the man with the snap-box, who works not with brush and pen but with lens and silver-bromide paper, it is our hope that this question will no longer trouble anyone. Fundamentally, is not the aim the same in one as in the other: contrasts of light and bodily volumes and the rendering of these contrasts in a planar image?! And by now we have surely also learnt a thing or two. It is a sad fact that much, so endlessly much of what is painted or maybe sculpted, is not art but un-art, and if we had only already arrived at the point where the two were kept cleanly apart, then the complaint would not be that there are so many art exhibitions but rather there would be outrage, rightful outrage at the untold number of un-art exhibitions, which who exactly wants to see?! No need to

add that what most photographers serve up to their clients, even if the portrait is 'nauseatingly similar' (as Liebermann put it), is of scant interest. But just as there is a difference between what Liebermann can do and what, let's say, a dilettante Arno Nadel churns out, exactly the same as the difference that exists between the achievement, the quality, the sheer personality of a Lerski or an Erfurth and the man who has to deliver happy wedded couples by the dozen.

The best that art has to give us is perhaps not even a painted picture but the enablement to see, better, more truly, and the ability to learn to see more vividly. But seeing more truly, more vividly also means living and experiencing more intensely, being more active than those 'who have eyes but do not see'. And we know that everything depends on one's mindset or as we say of artists, encumbering them with big words in the time-honoured manner, on one's *Weltanschauung*. That photographers are above all dependent on how things are set – anyone who is still not sure about that, despite the immense photographic exhibitions presented last year, need only take a closer look at Werner Gräff's book *Es kommt der neue Fotograf* (*Here Comes the New Photographer*). What is striking is not the What, but how the new photographer treats his subject matter, how he composes with his particular means: light and dark, perspective, superimposition, details, and so on. And no words need be lost pointing out that these new photographers are supremely able to see, more than that – that many of their works are pre-eminently suited to opening our eyes, to teaching us to see things and forms that we were never previously able to see with such intensity. To what extent that is a capacity of art need not, as we said, concern us here. Without doubt the technical developments that the new photographers have presented us with have widened our horizons, in a word, have enriched us. Be they artists or be they photographers, it could be very interesting to compare, using the possibilities open to us today, how they solve the greatest task of art throughout the ages – creating a likeness of a human being.*

The first question that the viewer of a portrait always asks is the extent to which it is a true likeness. For the last thirty or forty years artists and art-interpreters have constantly reiterated the same thing: likeness, why, that's not even of the slightest importance. This can only be understood in light of the aestheticising attitude that shaped the art-production and art-experience of those earlier generations. The days of *fin de siècle*, the days of the aestheticising snob are – praise the Lord – over, even if some people, as though nothing had happened, as though things are as they ever were, still seem to be living in those not so good, old days. We, today's people, who no longer have time for the kind of art that has to be preserved under a glass cloche, who are of the opinion that art is not to be placed somewhere outside life but feel that in its own, that's to say, spiritual,

way, it is supposed to serve life, we find the layman's enquiry as to the likeness not at all shocking. We even find it justified in the case of a portrait. The point of the portrait is, after all, to present him, the layman, with a picture of a particular person. He wants to know what Frederick the Great looked like, he wants to have a picture of his father, his wife, his child – as they are. It is not enough that this picture is a work of art, it also has to be an authentic representation of that one, particular person. If artistic work is defined as non-purposeful forming, then the portrait is clearly something other than that, namely purposeful forming. I remember once, in the company of some by no means unknown Parisian painters, a perfectly serious discussion as to whether the portrait, in the sense of purposeful forming, should not in fact be regarded as the preserve of the applied arts. Of course that's a paradoxical exaggeration, but the justified expectation of likeness does touch on an issue in portraiture, which the artist is otherwise unfamiliar with.

Which brings us to Pontius Pilate's question: what is truth? Or rather, what is a likeness? Naturally, in any discussion of 'likeness' one is hardly likely to trust the opinion of the artist who has been saying for decades that likeness is of no importance. The immediate assumption is that it is not a likeness! This may often be the case, but all too often the viewer has fallen victim to autosuggestion: it is by an artist, therefore it cannot be a likeness. At the same time, it is impossible to imagine a photographer not producing a likeness, unless he is generally known to bungle his work. Without doubt, there is always a strong element of suggestion. Take the situation where you happen to see photographs of a well-known public figure, by all sorts of different photographers, as a group, side by side. Were all these shots the same, or only similar? How endlessly different were all their 'approaches' – no less different than if the same number of artists had drawn or painted that figure. There are some examples of this in the exhibition: the same head taken by different photographers. Additional examples that would have been very compelling in these circumstances unfortunately had to be excluded since there was so much else we wanted to accommodate. The photographer Yva once made a whole series of shots of a well-known actress, each one different, so very different that without the express confirmation that it was the same woman every time, one would have been convinced that these were pictures of a dozen different people. But we do not even have to go that far. Anyone who has ever been photographed will have experienced something of that sort. Three or four pictures are taken – one 'captures' the subject better than the others. Friends and relatives are asked for an opinion; it turns out that first this and then that picture is identified as the 'best likeness' and that almost always certain pictures are rejected as nothing like the subject. Sometimes the photograph has chanced on a characteristic look, sometimes

not. The camera does not lie; it shows exactly what it was set to show. How much that can be a matter of *corriger la fortune*, how effectively one can flatter with photography, especially with photography, surely hardly need be said?! And although the camera may not lie, it can also lie very excellently indeed. Maybe, just maybe, that is even the reason why photographic pictures are so widely popular.

Schopenhauer – whom we know not to be the person who gazes down on the Frankfurt Promenade, a trifle bored, from the plinth of his memorial – objected to the painter Hamel's determination to portray him in exactly the perfectly ordinary way that he saw him sitting there. Schopenhauer actively resisted this inferior mode of representation and of being represented: 'This portrait,' said he, 'is an astounding likeness, it is most accurately painted – but it is not I. That is a petty village elder. Take note, young man, a portrait should not be a mirror image, that is better done with a daguerreotype. A portrait must be a lyrical poem, through which the whole personality talks to us, with all its thoughts, feelings and desires.' An artist, as long as he is not that kind of a Hamel, always strives to portray not only the features of a person, but the entire personality. He does not create a mirror image, he depicts characteristics. How telling is the head of Döblin by Kirchner; the photograph taken at the same time seems so dated. And if, in his representation of an entire personality, the artist suppresses certain details that are not characteristic of the person as a whole, then this is so that he may arrive at a visual concept of that particular person. In so far as he is a forming artist, with no desire to merely produce a flattering paraphrase for the salon – which is still much favoured by some – he will try to create what I call an essence-portrait. That is to say, aside from the visual aspect of the portrait, he will convey a concept or at least a sense of the spirit of the person whom he is portraying. At present this is not possible with mechanical means, for all the advanced nature of the technology and however sophisticated the apparatus; but who knows, perhaps they will surprise us yet …

The reluctance, that wariness of going to a painter or draughtsman these days, even to a photographer – for many hardly different to their fear of going to the dentist; after all, you have no idea how things will turn out – presumably arises from the fact that people are not clear as to what they want to have portrayed: the person or the personality.

By the way, a fantastic notion, what if … what if photography had already been invented some hundreds of years ago? What if, as we are doing today in our exhibition, we could place Dürer's drawing of his mother, Cranach's portrait of Luther or that wholly exceptional sequence of portrait drawings by Holbein next to the corresponding photographs of those subjects? How much that would surely reveal of the work of those masters and of the psychology of artistic creation per se!

** We refer readers at the same time to the special Portrait issue we published in March of last year.*

Note
1 On the Kunstblatt Exhibition, *Portrait-Drawings, -Prints and -Photographs* at Reckendorfhaus, Berlin, in February 1930.

Translated by Fiona Elliott

Edvard Munch
Response to *Das Kunstblatt*

I would like to suggest to you to start the
 debate
Photography – Portrait and
Painted portrait
Photography and Portraiture
The first condition is that when one wants to
create a portrait
it should become art

The second condition for
a portrait is that it should not have a
 resemblance
– The first condition is that
it should be art
So resemblance is permitted – I ask him
firstly to find a photographer I add –
it is, in fact, difficult for an artist to avoid
resemblance
When one comes to me to be painted and
and I ask him to speak to a photographer –
For all that, I can well admire and understand
Dix who through artistic concern has
to strive for distinct resemblance –
A mechanical production made by a judicious
 hand
can provide good results –
All the same – I admire Dix just who through
artistic concern strives for and enjoys finding

exact resemblance
Their response is always – No I want
a work of art –
Alright then – so you must accept
a work of art –
– But one does not
– The wish – is for the painter to see
like a camera –
– The person must
be seen in the way that he knows he is – As
he sees himself
during the thousands of secret moments
over the course of the many dramas of life –
– as his tailor has seen him – and that allure
he wanted to give him –
as his sweetheart has seen him –
(as his mummy – has seen him)
and as his many cousins has seen him –
Only not as the artist sees him
– He must be as people
have seen him on the balustrade
a public man –
Only not the first
impression that is the first condition
for this to become a work of art
What would one say if a
poor painter wanted to paint
a flock of geese – and they all began
suddenly to squawk
and refuse his way of painting them –
Or if a painter sits enthused
by a red house in a landscape – and
in the middle of his work he hears
the house cry out through its gate –
That is not what I look like – my lines
and my colours are finer
It does not look like me
Kunstbladet's edition on photography
is interesting – and contributes to the solution –
everything in its place – Photography in its
 place –
Art in its place – and art [is just] assisted
And for once it is good to be able to say:
Impressionism is neither a main station
nor a terminus station
The train continues on –

Edvard Munch
Note, MM N 305
early 1930s
Oslo, Munch-museet

*Translated by Luce Hinsch
and Laura Bennett*

THE AVERTED EYE

'Every year, as if determined to record the result of the passing of time, he produced a self-portrait,' wrote Munch's collector and friend, Rolf E. Stenersen. Munch intensified his production of self-portraits during the second half of his career. He painted more than forty of them between 1900 and 1944, compared to just five in the nineteenth century, not taking into account his many drawn, engraved or photographic portraits. Through self-portraits Munch turns the gaze inside out. This is particularly apparent in the series of drawings and paintings that he created in 1930, when a haemorrhage in his right eye interfered with his vision. By drawing and painting what he could see through his damaged eye, the Norwegian artist depicted his gaze, vision itself, or the 'inside of sight', to pick up on a proposition suggested by Max Ernst in the same period. Yet again in this way, Munch provides evidence of his modern eye.

115
The Artist's Injured Eye: Optical Illusion from the Eye Disease
1930
Watercolour and pencil on paper
49.7 x 47.1
Munch-museet, Oslo

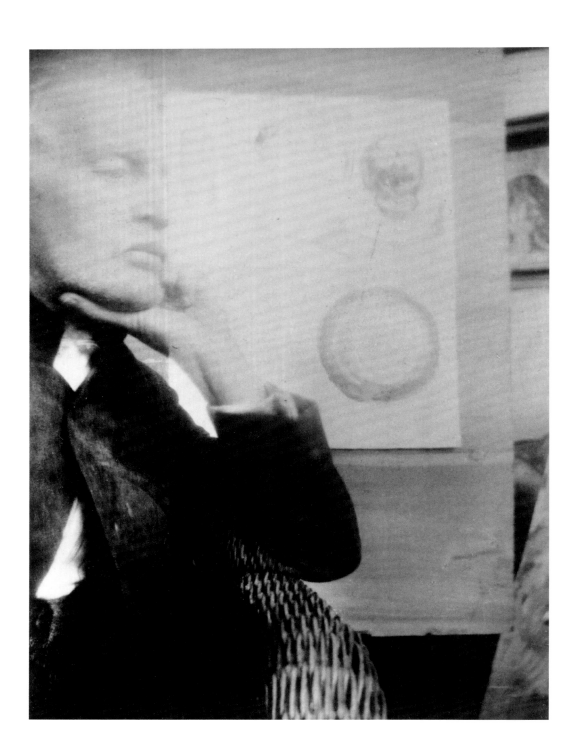

Ingebjørg Ydstie

'Painting is what the brain perceives through the filter of the eye'

Fig.129
Self-Portrait, Ekely
1930
Photograph, gelatin silver print
on paper (posthumous print
from original negative in
O. Vaering's Archives)
11.6 x 8.6
Munch-museet, Oslo

Munch sustained a serious eye injury in 1930; a rupture of the retina led to a haemorrhage in the vitreous body of his right eye. Munch had been suffering from hypertension, which may have had a triggering effect. The ophthalmologist Dr Johan Ræder was sent for; he attributed the injury to chronic strain and prescribed rest. The medical report was written both in Norwegian and German, in order to shield the patient from any taxing communication with the outside world.

> The painter Mr Edvard Munch is suffering from an acute ocular disease caused by persistent overexertion. He requires total physical and mental rest for a long period of time. Any disturbance, whether verbal, written, by telephone or telegram is to be completely avoided.[1]

Munch considered his right eye to be his better one; precisely the one he used for painting. He had reduced visual acuity in his left eye, a handicap that he attributed to a blow he had received in a fight in 1904.[2] On 25 February 1932, Ræder renewed the medical report, adding: 'The injured eye is the one with which he has always worked, [... given that] the vision in the other eye has always been weaker.' In March 1938 a new medical report specified that 'a similar condition has also affected the left eye, so he [the patient] is now threatened with complete blindness in both eyes'.[3] Munch's fears about the possibility of such an impairment were well-founded, but he would never again fall as ill as he had in 1930.

In a note dated 2 June 1930, while Munch was still unable to paint, he describes the spectacular visual sensations that resulted from the injury:

> A large, dark bird moved slowly in front of me – with dark brown feathers – a vivid blue hue emanated from it that went over to green and then to a lovely radiant yellow ring –
> It moved about as I crossed the room – and everything it touched with its colours moved – Serpents crawled around

the legs of chairs and table – around the chaise longue fat serpents in the most magnificent colours moved and twisted – [changing] to a dark brown – to carmine – cinnabar and golden yellow. It flew up onto the wall and the entire room began to move … at night while I was sipping my glass of wine – another world lit up – fireworks of gold.[4]

Over the following weeks and months the haemorrhage was slowly reabsorbed. Munch gradually recovered his sight over the summer. During his convalescence, in August and September, he created a systematic graphic documentation by projecting on paper the impressions of his diseased retina, resulting in a series of vivid watercolours and drawings. As always, the artist studied what he could see; this time the distortion that the injury had caused in the internal workings of his eye. This small group of artworks forms a remarkable artistic, medical and personal document that provides a glimpse into Munch's working methods. Covering his left eye with his hand, he obtained a greater concentration of the problems in his right. He painted what he was able to identify as vibrant and dazzling concentric circles (no.128). This effect may have been achieved by exposing his eye to the sunlight, or to stark electric light (no.115).

He studied the spot with different pairs of glasses, with blue lenses and in a variety of lighting conditions including sunlight, electric light and the light at dusk (no.129). He also made renderings of the feathered bird that he had described in June, and which he now described as a swarm of crows (nos.120, 126). In a long note from September 1930 he described the dynamics of his condition as follows:

The dark spots, like small flocks of crows, often appear high up there when I look up at the sky – It is conceivable that it is the residue of blood that has collected around the periphery of the damaged spherical area – which becomes scattered when submitted to a sudden movement or the impact of intense light. It could be that it is absorbed or dispersed by the fluid that lies around the sphere – The large shaft that seems to originate from the iris could be an accumulation of the black specks, which take 10 minutes to disappear. One could say that when the specks lie on the other side of the periphery, the circle is clearer and redder, or that the bird's beak with the body are more clearly visible.[5]

As the spot diminished, Munch began to integrate it into the drawings he was making of his surroundings. The organic structure of the eye was at this point able to form a cicular shape surrounding a menacing bird. In a drawing dated 20 September 1930 he noted that the opening of the bird's beak was wider, that a new kind of sharp beak had appeared, and that the bird's neck seemed longer than it had been (no.121). In a watercolour dated from the same day, he depicts a landscape of a house on a road in acute perspective, in which the shape of the ominous beaked bird with widespread wings appears in an eye-like figure in the shape of a moon (no.123). The same day, the artist directed his injured gaze at a tree and wrote beneath a drawing 'Blue spruce 7m distant, 3½ metre tall' and beneath another 'Blue spruce 3m distant, 2m tall'. Munch had a remarkable sense of distance and was also particularly skilled in drawing perspective. Once again we can see a concentric eye on the sheet, with the comments 'Dark violet. ½ metre distant from white door. Electric light', followed by a succinct metaphysical question: 'Do ghosts exist?' (no.126). The note shows that Munch compares his injury to his long-standing questions about spiritualism. His diseased eye interested him as a source of perceptual effects that a physiologically healthy eye would never have been able to capture. On 28 September he recorded the following phrase on a watercolour representing a country road punctuated by a post: 'The eye's point of focus at the top of the post is invisible' (no.124). The stain on the post now

looks like a circle with long threads, almost like an observed real object. A nocturnal scene is sketched on the same sheet; this time the stain is shown hovering near a tree, as if it were hanging off one of the branches. The eyeball is rendered as a round, moon-shaped disc. If we were not aware of the existence of this code, caused by the diseased eye, the shape could be interpreted as a reference to an external natural object, and not as the expression of an internal distortion of the eye. In another watercolour, Munch has turned his weakened gaze on a group of moving people (no.125).

An examination of the sources of Ræder's notes and medical reports does not allow for an exact diagnosis of the haemorrhage, which is interpreted as one of the consequences of Munch's nervous exhaustion. The painter's notes on his drawings and visual experiments do not contribute towards clarifying the medical causes. Nevertheless, it is interesting to note that Munch anticipated by seventeen years the methods of the Swiss doctor Marc Amler, in the diagnosis of macular disorder, although the doctor was not aware of the artist's in-depth observations.[6]

In Munch's case, however, a clinical objective interest in the subject was coupled with a subjective artistic study, and linked to self-representation marked by anxiety and death. 'Painting is what the brain perceives through the filter of the eye,' wrote Munch in an undated note, an idea that may well have been formulated during this period, but which represented thoughts about perception that he had developed long ago.[7]

In a watercolour where he portrays himself as a bedridden patient, Munch covers his left eye with his hand. Here the blind spot takes on the shape of a sniggering blue skull that hovers above the artist's bed (no.127). In another equally sinister watercolour, the bird image becomes the physical manifestation of an animal fiercely attacking him. Munch depicted himself naked and vulnerable, on his knees, about to be annihilated by the overwhelming ferocity of this disembodied bird of prey (no.122). The constant mental fatigue that the illness must have caused him is forcefully expressed here as an excruciatingly painful and crushing destructive force. In another striking self-portrait, Munch depicted himself up close and again with his hand in front of his left eye, facing the wounded eye's winged bird of prey (no.117).

Munch also made his illness the subject of two highly expressive paintings, in which the dramatic power of self-representation was fuelled by the manifestation of anxiety (nos.116, 118). In one he made an explicit reference to the figure of *The Scream*, his 1893 masterpiece. The picture already formed part of the Nasjonalgalleriet collection, but the artist had painted a new version for himself, most likely in 1910 (fig.130). He would have therefore been able to study the picture closely when working on this self-portrait. With its title *The Scream*, Munch indicated that he had created a picture with colours denoting sound. All his writings on *The Scream*, such as the one from 1892, made it clear that the point of departure for the picture was an actual sensory experience: 'I felt as though a scream passed through nature – I thought I heard a scream.'[8] This pictorial representation of modern existential angst is an essential marker in Western art. The picture's apparent rough and immediate quality rests on careful calculation in which little is left to chance. It would be a mistake to see *The Scream* as an acute painterly outlet for spontaneous feelings.[9] It is therefore interesting that Munch, in his in-depth study of his ocular disease, should have linked the theme of *The Scream* to difficulties in perceiving colours and sounds. He sometimes suffered from hearing disabilities, mainly connected to recurrent colds. 'For I have often suffered from terrible ear problems myself,' Munch wrote with empathy to his sister Inger who was suffering in this way at the same time that he was afflicted by his eye disease.[10] He obviously felt that his entire sensory system had been subjected to duress. The

use of the figure from *The Scream* in his self-portrait with the injured eye bears witness to personal despair, but also to an awareness of links between sounds and colour effects, which he thought of as an analogy between painting and music.

'What we hear are sound waves that are absorbed by the membrane in the ear – What we see are light waves that affect the membrane of the eye. Poetry is the perception of waves by the eye and the ear. Painting is what the brain perceives through the filter of the eye.'[11] Munch emphasises his suggestion with a reference to *The Scream*: 'These light effects not only resulted in oscillations of the eye, they also resulted in oscillations of the ear – so that I actually heard a scream. I then painted the picture *The Scream*.'[12] He spoke of the sensory apparatus as a 'receiving device' and speculated in an earlier note as to how vision would have evolved if man had been deprived of other sensory mechanisms:

> We see what we see – because our eyes that are made constituted in such a way – What are we – [other than] a concentration of energy in motion … Had we had different, stronger eyes we would be able, like X-rays – to reveal … the skeleton – had we had different eyes – we would be able to see our external astral casing – and we would have different shapes.[13]

Munch had a holistic and romantic understanding of the existence of cosmic life in all things. In a speculative way, he perceived a mystical kind of intersubjectivity with his environment, in which a hidden nature revealed itself to him. This audacious understanding supported his profound fascination with photography, radio, X-rays and electricity. But he could also imagine this concept in the form of spiritual wavelengths.[14]

The hypersensitive interest that Munch demonstrated for variable conditions of observation constitutes one side of his perceptual self-observation, and was recognised as one of the creative and exploratory factors of his work early in his career. Arne Eggum noted that the method of self-discipline that Munch adopted in order to study his ocular disease had also served as a foundation for the artwork that had initially made him famous, *The Sick Child* (1886; see the versions from 1907 and 1925 (nos.12, 13). Munch later explained that the painterly expression centred on the focus he applied to the child's head, while the other parts of the picture were painted in peripheral vision.[15] He also revealed that he had fluttered his eyelashes in order to obtain a diffuse perception, giving the impression that the depiction of the sick young girl was seen through tears. This radical experimentation stretched the limits of the naturalist method in which Munch had been trained. Eggum also supports his suggestion with a note from August Strindberg, written for his essay *Deranged Sensations*, published in 1894. The playwright described a similar sensory experience, marked by 'tears with their corrosive salts that have affected my corneas so that it has been granted me to see my own blood vessels projected as if by a magic lantern'.[16] Munch's radical visual experiments unquestionably served as a foundation for Strindberg's experimental approach.

Munch would not repeat the work linked to his eye disease after the brief and intense phase of the autumn of 1930. One of the reasons was, of course, the improvement in his condition, but the study had also provided artistic results that were satisfying enough for the painter to consider them solved. Some months after Ræder reissued his medical report in 1932, the doctor wrote to him that it had been 'an honour and a pleasure for me to treat the eyes of our greatest artist' yet, at the same time, thanked him for the portrait of a doctor friend of the painter. It was not by chance that Munch chose to give him a lithographic portrait of the professor, Kristian Schreiner (no.81).[17] Schreiner later repeated a remark made by Munch during a conversation at Ekely: 'Here we are, two anatomists

Fig.130
The Scream
?1910
Tempera and oil on unprimed board
83.5 x 66
Munch-museet, Oslo

sitting together; one an anatomist of the body, and the other of the soul. I know full well that You would like to dissect me. But beware, I too have my scalpels.'[18]

Munch had the greatest respect for scientific knowledge but he valued his own experiences just as much, and considered his visual observations equally valid, and this undoubtedly also applied in relation to Ræder. Munch often said that he was ten years ahead of scientific discoveries and, in the 1930s, he compared radio lectures and popular science articles on physical and biological phenomena with his own visionary theories.[19]

Despite this quasi-scientific attitude, Munch held firmly to his belief in the dramatic origin of his injury in the violent fight of 1904. In a short text entitled 'the Christ painter', he illustrated the injustice of his suffering with the drawing of a man stabbing another in the eye (fig.131). In Munch's paranoid depiction, the attack was a deliberate and malicious conspiracy, brought on by the blatant envy aroused by both his fame and his talent: 'He has one good eye and one bad one – Let us pluck out the good one – he can use the bad one to paint … It will feel really good [sic] – when he is reduced to painting badly – With the bad eye we will come forth.'[20]

A handwritten note found in Munch's archives, probably written by Ræder, describes the symptoms in concise scientific terms and concludes that the blindness was most likely the outcome of hypertension.[21] Munch learned to use each eye alternately according to its respective abilities, both with and without glasses. Nor did he follow Ræder's order prescribing sufficient rest; he continued to read, even though the text was marred by shadows. There was no doubt, however, that he did use the doctor's medical report as a means to avoid unwelcome contact with people he did not wish to see. When his left eye was affected in 1938, he was given a harsh reminder: 'When one eye is endangered then they both are, for they have the same roots,' he remarked in a later interview.[22]

Like most people, Munch tried to bear the afflictions of old age with dignity. In the draft of a letter to an unknown recipient in 1939, however, he complains of people's tendency to view his woes as ordinary afflictions. He, a well-known painter, felt it was an injustice to have to manage the practical trivialities from which an artist should have been spared:

> When you think about it, you will surely be able to understand that I toil with a worn out body and many things have contributed to wearing down my nerves – It has not been easy for me to be compelled to explain this to people and almost always be met with a shrug of the shoulders – 'That is how it is for everyone.' I have in fact destroyed the eye that I have used to paint all of my pictures with and I must continue to paint with my poor reserve eye, the left one, and even so with strong glasses – Last year I nearly destroyed this one as well – It is because I have been burdened with all manner of things that have nothing to do with my profession.[23]

It is interesting that Munch should use the term 'profession'. His speculative theories on 'crystallisation' and the metaphysical relationships between microcosm and macrocosm were in no way academically sound, whether in the field of natural sciences, the theory of perceptions or philosophy. Munch cannot be considered an intellectually schooled artist, but rather as a receptive and exceptionally sensitive interpreter of the ideas of his time. As an artist, on the other hand, he was impartial in his investigations and as an experimentally driven craftsman he was unsurpassed. It is through the probing exploration of his own sensory experiences that he was able to arrive at radical visual innovations in his artistic production. Munch's consistent work with his ocular disease as subject matter represents a relatively isolated body of work, yet it allows us to get right to the heart of his artistic creativity.

Translated by Ingrid Junillon and Laura Bennett

Notes

1 Dr Ræder's prescription, dated
10 May 1930 in Oslo, Oslo, Munch-
museet Archives. For an exhaustive
interpretation of Munch's eye disease,
see Arne Eggum, *Munch og fotografi,*
Oslo 1987, pp.174–9; Michael
F. Marmor, 'Munch and Visions from
Within the Eye', in Michael
F. Marmor, James G. Ravin, *The Eye
of the Artist,* Saint-Louis (MO) 1997,
pp.204–12; Atle Næss, *Munch. En
biografi,* Oslo 2004, pp.485–7.

2 Munch often returns to the subject
of the confrontation in his correspon-
dence and notes, see for example MM N
666 (in which the 1904 fight with
Haukeland is seen as the cause of the
illness that worsened in 1938), MM N
354, MM N 429 and MM N 430 (in which
he mentions a 'blow to the eye with a
ring made of iron'), Oslo,
Munch-museet.

3 Ræder's prescriptions, dated 27
September 1930, 25 February 1932 and
29 March 1938 respectively, Oslo,
Munch-museet.

4 Oslo, Munch-museet, MM T 2748,
ms.59.

5 Oslo, Munch-museet, MM T 2167,
respectively dated 7, 10 and 12
September 1930.

6 Marmor and Ravin 1997, p.208.

7 Oslo, Munch-museet, MM T 2747.

8 Oslo, Munch-museet, MM N 72;
for an overview of texts about *The
Scream,* see Øivind Storm Bjerke,
'Scream as Part of an Art Historical
Canon', in Ingebjørg Ydstie ed., *The
Scream,* Oslo, Munch-museet, 2008,
pp.31–6.

9 Biljana Topalova-Casadiego, 'The
Two Painted Versions of Scream: An
Attempt at a Comparison Based on
Technical Painting Characteristics',
in Ydstie 2008, pp.87–99.

10 Oslo, Munch-museet, MM N 1341
(probably dating from the 1930s, given
the reference to his ocular disease).

11 Oslo, Munch-museet, MM T 2747.

12 Ibid.

13 Oslo, Munch-museet, MM T 2785,
ms.102.

14 Ibid., MM T 2748.

15 H.P. Roede, 'Edvard Munch på
klinikk i København', *Kunst og
kultur,* 1963, pp.69–70;
see also Eggum 1987, p.30 and p.177.

16 Extract, quoted in Eggum 1987,
p.177, published in August Strindberg,
*Samlåde Skrifter. Prosabiter från
1890–talet,* Stockholm 1917, p.543.
Strindberg published a text with the
title 'Sensations détraquées' in *Le
Figaro, Sunday Literary Supplement,*
dated 17 November 1894, but this
quote is not included, contrary to
Arne Eggum's erroneous indication.

17 Letter from Ræder to Munch,
dated Oslo 18.4.1932, pp.106–7, Oslo,
Munch-museet.

18 Kristian Schreiner, 'Minner fra
Ekely', in *Edvard Munch som vi
kjente ham. Vennene forteller,* Oslo
1946, pp.18–19.

19 Oslo, Munch-museet, MM T 2748,
note 4, with the respective dates of
February 1930 and June 1939.

20 Oslo, Munch-museet, MM T 248.

21 Oslo, Munch-museet, MM N 351.

22 Interview with Munch by N.
Rygg, in which he also refers to a
dental operation as the possible cause
of the 1930 injury, *Kunst og Kultur,*
1946, pp.106–7.

23 Draft letter by Munch to an
unknown recipient, probably a close
friend such as Jens Thiis or Christian
Gierløff, MM N 281, c.1931; also see the
sketch of Munch's letter to his sister
Inger, dated 10 July 1942, MM N 1241,
Oslo, Munch-museet.

Philippe Lanthony

The Entoptic Vision of Edvard Munch

In 1930, at the age of sixty-seven, Edvard Munch suffered from a sharp decline in the sight in his right eye. He consulted Dr Ræder, a professor of ophthalmology in Oslo, who diagnosed an intraocular haemorrhage, possibly resulting from arterial hypertension. The painter's sight gradually improved over the following weeks and he then began to depict, both through drawing and painting, the distinctive visual impressions caused by the pathological changes in his eye, or to paint what is otherwise known as 'entoptic vision'.

Entoptic vision is the visual phenomenon that consists in observing the structures that belong to our own eye.[1] It would be incorrect to refer to an 'optical illusion' here, because these entoptic images have a genuine anatomical cause, and although their visual expression is subjective, their determinism is completely objective. Entoptic phenomena have been known about for centuries, and were studied in detail by physiologists such as Johannes Evangelista Purkinje (1787–1869)[2] and Hermann von Helmholtz (1821–1894).[3] They usually pass unnoticed in everyday life due to their permanence, but they become noticeable when they are secondary to eye conditions because their occurrence is shocking and worrying for the patient. A common example is the appearance of 'floaters', small dark spots that move around at will within the field of vision, particularly when the eyes move. If the patient is an artist, he can readily represent these through drawing. The Swiss painter and writer Rodolphe Töpffer (1799–1846) provided an unusual illustrated account of these phenomena, which he picturesquely named 'toads' and 'jelly-like threads'.[4] The scientific illustrator Lee Allen (1910–2006) observed and drew the haemorrhages caused by the degeneration of his retina. At the start of his study he said: 'When I first noticed the spots in my vision … I knew immediately that it was my responsibility to record them. They were, however, strictly internal images that could not be photographed, so I started to make free-hand drawings of what

116
Disturbed Vision
1930
Oil on canvas
80 x 64
Munch-museet, Oslo

I, but no one else, could see.'[5] Munch undoubtedly followed the same reasoning, but he went beyond the simple ophthalmological semiology, and the representation of his entoptic images led him to study the fundamental phenomena of the representation of space in painting.

Munch's Entoptic Imagery
The first images Munch represented were simple circular shapes, containing patches of different colours and textures. The light centre suggests that this is the appearance of the field of vision when the eye is staring at a light source. It is surrounded by coloured rings, but the order of the colours does not depict that of the spectrum, something which excludes the optical process of diffraction (nos.115, 128, 129).[6]

The works in which Munch depicted himself are considerably less ambiguous, hiding his left eye with his hand in order to study what he could see with his diseased right eye. One of the first of these shows a figure lying in a bed, concealing his left eye and observing a large blue-black patch in front of him through the diseased right eye. The patch has the appearance of a skull, thanks to a row of teeth, a detail clearly added afterwards for the morbid effect obtained. Sticking with the simple painted image, one might conclude that this patch depicts the medically diagnosed ocular haemorrhage, and is a positive scotoma in the centre of the field of vision (see no.127).

A second drawing shows Munch hiding his left eye as before, in order to observe his entoptic image through his right eye. This is not a genuine self-portrait created with the help of a mirror, since the image does not show the left-right reversal, but rather a convincing self-representation. The illustration here is much more telling; the observed patch has the shape of a large bird occupying the lower part of the painting, with a small, rounded, ring-shaped head and a long, thin beak. The appearance of this ring is well known to ophthalmologists, who

see it daily in their clinical practice. It is that which is observed when the vitreous body becomes detached (see no.117).

Vitreous Body and Entoptic Image
The vitreous body is a semi-liquid mass, similar to an egg white, which fills the entire cavity of the eyeball, located behind the crystalline lens. It is bordered by a wall, which is in fact simply a peripheral condensing of its substance, and adheres to the retina, the innermost layer of the coatings of the eye. This adhesion is marked, in particular, by a thickened ring near the optic nerve disc, the point at which the optic nerve leaves the eye. As the eye ages, the vitreous mass becomes detached from the retina, particularly where the ring surrounds the optic disc. This detached vitreous ring is clearly visible to ophthalmologists examining the fundus of the eye with an ophthalmoscope (fig.132).[7] This detached circular shape, however, near the visual axis, is also visible to the patients, who readily describe it to their doctor as being like a 'hoop', 'ring', 'crown', or an 'eel', 'butterfly net' and even a 'sperm'. It is this then that Munch interpreted as the rounded head of a bird, its beak being the vitreous extension (no.116).

The Spatial Location of the Entoptic Image
The representation of space in painting was of particular interest to Munch (see 'Optical Space', pp.80–105), as is shown by his studies of perspective, motivated by his fondness for photography. He could not have failed to wonder 'How is it that I can see a bird in my field of vision, at a certain distance in front of me, when the physical cause, the haemorrhage, is inside my eye?' In everyday life, we have the impression that objects are visually positioned in the physical surroundings to which they belong. However, when the physical object causing the entoptic image is located within the eye itself, we do not position the entoptic image inside the eye (that would make

little sense) but at a certain distance within the surrounding space. Where exactly? In order to answer this question, Munch added visual indications and began to paint the subjective bird located in the objective environment. He drew the room he was in, marking the vanishing point, perspective and the relative size of the objects. In *The Artist with a Skull* (see no.127), the entoptic image (the skull) is represented as being close to the eye (less than one metre). The subjective image of the skull has a size around twice that of the head of the painter, spatial indications that already show that the entoptic image is seen in a near space, and that it is a notch in the field of vision in the form of a positive scotoma.[8] Munch clarified this spatial data in two representations of the room he was in (fig.133).

The two pictures have the same format; they have the same viewpoint, and the two birds are the same size. What is different is the figure (self-portrait or self-representation), which is twice as large. This variation in the size of the figure simply means that he is further away; but the constant size of the subjective bird means, in the same way, that he does not appear to have changed position. In this indoor setting, the entoptic bird appears much closer to the observer (or rather to the point of view of the painter) than any other object in the room. The figure depicted in the background has an uncertain role, as the point of view appropriate for looking at the picture is that of the painter or the spectator, for whom the foreground consists of the image of the entoptic bird.

Entoptic Image in Nature

For Munch the next stage was to study what happened when the bird was visible in an outdoor setting, against the sky, or rather, optical infinity. Munch studied this in a series of fairly simple drawings, something which suggests that they were made from life, outside. He added, however, a rich environment of figures, trees, houses and the horizon line. The entoptic bird is

Fig.134
**Sketches of Heads and the Artist's
Injured Eye, with Text**
Indian ink, pencil and crayon
on paper
18.1 x 22.3
Munch-museet, Oslo

represented here away from the visual axis, in the upper visual field and at the temporal side. The presence of figures in some of the drawings would suggest that the bird was positioned above them, further away, somewhere in the sky (see nos.123–4).

Evolution over Time

Munch would spend several weeks carrying out these drawings, as is shown by their large number. It follows that his entoptic study was also carried out over a certain period, showing the changes in appearance of the images as time went on. The most obvious was the change in appearance of the bird's body, which was firstly a huge, wide and dark patch, but then slowly broke up and crumbled, unlike the rounded head, which changed little and remained almost on its own at the end of the bird's evolution. These changes in appearance can be logically attributed to the gradual reduction of the ocular haemorrhage. These morphological changes overlapped with changes in positioning. While the entoptic patch was at first located in the centre of the field of vision, it was possible to establish in the later drawings that the bird had moved upwards and towards the edge, flying across the sky in particular drawings. Once again this has a well-known anatomical cause. After the vitreous mass detaches, gravity causes it to sink to the lower part of the eyeball and the vitreous ring follows this movement. For the patient, however, it appears to rise up, due to the inversion of the eye's optical system, which means that images are upside-down on the retina.[9]

In conclusion, Munch made the most of entoptic phenomena in order to study the fundamental conditions of the positioning of visual objects in our environment. This was a remarkable intellectual approach; he took advantage of his illness in order to carry out an optical and physiological study. I have focused solely on the optical and physiological aspects of Munch's eye disease in this short article because they are not widely known. This is not to deny the psychological and psychoanalytical aspects of the images seen by the artist.[10] The interpretation he made of his entoptic patches, understood as a bird, could be likened to those of the patients who underwent Rorschach's test, providing an interpretation of the examined images that reflected psychological constraints. However, whether the painter is reproducing images from the outside world, or entoptic images that were visible to him alone, or even purely imaginary forms, what he never ceases to show us on canvas is the reflection of his creative spirit.

Translated by Laura Bennett

Notes

1 Philippe Lanthony, *Des yeux pour peindre,* Paris, RMN, 2006.

2 Nicholas J. Wade, Josef Brozek, *Purkinje's Vision: The Dawning of Neuroscience,* London 2001.

3 Hermann von Helmholtz, *Optique physiologique,* trans. from German by É. Javal, N.-T. Klein, Paris 1867.

4 David Kunzle, *The Eyesight of Rodolphe Töpffer, Historia Ophthalmologica Internationalis,* vol.2, 1981, pp.57–84.

5 Lee Allen, *The Hole in My Vision: An Artist's View of His Own Macular Degeneration,* Iowa City (IA) 2000.

6 Michael F. Marmor, James G. Ravin, *The Artist's Eyes: Vision and the History of Art,* New York 2009.

7 Gérard Brasseur, *Pathologie du vitré,* Paris 2003.

8 Patrick Trevor-Revor, *The World Through Blunted Sight: Inquiry Into the Influence of Defective Vision on Art and Character,* London 1988.

9 Archimède Busacca, Hans Goldmann, Suzanne Schiff-Wertheimer, *Biomicroscopie du corps vitré et du fond d'oeil,* Paris 1957.

10 Joëlle Moulin, *L'Autoportrait au XXᵉ siècle,* Paris 1999.

117
The Artist's Injured Eye (and a Figure of a Bird's Head)
1930
Crayon on paper
50.2 x 31.5
Munch-museet, Oslo

118
Disturbed Vision
1930
Oil on canvas
80 x 64
Munch-museet, Oslo

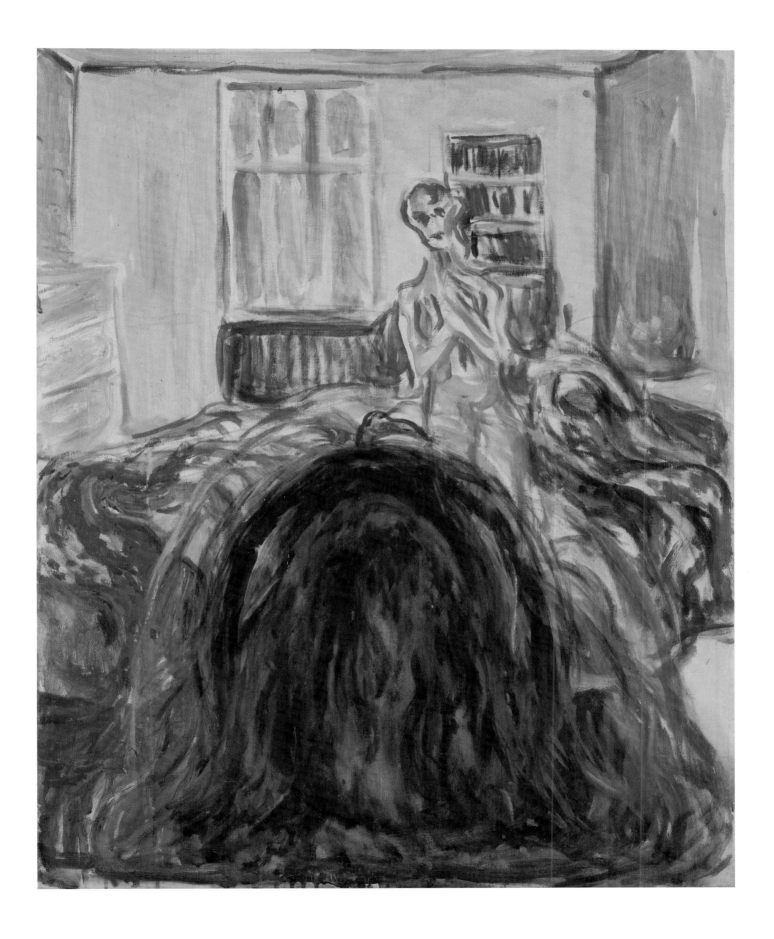

20 Sept.
*The distance between the bird's beak
and the new beak below appears
larger
larger. There appear 2 letters
when before there was 1 let(ter?)**
*The bird's neck
seems longer
The left side
is lighter –
Meaning that
the chin (?) is eaten up on
this side*

*N The bird's head with
the beak*

* I assume here that Munch only
wrote half the word *boks-tav*
(letter). Otherwise the word *boks*
(box) would not make sense.

119
**The Artist's Injured Eye
(with Birds)**
1930
Crayon on paper
22.2 x 18.1
Munch-museet, Oslo

120
**The Artist's Injured Eye:
Two Sketches**
1930
Crayon on paper
40.8 x 25.9
Munch-museet, Oslo

121
**The Artist's Injured Eye:
Two Sketches with Text**
1930
Indian ink on paper
35 x 23
Munch-museet, Oslo

122
**The Artist's Injured Eye:
Kneeling Nude with Eagle**
1930
Watercolour on paper
50 x 32.2
Munch-museet, Oslo

123
The Artist's Injured Eye:
Landscape with House and People
1930
Watercolour and pencil on paper
32.8 x 47.1
Munch-museet, Oslo

124
The Artist's Injured Eye:
Sketches of Optical Illusions
1930
Watercolour, charcoal and crayon
on paper
64.8 x 50.2
Munch-museet, Oslo

125
**The Artist's Injured Eye:
Sketches of Optical Illusions**
1930
Watercolour and crayon on paper
50 x 64.6
Munch-museet, Oslo

126
**The Artist's Injured Eye:
Sketches with Optical Illusions**
1930
Watercolour and crayon on paper
49.8 x 65.1
Munch-museet, Oslo

127
**The Artist with a Skull: Optical
Illusion from the Eye Disease**
1930
Watercolour and pencil on paper
65 x 50.2
Munch-museet, Oslo

128
**The Artist's Injured Eye:
Three Optical Illusions**
1930
Watercolour on paper
50 x 64.6
Munch-museet, Oslo

129
**The Artist's Injured Eye:
Six Optical Illusions**
1930
Watercolour on paper
50 x 64.6
Munch-museet, Oslo

130
Self-Portrait with Wounded Eye
c.1930
Charcoal and oil (and lithographic
chalk?) on canvas
90 x 72
Munch-museet, Oslo

Iris Müller-Westermann

A Modern Eye: Edvard Munch's Self-Portraits after 1908

131
Self-Portrait in the Clinic
1909
Oil on canvas
100 X 110
The Rasmus Meyer Collection,
Bergen Kunstmuseum

Self-portraits are a *leitmotiv* running through Edvard Munch's artistic work. From the earliest days of his career in the 1880s until his death in 1944 he was intensely preoccupied with his own persona and created around seventy self-portrait paintings, twenty prints and over a hundred drawings, watercolours and sketches. His main interest was not in depicting his external appearance but in exploring and investigating his own self. Munch's unsparing examination of himself amounts to one of the most impressive representations of the human being in the history of art. Taken as a whole, these images form a fascinating visual autobiography spanning six decades and reflecting the course of a human life. It seems that Munch used the pictorial process of the self-portrait as a way of exploring and understanding situations or circumstances that particularly affected him. Yet he only ever exhibited just a few of these self-interrogations. For him they were more of a private matter, not to be exposed to the public gaze.

In his self-portraits Munch reflects on his role as an artist and a human being in society. In them he played out different roles, examined his complex and complicated relationship to the other sex, pictured his relationships with those who commissioned him, or scrutinised himself in the light of biblical figures. As an artist, he explicitly portrayed himself in only three of his paintings. Some of his representations of himself are more like portraits, others are about him rather than of him. In his self-portraits Munch questioned accepted social norms and ideas around the turn of the twentieth century and portrayed his own subjective reactions to a world in which everything was in doubt. While the images of himself in the first decade of the twentieth century predominantly show him as a victim of society, often as a suffering figure, this changed following his return to Norway in 1909. After many years of self-imposed exile, he at last found himself recognised as an artist in his native country.

281

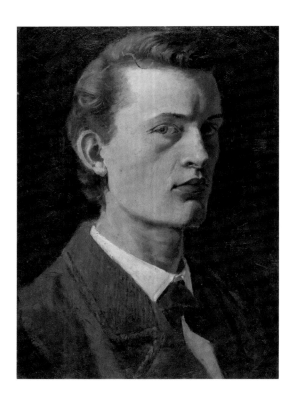

Munch's explorations of his own persona are more than merely subjective reactions to his experiences. As a body of work they reveal the fundamental alienation and existential loneliness of the modern human condition. His enduring interest in himself as a pictorial subject places him in the tradition of the great self-portraitists – the doubters, the questioners and the visionaries – from Rembrandt to Goya to van Gogh and Gauguin. However, Munch was the first painter to create such a comprehensive and nuanced picture of his own condition as a human being.[1]

Munch painted his first self-portrait at the age of eighteen in 1882 (fig.135). At this point, his main attention was on capturing his own features and creating a likeness of his external appearance. By his second portrait he had already changed his focus. From that moment onwards his interest was in making visible the invisible. In the decades to come, always striving to penetrate the surface and to see behind the façade, he experimented widely with different artistic strategies.

In the 1890s, in what could be described as a form of expressive symbolism, Munch developed highly concentrated metaphors and pictorial formulas for internal experiences. With this, and his enquiry into artistic techniques and the increasing liberation of his own pictorial means from pure representation in the early twentieth century, he did much to pave the way for expressionism.

The general view of art historians is that Munch's work from the 1890s until his nervous breakdown in 1908 is the most important. Far too little attention has been paid to the artist's later work, made during the following thirty-five years. This may in part be because Munch remained detached from the sequence of art movements that unfolded during the early twentieth century – from cubism, dada, surrealism to new objectivity and pure abstraction – making it difficult to place his work, since it does not fit into any of the usual classifications.

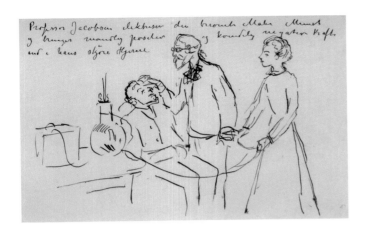

The intention in this exhibition and catalogue is to widen our view of his work. The selection of self-portraits is mostly drawn from the years after 1908 and includes Munch's last portraits from the 1940s. Rather than allowing himself to be swept up in the latest stylistic trends, Munch always remained true to himself and developed a powerful body of late work that includes self-portraits unlike anything elsewhere in art history. From the second decade of the twentieth century onwards he engaged with his own persona ever more frequently, with illness, loneliness, ageing and death now coming to the fore.

Recovery and the Beginning of Clean Living

In the late summer of 1908 years of excess and high levels of alcohol consumption led to Munch suffering a physical and mental breakdown with acute psychosis. He attributed it to the 'long years of persecution – conducted privately by means of the most violent attacks on my art':[2] 'I've been persecuted by almost everyone – blow upon blow every time I came home.'[3] On 3 October 1908 Munch went for a rest cure to the nerve clinic run by Professor Dr Daniel Jacobson at Kochsvej 21 in Copenhagen/Fredriksberg. Besides rest, plentiful sleep, warm baths and massages, the therapy also included 'electrifications'. Treatments with low-voltage currents were popular at the time, but should not be confused with electroshock therapy, which was introduced later on. Munch portrayed the treatment in a drawing, depicting the rebalancing of the male and female energies within him that he felt were out of kilter (fig.136). He made a note on the drawing: 'Professor Jacobson electrifying the famous painter Munch and introducing positive male energies and negative female energies into his fragile brain.'

Munch was forty-five years old when he painted his *Self-Portrait in the Clinic* (1909) in Copenhagen (no.131). As in the famous *Self-Portrait with a Bottle of Wine* (1906) from his time in Weimar (fig.137), he is seen sitting on a chair facing the viewer. But now, instead of his head being lowered, he is looking straight at the viewer. Whereas the face is painted in great detail, with a fine brush, Munch's body and the room he is sitting in are depicted by means of broad horizontal and vertical lines. A sense of energy and dynamism emanates from the complementary contrast of the violet tones of Munch's body and the yellow-orange hues of the wall, and from the red of the chair contrasting with the green beneath the window.

Self-Portrait in the Clinic is generally regarded as evidence of the artist having been restored to health, optimistically looking to the future with renewed vigour. Ragna Stang sees a 'rejuvenated Munch' in this picture and comments, 'this painting breathes manly strength and a positive outlook on life'.[4] Although Munch's pose is more solid than in *Self-Portrait with a Bottle of Wine*, the technique used in this painting conveys the precariousness of his new-found mental equilibrium. If we read this experimental technique 'literally', it could be seen as a metaphor for the recovering artist, slowing piecing his body and his surroundings back together again – line by line – now that the rift in his mind had been healed by the rebalancing of 'negative and positive energies'. But the fabric of this painting is not yet whole, for the grounded canvas is still visible in many places. The world outside the window looks bright, but it is only sketchily visible, as though it were not yet entirely the artist's concern. In a letter of 12 November 1908, written by Munch to his friend Jappe Nilssen, he describes exactly this sense of disconnection from the outside world: 'My strength is steadily returning. Have been outside twice with the nurse – a strange feeling, being back in the noisesome world – I have almost got used to my cloistered existence in my room. And it has a certain charm – staying away from the world.'[5] There is a photographic self-portrait (no.9) that shows Munch in his room facing his as yet unfinished painting of himself. The

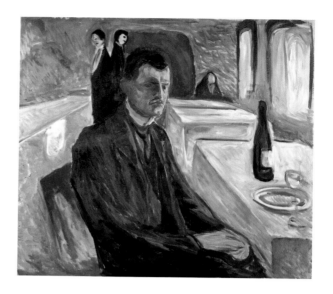

artist seems to be in dialogue with himself as the nurse steps into the room with drinks on a tray.

The months in the clinic were not only a period of recovery, but also, in artistic terms, an astonishingly productive time. Besides the self-portrait and the impressive full-length portraits of Dr Jacobson and the Danish writer and friend of Munch, Helge Rode (now in the Moderna Museet in Stockholm), Munch also made the drawings for his folio of lithographs *Alpha and Omega*.

In autumn 1908, three days after he had been admitted to Dr Jacobson's clinic, Munch was made a Knight of the Royal Norwegian Order of St Olav (1st class).[6] Although Munch had long been a celebrated artist in Germany – with numerous exhibitions, commissions and publications (Max Linde, his patron from Lübeck, published a book in 1902 with the title *Edvard Munch und die Kunst der Zukunft* [*Edvard Munch and the Art of the Future*]) – his native country of Norway had hitherto refused him the artistic recognition he had long yearned for. This honour was thus an important signal to the recovering artist.

With the help of his closest friends Jappe Nilssen, Jens Thiis, Ludvig Ravensberg and Christian Gierløff, while he was still in the clinic Munch managed to arrange an exhibition at the Kunstförening in Copenhagen, with two hundred works, and another exhibition in Kristiania,[7] with one hundred paintings and two hundred prints.[8] In Kristiania this led to the purchase of five major paintings by the Nasjonalgalleriet, on the initiative of Jens Thiis, who had been the director there since December 1908.[9] Norwegian private collectors also bought numerous works of art. The exhibition subsequently transferred to Bergen, where the collector Rasmus Meyer bought a large number of paintings and prints once the exhibition had closed, including the *Self-Portrait in the Clinic*.

Whereas *Self-Portrait with Wine Bottle* of 1906 shows the artist at the height of the crisis, *Self-Portrait in the Clinic* marks the turning point in his recovery. Of the self-portraits he had made in the preceding years, which Munch himself described as 'self-examinations in difficult times',[10] he regarded these two as his best and included them in all his most important exhibitions from then onwards.

Return to Norway

On 30 April 1909, Munch left the clinic and Copenhagen after almost seven months. Shortly before that, as though to prepare Norway for the return of its renowned son, an article by Christian Gierløff, writing under the pseudonym Kyng, appeared in the newspaper *Dagbladet* (23 March 1909) with the title 'Livet er farver' ('Life is Colours'). Munch now moved back to Norway, settling first in Kragerö on the Kristianiafjord, then in Jeløya and, in 1916, on the outskirts of Kristiania.

In February 1916 he travelled to the west coast of Norway in connection with an exhibition of his at the Society of Artists in Bergen. It was here that he painted one of the most important self-portraits of the 1910s. In *Self-Portrait in Bergen* Munch takes stock of his role as an artist and of his relationship to the world.[11] By now he was an internationally celebrated artist. In 1912 he had his decisive European breakthrough at the legendary Sonderbund exhibition in Cologne. Like Paul Cézanne, Vincent van Gogh and Paul Gauguin, he had a whole room to himself, in his case containing over thirty paintings, acclaimed as the precursors of modernist art. But now, in 1916, the First World War was raging in Europe.

All alone, he stands on a balcony or at a window, turning away from the hustle and bustle of the square down below him. The artist's right eye, at almost the exact centre of the painting, is the anchor and focus of the composition. His eye is the

opening through which he has access to the world, even as he maintains a physical distance from it. His gaze and facial expression reveal his own painful awareness that he is not part of that world. Here, against the backdrop of the political situation in Europe, Munch reiterates what he had said once before to his beloved Tulla Larsen, in 1899: '... don't reproach me, pity me instead – as one who neither can nor wants to live life – as I sit with aching longing at the window and see myself surrounded by strange, noisesome – terrible life'.[12]

The angle of the artist's body, leaning diagonally into the picture from the left, and his head turned towards the viewer create the impression of movement, or rather, of a moment in time. The fact that Munch is on the move – perhaps a metaphor for his being at home nowhere – is underlined by the coat he is wearing. However, at the same time as Munch sets himself apart from other people in the Bergen portrait, he creates a strong connection between himself and the church tower in the distance.[13] His eye corresponds to the window in the church tower and the isolation of his head reaching upwards into the air echoes that of the tower.

That this affinity between the artist's head and the church is not merely coincidental is confirmed by the drawing *There Are Worlds in Us,* from 1894 (fig.138). The composition of the self-portrait in Bergen seems to be prefigured in this work: the figure some considerable height above the ground, looming into the picture from the left, has one large eye turned towards the viewer and directly connected with the church in the centre of the composition. Below the figure, people are streaming into the church along a wide pathway. In another drawing, a self-portrait most probably made before 1915 (fig.139), Munch adopts the position of the figure in *There Are Worlds in Us;* there is even an indication of similar crowds of people down below him. In this case the window frame, against which the artist is leaning, lost in thought, coincides with the edges of the

image. The church is replaced by clouds and it is these clouds that the artist connects with, not the people.

Munch had already experimented with an eye in the centre of the composition in 1912, in a self-portrait print.[14] In this case the right eye is a funnel-like opening, through which the world can find a way into the artist's body. The *Self-Portrait in Bergen*, which looks so spontaneous, is in fact the outcome of a number of different visual strands.

Defying Death Once Again

Even when Munch was suffering from Spanish flu in late 1918 and early 1919, he did not take his eyes off himself. He recorded the different stages of the illness, including a very real sense of his own mortality, in a series of paintings and sketches.[15] Munch survived; he was not one of the estimated 25 to 50 million people, above all in the age group twenty to forty, who died across the world in the pandemic of 1918–20. In the large-format *Self-Portrait with the Spanish Flu* (no.135) the artist is seen sitting listlessly by his bed in a wicker chair. The pale beige tones of his face all but merge into the yellow-orange wall behind him, and it seems to take him all his energy to turn his head to the viewer. The eyes are only vaguely indicated, the mouth is slack and open. The hands – almost at the centre of the composition – form a core of powerlessness.

Strong accents in primary colours frame the figure of the sick man. The yellow of the wicker chair, the blue of the bedpost and the strong red of the blanket over Munch's lap make the patient appear all the more lifeless.[16] In a conversation about this painting, Munch asked the young art collector Rolf Stenersen: 'Does it seem repellent? ... Can you smell it? ... Yes, can't you see that I'm in a state of decay?'[17] The application of the paint also creates an impression of dissolution: the colour is thin and sketchily laid down; in some places it almost has the translucence of watercolours. The extreme flatness of the image

Fig.138
There are Worlds in Us
1894
Crayon on paper
36.3 x 31.4
Munch-museet, Oslo

Fig.139
Study for 'Self-Portrait in Bergen'
c.1915
Crayon on paper
26.4 x 42.6
Munch-museet, Oslo

shows the artist living in a space with no perspectives and underlines the great precariousness of his situation.

Yet, even though this painting is about illness and about a person at the mercy of forces that he cannot control, in its monumentality it is also a testament to the artist's will to survive. Munch's *Self-Portrait with the Spanish Flu* is one of the most compelling self-portraits in art history, and there is a sense here of his intense interest in Rembrandt's late self-portraits.[18]

Munch also captured his drawn, weakened features in a series of chalk drawings, one of which conveys an acute impression of delirium and fear. Elsewhere, in a watercolour, he tried out the 'discolouration' of his face, which appears to melt into the colour of the wall; in another two studies he worked out the most effective pose. The open mouth and weakened features already exist in one of these, but at this point the artist is still sitting almost directly facing the viewer (fig.140). The angle of the figure in the painting means that he has to turn his head, with considerable difficulty, to look out of the painting, and underlines the debilitated state of the patient.

In yet another chalk drawing Munch alludes directly to his early painting, *The Sick Child* 1885–6. Like the model for his ill sister, Betzy Nielsen, he is seen sitting up in bed, supported by numerous pillows – but here Munch is all alone, with menacing shadows taking form on the wall.

The Hermit of Ekely

Despite large-scale, important retrospectives in Zurich, Bern and Basel in 1922 and in Göteborg in 1923, in the self-portrait *The Night Wanderer* 1923–4, the viewer is not confronted with a man of the world, a celebrated artist (no.137). On the contrary, the painting conveys a sense of existential loneliness and bewilderment. It captures a fleeting moment at Ekely, as though the artist wandering at night through his sparsely

furnished home had suddenly caught a glimpse in a mirror of his own gaunt form in a dressing gown. Munch had purchased Ekely, once a market garden with over four hundred fruit trees on the outskirts of Kristiania, in January 1916. This was to remain his main place of residence until his death in 1944. The light from an electric bulb casts a yellow reflection on the artist's face and turns his dishevelled hair into a garish, sulphurous-yellow wreath, calling to mind Rembrandt's self-portrait as an old man c.1666, now in the Wallraf-Richartz-Museum of Cologne.

Compared to a related sketch (fig.141), in the painting Munch further dramatised the perspective. The pictorial space recedes sharply, as though caught in a vortex. The floor, 'tipped up' towards the viewer, provides no secure foothold; on the contrary, it looks like a surface that one might sink into at any moment. With the perspective thus shifting between two levels, the pictorial space becomes a metaphor for instability. The artist leans out of the canvas, as in *Self-Portrait in Bergen*. From dark, shadowy eye-sockets he stares at his own mirror image, questioningly and in shock. Although the room is almost empty – save for a grand piano – the pictorial space seems confined, like a prison cell cutting the artist off from the rest of the world. In his isolation, there seems to be an affinity between Munch and Ibsen's John Gabriel Borkman, who paces up and down in his room like a restless wolf in a cage. In one of his studies of Borkman in the 1920s, Munch explicitly made this connection between Borkman and himself as the night wanderer.

In a drawing from 1919, Munch shows himself shocked by suddenly coming upon the sight of himself in a mirror at night (fig.142).[19] In the painting, the picture surface replaces the mirror in which the artist registers his own presence. This dramatisation sees the viewer coming face to face with the sight of Munch as though this were his own mirror image.

The self-portrait *The Night Wanderer* comes from the chasms of the sleepwalking artist's mind. It depicts Munch's balancing act in the uncertain terrain of life. As he put it:

The second half of my life has been nothing but a struggle to keep myself upright. My path took me along the edge of an abyss, a bottomless pit. I had to leap from stone to stone. Every so often I left the path and threw myself into the commotion of life, amongst people. But I always had to return to the path along the abyss. That is the path I have to follow, until I plunge down into the depth. This fear of life has hounded me since ever I first could think. My art was self-confession. It was like the telegrams warning of disaster from the telegrapher on a sinking ship. And yet, I also have the feeling that in my case the fear of life is also a need, like the illness. Without the fear of life and illness I would be a ship without a helmsman.

Uwe M. Schneede regards the radicalism of this kind of self-scrutiny as a continuation of the 'tradition of the visionary figure who is torn and in despair, plagued by nightmares, from Hölderlin to Beckett and Thomas Bernhard, from Goya to Bacon'.[20]

In *Self-Portrait with Bottles*, also known as *The Alchemist* (no.136),[21] the artist faces forwards like a barman behind a table laden with an array of wine bottles from different countries, while the viewer takes on the role of the guest on the other side of the table. Munch is holding a glass in his right hand; his left hand is raised, ready to select the desired bottle.

Johann Langaard recounted that this composition was inspired by the bottles that Munch received as a present on his 75th birthday on 12 December 1938.[22] In an oil sketch of the artist's left hand, reaching out to one of the bottles on the table, several bottles still seem to be full, whereas they are empty in the painting. It seems the lonely party lasted quite some time.[23]

Facing Death

From around 1940 onwards Munch's self-portraits deal exclusively with the subject of death and the artist's mortality. *Self-Portrait by the Window* portrays the artist's last resolute defiance of death (no.139).[24] Facing straight forwards, with a tense expression and the corners of his mouth turned right down, Munch has set himself up next to the window in a room in Ekely, undaunted by the cold weather that symbolises rigidification and death. The terracotta orange of his head attests to his indomitable energy, which radiates outwards into the area behind him, in contrast to the cold whites, greys and greens of the landscape on the right. Munch's resistance is shown to be all the more unwavering by the fact that the cold, seeping in from outside, has already deposited a layer of frost on the radiator beside him. As yet he still has enough strength and willpower to fight insidious death. While he turns his back on the cold and death, he gazes past the viewer into his own soul and at the strength that he is summoning up here, one last time. Life and death meet in this painting as two distinct spheres. For all his resistance to nature, the human being will always lose out in the end. Despite his demonstration of will, it is clear in *Self-Portrait by the Window* that the artist is all too aware of the inevitable outcome. In his last self-portraits it is the matter of relinquishing his own will to the forces of nature that concerns Munch.

In *Self-Portrait* (no.138) the eyes gaze straight ahead, veiled and immobile. The mouth, no longer entirely in control, is slightly open. The figure's sparse, unkempt hair stands out from his head. The flesh of the upper body is transparent, as though on an X-ray, revealing the ribs – a portrayal of human mortality.[25] In contrast to the defiant resistance to death in *Self-Portrait by the Window,* dying is now shown as the fearful loss of control over one's own body. During this process the body loses its coherence and falls into decay. This is exemplified both in the fluid watercolour-like, fragmentary application of paint, which in effect dissolves the figure instead of holding it together, and in the dissonant colour palette of pinks, blues, greens and yellows. In the painting the shadow cast by the figure is already turning towards the light, whereas the artist is still lingering in indeterminate darkness.

Munch played out different scenarios: a pen drawing shows his face from the front. The widened eyes are filled with the fear of death, calling to mind a comment made by Munch as a young man: 'It's strange to completely disappear – that you have to – that the moment has to come when you will say to yourself, now you've got just 10 minutes 5 minutes and then it will happen – and you will feel yourself little by little turning into nothing.'[26] The viewer also sees their own terror in Munch's face.

In the same way that Munch pictured all the different phases and aspects of his life, in his last years he felt a deep need to engage with his own death. 'I don't want to die suddenly, or without knowing it. I want to have that last experience, too,' as he said to his model Birgit Prestoe.[27] 'We experienced death during birth – We still have the most remarkable experience to go through: actual birth, which is called death – birth, what into?'[28]

In the large-format self-portrait where Munch is seen standing between a grandfather clock and his bed, presumably from around 1940 (no.141), death is seen as a metaphorical transition between two worlds.[29] Between the monument to time that has now run out – a clock face with neither numbers nor hands – and the bed – the place where we are born and where most of us die – the artist stands on the threshold to death, upright and waiting: 'He is ready to take that last step.'[30] The opened double door reveals a welcoming, yellow room beyond the artist, with paintings on the wall attesting to the work he has done.[31] A rich lifetime of creative work is now

Fig.140
Study for *Self-Portrait with the Spanish Flu*
c.1919
Pastel on paper
12.8 x 11.7
Munch-museet, Oslo

Fig.141
Study for *The Night Wanderer*
c.1923–4
Wax crayon on paper
29.9 x 23.7
Munch-museet, Oslo

behind him. His senses no longer perceive the outside world. Eyes and mouth are closed. Red spots top his ears like plugs. The bed, with its red and black patterned bedspread, is an alien presence in the context of the rest of the composition. The abstract pattern is reminiscent of Munch's own notion of death as a process of crystallisation. 'Death is the beginning of life – a new crystallisation.'[32] The floor that the artist is standing on conveys no sense of security; it is an enigmatic, reflective surface – as enigmatic as any answer to the question as to what awaits the artist on the other side.

There is a series of sketches that connects directly with this self-portrait. In one of them the artist is already seen as a full-length figure, as in the painting. But here the figure is still standing in front of the clock, leaving a passage between the clock and the bed into the workroom with the paintings on the wall. It is only in the final painting that the artist stands in this passageway. In the sketches it is possible to trace the decreasing activity of the figure, until in the painting he at last reaches the point where he is ready to hand over to death.

In the gouache *Self-Portrait: A Quarter Past Two in the Morning* (no.140) the artist anticipates the moment of his own death.[33] He is no longer waiting between the clock and his bed. The emaciated, already dematerialised, translucent-looking body is rising up out of the chair; the artist's face is caught in the glow of a supernaturally bright, yellow light. He is not rising up of his own free will. It is another power that is calling him away. The gaze staring straight ahead betrays fear mingled with the knowledge that he now has no other choice. The dark shadow behind him indicates the presence of death, even as the surroundings are in the process of dissolving around the dying man. After a long life, Munch died peaceably on 23 January 1944, at Ekely.

Fig.142
**Self-Portrait in Front of a Mirror:
The Night Wanderer**
c.1919
Pastel on paper
12.8 X 17.7
Munch-museet, Oslo

Conclusion

Edvard Munch's self-portraits are visual contemplations that often consist of several pictorial, ideas-based or literary strands. It is only in the final painting that these different aspects come together to the artist's own satisfaction. We have seen this in the development of some of his self-portraits and related drawings.

Experimentation was always an essential factor in Munch's art. We have seen in the *Self-Portrait with the Spanish Flu, The Night Wanderer* and the *Self-Portrait between the Clock and the Bed* how Munch would imbue the greatest possible drama into the structure and the often stage-like pictorial space. His interest in contemporary theatre and his experience designing stage sets for Max Reinhardt's avant-garde Deutsches Theater in Berlin stood him in good stead in this connection. In his experiments he would sometimes abandon a single perspective and combine different angles. The ensuing disruption of the pictorial space always impinges on the meaning of the painting.

As we see in his self-portraits, Munch experimented with painterly techniques as long as he lived. Sometimes he applied the paint thickly, sometimes as a wash. Sometimes he made the paint so thin that it left rivulets on the canvas, at other times he would squeeze it straight out of the tube. He often left areas of grounded canvas visible and open – reminding the viewer that the painting represented its own reality and was not a view out of a window into a visible world. Yet Munch never took self-referentiality to the point of abstraction. All his life his focus was on the mutual interaction of contents and material, and in his paintings he consistently strove to strike a balance between construction and deconstruction, between the structuring of a picture and its dissolution – a balance that is hard to sustain.

Munch created immensely powerful paintings that relate to external reality but more so to an internal reality; at the same time they are also virtuosic meditations on painting and investigations into the means of painting. It is within this complex interplay that we see Munch's ongoing efforts to understand his own being.

Although he was a widely celebrated artist both at home in Norway and abroad, from the 1910s onwards he never portrayed himself as a fêted, self-confident, princely artist. He was not interested in painting certainties, but in formulating questions concerning human existence and in seeking answers to them in his paintings. Munch never stopped searching, as he made his way on his journey through life.

However, what he found out about himself and in himself was not a clearly defined persona, but endless different facets and fragments of his own self. Munch's self-portraits convey an image of a modern person, for whom stereotypes and traditional frameworks have become obsolete and who constantly has to struggle to establish new certainties. All his life, Edvard Munch was a modern spirit with a modern gaze.

Translated by Fiona Elliott

Notes

1 See Iris Müller-Westermann, *Edvard Munch. Die Selbstbildnisse*, Munich 2005.

2 Letter from Munch to Jappe Nilssen, Copenhagen, 4 February 1909, in Erna Holmboe Bang, *Edvard Munch og Jappe Nilssen. Efterlatte brev og krittiker*, Oslo 1946, p.32.

3 Letter from Munch to Jappe Nilssen, Copenhagen, 3 February 1909, in Bang 1946, p.30.

4 Ragna Stang, *Edvard Munch. Der Mensch und der Künstler*, Königstein-im-Taunus 1979, p.219.

5 Letter from Munch to Jappe Nilssen, Copenhagen, 12 November 1908, in Bang 1946, p.23.

6 Although Munch did not usually set great store by awards, on this occasion he wrote to his friend Jappe Nilsson: 'As for the order, you know that these things have never mattered much to me – yet this time it feels as though a hand is reaching out to me from my country …', letter from Munch to Jappe Nilssen, Copenhagen, 27 October 1908, in Bang 1946, p.22.

7 From 1624 to 1877 the capital of Norway was called Christiania, from 1877 to 31 December 1924 it was Kristiania, since when the name Oslo has been used.

8 See the letter from Munch to Jappe Nilssen, Copenhagen, 31 January 1909, in Bang 1946, p.29.

9 The Nasjonalgalleriet in Kristiania bought *The Day After* (1894), *Puberty* (1893), *Ash* (1894), *Two Young Girls under the Verandah in the Rain* (1902) and *The Frenchman (Marcel Archinard)* (1904). See Jens Thiis, *Edvard Munch og hans samtid. Slekten, livet og kunsten og geniet*, Oslo 1933, p.291.

10 Letter from Munch to Jappe Nilssen, Copenhagen, 9 March 1909, in Bang 1946, p.41.

11 See Uwe M. Schneede, 'Selbstprüfungen in schwierigen Jahren. Edvard Munchs Selbstporträts aus dem 20. Jahrhundert', in *Edvard Munch. Höhepunkte des malerischen Werkes im 20. Jahrhundert*, exh. cat.

Kunstverein in Hamburg, Hamburg 1984, pp.65–75, 70; Arne Eggum, *Edvard Munch: Symbols and Images*, exh. cat., The National Gallery of Art, Washington, DC, 1978 (2), pp.28ff.

12 Draft of a letter from Munch to Tulla Larsen, Paris, 25 May 1899, Munch-museet, Oslo, EM/B7.

13 The seeds for a connection between the head and something above or beyond it were already sown in compositions from the 1890s such as *Vision* (1892) and *Self-Portrait Beneath a Woman's Mask* (c.1893).

14 Gerd Woll, *Edvard Munch: Complete Paintings. Catalogue raisonné*, London 2009, no.394.

15 It is clear from a letter of 16 March 1919 from Helga Rogstad – a former model of Munch's – to Munch himself, that he was already in good health again by mid-March 1919, Munch-museet, Oslo.

16 Thiis 1933, p.316.

17 Rolf Stenersen, *Edvard Munch. Naerbilde av et genie*, Oslo 1994 [1945], p.60.

18 Ludvig O. Ravensberg, 'Edvard Munch pa naert hold', in *Edvard Munch som vi kjente ham. Vennene forteller*, Oslo 1946, pp.182–221, 197.

19 We date this drawing to c.1919. The sketches on the preceding and following pages of the sketchbook relate directly to *Self-Portrait with the Spanish Flu*.

20 Schneede 1984, p.73.

21 On *Self-Portrait with Bottles* see J.H. Langaard, *Edvard Munch selvportretter*, Oslo 1947, pp.11, 147; see also Gottard Jedlicka, 'Über einige Selbstbildnisse von Edvard Munch', in *Wallraff-Richarz-Jahrbuch XX*, 1958, pp.248ff.

22 See Langaard 1947, p.161.

23 On 23 January 1939, shortly after Munch's 75th birthday, there was an auction in Oslo of fourteen paintings removed from German collections. Munch commented on this event: 'I have now been thrown out of

Germany for the second time … It's a good thing that I was always so reluctant to sell. They went on their knees in Germany, and here, to be allowed to buy something. In great sadness I sold paintings that were very important for my future work.' Letter from Munch to Jens Thiis, n.d., presumably 1939, Munch-museet, Oslo.

24 Langaard 1947, p.150, fig. p.151. Langaard dates *Self-Portrait at the Window* to 1942; it is pictured before it was finally finished. The view of the snow-covered trees is only indicated at this point. In the version we know today, the trees are painted in much more detail. On *Self-Portrait at the Window* see, for instance, Eggum 1978 (2), pp.29, 31; Arne Eggum, *Edvard Munch. Gemälde, Zeichnungen und Studien*, Stuttgart 1986, p.282, Schneede 1984 (1), p.73; Barbara Schütz, catalogue text in *Edvard Munch*, Museum Folkwang, Essen 1987, p.338; Frank Höjfödt, catalogue text in Gerd Woll, Per Bjarne Boym, *Edvard Munch: Monumental Projects, 1909–1930*, exh. cat., Lillehammer Kunstmuseum, Lillehammer 1994, p.144.

25 I date this self-portrait to 1942–3, see also Schütz 1987, p.340; it is not listed in Langaard 1947.

26 Dated c.1889, manuscript, Munch-museet, Oslo, MM T 2761, p.21.

27 As cited in Birgit Prestoe, 'Smatrekk om Edvard Munch', *Kunst og Kultur*, 1946 (2), p.144.

28 September 1932, manuscript, Munch-museet, Oslo, MM T 2748, p.127.

29 Langaard 1947, pp.11, 146, dated 1940; Eggum 1986, p.280, dated 1940–2. On *Self-Portrait: Between the Clock and the Bed* see also Langaard 1947, p.13; Jedlicka 1958, pp.254–6; Eggum 1986, p.282; Schneede 1984 (1), pp.73ff; Iris Müller-Westermann, 'Edvard Munchs Selbstbildnisse. Widersprüche als Herausforderung', in *Wunderblock. Eine Geschichte der modern Seele*, exh. cat., Vienna 1989, pp.523ff; Reinhold Heller, *Edvard Munch, Leben und Werk*, Munich 1993, p.138.

30 Schneede 1984, p.74; Jedlicka 1958, p.256, on the other hand, regards this self-portrait as a picture of the artist's fear of death. I do not share A. Eggum's view that here Munch was treating his own 'old age with ruthless irony', Eggum 1986, p.282.

31 Jedlicka 1958, p.254, talks of the painting being structured like a triptych. With regard to the paintings on the wall: the nude on the right, in a tall, vertical format, is based on *Krotkaja* (M 752) of 1926–7. I have not been able to identify the 'orange' portrait of a lady.

32 Edvard Munch, 'Kunnskapens tre' ('The Tree of Knowledge'), 1913, Munch-museet, Oslo, T 2547.

33 This gouache is not mentioned in Langaard 1947, see also Eggum 1986, p.281; Schneede 1984 (1), p.74. We agree with Eggum's date of 1940–4.

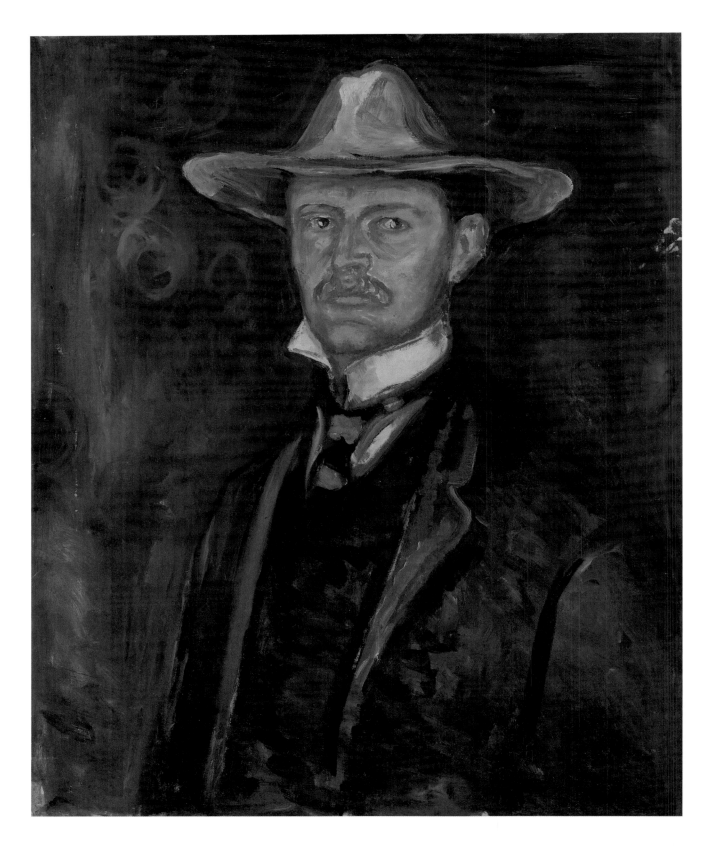

132
Self-Portrait in Broad-Brimmed Hat
1905–6
Oil on canvas
79 x 64
Munch-museet, Oslo

133
Self-Portrait in Bergen
1916
Oil on canvas
89.5 x 60
Munch-museet, Oslo

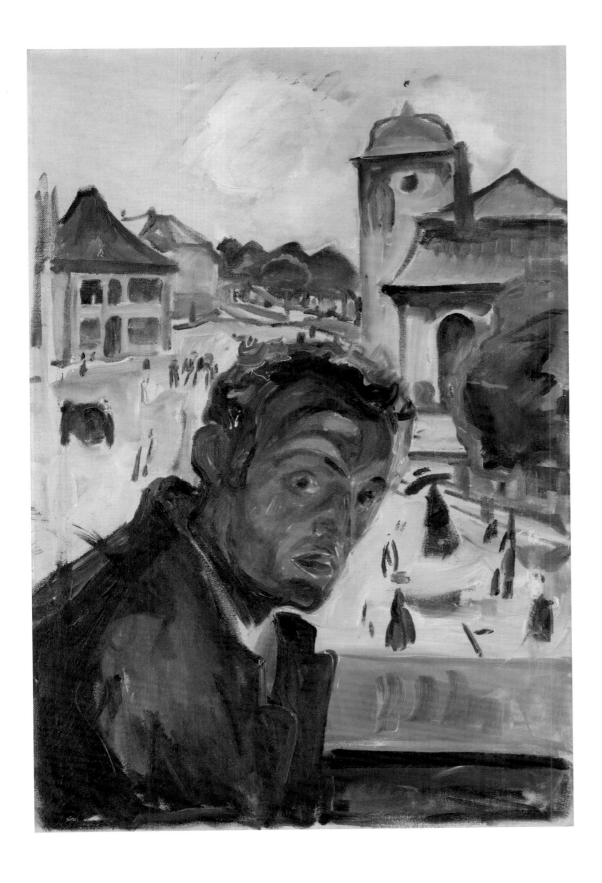

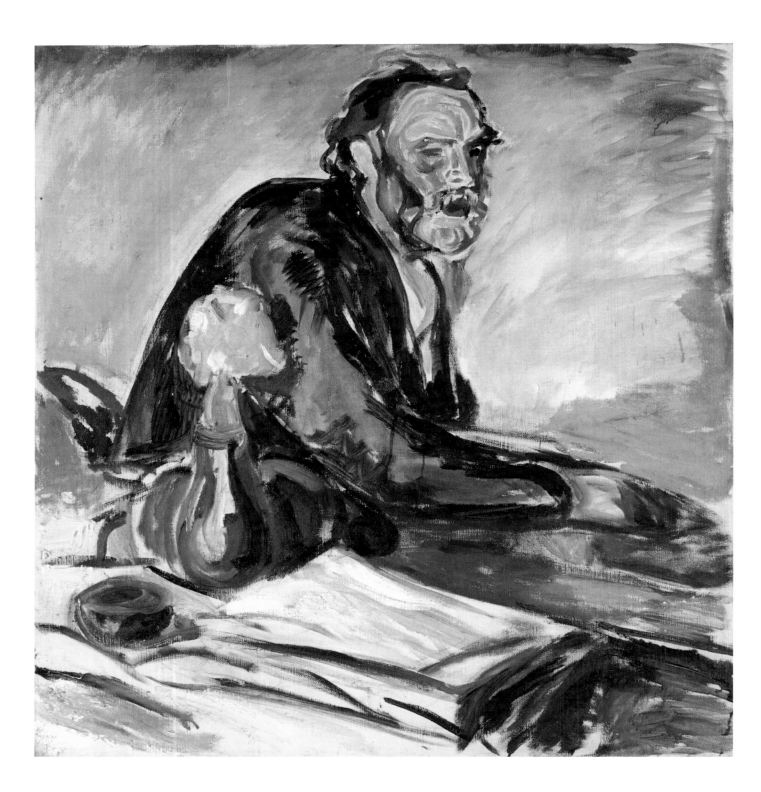

134
Man with Bronchitis
1920
Oil on canvas
100.5 x 95
Munch-museet, Oslo

135
Self-Portrait with the Spanish Flu
1919
Oil on canvas
150 x 131
Nasjonalmuseet for kunst, arkitektur
og design, Oslo

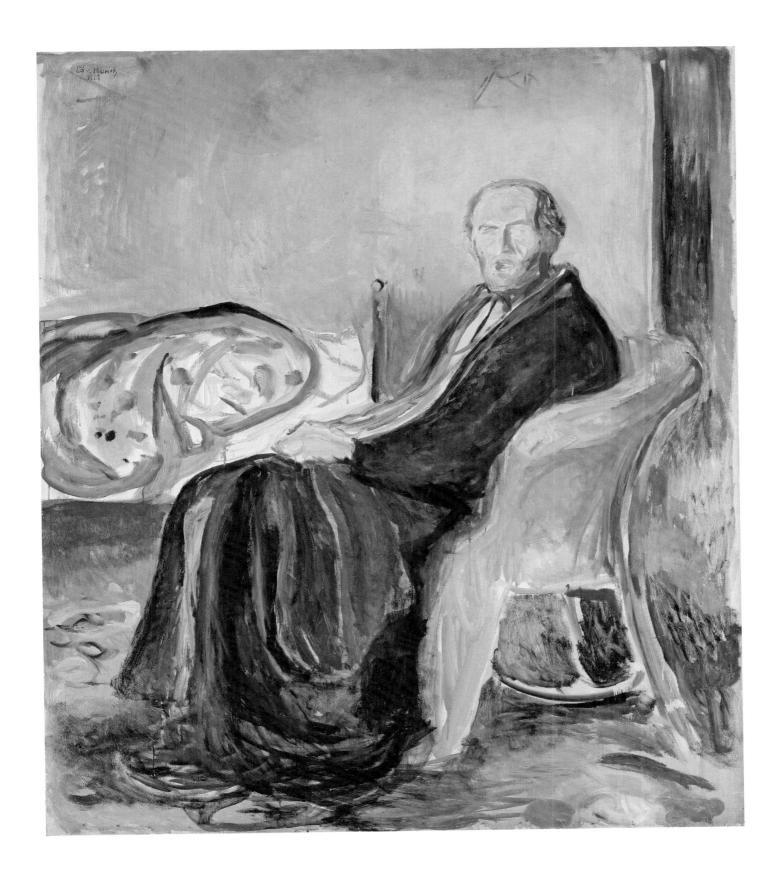

136
Self-Portrait with Bottles
?1938
Oil on canvas
118 x 93
Munch-museet, Oslo

137
The Night Wanderer
1923–4
Oil on canvas
90 x 68
Munch-museet, Oslo

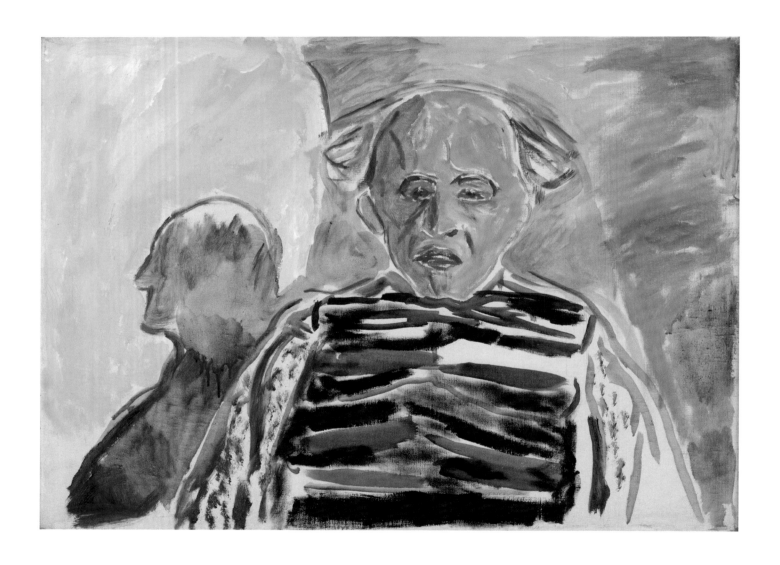

138
Self-Portrait
1940–3
Oil on canvas
57.5 x 78.5
Munch-museet, Oslo

139
Self-Portrait by the Window
1940–3
Oil on canvas
84 x 108
Munch-museet, Oslo
Not exhibited

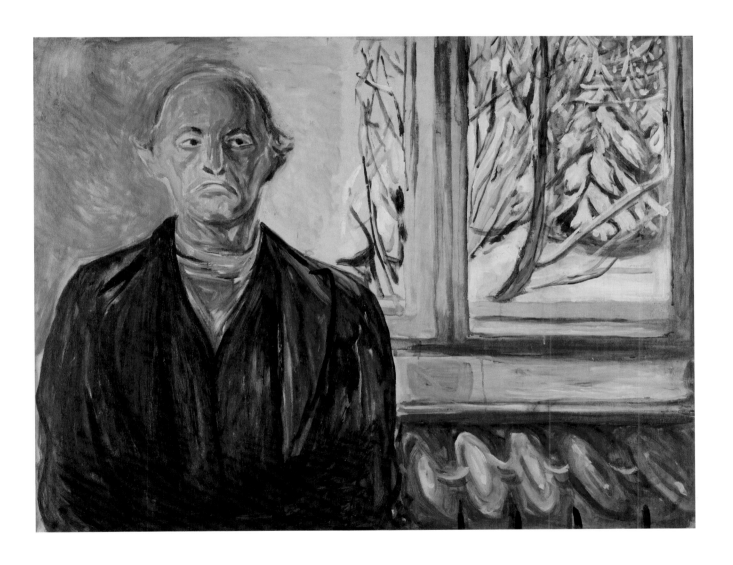

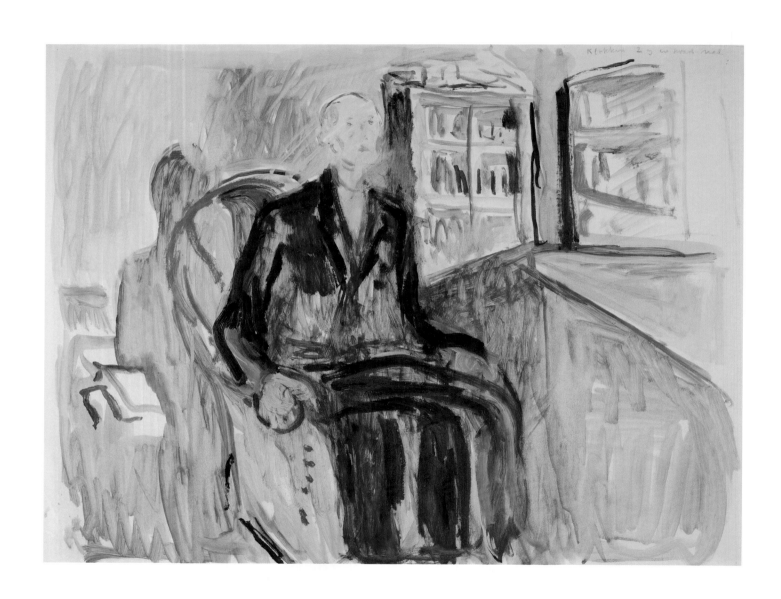

140
**Self-Portrait: A Quarter Past Two
in the Morning**
1940–4
Gouache on canvas
51.5 x 64.5
Munch-museet, Oslo

141
**Self–Portrait: Between the Clock
and the Bed**
1940–3
Oil on canvas
149.5 x 120.5
Munch-museet, Oslo

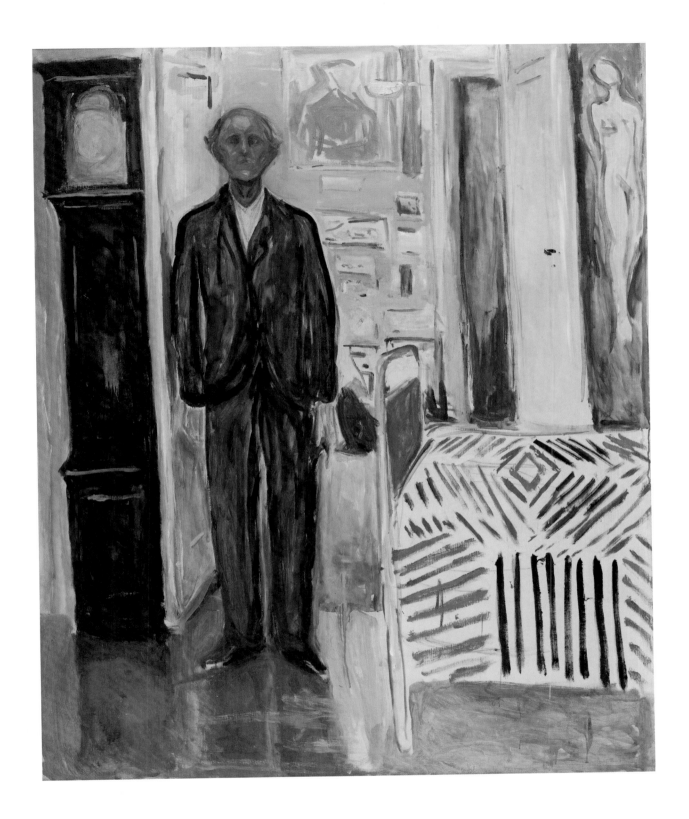

Chronology

1863
Munch is born on 12 December in Løten in the Norwegian region of Hedmark. His father is an army doctor and his mother comes from a wealthy family of naval officers and timber merchants.

1868
His mother, Laura Cathrine, dies of tuberculosis.
Munch's aunt, Karen Bjølstad, takes over the children's education.

1877
Sophie, the eldest of the five children, dies of tuberculosis on 9 November.

1879
Munch enrols at Kristiania Technical College, in accordance with his father's wishes.

1880
Admitted to the Royal College of Art and Design, to study sculpture under Julius Middelthun.

1882
Munch rents a studio in Kristiania and receives advice and encouragement from the naturalist painter, Christian Krohg. Like Krohg and the painter Frits Thaulow, Munch seems to have used a camera obscura and a camera lucida to assist with his drawing.

1883
First group exhibitions in Kristiania, at the autumn Salon in particular, in which he would participate on many more occasions.

1884
On contact with Kristiania's artistic and literary Bohème, Munch makes the acquaintance of the anarchist writer, Hans Jæger. Munch makes a late summer visit to the open-air academy in Modum founded by Thaulow.

1885
Three-week stay in Paris thanks to a bursary funded by Thaulow.

1886
Munch spends the summer on the island of Hisøya with Hans Jæger.
At the autumn Salon his canvas *The Sick Child* 1885–6 is judged to be slapdash and unfinished, causing a scandal.

1889
First solo exhibition in Kristiania in April at the Studentersamfundets Lille Sal, the Students' Union.
In May, Munch takes part in the Universal Exhibition in Paris with *Morning*.
He spends the summer in Åsgårdstrand, a small coastal village one hundred kilometres to the south of Kristiania.
A second bursary allows Munch to return to Paris once again, and to study under Léon Bonnat.
His father dies in November, causing Munch to sink into a deep melancholy.
Munch moves to Saint-Cloud, where he begins to write an illustrated journal.

1890
The Danish poet Emanuel Goldstein initiates him into symbolist thought.
Spends the summer in Åsgårdstrand and Kristiania.
A further stay in France thanks to a third bursary.
Five of his paintings are destroyed in a fire in Kristiania in December.

1891
Spends the summer in Åsgårdstrand and Kristiania.
Visits Copenhagen, Paris and Nice in the autumn thanks to a government-funded bursary.
Participates in his first exhibition in Germany, at the Glaspalast in Munich in July.
The picture *Night in Nice* becomes part of Oslo's Nasjonalgalleriet collection.

1892
Visits Nice in February–March, then stays in Saint-Jean-Cap-Ferrat as a guest of the artist Christian Skredsvig.
Spends the summer in Åsgårdstrand, then in Kristiania.
Solo exhibition at the Verein Berliner Künstler (Berlin Union of Artists) in November: his works are described as 'an insult to art'. Closing after just one week, the exhibition is later shown in Düsseldorf, Cologne, and then again in Berlin.

1893
Munch settles in Berlin and becomes close to the literary circle at the Zum Schwarzen Ferkel (The Black Piglet) tavern where he meets with August Strindberg, Dagny Juel, Stanislaw Przybyszewski, Holger Drachmann and Richard Dehmel, among others.

1894
Returns to Norway in May.
Publication of the first monograph dedicated to his work: *Das Werk des Edvard Munch*, with essays by Przybyszewski, Julius Meier-Graefe, Willy Pastor and Franz Servaes.
Meets Count Prozor, Henrik Ibsen's translator, and the theatre director Aurélien Lugné-Poe towards the end of September.
First engravings printed in Berlin at the end of the year.

1895
In Norway, he spends time with the Norwegian poet, Sigbjørn Obstfelder, and the Danish writer and critic, Helge Rode.
In June, Meier-Graefe publishes a portfolio of eight engravings by the artist.
Munch invites Ibsen to visit his solo exhibition at the Blomqvist Gallery in Kristiania in October.
The Nasjonalgalleriet purchases *Self-Portrait with a Cigarette*.
His brother Andreas dies of pneumonia on 15 December.

1896
He spends time with Strindberg, Meier-Graefe, Obstfelder, Vilhelm Krag, Frederick Delius, Hermann-Paul, Stéphane Mallarmé and Yvanhoé Rambosson in Paris.
Takes part in the Salon des Indépendants for the first time, and has a solo exhibition at Siegfried Bing's Salon de l'Art nouveau in May, on the occasion of which an article by Strindberg appears in *La Revue blanche*.
The Norwegian collector Olaf Schou commissions a copy of *The Sick Child* from him.
Munch illustrates the programmes for *Peer Gynt* (1867) and *John Gabriel Borkman* (1896), two plays by Ibsen performed at the Théâtre de l'Œuvre under the direction of Lugné-Poe.
He creates lithographs of his most well-known subjects, such as *The Sick Child* and *By the Deathbed*.
He illustrates the *Flowers of Evil* by Charles Baudelaire for Les Cents Bibliophiles, and produces the lithograph *Anguish* for the *Album of Painters and Engravers* by Ambroise Vollard.

1897
Spends the winter in Paris.
Exhibits ten canvases at the Salon des Artistes Indépendants in Paris in April, including some works from the *Frieze of Life*.
On returning to Norway in June, he spends July in Åsgårdstrand.
Autumn exhibition at the Diorama in Kristiania.

1898
Spring visits to Berlin and Paris. Returns to Norway in June and buys a house in Åsgårdstrand.
The German periodical *Quickborn* commissions illustrations from him for a special edition that includes texts by Strindberg.
Meets Tulla Larsen, with whom he would go on to have a tumultuous love affair.
Exhibition at the Art Salon in Dresden in December.

1899
Visits Nordstrand and Paris with Tulla Larsen, then Nice, Florence and Rome.
Spends the summer and autumn in Åsgårdstrand.
Admitted to the Kornhaug sanatorium at the start of the winter.

1900
Visits Berlin and Dresden, where he exhibits at the Arno Wolfframm Gallery.
Travels around the South of France, to Nice in particular, with Tulla Larsen, before continuing on to Italy.
Further admission to a sanatorium, this time in Switzerland.
Exhibition at the Diorama in Kristiania in December.

1901
Munch becomes close to the Norwegian painter Ludvig Karsten.
Takes part in the International Exhibition organised at the Glaspalast in Munich in June.
He paints the first version of *Girls on the Bridge* for Olaf Schou during the summer.
Settles in Berlin once again in November and takes part in the Vienna Secession.

1902
Purchases his first camera: a Kodak Bull's-Eye no.2 made by the American manufacturers, Eastman.
Exhibits the *Frieze of Life* at the Berlin Secession in April.
Albert Kollmann visits Åsgårdstrand during the summer.
Kollmann, an art buff, goes in search of support, commissions and sales for Munch in Germany, and would become one of his principal patrons.
Dramatic break-up with Tulla Larsen in September: Munch's left hand is injured by a revolver shot and he loses a phalanx.
Max Linde, an ophthalmologist, collector and friend of Munch, purchases an important group of engravings from him in the autumn, depicting his family and home, and writes *Edvard Munch und die Kunst der Zukunft*.
At his home, in Lübeck, the artist meets Gustav Schiefler, a judge, collector, patron and art critic who demonstrates considerable interest in his graphic works.

1903
Munch spends the winter in Berlin: January and November exhibitions at the Paul Cassirer Gallery.

While in Paris in March, he spends time with Eva Mudocci, whom he had met the previous year.
Meets the composer Frederick Delius in Grez-sur-Loing (Seine-et-Marne).
Spends the summer in Åsgårdstrand.
Exhibition at the Blomqvist Gallery, then at the Diorama in Kristiania in the autumn.
The Russian collector Ivan Morozov purchases the 1902 version of *Girls on the Bridge*.
Spends the autumn in Berlin and Lübeck.

1904
Spends the winter in Berlin.
Stays in Lübeck then Weimar, where he is a guest of Harry Graf Kessler, man of letters and patron of the arts.
In January he becomes a member of the Berlin Secession and exhibits at the Vienna Secession.
Meets the architect Henry Van de Velde and the artist Hermann Schlittgen.
The dealer, Bruno Cassirer, offers him an exclusive contract to sell his graphic works.
Important autumn exhibitions at Den Frie Udstilling (The Free Exhibition) in Copenhagen, and at the Diorama in Kristiania.

1905
Returns to Berlin and spends time in Hamburg during the winter.
Three-year contract with the Commeter Gallery for the sale and exhibition of his paintings.
Retrospective at the Mánes art association in Prague in February.
Returns to Norway during the period of political unrest leading to the separation between Sweden and Norway.
Munch and Ludvig Karsten argue and come to blows in the middle of summer. Munch leaves Norway hurriedly for Copenhagen, then travels to Chemnitz in September.
He would not return to Norway until 1909.
Stays in Hamburg and Bad Elgersburg in October, where he is treated for a nervous disorder and alcoholism.

1906
Munch spends time in Bad Kösen and Bad Ilmenau. During a visit to Weimar he is invited to teach at the Academy of Art, but his alcoholism prevents the project from coming to fruition. Max Reinhardt, the director of the Berlin theatre, Die Kammerspiele, the capital's new, intimate theatre, employs Munch to create the sets for Ibsen's *Ghosts* (1881) and *Hedda Gabler* (1890). In mid-October the painter travels to Berlin to attend the rehearsals of *Ghosts*.
Exhibitions in various European cities: Magdeburg, Berlin, Dresden, Hamburg, Bremen, Jena, Chemnitz, Hagen, Weimar, Copenhagen and Budapest.

1907
He spends the winter in Berlin working on the foyer decorations for Max Reinhardt's theatre,

subsequently known as the Reinhardt Frieze. The contract with the Commeter Gallery is cancelled.
He takes part in the Berlin Secession exhibition in April.
Munch spends time in Warnemünde, a seaside resort on the shores of the Baltic Sea in the autumn, experimenting with a variety of pictorial and photographic techniques.
The first volume of the catalogue of his graphic works is published by Gustav Schiefler, *Verzeichnis des Graphischen Werks Edvard Munchs bis 1906*.
The Paul Cassirer Gallery in Berlin opens an exhibition in September entitled *Cézanne, Herrmann, Matisse, Munch*.

1908
Spends the winter in Berlin.
Visits Paris in February and Warnemünde in March.
First works in a series dedicated to the theme of workers.
On his request, Munch is admitted to Dr Jacobson's clinic in Copenhagen in the autumn, where he is treated for a nervous breakdown until the following spring. He continues to work nevertheless, taking many photographs of himself, and to exhibit.
He is made a Knight of the Royal Norwegian Order of St Olav.

1909
Important exhibition in Kristiania, then in Bergen, Stavanger and Kristiansand, in the wake of which, Rasmus Meyer, a collector from Bergen, purchases an important set of works.
Jens Thiis acquires five major works for the Nasjonalgalleriet in Kristiania, including *Puberty*. On the invitation of Olaf Schou, Thiis chooses seven of Munch's paintings from the collector's Norwegian works, including the second version of *The Sick Child* 1896, which he would then swap for the first version 1885–6, as well as the first version of *Girls on the Bridge*.
On his return to Norway in May, Munch rents a house in Kragerø, located on Norway's south coast, around 200 km from Kristiania, where he sets up an outdoor studio.
He takes part in the competition to decorate the new lecture hall at the University of Kristiania.
Meets the cinema producer, Halfdan Nobel Roede, who would purchase several canvases from him.

1910
Spends the winter and spring in Kragerø.
Exhibits the preliminary studies for the University at the Diorama in Kristiania in March.
Munch works on other monumental works at the same time, such as *Workers in the Snow*.
While searching for a larger space in which to work, he purchases a property in Hvitsten, on the Kristiania fjord, in November and spends the winter and spring there.
The lithographic portrait of Anna and Walter

Lestikow appears in the background of a film produced by Roede, *Under Forvandlingens Lov (Under the Law of Metamorphosis).*

1911
The Kosmorama, the first cinema in Kristiania, opens on 8 January. Its owner, Roede, has prints by Munch hung on the walls.
Large exhibition at the Diorama in Kristiania in April.
Spends the autumn and winter in Kragerø.

1912
Spends the winter in Kragerø.
Takes part in the international Sonderbund exhibition in Cologne, which brings together works by van Gogh, Gauguin and Cézanne, as well as young German and European avant-garde artists. An entire room is dedicated to Munch, as to Picasso.
First exhibition in the United States in December at the American Art Galleries in New York entitled *Contemporary Scandinavian Art.* The exhibition then travels to Buffalo, Toledo, Chicago and Boston.

1913
Some time around March, Munch is once again looking for a larger working space, and rents a farm in Jeløya on the Kristiania fjord.
Visits Berlin, Frankfurt and Cologne, then Paris, London, Stockholm, Hamburg, Lübeck and Copenhagen.
Hugo Perls visits Hvitsen. During his stay, Munch invites the art historian to the cinema on several occasions.
Spends the autumn in Norway, and then returns to Berlin in October.

1914
He visits Paris, Copenhagen, Frankfurt and Berlin before spending the rest of the year in Norway.
On 29 May his plans for the University are accepted following disagreements lasting several years.
The declaration of the First World War leads to a wave of panic in Kristiania, which would soon come to be known as 'Black Monday'. Munch probably creates the engraving *Panic in Oslo* after this event.

1915
Spends spring and summer in Hvitsten.
Visits Trondheim, Moss and Copenhagen.
Takes part in the Universal Exhibition in San Francisco in February.
Solo exhibition at the Blomqvist Gallery in October.

1916
He purchases the property at Ekely on the outskirts of Kristiania, where he would end his days.
On 19 September the decoration for the University of Oslo is completed: the work *The Sun* is the central panel.
New solo exhibition at the Blomqvist Gallery in October.

1917
Curt Glaser publishes a monograph dedicated to the artist.
Solo exhibition in Copenhagen.
Retrospective at the Blomqvist Gallery in October.

1918
Munch exhibits his scenes of rural and workers' life at the Blomqvist in February, as well as a new version of the *Frieze of Life,* including a late version of *The Sick Child* 1909. He also exhibits a new canvas entitled *The Death of the Bohemian* 1915–17, which depicts the death of Hans Jæger.
The artist buys a farm at Vestby, in the south of Norway where he has a large wooden outdoor studio built to hang his canvases and rework them regularly.

1919
Munch paints a self-portrait of himself while suffering from Spanish flu.
He carries out a painting inspired by the fire that took place on 17 September in the Grønland area of Kristiania.

1920
The artist paints and draws the labourers working on the construction of a second workshop at Ekely during the summer.
He travels to Paris and Berlin for the first time since the war.

1921
Visits Berlin, Wiesbaden and Frankfurt.
Important exhibitions in Berlin, Dresden, Chemnitz, Hamburg and Munich.
The Freia chocolate factory in Kristiania commissions paintings from him to decorate its canteen.

1922
Visits Bad Nauen, Wiesbaden and Berlin in April.
Major retrospective exhibition at the Zurich Kunsthaus, followed by Berne and Basel.
In August he makes a lithograph on the theme of the funeral of the German Foreign Minister, Walter Rathenau, who had been assassinated by right-wing extremists.
With Curt Glaser acting as intermediary, Munch purchases seventy-three graphic works by German artists in order to provide them with financial support.

1923
In March he is the guest of honour, along with the Danish artist J-F. Willumsen, at an exhibition of Nordic art taking place in Gothenburg.
Travels to Zurich, Berlin, Norway and Stuttgart.

1924
April exhibition at the Neue Galerie in Vienna. The artist donates a set of graphic works, which is then put up for sale. The profits are intended to support struggling German artists.

1925
Kristiania takes the name Oslo on 1 January.
Visits Lübeck, Berlin, Venice, Munich and Wiesbaden in May.
Spends the summer in Norway.
Takes part in the International Exhibition organised at the Zurich Kunsthaus in August.
In October he leaves for Paris, then visits Copenhagen, Berlin, Chemnitz, Leipzig, Halle, Heidelberg and Mannheim.

1926
Spends the spring in Germany and the summer in Norway.
Returns to Germany in the autumn.
Important exhibition at the Mannheim Kunsthalle in November.
Munch gives a camera to his sister Inger and teaches her how to take photographs.
At Christmas, he takes a series of photographs of his works in his Ekely studio.
His sister Laura dies.

1927
Important retrospective in February at the Nationalgalerie in Berlin, then at the Nasjonalgalleriet in Oslo.
Visits Munich, Rome, Florence, Berlin, Dresden, Cologne and Paris.
On 31 August, the artist witnesses a fire in a building near his own, and reproduces the event in a painting.
He takes part in the 26th International Exhibition organised by the Carnegie Institute in Pittsburgh, which would then circulate to several American cities.
Munch begins to work on the decorations for the new Town Hall in Oslo.
He completes the sixth version of *The Sick Child.*
He regularly takes photographs between 1927 and 1932 with a variety of cameras. He also purchases a small amateur Pathé-Baby film camera, which he uses to make short films in Dresden, Oslo and Ekely.

1928
Munch makes several sketches for the decoration of Oslo Town Hall, which would never be realised.
Publication of the second volume of the catalogue of his graphic works by Schiefler.
Takes part in the New Secession in Munich in June.

1929
Munch paints and draws the labourers working on the building site for the extension of his studio at Ekely.

1930
Afflicted by an ocular disease, the artist carries out a series of drawings during his convalescence from May to August.
Many photographic self-portraits in his studio at Ekely.
Munch reacts to the publication of an article by Paul Westheim on drawn and photographic portraiture in the German magazine *Das Kunstblatt,* by drafting an article for the

magazine *Kunst og Kultur*. On this occasion
he creates a series of outdoor photographic
portraits.

1931
His aunt, Karen Bjølstad, dies.
In April, the Alfred Flechtheim Gallery in
Berlin dedicates an important exhibition to
him, which later travels partially to
Düsseldorf and Duisburg.
Visits Kragerø in October.

1932
Edvard Munch – Paul Gauguin exhibition in
February at the Zurich Kunsthaus.

1933
Jens Thiis and Pola Gauguin, the painter's
son, each publish a monograph about the
artist.
Munch receives the Grand Cross of the Royal
Norwegian Order of St Olav.

1937
The Nazis confiscate eighty-two of Munch's
works from public German collections,
judging them as 'degenerate'.
Participates in the Universal Exhibition in
Paris, as well as other important exhibitions
in Stockholm, Amsterdam and Bergen.
Visits Gothenburg in the autumn.

1938
Renewed eye problems.
Some graphic works made in Germany are
sold at auction in Oslo, many of which are
purchased by the Nasjonalgalleriet.

1939
The sale at auction in Oslo of the works by
Munch that had been confiscated from
German museums.
Takes part in the *Art in Our Time* exhibition
at the Museum of Modern Art in New York.

1940
German troops invade Norway.
The artist lives alone at Ekely and spurns all
contact with the Nazis.
He begins to work on his last self-portraits.

1944
Munch dies on 23 January at Ekely. His entire
estate is bequeathed to the City of Oslo,
including 1,100 canvases; 18,000 prints; 4,500
drawings and watercolours; 6 sculptures; 183
photographs; and 92 sketchbooks, as well as
his manuscripts and his library.

Compiled by Aurore Méchain
Translated by Laura Bennett

Select Bibliography

Catalogues Raisonnés

Gerd Woll, *Edvard Munch: Complete Paintings: Catalogue Raisonné*, London 2009, 4 vols

Gerd Presler, *Edvard Munch: Werkverzeichnis der Skizzenbücher*, Oslo and Munich 2004

Gerd Woll, *Edvard Munch: The Complete Graphic Works*, New York 2001

Gustav Schiefler, *Verzeichnis des graphischen Werks Edvard Munchs*, 2 vols.; vol.1: *Bis 1906*, Berlin 1907; vol. 2: *1906–1926*, Berlin 1928; facsimile edn, Oslo 1974

Sigurd Willoch, *Edvard Munchs raderinger*, Oslo 1950

Munch's Writing and Correspondence

J. Gill Holland (ed.), *The Private Journals of Edvard Munch: We Are Flames Which Pour out of the Earth, Madison*, Madison, Wisconsin 2005

Poul Erik Tøjner (ed.), *Munch: In His Own Words*, Munich and London 2001

Arne Eggum (ed.), *Edvard Munch and Gustav Schiefler: Briefwechsel*, 2 vols., Hamburg 1987, 1990

Edvard Munch, *Alpha et Omega*, Amiens 1990

Bente Torjusen (ed.), *Words and Images of Edvard Munch*, London 1989

Gustav Lindtke (ed.), *Edvard Munch and Dr. Max Linde: Briefwechsel, 1902–1928*, Lübeck 1974

Inger Munch and Johan H. Langaard (ed.), *Edvard Munchs Brev: Familien*, Oslo 1949

Biographies

Atle Naess, *Munch et les couleurs de la névrose*, Paris 2011

Curt Glaser, *Une visite à Edvard Munch, 1927*, Paris 2008

Ketil Bjørnstad, *The Story of Edvard Munch*, London 2005

Sue Prideaux, *Edvard Munch: Behind the Scream*, New Haven and London 2005

Inger Alver Gløersen, *Munch as I Knew Him*, Hellerup 1994

Reinhold Heller, *Munch: His Life and Work*, London 1984

Rolf Stenersen, *Edvard Munch: Close-Up of a Genius*, Oslo 1969

Studies of Munch's work

Ingrid Junillon, *Edvard Munch face à Henrik Ibsen: Impressions d'un lecteur*, Peeters 2009

Joan Templeton, *Munch's Ibsen: A Painter's Visions of a Playwright*, Seattle and Copenhagen 2008

Erik Mørstad, 'The Improvisations of Edvard Munch', *Kunst og Kultur*, vol.90, no.3, 2007, p.139–59

Arthur Lubow, 'Edvard Munch: Beyond the Scream', *The Smithsonian*, vol.36, no.12, 2006, pp.58–67

Erik Mørstad (ed.), *Edvard Munch: An Anthology*, Oslo 2006

Nikolaus Bernau, 'Wo hing Munchs Lebens-Fries? Max Reinhardt und das deutsche Theater', *Blätter des deutschen Theaters*, no.2, 2005.

Ingrid Junillon, 'Les autoportraits d'Edvard Munch à la lumière du mythe de Narcisse', *Textures*, no.9, October 2003, pp.147–79

Jay Clarke, 'Munch, Liebermann, and the Question of Etched "Reproductions"', *Visual Resources*, vol.16, no.1, 2000, pp.27–63

Petra Halkes, 'The Scream in the Age of Mechanical Reproduction', *Parallax*, vol.5, no.3, 1999, pp.114–28

Dorothy Kosinski, 'Edvard Munch and Photography', in *The Artist and the Camera: Degas to Picasso*, exh. cat., Dallas Museum of Art, 1999, pp.194–211

Iris Müller-Westermann, 'Edvard Munch: Marats Tod 1902–1930', in Elger Dietmar (ed.), *Die Metamorphosen der Bilder*, exh. cat., Sprengel Museum, Hannover 1992

Arne Eggum, *Munch and Photography*, New Haven and London 1989

David Loshak, 'Space, Time and Edvard Munch', *The Burlington Magazine*, vol.131, no.1033, April 1989, pp.273–82

Uwe M. Schneede, *Edvard Munch: Das kranke Kind: Arbeit an der Erinnerung*, Frankfurt 1984

Arne Eggum, *Edvard Munch: Peintures, esquisses, études*, Paris 1983

Ragna Stang, *Edvard Munch: The Man and the Artist*, London 1979

Kirk Varnedoe, 'Christian Krohg and Edvard Munch', *Arts Magazine*, vol.59, no.8, April 1979, pp.88–95

Werner Brunner, 'Der halbierte Edvard Munch. Zu den Arbeiterbildern', *Spuren*, vol.4, 1978, p.46–8

Henning Bock and Günter Busch (eds.), *Edvard Munch: Probleme, Forschungen, Thesen*, Munich 1973, see particularly Josef Adolf Schmoll Gen. Eisenwerth, 'Munchs fotografische Studien', pp.187–225

J. P. Hodin, *Edvard Munch*, London 1972

Exhibition Catalogues

Mai Britt Guleng (ed.), *eMunch.no – Text and Image*, exh. cat., Munch-museet, Oslo 2011

Michael Juul Holm and Henriette Dedichen (eds.), *Warhol After Munch*, exh. cat., Louisiana Museum of Modern Art, 2010

Marc Restellini (ed.), *Edvard Munch ou l'anti-Cri*, exh. cat., Pinacothèque de Paris, 2010

Jay A. Clarke (ed.), *Becoming Edvard Munch: Influence, Anxiety and Myth*, exh. cat., Art Institute of Chicago, 2009

Michael Fuhr (ed.), *Edvard Munch und das Unheimliche*, exh. cat., Leopold Museum, Vienna 2009

Øystein Ustvedt (ed.), *Edvard Munch: Det syke barn / The Sick Child*, exh. cat., Nasjonalmuseet, Oslo 2009

Ingebjørg Ydstie and Mai Britt Guleng (eds.), *Munch becoming Munch: Artistic Strategies 1880–1892*, exh. cat., Munch-museet, Oslo 2008

Dieter Buchhart (ed.), *Edvard Munch: Zeichen der Moderne*, exh. cat., Fondation Beyeler, Basel 2007

Edvard Munch: The Decorative Projects, exh. cat., The National Museum of Western Art, Tokyo 2007

Kynaston McShine, Reinhold Heller et al., *Edvard Munch: The Modern Life of the Soul*, exh. cat., The Museum of Modern Art, New York 2006

Christoph Kivelitz, and Rosemarie E. Pahlke (eds.), *Munch Revisited: Edvard Munch und die heutige Kunst*, exh. cat., Museum für Kunst und Kulturgeschichte, Dortmund 2005

Iris Müller-Westermann, *Munch by Himself*, exh. cat., Royal Academy of Art, London 2005

Magne Bruteig, *Edvard Munch. Dessins et aquarelles*, exh. cat., Musée d'Ixelles, Paris 2004

Achim Sommer and Nils Ohlsen (ed.), *Edvard Munch: Bilder aus Norwegen*, exh. cat., Kunsthalle, Emden 2004

Klaus Albrecht Schröder and Antonia Hoerschelmann (eds.), *Edvard Munch: Thema and Variation*, exh. cat., Albertina, Vienna 2003

Carmen Sylvia Weber (ed.), *Edvard Munch: Vampir: Versions of a Key Picture of Early Modernism*, exh. cat., Kunsthalle Würth, Schwäbisch Hall 2003

Kellein, Thomas (ed.), *Edvard Munch 1912 in Deutschland*, exh. cat., Kunsthalle, Bielefeld 2002

Jeffery Howe (ed.), *Edvard Munch: Psyche, Symbol and Expression*, exh. cat., Boston College McMullen Museum of Art, 2001

Elisabeth Prelinger (ed.), *After the Scream: The Late Paintings of Edvard Munch*, exh. cat., The High Museum of Art, Atlanta 2001.

Annie Bardon (ed.), *Munch und Warnemünde 1907–1908*, exh. cat., Kunsthalle, Rostock 1999

Arne Eggum, Petra Pettersen and Gerd Woll (eds.), *Munch og Ekely 1916/1944*, exh. cat., Munch-museet, Oslo 1998

Patricia G. Berman and Jane Van Nimmen, *Munch and Women: Image and Myth*, exh. cat., San Diego Museum of Art, 1997

Arne Eggum (ed.), *Edvard Munch Portretter*, exh. cat., Munch-museet, Oslo 1994

Uwe M. Schneede and Dorothee Hansen (eds.), *Munch und Deutschland*, exh. cat., Hamburger Kunsthalle, Hamburg 1994

Per Bj. Boym and Gerd Woll (eds.), *Edvard Munch: Monumental Projects, 1909–1930*, exh. cat., Lillehammer Art Museum, 1993

Marion Keiner, Johann-Karl Schmidt and Ursula Zeller (eds.), *Edvard Munch und seine Modelle*, exh. cat., Galerie der Stadt Stuttgart, 1993

Arne Eggum and Rodolphe Rapetti (eds.), *Munch et la France*, exh. cat., Musée d'Orsay, Paris 1992

Mara-Helen Wood (ed.), *Edvard Munch: The Frieze of Life*, exh. cat., National Gallery, London 1992

Ulrich Weisner (ed.), *Edvard Munch: Liebe, Angst, Tod: Themen und Variationen, Zeichnungen und Graphiken aus dem Munch-Museum Oslo*, exh. cat., Kunsthalle, Bielefeld 1980

Arne Eggum et al., *Edvard Munch: Symbols & Images*, exh. cat., National Gallery of Art, Washington 1978

Pål Hougen (ed.), *Edvard Munch and Henrik Ibsen*, exh. cat., Steensland Gallery, St. Olaf College, Minnesota 1978

Peter Krieger (ed.), *Edvard Munch: Der Lebensfries für Max Reinhardts Kammerspiele*, exh cat., Nationalgalerie, Berlin 1978

Uwe M. Schneede (ed.), *Edvard Munch: Arbeiterbilder, 1910–1930*, exh. cat., Kunstverein, Hamburg 1978

Pål Hougen and Ursula Perucchi-Petri (ed.), *Munch und Ibsen*, exh. cat., Kunsthaus, Zurich 1976

Edvard Munch: 1863–1944, exh. cat., Musée national d'art moderne, Paris 1974

Exhibited Works

Numbers at the end of entries refer to illustrations.

Measurements of artworks are given in centimetres, height before width and depth.

Self-Portrait
Selvportrett
1882
Oil on paper mounted on cardboard
26 x 19
Munch-museet, Oslo
1

Vampire
Vampyr
1893
Oil on canvas
80.5 x 100.5
Göteborgs konstmuseum, Gothenburg
14

Ashes
Aske
1895
Oil on canvas
120.5 x 141
Nasjonalmuseet for kunst, arkitektur og design, Oslo
10

Self-Portrait
Selvportrett
1895
Lithographic crayon, tusche and scraper
46.2 x 32.4
Munch-museet, Oslo
3

Towards the Forest I
Mot skogen I
1897
Woodcut
49 x 64
Munch-museet, Oslo

The Kiss
Kyss
1897
Oil on canvas
99 x 81
Munch-museet, Oslo
16

Red Virginia Creeper
Rød villvin
1898–1900
Oil on canvas
119.5 x 121
Munch-museet, Oslo
52

Street in Åsgårdstrand
Gate i Åsgårdstrand
1901
Oil on canvas
88.5 x 114
Kunstmuseum Basel, gift from Sigrid Schwarz von Spreckelsen and Sigrid Katharina Schwarz, 1979
53

Edvard Munch's Exhibition at Blomqvist's in Kristiania
Edvard Munchs utstilling hos Blomqvist, Kristiania
1902
Photograph, collodion print on paper
9.6 x 9.3
Munch-museet, Oslo
35

Edvard Munch's Exhibition at Blomqvist's in Kristiania
Edvard Munchs utstilling hos Blomqvist, Kristiania
1902
Photograph, collodion print on paper
9.4 x 9.3
Munch-museet, Oslo
34

The Girls on the Bridge
Pikene på broen
1902
Oil on canvas
100 x 102
Private Collection
20

Self-Portrait on a Trunk in the Studio, 82 Lützowstrasse, Berlin
1902
Photograph, gelatin silver print on paper
7.9 x 8
Munch-museet, Oslo
5

Self-Portrait in Bed
Selvportrett, i sengen
c.1902
Photograph, collodion print on paper
10 x 9.5
Munch-museet, Oslo
Fig.15

The Yard of 30B Pilestredet in Kristiania
Bakgården i Pilestredet 30B i Kristiania
c.1902
Photograph, gelatin silver print on paper
8.9 x 9.2
Munch-museet, Oslo
42

'The Girls on the Bridge', in the Yard of 30B Pilestredet in Kristiania
Pikene på broen i bakgården i Pilestredet 30B i Kristiania
c.1902
Photograph, collodion print on paper
10 x 9.7
Munch-museet, Oslo
41

The Yard of 30B Pilestredet in Kristiania
Bakgården i Pilestredet 30B i Kristiania
c.1902
Photograph, gelatin silver print on paper
9 x 9
Munch-museet, Oslo
43

On the Operating Table
På operasjonsbordet
1902–3
Oil on canvas
109 x 149
Munch-museet, Oslo
47

Self-Portrait in the Garden at Åsgårdstrand
1903
Photograph, gelatin silver print on paper
8.7 x 8.4
Munch-museet, Oslo
6

Self-Portrait Naked in the Garden at Åsgårdstrand
1903
Photograph, gelatin silver print on paper
8.6 x 8.2
Munch-museet, Oslo
7

Self-Portrait Inside the House at Åsgårdstrand
Selvportrett, i huset på Åsgårdstrand
c.1904
Photograph, gelatin silver print on paper
8.8 x 9.5
Munch-museet, Oslo
25

The Beach at Åsgårdstrand
Stranden i Åsgårdstrand
c.1904, posthumous print
Photograph, gelatin silver print on paper
8.6 x 8.6
Munch-museet, Oslo

Two Human Beings: The Lonely Ones
To mennesker. De ensomme
1905
Oil on canvas
80 x 110
Philip and Lynn Straus
18

Self-Portrait in Broad-Brimmed Hat
Selvportrett med bredbremmet hatt
1905–6
Oil on canvas
79 x 64
Munch-museet, Oslo
132

Weeping Nude
Grätende kvinneakt
1906
Charcoal on paper
58 x 39.5
Munch-museet, Oslo
Fig.61

Set Design for Henrik Ibsen's
'Ghosts'
Sceneutkast til Gjengangere
1906
Tempera on canvas
60 x 102
Munch-museet, Oslo
56

New Snow in the Avenue
Nysnø i alleen
1906
Oil on canvas
80 x 100
Munch-museet, Oslo
45

Self-Portrait
Selvportrett
c.1906
Photograph, collodion print on
paper
8.9 x 9.5
Munch-museet, Oslo
24

Self-Portrait
Selvportrett
c.1906
Photograph, collodion print on
paper
8.1 x 8.3
Munch-museet, Oslo
23

Self-Portrait in a Room on the
Continent I
Selvportrett i et rom på
kontinentet I
c.1906
Photograph, gelatin silver print
on paper
9 x 9
Munch-museet, Oslo
26

Self-Portrait in a Room on the
Continent II
Selvportrett i et rom på
kontinentet II
c.1906
Photograph, gelatin silver print
on paper
8.3 x 8.7
Munch-museet, Oslo
27

The Sick Child
Det syke barn
1907
Oil on canvas
118.7 x 121
Tate. Presented by Thomas Olsen
1939
12

Self-Portrait at 53 Am Strom in
Warnemünde
Selvportrett i 53 Am Strom i
Warnemünde
1907
Photograph, gelatin silver print
on paper
9 x 9.4
Munch-museet, Oslo
37

Self-Portrait with Housekeeper at
53 Am Strom in Warnemünde
Selvportrett med husholderske i
53 Am Strom i Warnemünde
1907
Photograph, collodion print on
paper
8.9 x 8.9
Munch-museet, Oslo
30

The Alte Warnow Canal Outside
53 Am Strom in Warnemünde
Alte Warnow Kanal utenfor 53
Am Strom i Warnemünde
1907
Photograph, collodion print on
paper
8.2 x 8.6
Munch-museet, Oslo

Edvard Munch's House, 53 Am
Strom in Warnemünde
Edvard Munchs hus i 53 Am
Strom i Warnemünde
1907
Photograph, collodion print on
paper
8.9 x 8.9
Munch-museet, Oslo

'Zum Süssen Mädel'
[To the Sweet Young Girl]
1907
Oil on canvas
85 x 130.5
Munch-museet, Oslo
59

The Murderess
Mordersken
1907
Oil on canvas
89 x 63
Munch-museet, Oslo
58

Jealousy
Sjalusi
1907
Oil on canvas
89 x 82.5
Munch-museet, Oslo
57

Weeping Woman
Gråtende kvinne
1907
Oil on canvas
103 x 87
Munch-museet, Oslo
69

Weeping Woman
Gråtende kvinne
1907
Oil on canvas
174 x 59.5
Munch-museet, Oslo
70

Weeping Woman
Gråtende kvinne
1907
Oil on canvas
121 x 119
Munch-museet, Oslo
65

Weeping Woman
Gråtende kvinne
1907
Bronze
38.2 x 27.5
Munch-museet, Oslo
75

Rosa Meissner at the Hotel Room
in Warnemünde
Rosa Meissner på Hotel Rohn i
Warnemünde
1907
Photograph, gelatin silver print
on paper
8.7 x 7.3
Munch-museet, Oslo
66

Self-Portrait on the Beach in
Warnemünde with Brush and
Palette
Selvportrett på stranden i
Warnemünde med pensel og palett
1907
Photograph, gelatin silver print
on paper
8.7 x 8.7
Munch-museet, Oslo
8

Rosa and Olga Meissner on the
Beach in Warnemünde
Rosa og Olga Meissner på
stranden i Warnemünde
1907
Photograph, collodion print on
paper
9 x 8.9
Munch-museet, Oslo
31

Self-Portrait with Rosa Meissner
on the Beach in Warnemünde I
Selvportrett med Rosa Meissner
på stranden i Warnemünde I
1907
Photograph, collodion print on
paper
8.9 x 8.7
Munch-museet, Oslo
32

Self-Portrait with Rosa Meissner
on the beach in Warnemünde II
Selvportrett med Rosa Meissner
på stranden i Warnemünde II
1907
Photograph, collodion print on
paper
8.5 x 8
Munch-museet, Oslo
33

Weeping Woman
Gråtende kvinne
1907–9
Oil on canvas
63 x 60
The Stenersen Collection, Bergen
Kunstmuseum, Bergen
68

Weeping Woman
Gråtende kvinne
1907–9
Oil and crayon on canvas
110.5 x 99
Munch-museet, Oslo
67

Self-Portrait 'à la Marat'
at Dr Jacobson's Clinic in
Copenhagen
Selvportrett 'à la Marat' på
dr. Jacobsons klinikk i København
1908–9
Photograph, gelatin silver print
on paper
8.1 x 8.5
Munch-museet, Oslo
29

Self-Portrait as an Invalid in the
Clinic of Dr Jacobson,
Copenhagen
Selvportrett med sykepleier på
dr. Jacobsens klinikk i København
1908–9
Photograph, gelatin silver print
on paper
8.5 x 9.1
Munch-museet, Oslo
9

Self-Portrait at Dr Jacobson's
Clinic in Copenhagen
Selvportrett på dr. Jacobsens
klinikk i København
1908–9
Photograph, gelatin silver print
on paper
9.2 x 9.2
Munch-museet, Oslo
28

Self-Portrait in the Clinic
Selvportrett fra klinikken
1909
Oil on canvas
100 x 110
The Rasmus Meyer Collection,
Bergen Kunstmuseum, Bergen
131

Weeping Woman
Gråtende kvinne
1909
Oil on canvas
88.5 x 72
Westfälisches Landesmuseum für
Kunst und Kulturgeschichte,
Münster
71

Self-Portrait in the Studio at
Skrubben in Kragerø
Selvportrett i atelieret på
Skrubben i Kragerø
1909–10
Photograph, gelatin silver print
on paper
9 x 9.4
Munch-museet, Oslo
36

Galloping Horse
Galopperende hest
1910–12
Oil on canvas
148 x 120
Munch-museet, Oslo
44

Man with a Sledge
Mann med kjelke
1910–12
Oil on canvas
77 x 81
Munch-museet, Oslo
77

Sailors in the Snow
Sjøfolk i snø
1910–12
Oil on canvas
96 x 76
Munch-museet, Oslo
93

Black and Yellow Men in the
Snow
Sort og gul mann i snø
1910–12
Oil on canvas
58 x 51
Munch-museet, Oslo
94

The Sun
Solen
1910–13
Oil on canvas
162 x 205
Munch-museet, Oslo
76

Children in the Street
Barn i gata
1910–15
Oil on canvas
92 x 100
Munch-museet, Oslo
78

Man and Woman by the Window
with Potted Plants
Mann og kvinne ved vindu med
potte blomster
1911
Oil on canvas
91 x 100
Munch-museet, Oslo
63

The Yellow Log
Den gule tømmerstokken
1912
Oil on canvas
129 x 160.5
Munch-museet, Oslo
48

Landscape and Dead Bodies
Landskap og døde Kropper
c.1912
Watercolour and charcoal on
paper
56.4 x 77.7
Munch-museet, Oslo
50

Self-Portrait Facing Left
1912–13
Woodcut with gouges
44 x 35.3
Munch-museet, Oslo
4

Workers on Their Way Home
Arbeidere på hjemvei
1913–14
Oil on canvas
201 x 227
Munch-museet, Oslo
51

Man and Woman
Mann og kvinne
1913–15
Oil on canvas
89 x 115.5
Munch-museet, Oslo
61

Kiss on the Shore by Moonlight
Kyss på stranden i måneskinn
1914
Oil on canvas
77 x 100
Munch-museet, Oslo
17

Puberty
Pubertet
1914–16
Oil on canvas
97 x 77
Munch-museet, Oslo
60

Sacrament
Sakrament
1915
Oil on canvas
120 x 180
Munch-museet, Oslo
64

Death Room
Dødsværelse-scene
c.1915
Gouache on paper
49.2 x 63.5
Munch-museet, Oslo
Fig.51

Self-Portrait in Bergen
Selvportrett i Bergen
1916
Oil on canvas
89.5 x 60
Munch-museet, Oslo
133

Vampire in the Forest
Vampyr i skogen
1916–18
Oil on canvas
150 x 137
Munch-museet, Oslo
15

John Gabriel Borkman: Borkman
in the Snow (Act IV)
John Gabriel Borkman: Borkman
i snøen (Akt 4)
1916–23
Charcoal on paper
48 x 65
Munch-museet, Oslo
54

Women in the Bath
Kvinner i badet
1917
Oil on canvas
72 x 100
Munch-museet, Oslo
80

Panic in Oslo
Panikk i Oslo
1917
Woodcut
38 x 54.6
Munch-museet, Oslo
87

Thorvald Løchen
Thorvald Løchen
1917
Oil on canvas
199 x 119
Munch-museet, Oslo
55

Workers on Their Way Home
Arbeidere på hjemvei
1918–20
Watercolour, crayon and charcoal
on paper
57 x 78
Munch-museet, Oslo
49

Self-Portrait with the Spanish Flu
Selvportrett i spanskesyken
1919
Oil on canvas
150 x 131
Nasjonalmuseet for kunst,
arkitektur og design, Oslo
135

Murder on the Road
Mord i alleen
1919
Oil on canvas
110 x 138
Munch-museet, Oslo
46

The Artist and his Model
Kunstneren og hans modell
1919–21
Oil on canvas
128 x 153
Munch-museet, Oslo
62

Building Workers in the Snow
Håndlanger på stigen
1920
Oil on canvas
127 x 103
Munch-museet, Oslo
96

Man with Bronchitis
Mann med bronkitt
1920
Oil on canvas
100.5 x 95
Munch-museet, Oslo
134

Fire
Brann
1920
Lithograph
54 x 74
Munch-museet, Oslo
88

Street Workers in the Snow
Gatearbeidere i snø
1920
Oil on canvas
105 x 151
Fram Trust
95

Starry Night
Stjernenatt
1922–4
Oil on canvas
120.5 x 100
Munch-museet, Oslo
83

The Night Wanderer
Nattevandreren
1923–4
Oil on canvas
90 x 68
Munch-museet, Oslo
137

Ashes
Aske
1925
Oil on canvas
139.5 x 200
Munch-museet, Oslo
11

The Sick Child
Det syke barn
1925
Oil on Canvas
117 x 118
Munch-museet, Oslo
13

The Death of the Bohemian
Bohemens død
1925–6
Oil on canvas
65 x 104
Munch-museet, Oslo
79

The House is Burning!
Huset brenner!
1925–7
Oil on canvas
80 x 135
Munch-museet, Oslo
89

Film made with a Pathé-Baby
camera in Dresden, Oslo, Aker
1927
5 min 17 sec, 9.5 mm black and
white silent film
Munch-museet, Oslo
84–5

The Girls on the Bridge
Pikene på broen
1927
Oil on canvas
100 x 90
Munch-museet, Oslo
21

The Late 'Frieze of Life' in the
Outdoor Studio at Ekely
Den sene Livsfrisen i uteatelieret
på Ekely
1927–30
Photograph, gelatin silver print
on paper
8.7 x 11.2
Munch-museet, Oslo
22

Execution
Eksekusjon
1929
Lithograph
26.5 x 40.5
Munch-museet, Oslo
Fig.105

The Artist's Injured Eye:
Landscape with House and People
Kunstneren og hans syke øye.
Landskap med hug og me
1930
Watercolour and pencil on paper
32.8 x 47.1
Munch-museet, Oslo
123

The Artist's Injured Eye: Kneeling
Nude with Eagle
Kunstneren skadded øye.
Knelende kvinnnelig akt med øye
1930
Watercolour on paper
50 x 32.2
Munch-museet, Oslo
122

The Artist's Injured Eye: Optical
Illusion from the Eye Disease
Kunstneren og hans syke øye. Seks
av optiske illusjoner
1930
Watercolour and pencil on paper
49.7 x 47.1
Munch-museet, Oslo
115

The Artist's Injured Eye: Sketches
of Optical Illusions
Kunstneren og hans syke øye.
Skisser av optiske illusjoner
1930
Watercolour, charcoal and crayon
on paper
64.8 x 50.2
Munch-museet, Oslo
124

The Artist's Injured Eye: Sketches
of Optical Illusions
Kunstneren og hans syke øye.
Skisser av optiske illusjoner
1930
Watercolour and crayon on paper
50 x 64.6
Munch-museet, Oslo
125

The Artist's Injured Eye: Three
Optical Illusions
Kunstneren og hans syke øye. Tre
optiske illusjoner
1930
Watercolour on paper
50 x 64.6
Munch-museet, Oslo
128

The Artist's Injured Eye: Sketches
with Optical Illusions
Kunstneren og hans syke øye.
Skisser av optiske illusjoner
1930
Watercolour and crayon on paper
49.8 x 65.1
Munch-museet, Oslo
126

The Artist's Injured Eye: Six
Optical Illusions
Kunstneren og hans syke øye. Seks
av optiske illusjoner
1930
Watercolour on Paper
50 x 64.6
Munch-museet, Oslo
129

Disturbed Vision
Synsforstyrrelse
1930
Oil on canvas
80 x 64
Munch-museet, Oslo
[Woll 1676]
116

Disturbed Vision
Synsforstyrrelse
1930
Oil on canvas
80 x 64
Munch-museet, Oslo
[Woll 1675]
118

Young Woman Weeping by the
Bed
Gråtende ung kvinne ved sengen
1930
Lithograph
40 x 36.2
Munch-museet, Oslo
72

Young Woman Weeping by the
Bed
Gråtende ung kvinne ved sengen
1930
Lithograph
40 x 36.2
Munch-museet, Oslo
73

The Artist with a Skull: Optical
Illusion from the Eye Disease
Kunstneren med kranium. Optisk
illusjon under øyesykedo
1930
Watercolour and pencil on paper
65 x 50.2
Munch-museet, Oslo
127

The Artist's Injured Eye
(and a Figure of a Bird's Head)
Kunstneren og hans syke øye,
med fugl
1930
Crayon on paper
50.2 x 31.5
Munch-museet, Oslo
117

Self-Portrait in front of 'Death
of Marat' I, Ekely
Selvportrett foran Marats død I.
Ekely
1930
Photograph, gelatin silver print
on paper (posthumous print from
original negative in O. Vaering's
Archives)
11.4 x 7.8
Munch-museet, Oslo
104

Self-Portrait in front of 'Death
of Marat' II, Ekely
Selvportrett foran Marats død II.
Ekely
1930
Photograph, gelatin silver print
on paper
11.2 x 8.8
Munch-museet, Oslo
106

'The Splitting of Faust', Collage
in the Outdoor Studio at Ekely
Fausts splittelse. Collage i
uteatelieret på Ekely
1932
Photograph, gelatin silver print
on paper
8.5 x 11.3
Munch-museet, Oslo
39

Self-Portrait in the Studio at
Ekely
Selvportrett i atelieret på Ekely
1932
Photograph, gelatin silver print
on paper
11.4 x 9
Munch-museet, Oslo
99

The Fight
Slagsmålet
1932
Oil on canvas
90 x 120
Munch-museet, Oslo
90

The Fight
Slagsmålet
1932-5
Oil on canvas
105 x 120
Munch-museet, Oslo
92

Uninvited Guests
Ubudne gjester
1932-5
Oil on canvas
75 x 101
Munch-museet, Oslo
91

The Splitting of Faust
Fausts spaltning
1932-5
Oil on canvas
100 x 117
Munch-museet, Oslo
86

Two Human Beings: The Lonely
Ones
To mennesker. De ensomme
1933-5
Oil on canvas
90.5 x 130
Munch-museet, Oslo
19

Self-Portrait with Bottles
Selvportrett med flasker
?1938
Oil on canvas
118 x 93
Munch-museet, Oslo
136

Self-Portrait
Selvportrett
1940-3
Oil on canvas
57.5 x 78.5
Munch-museet, Oslo
138

Self-Portrait: Between the Clock
and the Bed
Selvportrett. Mellom klokken og
sengen
1940-3
Oil on canvas
149.5 x 120.5
Munch-museet, Oslo
141

Self-Portrait: A Quarter Past Two
in the Morning
Klokken to og en kvartnat
1940-4
Gouache on canvas
51.5 x 64.5
Munch-museet, Oslo
140

Kristian Schreiner, Standing
Kristian Schreiner, stående
1943
Woodcut
70.1 x 34.7
Munch-museet, Oslo
81

Kiss in the Field
Kyss på marken
1943
Woodcut
40.5 x 49
Munch-museet, Oslo
82

Index